ART AND MIRACLES IN
MEDIEVAL BYZANTIUM

ART AND MIRACLES IN MEDIEVAL BYZANTIUM

* * * * * * * * * *

THE CRYPT AT HOSIOS LOUKAS AND ITS FRESCOES

* * * * * * * * * *

CAROLYN L. CONNOR

PRINCETON UNIVERSITY PRESS
PRINCETON, NEW JERSEY

Copyright © 1991 by Princeton University Press
Published by Princeton University Press, 41 William Street, Princeton, New Jersey 08540
In the United Kingdom: Princeton University Press, Oxford

LIBRARY OF CONGRESS CATALOGING-IN-PUBLICATION DATA

Connor, Carolyn L. (Carolyn Loessel)
Art and miracles in medieval Byzantium : the crypt at Hosios Loukas
and its frescoes / Carolyn L. Connor.
p. cm.
Includes bibliographical references and index.
ISBN 0-691-04084-2 (alk. paper)
1. Mural painting and decoration, Byzantine—Greece—Voiōtia.
2. Mural painting and decoration, Greek—Greece—Voiōtia.
3. Orthodox Eastern Church and art. 4. Salvation in art.
5. Christian art and symbolism—Medieval, 500–1500—Greece—Voiōtia.
6. Crypts—Greece—Voiōtia. 7. Hosios Loukas (Monastery :
Voiōtia, Greece) I. Title.
ND2754.V64C66 1991
755'.2'094951—dc20 90-44684

This book has been composed in Linotron Bembo

Princeton University Press books are printed on acid-free paper
and meet the guidelines for permanence and durability of the
Committee on Production Guidelines for Book Longevity
of the Council on Library Resources

Printed in the United States of America by
Princeton University Press, Princeton, New Jersey
1 3 5 7 9 10 8 6 4 2

To Bob, Chris, and Steve

CONTENTS

* * * * * * *

ILLUSTRATIONS

* * * * * * *

THE illustrations appear at the end of the book. Locations of frescoes, indicated in parentheses by letter and number or direction, are keyed to the plan in figure 10. All photographs are by the author, unless otherwise noted.

COLOR PLATES

FIGURES

ACKNOWLEDGMENTS

* * * * * * *

THIS BOOK, a revision of my doctoral dissertation, owes its greatest debt to Thomas Mathews of the Institute of Fine Arts of New York University. Not only did he make himself available at all times but was always willing to apply his remarkable insights and knowledge to my task and to share my joy and excitement in it; I feel extraordinarily fortunate for his guidance. I would also like to thank Doula Mouriki of the Polytechnion in Athens, who first directed me toward this study and for whose generosity with her time and expertise I am immeasurably grateful. Peter Brown of Princeton University unfailingly provided advice, criticism, and inspiration when they were most needed. Joanna Hitchcock of Princeton University Press worked with amazing speed and skill as well as good cheer to help bring this work into print. Other friends and colleagues who contributed to this book in various ways are too numerous to name, but I remember them all with sincere gratitude.

The fieldwork and photography for this book were carried out in Greece in 1984 and 1985 with the support of Theodore Rousseau Fellowships awarded by the Institute of Fine Arts. A substantial portion of the writing was done at Dumbarton Oaks, where I was the recipient of a Summer Fellowship in 1985. I enjoyed a J. Clawson Mills Fellowship at the Metropolitan Museum of Art in 1988–89, which enabled me promptly to revise and prepare this manuscript for publication; it also provided the opportunity for a most productive and congenial association with the Medieval Art Department and the Watson Library.

The most vital support has come from my husband, Bob, with his patience, encouragement, and criticism, not to mention his unending willingness to do battle with our computer when I had technical difficulties. Likewise, I salute my sons Chris and Steve, who grew up with this book; I thank them for their help with the photography, and for their music. I dedicate this book to them.

Chapel Hill, North Carolina
August 24, 1989

ABBREVIATIONS

* * * * * * *

AB	*The Art Bulletin*
AASS	*Acta sanctorum* (Antwerp, 1643ff.)
AJA	*American Journal of Archaeology*
BCH	*Bulletin de Correspondance Hellenique*
BIAB	*Bulletin de l'institut archéologique bulgare*
BSA	*Annals of the British School in Athens*
BZ	*Byzantinische Zeitschrift*
CA	*Cahiers Archéologiques*
CorsiRav	*Corsi di Cultura sull'Arte Ravennate e Bizantina*
CP	*Synaxarium Ecclesiae Constantinopolitanae*, ed. H. Delehaye in *Propylaeum ad Acta Sanctorum* (Brussels, 1902)
CRAI	*Comptes rendus de l'Académie des Inscriptions et Belles Lettres*
DACL	*Dictionnaire d'archéologie chrétienne et de liturgie* (Paris, 1907ff.)
DCAE	*Deltion tēs Christianikēs Archaeologikēs Hetaireias*
DOP	*Dumbarton Oaks Papers*
EO	*Echos d'Orient*
JOB	*Jahrbuch der Oesterreichischen Byzantinistik*
Lex ChrIk	*Lexikon der christlichen Ikonographie*
LexTK	*Lexikon für Theologie und Kirche*
OCA	*Orientalia Christiana Analecta*
OCP	*Orientalia Christiana Periodica*
PG	*Patrologiae Cursus, series Graeca*, ed. J. P. Migne (Paris, 1857ff.)
REB	*Revue des Etudes Byzantines*
RBK	*Reallexikon zur Byzantinischen Kunst*
RQ	*Römische Quartalschrift*

ART AND MIRACLES IN
MEDIEVAL BYZANTIUM

INTRODUCTION

* * * * * *

ON STEPPING OUT of the bright Greek sunlight and descending a short flight of steps to enter the crypt below the great church at the monastery of Hosios Loukas, the modern visitor is at first hard-pressed to discern what this cool, spacious, dimly lighted interior represents. Gradually, in the light from the doorway and a small window, figures and colors on richly painted surfaces begin to emerge. From the vaults overhead haloed faces gaze down, and around the walls are scenes showing Christ, the Virgin, and apostles, all surrounded by intricate and varied ornament. Sheltered in this lavish setting are three massive tombs, two on either side of the sanctuary and one in a niche directly opposite the doorway, prominently labeled on its modern facing of white marble: "The Tomb of Saint Loukas." We are standing then in a holy space intimately associated with the monk Loukas, the monastery's tenth-century founder, a healer and worker of miracles whose fame brought crowds of pilgrims and also great wealth to the place, making it one of the most sumptuous and ambitious of all Byzantine monastic foundations.

Perhaps it is understandable that this burial chapel has received little attention through the years, for the two beautifully preserved churches at the monastery have overshadowed it. The great domed Katholikon contains the most comprehensive program of mosaic decoration of the middle Byzantine period, dazzling in its array of christological scenes, figures of saints, and ornament, while adjoining it the elegantly proportioned church of the Panagia with its refined sculptural decoration complements its more grandiose neighbor. The crypt, on the other hand, accessible only by the stairway on the south side of the Katholikon, was until recently coated with a thousand years' accumulated soot, badly obscuring the frescoes. However, a cleaning by the Greek Archaeological Service in the 1960s revealed the excellent state of preservation, as well as the high artistic quality of these frescoes.

Virtually all wall surfaces in the crypt are painted in fresco in fresh, bright colors, and the program is exceptional in its completeness. In eight lunettes around the walls appear scenes of Christ's Passion and Resurrection. In the vaults overhead are forty medallion portraits of apostles, warrior martyrs, and holy men, all set within floral and geometric borders and imitation polychrome marble revetment. Most inscriptions are still clearly legible. Hues range from somber cobalt blue and rich jade green to subtle pastel shades of blue, pink, ocher, and gray. Draperies are enlivened by dramatic linear and zigzag plays of folds and white highlights. Figures are further animated by intense expressions and graceful attitudes and gestures. The style of the frescoes is closest to the mosaics and frescoes of the Katholikon above, but shares many features with art of the tenth-century "Macedonian Renaissance," as well as with eleventh-century monumental painting. The sophistication of the work suggests models from the artistic capital of the empire, Constantinople. The need to catalogue and interpret this body of material is evident, for

these newly "rediscovered" frescoes are among the most remarkable survivals from the medieval period.

The frescoes were first studied by George Sotiriou, who published a short article on them in 1930; unfortunately Sotiriou was unable to provide full description and illustration at this time. Certain frescoes in the crypt were cited in an article of 1969 by Manolis Chatzidakis, of importance for its examination of the questions of the date and foundation of the monastery even though its central thesis has not won general acceptance. It was not until Eustathius Stikas's publications of 1970 and 1974 of the restoration work at the monastery that an archaeological report on the monument was made available along with an approach to some of the most important points it raises. The first of Stikas's valuable works recorded the dramatic results of the cleaning of some of the frescoes; its two dozen illustrations of the crypt, however, made clear the need for a comprehensive documentation with high-quality photographs and details suitable for scholarly study. More recent publications have dealt with other aspects of the monastery (see especially the works by T. Chatzidakis-Bacharas, L. Bouras, and D. I. Pallas listed in the bibliography). While the mosaics of the Katholikon continue to hold a central position in the history of Byzantine art, the frescoes of the crypt have remained relatively unknown and the implications of their program unexplored. The time has come for the crypt with its frescoes to take its place among the great artistic accomplishments of the time. In addition study of the crypt provides us with the key to understanding this important monastery as a whole, its origins and its place in medieval Byzantium.

WHEN I started work on the crypt in 1983 I was not yet fully aware of its significance or of the approach its study would require. Drawn by the beauty of the frescoes, I felt they needed to be analyzed artistically and iconographically and brought to the attention of scholars in the field. Thanks to the generous help of Greek colleagues, Doula Mouriki in particular, I was able to study and photograph the frescoes in several intensive campaigns. As the work progressed, however, the wider implications of the crypt and its decoration became more apparent. Suddenly the issues raised by the material began to take on new dimensions: the possibility of exploring, for example, how artists worked side by side in different media, how patrons saw themselves within the monastic world, what were the practices of a miracle cult, and where the crypt stands in relation to ancient monastic burial traditions. Otherwise remote subjects became accessible as I delved into the monument's meaning. Although the dating and patronage of Hosios Loukas were not originally central concerns in my study, the final synthesis of findings pointed unmistakably to answers to these long-debated questions as well. The need to explore the diverse themes in the material underlined the importance of setting this monastery in its contemporary artistic, religious, social, and historical context.

The questions posed by the frescoes and their physical setting led to a progressively deeper understanding of their meaning. A homely analogy to the process would be the peeling of an onion, with successive layers of meaning emerging as one progressed. A variety of sources gradually made it possible to understand the successive layers and relate them to their contemporary context. Among these documents were monastic

charters, service books, land records, and—the most crucial and fascinating of all—the Vita or Life of St. Luke of Steiris, the biography of the monastery's founder, whom I will call Holy Luke from here on.

This Vita, probably written by an anonymous monk in the 960s, relates in vivid detail the saint's childhood, rebellious youth, self-imposed ascetic training, and miracles, including his ability to levitate and prophesy. Among this document's most important contributions are its descriptions of the founding and building phases of the monastery. From these can be derived, we will see, new and precise dates in the tenth century for the building of the Panagia church and the Katholikon with its crypt. The Vita also describes the healing cult and the wide variety of beliefs and practices focused on the saint's tomb. At the end of the Vita are fifteen accounts of posthumous healing miracles, sometimes experienced after the application of oil from the lamp hanging over the tomb or of moisture exuded from it, and sometimes through incubation, the practice of allowing certain suppliants to sleep by the tomb at night to await helping dreams or visions. Not only are the miracles witnesses to the function of the crypt, but they also provide through a wealth of incidental detail a glimpse of a cross section of middle Byzantine society and its relation to the monastery. One can even imagine being part of the crowd that gathered at the monastery every February 7, Luke's feast day, when this Vita was read aloud to the assembled faithful. This document, to which we will refer frequently, responds to many questions posed by the crypt and its decoration and also provides a new perspective on the monastery as a whole. A collaborative translation and commentary of the Vita is forthcoming. Substantial excerpts are utilized in this work to help illustrate and describe the monastery's context and to assess the chronology and dating of its churches.

THE many-faceted approach just described is reflected in the division of this book into three chapters. Since the book is based on the frescoes of the crypt, the first chapter presents them in catalogue form, with technical descriptions and iconographic analyses of each unit of the decoration, along with a complete set of plates. I took the photographs in two summer campaigns at the monastery, in 1983 and 1984. By using infrared and ultraviolet photography I was able to read several inscriptions on the portrait medallions that scholars have never before seen; this new information made possible a more comprehensive study of the overall program of the frescoes. Repaintings in some of the frescoes were also shown using these methods, which hold interesting possibilities for the study of other monuments.

Since the catalogue cannot of itself elucidate the meaning and interpretations of the frescoes, the chapter continues with discussions of their program and style. A close examination reveals that the themes of the program of the frescoes are thoroughly in keeping with the crypt's evident use as a funerary chapel. The concerns for salvation and resurrection lie behind the choice and arrangement of scenes and portraits—for example, scenes from the Passion of Christ are accompanied by scenes showing the events of Holy Week. The apse has unfortunately suffered extensive water damage and now has only a small area of plaster clinging to the brick and stone masonry. This patch, however, car-

ries the incised outline of a halo and traces of pigment of an inclined head, sufficient evidence to confirm that the subject of the fresco was the Deesis, the image of Christian intercession par excellence. This image, of which my photographs recorded the last traces, is the key to the program's meaning. The Deesis with its intercessory and eschatological connotations should be understood in conjunction with the compositions of the vault inside the entrance to the crypt; on entering one finds overhead the figure of Christ with arms outstretched toward a group of monks on the left wall and Luke of Steiris on the right. The hope of salvation is thus implicitly extended to every suppliant entering the crypt. The theme of intercession is reiterated in the vaults with their medallion portraits of warriors, apostles, and holy men. The preponderance of monks and holy men among these portraits, especially those famed for their miraculous powers, not only glorifies the monastic tradition but, as I will show, also stresses another function of the crypt: miracles were worked here at Holy Luke's tomb. The program of the frescoes reflects the crypt's specific role as a charged and holy place deep within the monastery and closely linked with the saint himself. Here his intercessory power was entreated and shared by the monastery's own community of monks and by those who traveled to the monastery hoping to experience miracles.

This first chapter thus deals directly with the frescoes introduced in the catalogue, analyzing in detail for the first time their program and style. As a result it is now possible to set this monument into its wider artistic environment and to show its relation to other media and programs of decoration. It is also from this chapter that the other two derive, for the frescoes also present the challenges taken up in the following chapters: the function of the crypt is discussed in the second chapter, and its social context in the third.

Crypts are rare in the Byzantine world and it is not immediately evident how such a crypt would have been used. It was thus necessary to explain how it functioned liturgically and to what degree the function had shaped the crypt's architecture and decoration. The second chapter is therefore entitled "Architecture and Liturgy." It was clear from the start that this crypt must have served as a burial chapel because it contains three tombs, including that of the founder and patron saint of the monastery. Architectural prototypes for the Hosios Loukas crypt can be identified, especially in Palestine at the monasteries of the great abbots Sabas and Euthymius of the fifth and sixth centuries. While architectural parallels for the middle Byzantine period are more difficult to establish, funerary practices indicate the close parallelism between the crypt at Hosios Loukas and koimeteria or funeral chapels, such as those at Bachkovo in Bulgaria or at the Pantocrator Monastery in Constantinople. The preserved typika or charters of these and of other now-lost monasteries describe the use of these chapels according to prescribed wishes of founders or to traditions concerning the burial and honoring of founders. An additional insight provided by this analysis of funerary practices is that a church's narthex in the middle and late Byzantine period was often used in ways similar to those of funerary chapels or crypts. Liturgies for burial and commemoration of monks and holy men at their tombs, described in service books, typika, and Lives of saints, confirm that celebration of the Eucharist was part of services of commemoration; because the sanctuary of the crypt is equipped with altar, chancel barrier, and prothesis niche, it appears

that the Eucharist was indeed celebrated in the crypt, probably as part of the services of burial and commemoration of monks, abbots, and patrons. A further liturgical use of the crypt emerges from consulting the Vita: its role in the miracle cult for which the monastery became famous. Through the example of Hosios Loukas I show that this crypt, properly interpreted, lets us recognize a feature of wider significance for the history of Byzantine architecture: architectural function repeatedly and continuously helped determine architectural form.

In the third chapter I discuss further features of the historical and religious context of the monument and thus reconstruct a hypothetical picture of the circumstances that inspired its creation. The initial problem is to explain the lavishness of the buildings and decoration of this remote monastery, for in size the Katholikon rivals the largest monastic foundations still standing. Although we know from descriptions in literary sources of what may have been comparable ensembles, the richness of mosaic and painted decoration and ornament is unsurpassed in any surviving church. Where did the money come from for such an undertaking? What was the incentive or stimulus for the project? Who might have been responsible? How was this expenditure justified in such an isolated location? A wide range of documents suggests answers to these questions: land tenure records, the charter of a burial society active in the region, and other texts offer a plausible reconstruction of the circumstances of the monastery's creation.

The first clue to the monastery's patronage was found in the frescoes, in four medallion portraits of abbots in the southeast vault of the crypt. The four subjects appear in sensitive, realistic portraits seemingly painted from life, rare occurrences in monumental decoration. The abbots, whose identities had never been adequately explained, can now be identified as two contemporary leaders of monasticism, Athanasius of Athos and Luke the Stylite of Constantinople, both of whom later were recognized as saints by the Orthodox church. With them, and I think intentionally associating themselves with these famous abbots, are the two principal monastic donors of the monastery, the abbots Theodosius and Philotheus.

The historical circumstances of this period in Byzantine history provide the logical connection between these abbots and the monastery. One of the most important events of the time was the reconquest in 961 of the island of Crete, an event that has a direct relation to our monastery: Holy Luke prophesied this recapture. Crete was held for over one hundred years by the Arabs, and during this period Arabs on the island were able to raid Greek lands, often devastating the coastal cities of the region and accumulating vast wealth. The recapture is very likely the key to the monastery's lavishness, for the booty from the campaign was probably the ultimate source of the funds needed to complete and decorate the Katholikon. Military leaders had paid for the building of monasteries before. The general Nicephorus Phocas had, for example, given to Athanasius of Athos the funds necessary to found the monastery of the Great Lavra. At Hosios Loukas military personnages frequently appear in the decoration of the Katholikon and the crypt. The Vita makes clear that the saint was often in contact with military and political leaders and the elite of the administrative region of Hellas. It is, moreover, explicit about the role of the general Krinites in the building of the first church on the site, the church of

the Panagia. Similarly, the Katholikon, built around the time of the recapture, is likely to have had patrons connected with the military and who had benefited from the fall of Crete.

We can be even more specific about the sources of patronage for Hosios Loukas. If, as seems likely, the Theodosius just mentioned was one of the abbots responsible for the building of the Katholikon, we can even claim that this Theodosius is in all probability the same person identified as Theodore Leobachos. One document mentions this Theodore as the most influential person in the monastery's history; another associates him with the wealthy governing Leobachos family of nearby Thebes; and an inscription at the monastery makes explicit the connection between Theodosius and Theodore. We know of the common Byzantine practice in which a wealthy member of the civil or military aristocracy retires to a monastery late in life, taking a saint's name starting with the same letters as his worldly name; often he handsomely endows the monastic establishment as his future place of burial and in return for the monks' eternal prayers for his salvation. In this way the wealthy Theodore Leobachos became the monk Theodosius, later the abbot who funded the building and decoration of the luxurious Katholikon. He finally was laid to rest here in the crypt along with his equally titled and wealthy brother Philotheus. Thus, as they had planned, these brothers were buried in the tombs near that of the revered saint, with their portraits, clearly labeled Theodosius and Philotheus, painted in the vaults above.

Now it is for the reader to approach the crypt and its setting, envisioning this program of frescoes, testing the arguments presented in this work, examining the passages from the Vita and their implications, addressing the many remaining questions concerning the monument, and extending the analogies to see if they pertain to other monuments of the medieval world. In order to make the book more accessible to the nonspecialized reader, I have transliterated most quotations from original sources. I have used Greek only where it is necessary for precision or to provide a linguistic context in more crucial passages.

Thanks in large part to the many useful suggestions and ideas offered by friends and colleagues in various disciplines, which greatly illuminated my work on this book, there is more light now at the foot of the steps as we visit the crypt at Hosios Loukas. These beautiful frescoes with their complex layers of meaning—long seen by monks and pilgrims in the flickering lamplight during services and prayers—lead us a little closer to the colorful individuals and society that produced them.

THE FRESCOES

THE FRESCOES OF the crypt cover virtually all the vault and wall surfaces; only the capitals and shafts of the four stone pillars and the walls of the bone vaults remain unembellished. Several types of decoration are immediately distinguishable and can be related to the various architectural surfaces. Structurally the crypt forms three clear divisions: the entranceway, consisting of a short barrel-vaulted passage; the main interior space, consisting of nine groin-vaulted bays supported by four central pillars and a sanctuary consisting of a groin-vaulted bay and an apse; and three barrel-vaulted passages on the west end, the so-called bone vaults (for these divisions see the plan in figure 2, and for views of the interior of the crypt see figures 3–9). The main block of interior space is approximately twenty-eight feet square and nine feet high.

The wall surfaces with painted decoration are well preserved, for the most part, throughout the crypt, with the exception of the apse where most of the plaster has fallen leaving bare brick and stone masonry. The entrance vault and the ten groin vaults retain almost all of their frescoes remarkably intact, although there is some surface damage from seepage of water. Eight of the lunettes created by the groin vaults around the walls retain their frescoes, while one, in the north end, has its plaster but no trace of painted decoration. The lower surfaces of the lunettes and walls on either side of the entrance have suffered somewhat due to vandalism; graffiti appear especially on the walls at the entrance.

The interior is lit only by natural light from the window in the apse and from the open entrance door, making it difficult for a visitor to distinguish much about the surroundings or the fresco decoration. Since there are no indications of further window openings, the medieval viewer must have relied on lamplight and candlelight; indeed, at the apex of every vault are hooks intended for the suspension of lamps. Artificial illumination of the walls or vaults reveals a wealth of figural compositions and areas of ornament in startlingly fresh, bright colors and subtle pastel hues, thanks to their recent cleaning by the Greek Archaeological Service.[1] They can be divided systematically into groups, as

[1] Stikas, "Nouvelles observations," p. 312: "Nous avons procédé dernièrement à la publication d'une étude concernant le monastère de St Luc. Nous y avons été poussé par le désir de publier les résultats d'une recherche qui s'est poursuivie durant une période de vingt cinq ans; rassemblement de nouveaux éléments, observations, riche matériel, à l'occasion de l'accomplissement, aux frais de la Société Archéologique, sous notre surveillance directe, en tant qu'architecte inspecteur (1938–1958), puis en qualité de directeur de la Direction d'Anastylose des monuments antiques et historiques, de travaux considérables de réfection, consolidation et anastylose des bâtiments de ce très important monastère byzantin."

outlined in the schematic plan in figure 10, by the types of subjects represented. In the apse was a Deesis, now destroyed. In the groined vaults are portrait medallions of forty saints and holy men set against ornamental backgrounds of rinceaux or stars. Around the walls are eight lunettes containing feast and Passion scenes. Above the entrance in the apex of the barrel vault is a rainbow medallion with a Blessing Christ; a group of monks is depicted on the left wall and the patron saint, St. Luke of Steiris, on the right. Ornamental bands frame the areas of figural decoration and line the soffits of the arches, emphasizing architectural divisions; painted panels imitating marble and intarsia revetment constitute the rest of the crypt's ornamental decoration, mostly around arches and in the lowest zone.

The spatial organization and decoration of the crypt are unlike the standard middle Byzantine church or chapel. For one thing, the crypt is not oriented around the relation between sanctuary and dome. Instead, the bays represent a uniform scheme of decoration, with ten articulated groin vaults each divided into four segments; these contain intersecting systems of three different categories of saints' portraits in their vaults: Warrior Martyrs, Apostles, and Holy Men. The illusion is not of one majestic vault as in a domed church but of many glimpses of star-studded skies from which emanate the mystical presences of saints.[2] Below the low vaults, the lunettes around the walls bring scenes of the life of Christ and his Passion into direct and intimate contact with the viewer. These are not inaccessible figures and scenes, distant and remote from those entering the crypt—as for example in the mosaic lunettes of the narthex or squinches of the naos in the Katholikon above; since the scenes are at eye level they are approachable, permitting a closeness and mingling of the viewer's space and that of the images, encouraging contemplation and private expressions of devotion. The following catalogue and iconographic analysis will serve as a first step toward understanding the fresco decoration of the crypt.

The catalogue is organized in the following way. The first category of decoration, the ten groin vaults with their portrait medallions, will be divided into three subcategories: warrior martyrs, apostles, and holy men. Twelve warrior martyrs appear in the vaults of the middle bays running from north to south (B, E, and I in fig. 10; see also figs. 11–24). On the main east-west axis are portraits of the twelve apostles (D, F, and G; see figs. 25–36). In the vaults of the corner bays (A, C, H, and J) are the holy men, sixteen in all (see figs. 37–52). The portrait medallions are referred to by bay (A through J) and by vault segment, numbered one through four starting in the north and proceeding clockwise (see the plan in figure 10). The basic information included at the beginning of each entry is: the location, the name of the saint (names have been anglicized or latinized throughout for easiest, most familiar usage—for example, Theodore rather than the transliteration from the Greek, Theodoros, or Vikentius rather than Bikentios), the saint's date(s), reference to the illustration by figure or plate number(s), the inscription as preserved, the saint's feast day according to the Synaxarium of Constantinople fol-

[2] The mosaic rinceaux and starry skies of the Mausoleum of Galla Placidia in Ravenna offer the best parallel with this type of vault decoration.

lowed by his epithet(s) in that document, and finally the column reference(s) in it after the abbreviation *CP*; finally, the reference to any special offices of commemoration. The text of each entry consists of first a technical then an iconographic description. The *Painter's Manual of Dionysius of Fourna*, a set of rules compiled in 1730–34 by the monk Dionysius, specifies how a painter should depict saints and events, in accordance with a long established tradition. References are made, where appropriate, to this important document.

The second category of decoration comprises eight scenes in lunettes around the crypt's walls: seven from Christ's Passion, Death, and Resurrection and the Dormition of the Virgin (figs. 53–77). The scenes are labeled according to their directional positions on the walls of their respective bays, as indicated on the schematic plan. Again, basic references follow the title of each scene: illustration numbers, inscriptions, relevant biblical passages, and liturgical references; the text again consists of a technical and an iconographic analysis.

The third category comprises the frescoes of the entrance vault (K on the plan) and lateral walls (figs. 78–81). The fourth major category is the ornament (figs. 84–93). The remaining compositions, the Deesis in the apse (fig. 83) and a scene of intercession on the southwest wall (fig. 82), will be discussed in the section "Program and Meaning," following the catalogue.

CATALOGUE

The Portrait Medallions

WARRIOR MARTYRS

B 1 *St. Theodore Stratelates*, died ca. 319. (fig. 11)

O A[ΓΙΟΣ], rest of inscription lost, but possibly visible a hundred years ago when Kremos made this identification.[3]

February 8: General, Great Martyr (*CP*, 451, 449, 735).

First Saturday in Lent (*Lenten Triodion*, pp. 283–98).

Theodore appears as a youth with a long oval face, curly brown hair, moustache (?), and pointed beard. He has a light yellow halo. He wears a light blue tunic with a yellow collar and a dark blue chlamys with a yellow *tablion* fastened with a brooch containing five pearls. In his right hand is a white cross. The background is dark green; on the left an alpha inside an omicron, the abbreviated *ho hagios*, is visible in faint white letters.

The condition of this portrait is poor to fair; it has suffered flaking, probably from water seepage, and general pitting; the eyes have been gouged out and appear as white patches. Around the outer contour of this head (like St. Demetrius's, B 2) is a "shadow," perhaps indicating an alteration.

The cult of St. Theodore Stratelates is associated with Euchaita in the Hellenopontus where he was martyred under Licinius ca. 319 during a persecution of the Christians.[4]

The *Painter's Manual* describes the saint as "a

[3] Kremos, *Phokika*, 2:194.

[4] See Delehaye, *Les légendes grecques*, pp. 11–39; he concludes Theodore Stratelates and Theodore Tiron are the same person in two capacities, as built on hagiographical accounts. See also Der Nersessian, *Psautiers grecs*, p. 97.

young man with curly hair and a brown rush-like beard."[5] The face in our fresco closely resembles an encaustic icon of the sixth century at Mount Sinai showing Theodore with the Virgin and Child, another saint, and angels,[6] as it also does a portrait of Theodore Stratelates in the Menologium of Basil II.[7] In the sixth-century church of Sts. Cosmas and Damian in Rome Theodore appears to the right in the apse composition in regal court dress; he has the same facial features as in our medallion.[8] In the Menologium he wears military dress with a thorax just as he does in the great full-length fresco portrait in the northwest chapel at Hosios Loukas[9] and in the mosaic image in the dome of the inner narthex at Nea Moni.[10] Both Theodores—Stratelates and Tiron—appear in the mosaic decoration of soffits of the main arches of the Katholikon at Hosios Loukas, again dressed in full military armor; Theodore Tiron appears once more in a bust in the *diakonikon* wearing tunic and chlamys.[11] His missing counterpart in the *prothesis* probably appeared similarly. Both types of dress were current in images with consistently similar facial features.

Theodore Stratelates is sometimes paired with St. George, also a Great Martyr of the church, as in the Katholikon mosaics and in two Sinai icons;[12] In the frescoes of Hagioi Anargyroi in Kastoria he appears in a row of full-length saints who include not only the Tiron but George, Demetrius, and Prokopius who are the other three saints whose portraits appear in vault B.[13] The same four appear among the standing military saints on the south wall of the pareeclesion at Kariye Djami.[14]

Bibliography: *LexChrIk*, 8:444–46; Mouriki, *Nea Moni*, pp. 142–43.

B 2 *St. Demetrius*, died ca. 300. (fig. 12)
ΔΗΜΗΤΡΙΟΣ (infrared photograph, see fig. 13).
October 26: Great Martyr, Thaumaturge of Salonika (*CP*, 163–66; also October 8 and April 9).

In the portrait Demetrius is young with an oval face, beardless but wearing a moustache. He has short, dark, curly hair that curls below his ears. His halo is ocher. His tunic is blue with a brown-gold collar; his chlamys is green with a brown-gold tablion covered with tendril ornament. He holds a white cross. The background is maroon; his name is in black.

The portrait is in fair condition, the fresco surface having suffered general flaking and pitting. The name, barely discernible in a normal photo, stands out clearly in the infrared photo (fig. 13); this technique also reveals a "shadow" around the outside contour of the hair, perhaps indicating an alteration.

According to tradition, Demetrius was martyred under Maximian at Salonika; soon after, the city adopted him as its patron saint and protector.[15] The great basilica of Hagios Demetrios was built in the fifth century; his cult centered first on his shrine in the nave and later on the *hagiasma* in the crypt; he is a *myroblytos*, that is, his relics emitted a healing "myrrh."[16]

The *Painter's Manual* describes him as "a young man with moustaches."[17] The earliest depictions of the saint appear in the mosaics of the basilica in Salonika and date from the fifth to seventh century; he is shown dressed in long tunic and chlamys with tablion;[18] the same is true in the scene of Demetrius's martyrdom in the Menologium of Basil II.[19] Lemerle claims this is

[5] Hetherington, *Painter's Manual*, p. 56.

[6] Sotiriou, *Sinai*, pls. 4–7; Wietzmann, *Sinai Icons*, pl. IV.

[7] *Il Menologio*, p. 383.

[8] Beckwith, *Early Christian and Byzantine Art*, p. 126.

[9] Chatzidakis, *Peintures Murales*, pp. 69–70 and pls. 4, 5; and *Il Menologio*, p. 383.

[10] Mouriki, *Nea Moni*, p. 142 and pls. 59, 198.

[11] Mouriki, (*Nea Moni*, p. 256) states "It is almost certain that a similar bust of Theodore Stratelates appeared in the corresponding position in the conch of

the prothesis, which has lost its mosaic decoration."

[12] Sotiriou, *Sinai*, pls. 4, 52.

[13] Pelekanides, *Kastoria*, pls. 21, 23.

[14] Underwood, *Kariye Djami*, 1:249–50.

[15] Delehaye, *Les légendes grecques*, pp. 103–9.

[16] PG, 116:1421, *Miracula S. Demetrii*.

[17] Hetherington, *Painter's Manual*, p. 56.

[18] Sotiriou, *Basilikē tou Hagiou Dēmētriou*, pls. 60, 62, 63, 65, 68, 71; though the facial type and dress are similar to Hosios Loukas, these early representations have no moustache and no curls below the ears.

[19] *Il Menologio*, p. 139.

the preiconoclastic type, whereas the warrior type showing Demetrius in armor comes later.[20] The warrior type appears in the Katholikon mosaic of St. Demetrius at Hosios Loukas; his features are similar both in the mosaic and in the fresco of the crypt: cleft chin, large stylized ears, and almond-shaped eyes with carefully delineated lids and shadows. However the fresco depicts him with a moustache whereas the mosaic does not. Nor does he have a moustache in a third depiction at Hosios Loukas—in the southwest chapel, where he appears in a full-length portrait and wearing armor.[21]

Demetrius is often associated with St. George, and with Procopius and Nestor as in an icon of the eleventh century at Mount Sinai.[22] An early fourteenth-century example of warrior saints in monumental decoration appears in the parecclesion at Kariye Dajmi in Istanbul; here he is paired with St. George in a row of the commanders of the army of holy martyrs.[23]

Bibliography: *LexChrIk*, 1:41–45; Réau, 3:372.

B 3 *St. George*, died ca. 303. (fig. 14)
Ο Α[ΓΙΟΣ] ΓΕ . . . ΙΟΣ
April 23: Glorious, Great Martyr; Victory Bearer (*CP*, 623).

The portrait of St. George is the best preserved in this vault. He has a pale, youthful face, distinctly rounder than those of the other holy warriors. Below the round contour of his brown hair is a double row of curls to just below his ears. His halo is ocher. He wears a bluish white tunic with a round medallion on the sleeve and a dark ocher collar, and a red-brown chlamys with dark ocher tablion covered with a tendril pattern. The chlamys is held by a brooch with four pearls. He holds a white cross. The background is apple green with some letters of his name legible, inscribed in black. The medallion is well preserved.

St. George is claimed by several countries. He is traditionally a native of Cappadocia—a soldier under Diocletian. Nikomedia or Lydda in Syria was the site of his martyrdom; at the Syrian site there was an important cult of St. George with many churches dedicated to him. The body was reputedly taken to Egypt from Syria where he was the special patron saint of military men.[24]

The *Painter's Manual* describes him as "a young man, beardless."[25] This is his general appearance in an early Sinai icon of the Virgin and Child with saints and angels where he stands on the right of the central group while St. Theodore Stratelates is on the left.[26] The same round-headed, curly haired facial type is preserved in the twelfth-century frescoes at the Hagioi Anargyroi at Kastoria where he is paired with St. Demetrius.[27] Here, as in the Katholikon mosaics at Hosios Loukas, he is part of an assembly of warrior saints that remains consistent but with some variations throughout Byzantine art.[28]

B 4 *St. Procopius*, died ca. 303. (fig. 15)
Ο Α[ΓΙΟΣ] . . . Κ . . . Π . . .
July 8: Great, Holy Martyr (*CP*, 805).

Procopius has an oval face and dark brown hair to well below his ears and he is beardless. The halo is light ocher. Over a light blue tunic with dark yellow collar he wears a dark blue chlamys with dark yellow tablion; collar and tablion are covered with a tendril pattern. He holds a white cross. The background is deep maroon; the abbreviated *ho hagios* of his name, appearing as an alpha within an omicron, is visible on the left in black; traces of several more letters are barely visible on the right.

The condition of this medallion is fair to poor as it is badly pitted and flaked from water seepage; the eyes have been rubbed out.

Procopius has the identical description in the

[20] "Anciennes représentations de St. Démétrios," *DCAE* (1980–81): 1–10.
[21] Stikas, *Oikodomikon Chronikon*, pl. 76.
[22] Sotiriou, *Sinai*, pl. 47.
[23] Underwood, *Kariye Djami*, 1:252 and pl. 253.
[24] Delehaye, *Les légendes grecques*, pp. 45–56.
[25] Hetherington, *Painter's Manual*, p. 56.

[26] Sotiriou, *Sinai*, pl. 6.
[27] Pelekanides, *Kastoria*, pl. 21.
[28] See Goldschmidt and Weitzmann, *Elfenbeinskulpturen*, pls. 32a, 33a, 38a, for ivory carving in the tenth and eleventh centuries; Underwood, *Kariye Djami*, 1:252 and pls. 488–501; Babić, *Chapelles*, pp. 107–10; Restle, *Cappadocia*, 3: pls. 508, 509.

Painter's Manual to St. George: "a young man, beardless," and along with George, Demetrius, and Theodore Stratelates he is among the first four martyrs listed in this section of the manual;[29] the same group makes up the group of portraits in vault B. Of all the military saints studied by Delehaye, Procopius has the clearest origins and history.[30] He was martyred in Palestine under Diocletian and his tomb and center of his cult are at the basilica of St. Procopius in Caesarea. Eusebius recounted his martyrdom and this account was used by Metaphrastes for his tenth-century version. Procopius was a lector before later becoming a soldier.

The oldest depiction of the saint is at Santa Maria Antiqua in Rome. He was popular in Cappadocian fresco decoration.[31] At Hosios Loukas he appears in mosaic in the south soffit of the western arch of the naos; here his full length portrait shows him fully armed but with very similar facial features to the crypt fresco. In a Sinai icon of the eleventh century he is depicted with Demetrius and Nestor;[32] the shape of his head and hair are similar to the Hosios Loukas fresco. In tenth- and eleventh-century ivories he appears armed with other military saints.[33] In the Hagioi Anargyroi, Kastoria, he has a different hair style.[34]

Bibliography: *LexChrIk*, 8:229–30.

E 1 *St. Nicetas*, died ca. 370. (fig. 16)
 Inscription lost; identified by Kremos.[35]
 September 15: Holy Martyr (*CP*, 45–46);
 PG, 117:50.

Nicetas appears as a young man with oval face, moustache, and short beard with slight cleft. His curly brown hair is fullest just below the ears. His halo is light ocher. He wears a light green tunic with ocher collar under a gray chlamys with light ocher tablion ornamented with diagonal hatching; a brooch with four pearls fastens the chlamys. He holds a white cross. The background is dark red; no traces of inscriptions are visible. The fresco is very well preserved.

Nicetas was martyred around 370 on the Danube by the Arians. His relics were brought to Mopsuestia (Cilicia) in 375; a church was founded in Constantinople to house some of his relics.

According to the *Painter's Manual* his appearance is "similar to the description of Christ."[36] He is depicted as a soldier in Cappadocian frescoes.[37] In the Menologium of Basil II, one of his rare depictions in manuscript painting, he is also in military dress but, though his features resemble those in our fresco portrait, he has no moustache.[38]

In the southwest chapel at Hosios Loukas, his full-length fresco portrait shows him in ceremonial dress; facial features and hair closely resemble the crypt fresco but there is only a hint of a beard with a slight cleft, and no moustache.[39]

Bibliography: *LexChrIk*, 8:42.

E 2 *St. Nestor*, early fourth century. (fig. 17)
 NE . . . TΩP
 October 27: Holy Martyr (*CP*, 167).

Nestor appears as a young man with oval face, brown moustache, and slightly cleft short beard. His hair is full and falls in loops to just below his ears. His halo is painted light ocher. His tunic is pinkish red with dark ocher collar; his chlamys, which is fastened with a brooch of four pearls, is dark gray-blue with a dark ocher tablion ornamented with a tendril motif. He holds a white cross with terminal dots at the ends of the arms. The letters of his name are faintly discernible in black on the green background; this background is painted with clearly visible brushstrokes in swirls of green with the lightest shade closest to the contour of the halo and progressively darker shades near the medallion's border. The fresco medallion is very well preserved.

[29] Hetherington, *Painter's Manual*, p. 56.
[30] Delehaye, *Les légendes grecques*, pp. 77–79.
[31] Restle, *Cappadocia*, 2:28–29, 124, 251.
[32] Sotiriou, *Sinai*, pl. 47.
[33] Rice, *Art of Byzantium*, pls. 99, 101.
[34] Pelekanides, *Kastoria*, pl. 23b.

[35] Kremos, *Phokika*, 2:194.
[36] Hetherington, *Painter's Manual*, p. 57.
[37] Restle, *Cappadocia*, 2:191.
[38] *Il Menologio*, p. 37.
[39] See Chatzidakis, *Peintures murales*, pls. 45, 48; Stikas, *Oikodomikon Chronikon*, pl. 73b.

Nestor belongs to the army of holy warriors through his association with St. Demetrius, with whom he was martyred at Salonika under Galerius when he killed the emperor's favorite gladiator in combat in the hippodrome.[40]

The *Painter's Manual* refers to him as "a young man, beardless."[41] In a Sinai icon of the eleventh century he appears as in this fresco with tunic, chlamys, and cross in his hand.[42] In the miniature showing his martyrdom in the Menologium of Basil II, his appearance is similar to the medallion but, as with Nicetas, he has no moustache in the miniature.[43] In his full-length portrait in the southwest chapel at Hosios Loukas, Nestor appears with cuirass and cloak; he is beardless with flowing hair and does not resemble his counterpart in the crypt.[44] An example of Nestor with a beard and moustache appears at Cefalù where he is the only warrior saint who is not beardless.[45]

Bibliography: *LexChrIk*, 8:35.

E 3 *St. Eustathius*, second century. (fig. 18)
 Inscription illegible except in infrared photograph (see fig. 19).[46]
 September 20: Holy and Great Martyr (*CP*, 59–61).

Eustathius or Eustace is depicted as a young man with brown hair, moustache, and slightly cleft short beard. His hair forms curls over his forehead and falls in loops to just below his ears. His halo is ocher. He wears a gray tunic with an ocher collar under a dark green chlamys with ocher tablion; collar and tablion are decorated with a tendril design. Four pearls indicate the

brooch fastening the chlamys. He holds a white cross. The background is deep red with the inscribed name only visible in the infrared photograph. The background is painted in swirls with the inner area around the halo being lighter in hue than the outer edges near the border of the medallion. The medallion is well preserved except for some deterioration on the surface of the hair.

Eustathius was martyred along with his family under Hadrian. His cult was popular in both the East and West in the Middle Ages.

In the *Painter's Manual* he is "Eustathius Placidas," described as "gray-haired, with a rounded beard."[47] In ivories he is bearded and appears in armor, as in the Harbaville triptych where he is paired with St. George.[48] In the Menologion of Basil II he appears at his martyrdom with his family, standing in the fire inside a great bronze bull; his portrait corresponds very closely to the crypt portrait medallion: he wears similar dress and has similar hair, moustache, and beard.[49] He appears in Cappadocian wall painting at Soğanlı Dere (second half of the eleventh century) and at Tokalı Kilise of the tenth century.[50] A further example in monumental wall painting appears at Hagios Nikolaos Kasnitzes in Kastoria.[51]

E 4 *St. Mercurius*, died mid-third century. (fig. 20)
 . . . ΚΟΥ . . . ΟΣ
 November 25 or 26: Holy Martyr (*CP*, 258–59).

Mercurius appears as a young man with a short

[40] Cormack, *Writing in Gold*, p. 59.
[41] Hetherington, *Painter's Manual*, p. 57.
[42] Sotiriou, *Sinai*, p. 47.
[43] *Il Menologio*, p. 141.
[44] Chatzidakis, *Peintures murales*, pls. 57, 59; from what remains of the medallion portrait in mosaic of Nestor in the soffit of the south arch in the naos of the Katholikon, it can be seen that he has flowing hair like the portrait in the southwest chapel (see Stikas, *Oikodomikon Chronikon*, pl. 43b). In a tenth- to eleventh-century example in monumental painting, at the Hagioi Anargyroi at Kastoria, he is a different type again (see Pelekanides, *Kastoria*, pl. 27a).
[45] Demus, *Mosaics of Norman Sicily*, p. 325, n. 527.

[46] The inscription was already illegible to Kremos one hundred years ago (see Kremos, *Phokika*, 2:194).
[47] Hetherington, *Painter's Manual*, p. 57.
[48] Rice, *Byzantine Era*, pl. 64.
[49] *Il Menologio*, p. 53.
[50] Restle, *Cappadocia*, 3:pl. 467; at Tokalı the scene of Eustathius's martyrdom along with his family in the bronze bull appears on the south parapet slab, just as it was depicted in the Menologium of Basil II. The similarity poses interesting questions about the models for the Tokalı artists as well as for the Menologium (see Epstein, *Tokalı*, p. 78 and fig. 117).
[51] Pelekanides, *Kastoria*, pl. 260b.

beard and a moustache. His broad rounded head is framed by curly dark hair coming down to just below his ears. His halo is ocher. His blue-gray tunic with brown collar is worn under a dark gray chlamys with brown tablion decorated with diagonal cross-hatching. The chlamys is held by a brooch with four pearls. He holds a white cross. The background is green; several letters of his name are legible to the right, painted in black. The background is painted in swirls with brushstrokes clearly visible; lighter shades of green appear mostly to the right of the halo and darker shades on the left. The portrait is well preserved except for the partially flaked inscription.

Mercurius is one of the four great martyrs of the Eastern church, along with George, Theodore, and Procopius; he is associated with Cesarea in Cappadocia, which was his place of origin according to hagiographical accounts.[52] He had an angelic vision, which lead to his conversion and martyrdom under Decius. Miracles took place at his burial spot.

The *Painter's Manual* describes him as "a young man with an incipient beard."[53] He is a popular saint in Cappadocian fresco painting.[54] He also appears in a fresco of the twelfth century at Hagios Nikolaos Kasnitzes in Kastoria.[55] In an eleventh-century fresco in the church of Hagios Merkourios on Corfou, he appears without beard or moustache but with the same general round facial type.[56] Manuscript painting preserves depictions of St. Mercurius: in the Homilies of Gregory of Nazianzus (Paris, Bibliothèque Nationale, gr. 510), he is shown killing Julian the Apostate;[57] he has short hair and beard and his features are similar to those in our fresco. His portrait in the scene of his martyrdom in the Menologium of Basil II strongly resembles the crypt medallion.[58]

In the Katholikon of Hosios Loukas he appears in the north soffit of the great western arch of the naos; in this full-length mosaic portrait he wears full military regalia, but the facial features are strikingly similar to the crypt portrait.[59]

I 1 *St. Photius*, died ca. 305. (fig. 21)
 Ο Α[ΓΙΟΣ] ΦΩΤΙΟΣ
 August 12: Holy Martyr, with Aniketus
 (*CP*, 885–86).

Photius's portrait shows him as a young beardless warrior. He has a slightly cleft chin and wavy black hair ending in loops below his ears. The halo is light ocher. His tunic is light blue-gray with a collar; his chlamys is brownish red with an ocher tablion ornamented with intersecting diagonal lines. The brooch pinning his chlamys consists of four pearls and a round green center stone. He holds a white cross with terminal dots at the end of each arm. The name is clearly legible in black against the green background. The portrait is in good condition with minor rubbing and flaking on the area of the chlamys.

Photius was martyred along with Aniketus of Nikomedia while an officer under Diocletian. The *Painter's Manual* describes them as Saints of Poverty, "young men, beardless."[60] They appear in Cappadocian fresco painting at Kılıçlar Kilise as full-length figures on the soffits of the arch leading into the prothesis; Photius is beardless and resembles the Hosios Loukas medallion, while Aniketus is young and bearded.[61]

I 2 *St. Arethas*, died ca. 523. (fig. 22)
 Ο Α[ΓΙΟΣ] ΑΡΕΘΑΣ
 October 24; Holy Martyr (*CP*, 160–61).

Arethas appears as a thin-faced old man with wavy gray hair and a beard ending in three points. His halo is dark ocher. His tunic is light green with an ocher collar decorated in a tendril design; the chlamys is blue-black with an ocher tablion ornamented in crisscrossing diagonal hatching. A brooch consisting of four pearls

[52] Delehaye, *Les légendes grecques*, pp. 91–92.
[53] Hetherington, *Painter's Manual*, p. 57.
[54] Restle, *Cappadocia*, 2:178–79 and pls. 9, 11, 28.
[55] Pelekanides, *Kastoria*, pl. 55a.
[56] Vocotopoulos, "Corfou," p. 159 and fig. 11.

[57] Omont, *Miniatures*, pl. LIV (409v).
[58] *Il Menologio*, p. 206.
[59] See Stikas, *Oikodomikon Chronikon*, pl. 40.
[60] Hetherington, *Painter's Manual*, p. 59.
[61] Restle, *Cappadocia*, 2:pl. 263.

with a red-orange center stone fastens the chlamys. He holds a white cross with terminal dots at the end of each arm. The name is clearly legible in black against the reddish brown background. The portrait is in good condition with random scratches scattered over the surface and some flaking in the halo.

Arethas of Nedschran was a soldier martyred in Ethiopia in ca. 523. He is described in the *Painter's Manual* as "an old man with a pointed beard."[62] The scene of his beheading appears in the Menologium of Basil II, but the white-haired, full-bearded face in the miniature is unlike that in the fresco just described. He appears paired with Eustratius in the ivory Harbaville Triptych.[63] In later fresco paintings of the fourteenth century, such as at the Protaton monastery on Mount Athos, the more full-faced classical type of the Menologium is retained.[64]

I 3 *St. Aniketus*, died ca. 305. (fig. 23)
Ο Α[ΓΙΟΣ] ΑΝΗΚΗΤΟΣ
August 12: Holy Martyr, with Photius (*CP*, 885–86).

Aniketus appears as a beardless young man with oval face and curly brown hair that comes down below his ears. He has an ocher halo. His tunic is dark blue-gray with an ocher collar ornamented with a tendril design; his chlamys is gray-brown with an ocher tablion ornamented in diagonal cross-hatching. The chlamys is held by a brooch consisting of four pearls with a green center stone. He holds a white cross with terminal dots at the ends of the arms. His name is clearly inscribed on the green background. The portrait medallion is well preserved.

Aniketus of Nikomedia was martyred with Photius under Diocletian in ca. 305. The pair, described in the *Painter's Manual* as "young men, beardless" among the Saints of Poverty, appear facing each other in the soffits of the

arches leading to the prothesis at Kılıçlar Kilise in Cappadocia; at Kılıçlar, however, Aniketus is bearded.[65]

I 4 *St. Vikentius*, died ca. 300. (pl. 1; fig. 24)
Ο Α[ΓΙΟΣ] ΒΙΚΕΝΤΙΟΣ
November 11: Holy Martyr (*CP*, 211–14).

Vikentius is depicted as a beardless young man with an oval face and dark brown hair falling in loops to below his ears. He has an ocher halo. He wears a tunic of light mauve with a collar decorated with tendril ornament; his chlamys is dark gray to black with an ocher tablion of diagonal cross-hatching; it is held by a brooch with four pearls and a center stone of orange. He holds a white cross with dots at the ends of the arms; the hand holding it is transparent and is barely discernible. The saint's name is clearly legible in black against the reddish brown background. The medallion's state of preservation is excellent.

Vikentius is commemorated on the same day as Victor of Egypt and Menas of Phrygia, who were martyred together under Diocletian according to the Synaxarium of Constantinople. The *Painter's Manual* refers to Victor and Vicentius as "young men, beardless."[66] All three appear in the scene of their martyrdom in the Menologium of Basil II where Vikentius closely resembles the portrait in our fresco.[67] His portrait appeared in one of the spandrels under the dome of the Katholikon at Hosios Loukas but has been lost.[68] In the frescoes of Tokalı Kilise in Cappadocia, his portrait appears on the east face of the arcade in front of the southeast chapel,[69] and in Sicily it appears at all the Palermo churches.[70] The medallion portrait of Vikentius at Kariye Djami depicts him as fair-haired and dressed in white sticharion with an orarion.[71] In all cases he appears in close proximity to St. Victor or St. Menas (or both).

[62] Hetherington, *Painter's Manual*, p. 57.
[63] Rice, *Byzantine Era*, pl. 64.
[64] Millet, *Athos*, pl. 56.3.
[65] Restle, *Cappadocia*, 2:pl. 263.
[66] Hetherington, *Painter's Manual*, p. 57.
[67] *Il Menologio*, p. 154.
[68] See Diez and Demus, *Mosaics*, pl. 4.

[69] Restle, *Cappadocia*, 2: plan x, no. 116.
[70] Demus, *Mosaics of Norman Sicily*: Cefalù on p. 14, Palatine Chapel on p. 39, Martorana on p. 80, and Monreale on p. 115.
[71] Underwood, *Kariye Djami*, 1:156–59 and pl. 164.

D 1 *St. Peter*, died ca. 64. (fig. 25)
Ο Α[ΓΙΟΣ] ΠΕΤΡΟΣ
June 29: Apostle, Martyr in Rome (with
Paul) (*CP*, 777–80).

The medallion shows Peter with broad cheeks
and curly gray hair and beard. Tightly curled
individual locks frame Peter's face and compose
his short, rounded beard. His halo is ocher. His
chiton is royal blue with boldly highlighted
folds; the tan himation loops over his right
shoulder and falls from the left in a zigzag pat-
tern. The edges of the himation are broken by
pairs of white striations. He holds a scroll in his
left hand and makes a gesture of blessing with
his right. His name is clearly legible, painted in
white on the red-brown ground, which is
painted in swirls, with the lightest values of
color being closest to the halo. The portrait is in
good condition with minor scratching mainly
in the lower half of the medallion.

Peter was, according to the symbolism of the
Gospels, the rock on which Christ built his
Church and one of the "princes of the apostles,"
along with Paul, the apostle to the Gentiles.
Named the first of the apostles, his life is mainly
known from the Acts of the Apostles. He was
martyred in Rome under Nero. The Basilica of
St. Peter's was built over his tomb in the fourth
century and became the most important pil-
grimage site in the western empire.[72]

The *Painter's Manual* describes Peter as "an
old man with a rounded beard, holding an epis-
tle which says: 'Peter the apostle of Jesus
Christ.' "[73] In the famous Sinai icon of St. Peter,
the proportions of face and beard correspond to
our medallion, although the technique is paint-
erly rather than schematic; the same general fa-
cial type as in our medallion can be seen in sev-
eral other Sinai icons, with dark outlines of hair
and beard and stiff, stylized curls over his fore-

head.[74] In the sixth-century apse mosaic of the
Transfiguration at Sinai, Peter's face, although
in three-quarter profile, is recognizably similar
to our medallion but lacking the stylized curls.[75]
Another sixth-century mosaic with St. Peter, in
the apse of the church of Sts. Cosmas and Da-
mian in Rome, shows Peter with a distinctive
band of hair meant to represent curls over his
forehead.[76] The same tight curls are seen in the
mid-eleventh-century monumental decoration
of the church of Elmalı in Cappadocia.[77] In the
Menologion of Basil II, the miniature with the
entry of October 4 shows Peter's crucifixion; he
has the same broad face and short white beard
with several round curls distinguishable in hair
and beard.[78] In the narthex of the Hosios Loukas
Katholikon, St. Peter appears in a full-length
portrait in the soffit of the arch to the left of the
door leading into the naos; his facial features are
finely rendered and detailed. The curls are more
bulbous than spiral-shaped, as in the crypt me-
dallion, and all traits are rendered less schemat-
ically in this case than in the fresco portrait.[79]

Bibliography: Butler, *Lives of the Saints*, June
29.

D 2 *St. John the Theologian*, died ca. 100. (pl. 2;
fig. 26)
Ο Α[ΓΙΟΣ] ΙΩ Ο ΘΕΩΛΟΓΟΣ
September 26: Evangelist, Apostle (*CP*, 79–
82).

St. John appears as an old man with broad fore-
head, receding white hair and a beard ending in
three wavy points; semicircular delineations
over his forehead emphasize its protuberance.
His halo is deep ocher. His blue chiton has jag-
ged and striated highlights in white; his gray hi-
mation has stylized folds and highlights. In his
left hand he carries a Gospel book and with his
right he makes a gesture of blessing. His name,

[72] Krautheimer, *Early Christian and Byzantine Ar-
chitecture*, pp. 33, 55–60.

[73] Hetherington, *Painter's Manual*, p. 52.

[74] Weitzmann, *Sinai Icons*, pls. CXII (B 57) and
CXXII (B 61).

[75] Forsyth and Weitzmann, *Sinai, Church and For-
tress*, pl. CLI.

[76] See Beckwith, *Early Christian and Byzantine Art*,
p. 103.

[77] Restle, *Cappadocia*, 2:179, 181; Rodley, *Byzan-
tine Cappadocia*, p. 182.

[78] See *Il Menologio*, p. 84.

[79] See Diez and Demus, *Mosaics*, pl. IV.

clearly inscribed in white, is seen against the uniform green ground. The state of preservation of the medallion is excellent.

St. John the Evangelist, author of the first Gospel, was the brother of St. James the Greater; they were fishermen by trade. After his calling by Christ, he was the "disciple whom Jesus loved" and was later entrusted by him with the care of the Blessed Virgin. According to tradition he wrote his Gospel in Ephesus and Revelations on Patmos; he died at Ephesus ca. 100, at the age of ninety-four, and the great Basilica of St. John the Divine was later built over his burial place.[80]

He is the most frequently depicted of the disciples in the scenes of the crypt, although shown young and beardless in these while the medallion portrait conforms to the description in the *Painter's Manual*: "an old man, bald, with a long sparse beard, holding a Gospel."[81] In several Cappadocian churches, fresco portraits of St. John correspond in their facial types to our medallion portrait.[82] In manuscript painting, the Menologium of Basil II shows St. John with closely corresponding features but with bulbous curls above his high forehead.[83] Closest in style to the Menologium portrait of John is the mosaic portrait of the apostle in the narthex of the Katholikon, although all of these render the same set of characteristic features; however, two wisps of hair above John's forehead in the fresco medallion appear as bulbous locks in the narthex mosaic and the Menologium portrait.[84]

Bibliography: Butler, *Lives of the Saints*, December 27.

D 3 *St. Bartholomew*, first century. (fig. 27)
Ο Α[ΓΙΟΣ] ΒΑΡΘΩΛΟΜΕΟΣ
June 11: Apostle; Martyr (with Barnabus)
(CP, 743–46).

Bartholomew's portrait shows him as a young man with dark hair and beard. Above his broad forehead is a loop of hair from which a number of short strands protrude; his short beard is divided into two wavy points. He has an ocher halo. The apostle is dressed in dark blue chiton and light gray himation, both with linear striations and stylized folds. He holds a scroll in his left hand and his right is held in an attitude of rest. Swirling brushstrokes are clearly visible in the red-brown background whose lightest values are seen nearest the halo; the name is inscribed in white. The medallion is in good condition with some rubbing or water damage in the halo and forehead of the saint.

There is no firm tradition on the life of Bartholomew except that he preached in the East, mainly in Armenia where he died; Eusebius mentions India as a region where he preached.

The description of him in the *Painter's Manual*, "a young man with an incipient beard," does not correspond to examples of his portraits. At Sinai in the medallions of the apostles framing the apse mosaic he appears similarly to the Hosios Loukas fresco; he has the same loop of hair over a high forehead and a dark bushy beard ending in two wavy points.[85]

Bibliography: Butler, *Lives of the Saints*, August 24.

D 4 *St. Paul*, died ca. 67. (fig. 28)
Ο Α[ΓΙΟΣ] ΠΑΥΛΟΣ
June 29: Apostle to the Gentiles; Martyr
(with Peter) (CP, 777–80).

The portrait shows Paul with a broad forehead and receding dark hair and a beard ending in three points. He has a wispy lock of hair on the crown of his head. Highlights on his forehead emphasize its protuberance. He has an ocher halo. His chiton is blue and the himation, painted in several shades of olive green with dark outlines and deep folds, loops over the right shoulder and falls from the left. He holds a book in his left hand and blesses with the right. His name is clearly legible on the green ground, which is undifferentiated in value;

[80] Krautheimer, *Early Christian and Byzantine Architecture*, pp. 112 and 256–57.

[81] Hetherington, *Painter's Manual*, p. 52.

[82] See for example Elmalı (Restle, *Cappadocia*, 2:169), Çarıklı (Restle, 2:195), Karanlık (Restle, 2:224), Tağar (Restle, 3:372).

[83] See *Il Menologio*, p. 68.

[84] See Diez and Demus, *Mosaics*, pl. 39, for the narthex mosaic.

[85] Forsyth and Weitzmann, *Sinai, Church and Fortress*, pl. CLV.

however, the spelling is a mistake, with an A instead of a Λ. The surface of the fresco is in fair condition with rubbing on the left side of the face and halo and scratch marks overall.

Paul was converted on the road to Damascus, as is known through his letters and through the Acts of the Apostles. A missionary in Athens, Corinth, Antioch, and Jerusalem, he traveled in Macedonia founding churches. In Italy he was associated with the apostle Peter, and his martyrdom under Nero took place on the Ostian way where the Basilica of St. Paul's outside the Walls stands, on the site of his burial.

The *Painter's Manual* describes Paul as "bald, with a brown, rush-like beard and grey hair, holding the fourteen epistles rolled up and tied together."[86] A Sinai icon with a medallion portrait of St. Paul is similar to the fresco portrait.[87] In the medallion portraits of apostles framing the apse mosaic at Sinai, St. Paul appears with the same traits as in the crypt fresco except that the lock of hair at the crown of his head is even more obtrusive. In the ninth-century manuscript of Cosmas Indicopleustes (Vatican, gr. 699), St. Paul bears a close resemblance to our medallion portrait. At Hosios Loukas his full-length portrait in mosaic appears on the soffit of the arch to the right of the door from the narthex into the naos. In this extremely sensitive portrait the traits correspond with the fresco except that the modeling and depth of characterization are greater in the mosaic; the bulbous forehead and lock at the crown of the head are also more prominent in the mosaic.

F 1 St. Mark. (fig. 29)
Ο Α[ΓΙΟΣ] ΜΑΡΚΟΣ
April 25: Apostle and Evangelist; (*CP*, 627–30).

In the fresco medallion Mark has short dark brown hair painted in curved lines. On his forehead a row of little ends of hair stray from a slightly dipping curl. He has an ocher halo. His tunic is blue-gray and his himation green, both with sharp striations of white highlights and dark folds. The edges of his himation have pairs of short strokes at intervals. He holds a jeweled book to which he gestures with his right hand. The background in pinkish brown shows darker swirls of paint on the left and right edges with lighter tones toward the halo. His name, inscribed in black, is clearly legible. The medallion is in very good condition with only minor flaking on his hand.

Mark wrote the second Gospel at the request of the Romans. His mission took him to Antioch, Cyprus, and Egypt. The Venetians stole his relics from Alexandria, and the cathedral of Venice, San Marco, housed them from the time of its founding in the ninth century.[88]

In the *Painter's Manual* he is described as "grey-haired, with a rounded beard, holding a Gospel." This description matches his appearance in an apse medallion at Sinai.[89] However, he already appears with dark hair and beard as in our fresco medallion in the sixth-century Rossano Gospels.[90] The same type prevails in miniature and manuscript painting in the middle Byzantine period.[91] In the narthex mosaic roundel of St. Mark in the Katholikon of Hosios Loukas, his features have more individuality than in the fresco; the face is broader and appears less ascetic, and two loops of hair hang over the forehead instead of the wisps of the fresco.[92]

F 2 St. Luke, died 63. (fig. 30)
Ο Α[ΓΙΟΣ] ΛΟΥΚΑΣ
October 18: Apostle and Evangelist (*CP*, 147–48).

Luke appears with a thin, almost haggard face; his very large eyes and thin cheeks give him a more ascetic and spiritual expression than the other apostles. His brown hair is composed of parallel rows of spiral curls and his thin beard ends in two short wispy points. His halo is

[86] Hetherington, *Painter's Manual*, p. 52.

[87] Weitzmann, *Sinai Icons*, pl. CXIIb (B 61).

[88] Krautheimer, *Early Christian and Byzantine Architecture*, p. 432.

[89] Forsyth and Weitzmann, *Sinai, Church and Fortress*, pls. CIII, CLVI A.

[90] See Beckwith, *Early Christian and Byzantine Art*, pl. 109.

[91] See Mouriki, *Nea Moni*, pp. 116–17 and nos. 4, 5; pls. 12, 340a, 340b.

[92] Diez and Demus, *Mosaics*, pl. 45.

ocher. He holds an ornamented book and makes a gesture of blessing with his right hand. His chiton is blue with angular striations and shading. The himation is similarly treated but has pairs of short strokes at intervals along its edges. The green background is painted in swirls with darker values on the border and lighter ones close to the halo. The name is clearly inscribed in black and the portrait is in good condition except for minor flaking on the hand and a "shadow" of lighter value pigment around the contour of the hair.

Luke wrote the third Gospel and the Acts of the Apostles and traveled with St. Paul and St. Mark to Philippi and Jerusalem. He was a physician. After Paul's death Luke traveled, particularly to Egypt, Achaea, Patras, and Thebes in Boeotia where he was bishop. His relics were taken from Boeotia to Constantinople and installed along with those of Andrew in the Church of the Holy Apostles in 357. The most popular legend concerning Luke is that he painted a portrait of the Virgin and Child.

The *Painter's Manual* describes him as "a young man with curly hair and a short beard, painting the Mother of God."[93] In the mosaic roundel in the apse at Sinai he appears as an old man with gray hair and rounded gray beard.[94] The Evangelist portrait of Luke in the Stauronikita Gospel Book on Mount Athos (cod. 43, fol. 12v) shows him as beardless and young, but with hair composed of bulbous curls.[95] In the narthex mosaic, similar curls appear in a full-length figure of St. Luke who has the same wispy beard as the Luke of the crypt.[96] In the Menologium of Basil II the scene of Luke's burial shows him with the same almost triangular ascetic face as in the crypt medallion.[97]

F 3 *St. Matthew*. (fig. 31)
Ο Α[ΓΙΟΣ] ΜΑΝΘΕΟΣ
November 16 or 17 (July 18, translatio):
 Apostle and Evangelist (*CP*, 227–30).

Matthew is shown as a gray-haired old man with prominent forehead and a beard ending in many sharp points. Three curled locks fall on the crown of his forehead above two concentric rings emphasizing its protuberance. His lively expression is enhanced by two pairs of white strokes in his eyebrows. He holds a Gospel whose cover is decorated with pearls, and he gestures toward it with his right hand. The chiton is blue-gray and himation light gray, both with bold striations and wedge-shaped delineations of folds; pairs of short strokes appear along the edges of the himation. The pinkish brown background is painted in swirling strokes with darker values on the outer contour of the medallion and lighter ones on the inside. The state of preservation of the medallion is very good with the name clearly inscribed in black.

According to legend he was born in Bethlehem, traveled in Ethiopia and Pontica and lived in Jerusalem and Antioch. He was martyred by stoning, then beheaded or crucified.

Matthew is described in the *Painter's Manual* as "an old man with a long beard, holding a Gospel."[98] In monumental decoration he appears in the mosaic roundel in the apse at St. Catherine's on Mount Sinai with the same prominent forehead as in our fresco but with a rounded beard;[99] here his name is inscribed ΜΑΤΘΕΟΣ. In the narthex mosaic in the Catholikon of Hosios Loukas, Matthew's portrait is inscribed ΜΑΤΘΑΙΟΣ and he is a gray-bearded old man with curls on his forehead, a different type from the crypt Evangelist who shares the prominent forehead with the Sinai image. It is worth noting that a roundel portrait of Matthias, one of the seventy apostles, appears at Sinai among the Twelve with his name inscribed ΜΑΝΘΙΑΣ.[100] The confusion in spelling might be explained by a confusion in models. St. Matthew's portrait appears in the Menologium of Basil II in a scene of his burial; here he

[93] Hetherington, *Painter's Manual*, p. 52.
[94] See Forsyth and Weitzmann, *Sinai, Church and Fortress*, pl. CLIX A.
[95] Beckwith, *Early Christian and Byzantine Art*, pl. 170.
[96] Cf. Diez and Demus, *Mosaics*, pl. 43.

[97] *Il Menologio*, p. 121.
[98] Hetherington, *Painter's Manual*, p. 52.
[99] Forsyth and Weitzmann, *Sinai, Church and Fortress*, pl. CLVII B.
[100] Ibid., pl. CLIII B.

shares the facial traits of the crypt fresco portrait.[101]

F 4 *St. Andrew,* died 60/62. (fig. 32)
Ο Α[ΓΙΟΣ] ΑΝΔΡΕΑΣ
November 30: Apostle (*CP,* 265).

Andrew has wavy hair falling below his ears and a beard that divides into three points. He has an ocher halo and wears a pink chiton with white highlights and dark gray himation. The edges of his himation are broken by pairs of short strokes at intervals. He holds a closed scroll in his left hand and blesses with his right. A distinctive feature of the portrait is the double wisps of hair protruding from his hair at five points; he also has two wavy strands of hair falling onto his forehead. His name in smudged black letters is legible on the jade green background. The state of preservation is good except for signs of gouging on the eyes and the smudging of the inscription.

Andrew, the brother of Simon Peter, is said to have had as his mission territory Pontus and Bithynia, also Skythian lands and various parts of Greece. He died in Patras. From there his relics were taken to Constantinople to the Church of the Holy Apostles, to be joined with those of Luke and Timothy.

The *Painter's Manual* refers to Andrew as "an old man with curly hair and his beard divided into two points; he holds a cross and a bound scroll."[102] In sixth-century portraits such as the medallion in the apse at Mt. Sinai, he has disheveled gray hair and a short gray beard.[103] The scene of his martyrdom appears in the Menologium of Basil II where his face closely resembles the crypt portrait, with shaggy white hair and beard.[104] The full-length portrait of Andrew in the narthex at Hosios Loukas represents the closest parallel to the crypt portrait, with closely corresponding facial proportions, parted wavy hair, and accented chin through the gray beard.[105]

G 1 *St. James,* died ca. 44. (fig. 33)
Inscription lost, but possibly visible a hundred years ago when Kremos made this identification.[106]
April 30: Apostle; Brother of Our Lord (*CP,* 155, 240, 640, 782)

James is depicted with straight dark hair that curls forward in a lock over his forehead from which short wisps of hair protrude and a short beard, slightly parted. He has an ocher halo. His chiton of royal blue and himation of dark gray have sharply contrasting striations indicating folds; along the inner contours of his himation are pairs of white strokes. In his left hand is a scroll toward which he gestures with his right hand. The right hand has a "shadow," which appears to be the result of clumsy overpainting. There is no trace of an inscribed name on the green ground, which has been painted in circular strokes with lighter values of green toward the halo. The medallion is in fair condition with much flaking on the lower-right portion; the eyes have been gouged out.

James, the brother of the Lord, known as James the Greater, was one of the three apostles who witnessed Christ's Transfiguration; little is known of his travels. He was martyred in Jerusalem but his relics were brought to Compostella in Spain where the church housing them became a major western pilgrimage site. Another tradition says they were brought to Constantinople.

The *Painter's Manual* describes James as "a young man with an incipient beard."[107] An early medallion portrait appears in the apse at Mount Sinai, where he has a square face with a cap of dark hair and a short, round beard.[108] His medallion portrait in mosaic in the narthex of the Katholikon of Hosios Loukas shows a round-faced person in comparison to our thin-faced philosopher image.[109]

[101] See *Il Menologio,* p. 186.
[102] Hetherington, *Painter's Manual,* p. 52.
[103] Forsyth and Weitzmann, *Sinai, Church and Fortress,* pl. CXVI A; see also the medallion portrait at San Vitale where he has the same disheveled appearance (Deichmann, *Ravenna,* pl. 337).
[104] *Il Menologio,* p. 215.

[105] See Diez and Demus, *Mosaics,* pl. 38.
[106] Kremos, *Phokika,* 2:194.
[107] Hetherington, *Painter's Manual,* p. 52.
[108] Forsyth and Weitzmann, *Sinai, Church and Fortress,* pl. CLVII A.
[109] Diez and Demus, *Mosaics,* pl. 51.

G 2 *St. Thomas.* (fig. 34)
> Inscription lost, but identified because of the correspondence of all the other apostles in the crypt with those of the narthex above.
> October 6: Apostle (*CP*, 113–14).

Thomas has short dark hair and is young and beardless. He has a lock, like James, over his forehead from which short wisps of hair protrude. His large cabbagelike ears frame a thin face with a somewhat pointed chin. His halo is ocher. He wears a blue chiton and light tan himation. His right hand is held in an attitude of blessing. No trace of his name survives on the brownish pink background. The entire medallion is badly rubbed and pitted; the eyes have been gouged.

Thomas, known as the "twin," was a Jew of humble birth and little is known about him. He is best known for his disbelief in the Lord's Resurrection until convinced by putting his hand into the wound (see the scene of the Incredulity of Thomas). According to legend he was martyred in India. His relics were transferred to Edessa in the fourth century.

In the *Painter's Manual* he is described as "a young man, beardless." An oval-faced, beardless Thomas appears among the portraits in medallions in the apse at Sinai.[110] At Hosios Loukas he appears in the narthex of the Katholikon in a full-length portrait with a fuller, heavier face than in the crypt fresco, although this Thomas closely resembles that in the crypt fresco scene of the Incredulity of Thomas. However in the Menologium of Basil II the same oval-faced, small-chinned facial type of Thomas as in the crypt medallion appears in the scene of his martyrdom.[111]

G 3 *St. Philip.* (fig. 35)
> . . . ΙΠ . . . ΟΣ
> November 14: Apostle; Martyr (*CP*, 221–22).

Philip is depicted as a young man, beardless and with short, straight brown hair. His oval face is framed by large "cabbage" ears. His halo is ocher. His mauve chiton and dark gray-blue himation have white highlights and dark shadows in sharp, stylized patterns. Along the edge of his himation are five pairs of short white strokes. In his left hand he holds a scroll, toward which he makes a gesture of blessing with his right hand. "Shadows" surround the contours of both hands, suggesting the hands were overpainted. His name painted in black is barely legible on the green background, which is painted in swirls with lighter values toward the border of the halo. The medallion is in better condition than the others in this vault, with very good preservation of the overall surface and colors.

Like James, Philip also came from Galilee and the two are often associated with one another. Philip was influenced by John the Baptist. He preached in Phrygia and was buried at Hierapolis; his relics were later brought to Rome.

Philip is depicted as a young man but with a long brown beard in the apse medallion at Sinai.[112] However he appears beardless, much as in the crypt medallion, in a Sinai icon of the tenth to eleventh century.[113] Most closely corresponding to the crypt portrait is that in the Menologium of Basil II in the scene of his martyrdom.[114] In the narthex of the Katholikon of Hosios Loukas Philip is also young and beardless.[115]

G 4 *St. Simon.* (fig. 36)
> Inscription lost, but possibly visible one hundred years ago when Kremos made this identification.[116]
> May 10: Apostle; called Zelotes (*CP*, 671).

Simon appears as a middle-aged man with dark receding hair and a short beard divided slightly in the middle. Framing his very high forehead, whose protuberance is emphasized by delineations, are spiral-shaped curls, three on each side. At the crown of his head is a small lock from which several wisps of hair escape. His halo is ocher. Simon wears a blue chiton and olive green himation, both with light highlights and

[110] Forsyth and Weitzmann, *Sinai, Church and Fortress*, pl. CLVI B.

[111] *Il Menologio*, p. 93.

[112] Forsyth and Weitzmann, *Sinai, Church and Fortress*, pl. CLV B.

[113] Weitzmann, *Sinai Icons*, pl. CXVI.

[114] *Il Menologio*, p. 182.

[115] Diez and Demus, *Mosaics*, pl. 44.

[116] Kremos, *Phokika*, 2:194.

dark shadows in sharp linear patterns. The edges of his himation have pairs of short strokes at intervals. He holds a closed scroll in his left hand and gestures toward it with his right. No trace of his name is visible on the brownish pink background, which is painted in swirls with the lighter values of color nearest the halo. The medallion is very well preserved.

Zelotes refers to Simon's zeal for Jewish law before his calling by Jesus.[117] Among many conflicting traditions some say he died in Edessa, others that he was martyred with Jude the apostle in Persia.

The *Painter's Manual* describes him as "an old man, bald, with a rounded beard."[118] At Sinai the apse medallion shows him as old and gray bearded, though he has the lock of hair at the crown of his head.[119] In the narthex of Hosios Loukas his portrait medallion shows him as having similar features to the crypt medallion, but the lock protrudes downward more and has a different shape.[120]

HOLY MEN

A 1 *St. Joannikius*, died ca. 845. (fig. 37)
Ο Α[ΓΙΟΣ] ΙΟΑΝΙΚΙΟΣ
November 4: Thaumaturgos; of Bithynia
(Hermit, Abbot) (*CP*, 191–92).

Joannikius appears as an old man with white hair and a long white beard divided into five strands. He wears the black mandyas and analabos of an abbot and carries a white martyr's cross.[121] His name is legible on the jade green background but the fresco has suffered badly from water damage and the surface is generally flaked and pitted; the left portion of the medallion has darkened from mildew.

St. Joannikius started a soldier's career in the Opsikion theme and fought the Bulgarians, but at forty he became a monk on Mount Olympos in Bithynia and founded several monasteries there.[122] An iconodule in the iconoclastic controversy, he became famous for his miracles, gifts of prophecy, and expulsion of demons.[123] He died in a cell near the Antidium monastery. His Life was written by the monk Sabas shortly after his death.[124] He is referred to as "our holy father" in the Synaxarium of Constantinople. A prayer by Joannikius is part of the service of "Little Compline."[125]

In the *Painter's Manual* he is described as "an old man with long hair and a long beard."[126] His medallion portrait appears in mosaic in the Katholikon where he is paired with Sisoes (here Sisoes appears in the adjacent vault segment); the same traits appear in both with equal lack of individuality. In the Menologium of Basil II he is shown praying to the hand of God; he wears the mandyas and analabos and has a halo; the text refers to him as "our holy father."[127]

Bibliography: Vita by Simeon Metaphrastes, *PG*, 116:36–92; *LexChrIk*, 7:198; in *Iconoclasm*, on Ioannikios, see pp. 113–31.

A 2 *St. Sisoes*, died ca. 429. (fig. 38)
Ο Α[ΓΙΟΣ] ΣΙΣΩΗΣ
July 6: The Great; Egyptian Monk; Hermit;
Thaumatourgos (*CP*, 801).

Sisoes is shown as an ascetic monk with white hair and beard, holding a white cross. The black outline of face and head are especially pronounced. The green background shows

[117] Butler, *Lives of the Saints*, 4:213.

[118] Hetherington, *Painter's Manual*, p. 52.

[119] Forsyth and Weitzmann, *Sinai, Church and Fortress*, pl. CLVIII A.

[120] Diez and Demus, *Mosaics*, pl. 46.

[121] For a description and terms for monastic dress, see Mouriki in Belting, Mango, Mouriki, *Pammacharistos*, p. 62, also P. Oppenheim, "Das Mönchskleid im christlichen Altertum," *RQ*, suppl. 28 (1931).

[122] See S. Vryonis, "St. Joannikios the Great 754–846 and the 'Slavs' of Bithynia." *Byzantion* 31 (1961): 245–48.

[123] *PG*, 117:141.

[124] *AASS* November 11, I (1894): 333–83.

[125] See J. B. Wainright, *The Byzantine Office* (London, 1909), p. 79.

[126] Hetherington, *Painter's Manual*, p. 60.

[127] *Il Menologio*, p. 158.

through in hair and beard. His name inscribed in white shows up clearly on the green ground. The condition of this medallion is fair, for there is general flaking of small areas over the entire surface.

Sisoes returned to the desert of Skete in Egypt while still a youth. He later sought out further solitude and lived on St. Anthony's mountain for sixty-two years. He was an exorcist and wonderworker, according to the Menologion account.[128]

The *Painter's Manual* describes him as "an old man with a wide beard, bald."[129] His medallion portrait in mosaic in the Katholikon corresponds generally to that of the crypt, but in neither is he bald. Later frescoes show him at the grave of Alexander the Great saying: "Ah death, who can escape thee."[130]

Bibliography: *LexChrIk*, 8:377.

A 3 *St. Makarius*, died ca. 829. (fig. 39)
Ο Α[ΓΙΟΣ] ΜΑΚΑΡΙΟΣ

April 1 and August 19: of Pelekete; Bithynian Abbot; Thaumatourgos (*CP*, 577–78, 909).

The saint's portrait, conventionally represented like the other holy men in vaults A and H, shows an ascetic old monk with white hair and beard carrying a white cross. His name is clearly legible on the green ground. The condition of the fresco is fair, with much flaking and pitting overall, especially on the black mandyas.

Makarius, a native of Constantinople, entered the monastery of Pelekete in Bithynia and became its abbot. (For a discussion of whether he might instead be Makarius of Egypt, see the section, "Program and Meaning," in this chapter.) He was a friend of Theodore of Studios and later his ally in the iconoclastic conflict. He was known for healing miracles, curing diseases of body and mind. He died in exile, banished by Leo the Armenian. His Life was written by the monk Sabas soon after his death.[131]

H 1 *St. Abramius*, died ca. 360. (fig. 41)
Ο Α[ΓΙΟΣ] ΑΒΡΑΜΙΟΣ

October 29: Hermit; Priest; Confessor (*CP*, 173ff.).

Abramius appears as an old monk with white hair and a long beard divided into two points. He wears the mandyas and analabos and carries a white cross. His name inscribed in white is clearly legible on the jade green background, which is painted in swirls. The darker shade of green ground ends abruptly just before the first letter of his name, suggesting repainting or replacement of an earlier inscription. The portrait medallion is in very good condition.

Abramius was an anchorite from Edessa; although from a wealthy family, he endured many hardships and lived in a hermit's cell for fifty years. He was a miracle worker and built the church of Beth-Kiduna. The Metaphrastian Menologium records his Acts; his niece was Mary the Egyptian who was converted by him, according to popular legends.[132]

The *Painter's Manual* refers to him as "an old man with a long pointed beard."[133] His portrait appears in a mosaic medallion in the Katholikon of Hosios Loukas where his conventionalized traits are very similar.[134] Abramius appears in the Menologium of Basil II praying to a hand of God and standing by a small oratory; his traits correspond to the crypt portrait, especially the high protruding forehead and long wavy beard.[135]

Bibliography: Vita (in Syriac) in *Analecta Bollandiana* 10 (1891): 5–49; *LexChrIk*, 5:7–8.

H 2 *St. Maximus*, died ca. 662. (fig. 42).
Ο Α[ΓΙΟΣ] ΜΑΖΗΜΟΣ

January 21 (translatio, August 13): The Confessor; Monk and Abbot (*CP*, 409; 887).

Maximus's portrait shows him as an old man with white hair, and a beard ending in four straggly points. He has several wisps of hair

[128] See *PG*, 117:525.

[129] Hetherington, *Painter's Manual*, p. 60.

[130] Sherrard, *Athos*, p. 66.

[131] See *Analecta Bollandiana* 32 (1913): 270–71; his Vita is in *Analecta Bollandiana* 16 (1897): 142–63.

[132] *PG*, 115:43; Mary's Vita is now translated by

S. Ashbrook Harvey and S. Brock, *Holy Women of the Syrian Orient* (Berkeley, 1987).

[133] Hetherington, *Painter's Manual*, p. 60.

[134] Schultz and Barnsley, *Monastery*, p. 53, n. 4; Stikas, *Oikodomikon Chronikon*, pl. 29.

[135] *Il Menologio*, p. 146.

falling over his forehead, a characteristic of Byzantine saints.[136] His long ascetic face is heavily delineated and outlined in dark brown. The furrow over his brows is pronounced and his eyes are small and close set. He wears the mandyas and carries a white cross. Swirling brushstrokes are visible in the background of jade green, on which his name is clearly inscribed; the spelling of his name with a Z instead of Ξ is unusual.

Maximus the Confessor, also known as Maximus the Great, was raised at court and became secretary to the emperor Heraclius. He then became a monk and later abbot of the the Chrysopolis monastery near Constantinople. He was an opponent of Monothelitism and participated in the Lateran Council of 649. His writings as a theologian are well known; he discusses principles of Christian life; he is one of the fathers of Byzantine monasticism and wrote the *Mystagogia*, an explanation of liturgical symbolism. He died in prison in 662.[137]

The *Painter's Manual* calls him "an old man, bald," which is not true of the Hosios Loukas images.[138] In the portrait medallion in mosaic in the Katholikon he has a pointed beard, but otherwise the two correspond.[139]

Bibliography: *LexChrIk*, 7:620–21.

H 3 *St. Theoctistus*, died ca. 466. (fig. 43).
Ο Α[ΓΙΟΣ] ΘΕΟΚΤΙΣΤΟΣ
September 3: of Palestine; Hermit, Abbot (*CP*, 9, 945).

Theoctistus is depicted as an ascetic old monk with white hair and a beard divided into two points. His forehead and cheeks have dark delineations. He wears the monk's mandyas and carries a white cross. His name is clearly legible on the jade green background. The medallion is in very good condition.

Theoctistus became abbot of the New Lavra near Jerusalem, which he founded after being the disciple of the great Palestinian father of monasticism, Euthymius; they are described by Cyril of Skythopolis as "one soul in two bodies."[140]

This portrait corresponds closely to that in the upper church in mosaic; the features are highly conventional and similar; especially similar are renderings of hair, chin, and beard.[141]

Bibliography: *LexChrIk*, 8:459.

H 4 *St. Dorotheus*, first half sixth century (fig. 44).
Ο Α[ΓΙΟΣ] ΔΩΡΟΘΕΟΣ
June 5: of Gaza; Monk, Abbot.

The portrait of Dorotheus shows him as an old man with white beard ending in three points. He wears the mandyas; four curved strands of hair stray onto his bulbous forehead. He holds a white cross. The jade green background of the medallion shows through in his face and beard; it is painted in swirls and his name is clearly legible in white letters. The medallion is in very good condition with some wear showing in the thinness of paint on his cloak.

Dorotheus became abbot of the Seridon monastery near Gaza, Palestine, in the sixth century. He wrote the *Didascalia* in which coenobiticism is described as the ideal form of life for monks; he also discusses the significance of the monastic *koukoulion* or abbot's cowl.[142]

Here he is conventionally represented with white hair and beard just as in the mosaic medallion in the Katholikon.[143]

Bibliography: *LexChrIk*, 6:94; *LexTK*, 2:524.

[136] This feature is called the *skourdos*; see Mouriki, "Portraits," p. 259.

[137] Schultz and Barnsley, *Monastery*, p. 52; Attwater, *Saints*, pp. 80–88; his Vita is in *PG*, 90:68–109.

[138] Hetherington, *Painter's Manual*, p. 59; in the description is included the saying of Maximus: "Brother subdue the flesh and spend your time in prayer."

[139] Cf. Stikas, *Oikodomikon Chronikon*, pl. 34.

[140] Flusin, *Miracle et histoire*, p. 124, and Schwartz, *Kyrillos von Skythopolis*, p. 14, line 24; for a report on the excavations and the newly discovered frescoes of

Theoctistus's monastery, see G. Kühnel, "Wiederentdeckte monastische Malereien der Kreuzfahrerzeit in der Judaischen Wüste," *RQ* 79 (1984): 163–88.

[141] Cf. Stikas, *Oikodomikon Chronikon*, pl. 34.

[142] *PG*, 88:1611–1844, esp. 1633D and 1632C; see also P. Oppenheim, "Das Mönchskleid im christlichen Altertum," *RQ*, suppl. 28 (1931); see Flusin, *Miracle et histoire*, p. 110 on Dorotheus of Gaza: "humility leads to prayer and the prayer makes one more humble; the more he does good, the more he humbles himself."

[143] Stikas, *Oikodomikon Chronikon*, pl. 34.

C 1 *St. Philotheus*, tenth century. (fig. 45)
 Ο Α[ΓΙΟΣ] ΦΙΛ . . . ΘΕΟΣ
 September 15: of Opsikion; Priest and Confessor; Thaumatourgos (*CP*, 47).

The portrait of Philotheus shows him as young and with a very short beard; he is bareheaded and has no halo. He wears a tunic with a square collar and the outlines of a stole or epitrachelion are visible on his shoulders. He carries a jeweled book and in his right hand is a cross with terminal dots on the arms. His name is barely legible on the reddish brown background, which is painted in swirls with the lightest values near the saint's head. Brushstrokes are clearly visible. The medallion's state of preservation is fair because much flaking and pitting of the surface has taken place; its condition is worst in the area of the face and hair.

Philotheus lived in the tenth century in the Opsikion theme. First he married, then became a presbyter, priest, and ascetic. He performed miracles such as changing water into wine. After his death his burial place became the source of healing miracles; a spring of healing oil gushed from it and it became a pilgrimage site.[144]

He is not included in the *Painter's Manual*, and he is not to be confused with Philotheus the Patriarch who is. His portrait corresponds with that of the upper church in mosaic in the southeast arch leading to the diakonikon; the features, dress, and attributes are all the same. Grouped with him in the Katholikon mosaics are Gregory of Nyssa, Hierotheus, and Dionysius the Areopagite.[145] In the Menologium of Basil II he appears as an old man with white hair and beard; he is dressed as a priest in sticharion, phelonion, and epitrachelion.[146]

 Bibliography: *LexChrIk*, 8:210.

C 2 *St. Loukas*, died ca. 953. (fig. 46)
 Ο Α[ΓΙΟΣ] ΛΟΥΚΑ . . .
 February 7 (May 3, *translatio*): of Steiris; Thaumatourgos (*CP* 449).

Holy Luke, or St. Luke of Steiris, the patron saint of the monastery, is depicted as a young man with a thin face, light brown hair and beard, and blue eyes. He wears a black analabos, chestnut brown mandyas with the koukoulion; Two vertical stripes and a row of dots indicate the usual stitched decoration of the koukoulion; however, a further band running horizontally across the front appears, a decoration found only on depictions of Holy Luke.[147] His hands are held in front of his chest, palms outward in an attitude of prayer. The jade green background is painted in swirls with lighter values closer to the saint's head. The name inscribed in black is legible, although rubbed. The state of preservation of the medallion portrait is fair, with general flaking and pitting of the surface, perhaps caused by seepage of water.

According to his Vita, the saint spent his life in rural Greece, in the neighborhood of Thebes and Corinth, except when he was apprenticed for ten years to a stylite in Zemenna near Sykeon in the Peloponnese. He settled in Steiris where he had a following among the villagers of the area. His community acquired a church from the strategos Krinites ca. 946, and another church sheltering his tomb was built after his death. Holy Luke was known for his gifts of prophesy and healing during his lifetime, and his tomb became the source of posthumous miracles (see chapter II).

The *Painter's Manual* describes him as "a young man with a pointed beard."[148] The crypt medallion portrait of Holy Luke corresponds in all respects to the mosaic portrait of the saint in the upper church, in the lunette of the north transept (fig. 96), except that in the mosaic his

[144] Cf. *PG*, 117:49–50, and *CP*, 47–48, on *elaion* versus *myron* as a source of healing.

[145] See Diez and Demus, *Mosaics*, pls. 26, 27.

[146] See Galavaris, "Portraits of St. Athanasius," for more examples of coexisting portraits showing a saint at different ages. See also *PG*, 117:49–50. The Menologion portrait is in *Il Menologio*, p. 38.

[147] Other examples of this distinctive band occur at Hosios Loukas in the saint's portrait in the northwest

chapel, in the north arm of the cross, on the west wall of the crypt; it also appears in his portrait in the Bari Exultet roll, no. 1 (see Chatzidakis, *Peintures Murales*, pl. 81).

[148] Hetherington, *Painter's Manual*, p. 60. After the short description follows: "Says 'God will bring glory to this place for ineffable reasons that he himself knows, and a throng of faithful will come to it to eternity.' "

eyes are black, not blue. The beard corresponds in shape and hue as do other details already cited, including his title of "hagios" rather than the "hosios" that is associated with the name of his monastery as a whole. Another portrait in the upper church, over the doorway of the northwest chapel into the north transept resembles this one in general but shows the saint as less gaunt and ascetic; in this too he wears the koukoulion but seems younger than in the other two. Due to their bad state of preservation the three other portraits of the patron saint of the monastery cannot be compared with the crypt medallion; however, they all share the characteristic of the koukoulion, which marks the great habit or *megaloschema* of the highest rank of monk, the abbot.[149] A more ascetic portrait appears in the Bari Exultet Roll (no. 1), where the characteristic thin features, pointed beard, and orant position recur but in a more severe, linear style.[150] Later full-length portraits of the saint appear on a pillar of the south aisle at Hagios Demetrios in Salonika[151] and on the right wall of the bema at Episkopi in Mani.

C 3 *St. Theodosius*, died ca. 529. (fig. 47)
Ο Α[ΓΙΟΣ] ΘΕΟΔΩΣΙΟΣ
January 11: The Coenobiarch; Abbot (*CP*, 388).

Theodosius appears as an old man with white hair and a beard ending in two points. He wears the megaloschema of an abbot, carries a cross with terminal dots on the arms and holds the palm of his left hand outward in a gesture of prayer. The background is reddish brown with the swirls of paint seen in a number of the medallions producing a halo effect around the saint's head. The ground shows through where the paint is thin, as on Theodosius's face. His inscribed name is legible but smudged. The condition of the medallion is good with some pitting, especially on the face.

Theodosius was born in Cappadocia, traveled in Egypt and later joined Sabas in Palestine where they wrote a monastic rule together. Influenced by Symeon Stylites, Theodosius founded a monastery near Jerusalem where he exorcised demons and healed the sick. His epithet "the coenobiarch" was acquired because he was named head of all Palestinian monks leading the cenobitic life. His followers built a church over his burial cave, which was a source of posthumous miracles.[152]

The *Painter's Manual* specifies that he is "an old man with a beard divided into two points."[153] An early image of Theodosius appears on an icon at Mount Sinai; here his features and garb bear a strong resemblance to the crypt medallion.[154] The full-length portrait of Theodosius in mosaic in the upper church shares the conventional features of the medallion portrait in the crypt; the rendering of hair, beard, dress, and pose correspond as precisely as between any portraits in the two media.[155] He is grouped in the Katholikon with the other Desert fathers, Pachomius, Sabas, and Euthymius.[156] At Nea Moni on Chios, a medallion portrait of Theodosius appears on the south arch of the narthex where he is rendered very similarly

[149] Cf. Chatzidakis, *Peintures Murales*, pl. 1, Stikas, *Oikodomikon Chronikon*, pl. 72 and below, fig. 81. On the monastic habit, see Oppenheim, "Das Mönchskleid," p. 148.

[150] Chatzidakis, *Peintures Murales*, pl. 81 (also Chatzidakis and Grabar, *La peinture byzantine et du haut moyen age* [Paris, 1965], fig. 85).

[151] Sotiriou, *Basilikē tou Hagiou Dēmētriou*, pl. 80.

[152] Cyril of Skythopolis in his short Life of Theodosius said he was an excellent cantor and that a complete life had been written by Theodore of Petra, a disciple of Theodosius (Festugière, *Moines de Palestine*, 3, no. 3:57–62). The prophetic element is an important part of his mission and his special concern is

safety from the attacks of spiritual beasts. See Flusin, *Miracle et histoire*, pp. 98–99. His gift of prophesy, like Euthymius's and Sabas's, is ranked with theirs; the monasticism described by Cyril is inherited from Anthony, as described by Athanasius; burial in one's monk's cave is also noted in his Life (see Flusin pp. 104, 120). See also Babić, *Chapelles*, pp. 21–22, where the archaeological evidence of Theodosius's monastery is presented.

[153] Hetherington, *Painter's Manual*, p. 59.

[154] See Weitzmann, *Sinai Icons*, pl. XCII (B.38).

[155] Cf. Stikas, *Oikodomikon Chronikon*, pls. 32a, 32b.

[156] The Lives of these Palestinian fathers were writ-

to the Hosios Loukas mosaic and fresco portraits, though the beard does not divide into points at Nea Moni.[157] He also appears in the narthex of Hagia Sophia in Salonika with his full title inscribed, Theodosius the Coenobiarch; his beard is shorter and distinctly divided into two stubby parts and he has two curls over his forehead, a different type from the Hosios Loukas or Nea Moni images.[158] The closest parallel for the Hosios Loukas portraits of Theodosius occurs in the Menologium of Basil II; facial features and the shape of the beard, ending in two long, wavy points, correspond closely.[159]

C 4 *St. Athanasius*, died 373. (fig. 48)
Ο Α[ΓΙΟΣ] ΑΘ . . . ΝΑΣ . . . ΟΣ
May 2 (with Gregory the Theologian; *CP*, 647) and January 18 (with Cyril of Alexandria; *CP*, 399): The Great; Archbishop of Alexandria

Athanasius appears as an old man with white hair and beard. He has three prominent spiral-shaped curls of hair over his forehead; five sections of his beard form a single shovel-shaped tip. Over his black phelonion he wears an omophorion with crosses whose arms are drop-shaped. He holds a jeweled book toward which he gestures with his right hand. The background of the medallion is light jade green with a swirl of darker green on the left. His name is legible but smudged, like all the other names in this vault. The condition of the portrait is good, although there is some flaking, especially on the crosses, and the green background shows through in the hair.

After spending years in the desert as an ascetic under St. Anthony, Athanasius became the champion of Orthodoxy in the Arian controversy. As one of the Doctors of the Church he is frequently depicted in church decoration and always wears a bishop's costume. His Life of Anthony is a portrait of the perfect disciple of Christ; he stresses the necessity of the struggle with the passions for the attainment of virtue.[160]

He is described among the holy bishops in the *Painter's Manual* as "an old man, bald, with a wide beard."[161] His full-length portrait appeared in Hagia Sophia in Constantinople in the northern arch of the nave in a row of holy bishops; the Fossati watercolor shows the lost mosaic.[162] His half-length portrait appears in the Katholikon in a large lunette on the north side of the bema; the saint is finely characterized in this detailed portrait, which closely resembles the more schematic one in the crypt, with bulbous curls and spade-shaped beard, and also round-lobed crosses on the omophorion.[163] The Katholikon mosaic of Athanasius shows him haloed, as in the Menologium of Basil II, where he appears with St. Cyril of Alexandria.[164] Here he wears a tight-fitting white cap or scarf, but the beard and omophorion appear as at Hosios Loukas.

Bibliography: *LexChrIk* 5:268–72.

J 1 *Our Holy Father Luke*, died 979. (pl. 3; fig. 49)
Ο ΟΣΙΟΣ ΠΑΤΗΡ ΗΜΩΝ ΛΟΥΚΑΣ
December 11; Luke the Stylite; Ascetic Monk (*CP*, 301).
(See the section "Program and Meaning" in this chapter for my disagreement with Chatzidakis about this identification.)

The portrait of Luke the Stylite is painted with exceptional care and realism. He has a long, thin face with a long white beard ending in two

ten by Cyril of Skythopolis in the sixth century (Festugière, *Moines de Palestine*, 3, nos. 1 and 2).

[157] See Mouriki, *Nea Moni*, pl. 77; this is an extremely fine and sensitive portrait, not as linear and stylized as at Hosios Loukas.

[158] This portrait's divergence from the other Theodosius portraits may be explained by comparing the portrait of Theodosius of Cilicia in the Menologium of Basil II (*Il Menologio*, p. 384) where the beard, turned-up moustache, and curls over the forehead correspond to the Hagia Sophia fresco; there must have been a confusion in models.

[159] *Il Menologio*, p. 310.

[160] Flusin, *Miracle et histoire*, pp. 103–8.

[161] Hetherington, *Painter's Manual*, p. 54.

[162] Mango, *Saint-Sophia*, pl. 61; the omophorion is worn with the hanging end in the middle rather than on the side as at Hosios Loukas.

[163] Diez and Demus, *Mosaics*, pl. 15.

[164] *Il Menologio*, p. 329.

wavy points; flesh is rendered impressionistically in rosy tones with touches of pink on cheeks and lips. He wears the koukoulion over his head; it has the characteristic vertical white lines and dots to indicate stitched decoration. Further white striations appear on either side of his neck where the cowl meets his mantle or mandyas; the usual decoration of the analabos is also indicated. The maroon background clearly shows brushstrokes along the contours of the figure. His name and epithet in black are legible although somewhat faded. The medallion is very well preserved.

Luke the Stylite was a soldier in his youth and fought the Bulgarians; he then turned to the ascetic life and was a monk at the Zacharias Lavra on Mount Olympos in Bithynia in 932. He spent forty-four years on a column in Chalcedon.[165] In his Vita he is described as the "new founder" of the Bassanios monastery in Constantinople, which he restored from ruins; he was also buried here.[166]

The *Painter's Manual* describes him as "young, grey-haired, with a beard divided into two points."[167] To confirm Luke's identity visually we can compare this portrait with one that has been identified as St. Luke the Stylite in the Menologium of Basil II.[168] The saint is seen in bust on his column surrounded by a railing, conforming to the usual depiction of stylite saints. He wears the koukoulion and his beard ends in two long wavy points, just as in the fresco; he also has the same lively, searching eyes and individualized features. The argument for this identification is outlined in the section "Program and Meaning."

Bibliography: *LexChrIk*, 7:465.

J 2 *Our Holy Father Theodosius*, tenth century. (fig. 50)

Ο ΟΣΙΟΣ ΠΑΤΗΡ ΗΜΩΝ ΘΕΟΔΩΣΙΟΣ

Ascetic Monk, companion of Luke of Stiris (Vita, Connor, *Life of Saint Luke*, chap. 63); Abbot of Hosios Loukas.

The portrait of Theodosius, like that of Luke the Stylite, is vivid and technically very refined. The face is that of an old white-bearded monk; his deep-set eyes look straight out rather than obliquely. Flesh is modeled illusionistically in warm tones; the realistic appearance of the beard, showing individual hairs, comes from its being painted with a dry brush. He wears the koukoulion ornamented with dots and vertical lines; two sets of short vertical strokes are visible on his shoulders and on the analabos. The black mandyas is subtly modeled to suggest the body beneath it. The name with its epithet is inscribed in black on the uniform jade green background. The medallion portrait is in an excellent state of preservation.

From the Vita of Holy Luke it is known that a monk Theodosius was one of the saint's associates and that he had a brother Philippus who was a wealthy *spatharios*, a high-ranking imperial court official, and who visited the monastery on occasion.[169] There is also a stone plaque found in the Panagia church at Hosios Loukas with a funerary inscription describing a wealthy and titled official named Theodore who had taken monastic vows and assumed the name Theodosius;[170] however, there is no proof that it refers to the same Theodosius as in our fresco.

The fact that Theodosius wears the megaloschema and has the epithet "*ho hosios pater he-*

[165] See Delehaye, *Les saints stylites*, pp. 195–237. The Vita of the saint survives in one manuscript and is edited and translated by A. Vogt, "Vie de S. Luc le Stylite," *Analecta Bollandiana* 28 (1909): 1–56. See also S. Vanderstuyf, "Etude sur saint Luc le stylite (879–979)," *EO* 12 (1909): 138–44, 215–21, 271–81, and *EO* 13 (1910): 140–48, 224–32.

[166] *EQ* 12 (1909): 279.

[167] Hetherington, *Painter's Manual*, p. 61.

[168] *Il Menologio*, p. 238. See Der Nersessian, "Remarks," pp. 109–11, where she establishes that this illumination in the Menologium, though lacking a

text, is meant to be Luke the Stylite on his column in Chalcedon.

[169] Connor, *Life of Saint Luke*, chap. 63.

[170] Sotiriou, *Archaiologikon Deltion* 6 (1920–21): 181–83 and fig. 5, "Report of the Byzantine Ephorate" (in Greek); for discussion of the date and meaning of the inscription, see Stikas, *Oikodomikon Chronikon*, pp. 28–29; Ihor Ševčenko has kindly offered a probable dating in the tenth or eleventh century. The inscription as translated by Thomas Mathews reads: "He was well named and rich in many titles both familial and imperial. In desiring after the attainment

mon" (see the subsequent discussion) indicates that he had the rank of abbot.[171] The first abbot in the group depicted to the left of the doorway of the crypt has been identified as the same Theodosius as in the medallion, but since the two faces bear little or no resemblance to one another, this cannot be considered definitive (cf. fig. 80).[172] Another Theodore whose name has been associated with the monastery is Theodore Leobachos; for my argument identifying Theodosius with this Theodore, see the section "Program and Meaning."

J 3 *Our Holy Father Athanasius*, died ca. 1000. (fig. 51)

Ο ΟΣΙΟΣ ΠΑΤΗΡ ΗΜΩΝ ΑΘΑΝΑΣΙΟΣ

July 5: Monk, Hermit; Founder of the Great Lavra on Mount Athos.

(For my disagreement with Chatzidakis on this identification, see the section "Program and Meaning.")

The portrait of Athanasius is, like those of Luke the Stylite and Theodosius, by an extremely skilled painter. It depicts a middle-aged ascetic monk with deeply shadowed eyes in a gaunt face and a brown beard. The modeling of cheeks and beard is soft and naturalistic; individual brushstrokes can be distinguished in cheeks and forehead. He wears the koukoulion, analabos, and mandyas decorated as in the preceding example. His name and epithet are inscribed in black on the maroon background.

The medallion's state of preservation is very good.

Athanasius founded the Grand Lavra in 961. His name was Abramius before he went to live in Constantinople where he came under the influence of Michael Maleinos. After becoming a monk on Mount Kyminas in Bithynia, he was introduced to Nicephorus Phocas, the future emperor, who became his friend and admirer and who later provided him with the funds to start construction on his own monastery on the Holy Mountain of Athos, of which he was both abbot and founder. The monastery was regulated according to the typikon written by Athanasius.[173] He died after falling from a ladder while helping build an addition onto the Katholikon. Already a pilgrimage center before his death, the Grand Lavra on Mount Athos continued as such afterward and his Vita describes the miracles that took place there.[174]

The *Painter's Manual* describes St. Athanasius as "a bald old man with a pointed beard."[175] As Galavaris points out, several portrait types of the saint seem to coexist, most notably with dark and white beards.[176] The crypt medallion portrait bears some resemblance to the earliest known of these portraits of Athanasius, where he has a dark beard, which is the frontispiece of a mid eleventh-century manuscript of his Life.[177] This pen drawing depicts the saint in his prime and is so sensitive and lifelike it could have been done by someone who knew him. The similarities between this and the crypt portrait support the identification of Athanasius,

of salvation the names were exchanged thus: formerly Theodoros, in turn Theodosios, distinguished proconsul, now the monk, the patrician who conducted himself nobly, now the katepano against the haughty, and the thrice bearer of the mystic garment. He claimed for himself nothing of the goods of this world except the coffin, which is of no value to those alive except as covering for the dead."

[171] Chatzidakis, "Date et fondateur," p. 140; C. Connor, "The Portrait of the Holy Man in Middle Byzantine Art," in *The 17th International Byzantine Congress: Abstracts of Short Papers* (Washington, D.C., 1986), pp. 72–73.

[172] Chatzidakis, "Date et fondateur," pp. 140–41.

[173] For this document and others pertaining to Athanasius's rule, see Meyer, *Die Haupturkunden*.

[174] See Lemerle, "La vie ancienne," pp. 67–84; on pp. 84–85. Lemerle describes and quotes an account in the Vita concerning an icon that was an exact portrait of the saint by the painter Pantoleon. This icon was brought to the Grand Lavra and according to the author of the Vita: "c'est celui qui jusqu'aujourdhui est vénéré par tous dans le tombeau du saint" (p. 85, n. 72). The Greek edition of the Vita appears in *Analecta Bollandiana* 25 (1906): 1–89.

[175] Hetherington, *Painter's Manual*, p. 59.

[176] Galavaris, "Portraits of St. Athanasius."

[177] Ibid., p. 102 and nn. 19, 20. See also *RBK*, 2: col. 1068, on portraits of Athanasius. However, Doula Mouriki has said that she finds the pen drawing resembles more closely portraits of St. Theodore Studites.

along with the reasons argued in the section "Program and Meaning."

Bibliography: *LexChrIk*, 5:267–68

J 4 *Our Holy Father Philotheus.* (fig. 52)
Ο ΟΣΙΟΣ ΠΑΤΗΡ ΗΜΩΝ ΦΙΛΟΘΕΟΣ

Monk, Abbot (?); Patron of Hosios Loukas (Offices and Prayers for the celebration of the translatio or *anakomide* of Holy Luke's relics on May 3: Kremos, *Phokika*, 2:71–132) at an unknown date.

The portrait of Philotheus shows a bald-headed old man with a long white beard. This is a more conventional and less individualized image than the other three in the vault. Hair and beard are heavily outlined; a semicircular line on his forehead suggests its protuberance. There is a curl at the top of his forehead; the beard parts into two thin wavy parts below a pronounced chin section. He wears the analabos and mandyas but no koukoulion, as in the other medallions of the

vault. His name is inscribed rather clumsily in thick black letters, whereas his epithet is in thinner, equally clumsy, letters. The background of the medallion is jade green and its general state of preservation is very good.

Philotheus has been identified with the third monk in the group depicted just inside the entrance to the crypt (fig. 79) and as the abbot who presents a model of the church to Holy Luke in a fresco of the northeast chapel of the Katholikon.[178] A Philotheus is mentioned in the text of the Offices and Prayers on the feast day of the translation or removal of Luke's relics.[179] This person was responsible for the transferal of the relics and for the building of the new church to house them. If this is the same Philotheus as described in the prayers, he would indeed deserve the honor of having his portrait among other distinguished abbots and patrons in the crypt. On his identification with the spatharios Philippus mentioned in the Vita, see the section "Program and Meaning."

THE SCENES IN LUNETTES

Christ's Entry into Jerusalem. (pls. 4–6; figs. 53–57)

Η ΒΑΙΟΦΟΡ . . .

First event in the Passion cycle (Mt. 21:1–13; Mk. 11:1–12; Lk. 19:28–41; Jn. 12:12–20). Palm Sunday (*Lenten Triodion*, pp. 485–510); one of the Twelve Great Feasts of the Christian Year (*Festal Menaion*, pp. 41–42).

In the scene of Christ's Entry into Jerusalem on the north wall of the northeast bay, Christ mounted on the ass and followed by St. John proceeds to the right toward the city of Jerusalem where he is greeted by four figures, the foremost of which holds out a palm branch. Two children also take part: one spreads a red garment under the ass's front hoofs and the other has climbed a palm tree to fetch branches. Branches are strewn on the ground and on a mountain that serves as a frame for the figures of Christ and St. John.

Christ sits frontally on the white ass; he is ha-

loed, robed in a dark blue himation, and carries a scroll in his left hand while gesturing with his right toward the elders (fig. 55). John wears a gray tunic and pale mauve himation and gestures toward Christ as if in conversation with him (pl. 5). Before the open gates of the city of Jerusalem stand three imposing figures (pl. 6; fig. 56). They have long hair and beards, and along with their robes of deep red and blue they wear prominent white scarves decorated with patterns of stars and parallel lines; these are draped around their shoulders like collars but with ends hanging down in a point. A fourth figure, seen only as a youthful face in three-quarter view, stands behind the others (pl. 6; fig. 57). Crenelated walls and a tower rise above the marble-framed gateway with its tympanum of a fish-scale design; the walls are built of light brown blocks indicated in naive diagonal perspective. The mountain is gray with three frothy white crags painted in jagged patterns. The ground zone is in several shades of green

[178] Chatzidakis, "Date et fondateur," p. 134 and fig. 6; pp. 140–41.

[179] Ibid., p. 130, and Kremos, *Phokika*, 2:99, 100, 130.

and the sky is dark blue with the title of the scene inscribed in white letters.

The scene is damaged in places—several patches are rubbed in the lower part and Christ's face is partly obliterated—but it is generally in a good state of preservation.

The simplicity and paring down of the elements in this scene are comparable to other monumental eleventh-century examples. At Daphni there are many similarities in the mosaic lunette of the Entry in the north transept, but the figures have multiplied: four children, two apostles, and six greeters at the city gates.[180] Although larger and intended to be seen from farther away, for it is in a church setting, the Daphni composition is not as bold nor the message as direct as that at Hosios Loukas.[181] Furthermore the gold ground of the mosaic tends to distance the event from the spectator, whereas the presence of even a highly stylized Mount of Olives in the background lends closeness and intimacy to the scene as it appears at Hosios Loukas, a comparable effect to that achieved in manuscript illuminations.[182] This clear and simplified version of the event appears at Tokalı Kilise in Cappadocia and on icons, such as the iconostasis from Sinai of the tenth to eleventh century.[183]

The frontal seated position of Christ is one characteristic of Byzantine depictions of the Entry; this is discussed by Maguire who cites exegetical sources using antithesis to elucidate the early adoption of the "enthroned" pose of Christ.[184] The enthroned Christ already appears in the sixth-century manuscripts, the Rossano and Rabbula Gospels.[185]

The most unusual element in our version of the scene is the appearance of the elders of the Gospel texts as three powerfully drawn Phari-

sees wearing wide and prominent scarves and with a contrastingly youthful person among them. Neither at Daphni nor in the Norman churches in Sicily does this group appear.[186] The unusual feature of the wide patterned collar is found, however, in an Armenian manuscript, the U.C.L.A. Gospels of ca. 1300.[187]

Bibliography: Schiller, *Iconographie*, pp. 18–23; *LexChrIk*, vol. 1: Einzug in Jerusalem; *DACL*: Rameaux.

The Crucifixion. (pl. 7; figs. 58–59)
 (Mt. 27:45–51; Mk. 15:21–40; Lk. 23:32–47; Jn. 19:18–31).
 Good Friday (*Lenten Triodion*, pp. 564–621).

The Crucifixion, on the east wall of the northeast bay, shows the crucified Christ between Mary and Saint John. Mountains frame the two latter figures in a landscape of waving plant tendrils.

Christ clad in long white loincloth partly stands on the suppedaneum and partly hangs from the huge black cross, which nearly fills the lunette space; his arms sag and his head falls slightly to the left. An incised line around the contours of the cross is clearly visible in the lower part; it stands on a gray rock before which there is a skull. The Virgin, clad in royal blue tunic and dark blue *maphorion* with yellow border turns and gestures toward the dead Christ with her right hand. John, in light blue tunic and gray himation, stands on the right holding his right hand in an attitude of grief; the himation is slung around his body and loops over his right arm in elegant folds while it forms parallel zigzag folds down his left side; the edges of his himation have pairs of white strokes at intervals (pl. 7; fig. 59). There is a system of rhythmic

180 Diez and Demus, *Mosaics*, p. 62 and pl. 92.

181 See Millet, *Iconographie*, pp. 255–84, on the "picturesque" versus the "classical" or severe versions of the scene.

182 Note the use of mountains as framing elements in the Menologium of Basil II.

183 See Epstein, *Tokalı*, pl. 80; Sotiriou, *Sinai*, pl. 40; cf. also pls. 57, 77, 116.

184 Maguire, *Art and Eloquence*, pp. 68–74.

185 Cecchelli, *Rabbula Gospels*; Rice, *Byzantine Era*, Rossano Gospels page with the Entry on p. 57,

pl. 45.

186 Cf. Demus, *Mosaics of Norman Sicily*, pls. 20B, 68; in the scene of the Rulers of the Synagogue the rulers wear ornamented scarves and collars as at Hosios Loukas. Demus states the prototype for these scenes was a cycle of miniatures (p. 271); see also p. 283. See Kitzinger, *Monreale*, pls. 72, 82, and figs. 5, 10.

187 Draft of forthcoming publication by T. Mathews, p. 126.4 and n. 9; fol. 252, also, in another version of the scene in the same manuscript, fol. 126.

and expressive highlights in white or off-white hues on both tunic and himation. Ocher and gray hills with four angular, fractured peaks frame the figures of Mary and John below the arms of the Cross; the broad green ground zone is covered with waving green tendrils, which are silhouetted against the mountainous background.

The composition has been damaged in the upper middle area and in patches on the lower left and center. Only the contours and underpainting are visible from the middle of Christ's torso upward.

The Crucifixion appears in two other locations at Hosios Loukas, in mosaic in the north lunette of the narthex of the Katholikon and in fresco in the northwest chapel.[188] In both of these cases the scene is similarly pared down to the basic elements. In the narthex mosaic we find a close correspondence in most details with the crypt fresco; the colors of John's garments are much lighter, pale pink and white, in the mosaic but the configurations of drapery just described correspond precisely (fig. 97). There appear additional elements—the inscription labeling the scene and the sun and moon—probably lost in the damaged portion of the crypt fresco. The northwest chapel fresco preserves an older type of crucifixion, with Christ's body straight and unbending, like other examples of the tenth century.[189] At Daphni the Crucifixion is limited to the three essential figures, but the three-figure composition was already popular in the tenth century, to which the ivories bear witness.[190] As noted by Mouriki, the Nea Moni Crucifixion, which includes three additional figures, shares many iconographic details with the ninth-century Homilies of Gregory of Nazianzus (Paris, Bibliothèque Nationale, gr. 510) as well as some eleventh-century manuscripts.[191] Thus there is no consistent pattern to distinguish tenth- from eleventh-century iconographic types. The cosmic symbols of sun and moon are not found at Nea Moni as they are at

Hosios Loukas but they do appear in the sixth-century Rabbula Gospels.[192] The closest stylistic and iconographic parallel to the crypt Crucifixion outside of Hosios Loukas is found in Cappadocia at Kılıçlar Kilise, dated to the early tenth century.[193]

Christ Washing the Disciples' Feet. (fig. 60)
 Part of introductory cycle to the Passion (Jn. 13:5–11).
 Maundy Thursday (*Lenten Triodion*, pp. 548–64).

Only the left portion of the scene is preserved. Christ bends over the basin and holds Peter's foot which he is wiping with a fold of his himation; a group of five disciples looks on from the left while one prepares to loosen his own sandals.

The haloed figure of Christ, clad in light brown chiton and dark blue himation is in slightly larger scale than the disciples. He bends over a very large ocher basin filled with blue water. To the left a disciple dressed in dark blue chiton and bright pink himation plants his right foot high on the bench, producing a dramatic effect by the diagonal sweep of his himation and by twisting to observe the central event. To his right another disciple dressed in gray-blue chiton and olive green himation gestures toward Christ while behind these two more figures are partly visible. The last disciple, whose feet seem to hover over the ground, is in front of a complicated bench painted in ocher with a pattern of close diagonal hatchings; it is made of various stretchers and supports but there is no distinguishable bench surface. The ground zone is dark green and the sky dark blue with no landscape elements or inscriptions preserved. Parts of a dark red band are visible along the lower edge of the composition.

The scene refers to the exchange between Christ and Simon Peter when Peter says: "Lord, not my feet only but also my hands and my

[188] Stikas, *Oikodomikon Chronikon*, pl. 14, and Chatzidakis, *Peintures murales*, fig. 25.

[189] *Ibid.*, p. 47; see also Mouriki, *Nea Moni*, pl. 32 and pp. 130ff.

[190] Diez and Demus, *Mosaics*, pl. 99, and Rice, *Byzantine Era*, pl. 67 and p. 80.

[191] Mouriki, *Nea Moni*, p. 130.

[192] Rice, *Byzantine Era*, p. 37, pl. 26.

[193] Rodley, *Byzantine Cappadocia*, pp. 43–44; and Restle, *Cappadocia*, 2:285, where even the incised outlines of the cross correspond with the Hosios Loukas fresco.

head!" (Jn. 13:9). The mosaic in the apsidal niche at the northern end of the narthex of the Katholikon shows the complete scene, with Peter holding his hand so as to indicate his head as Christ wipes his feet (fig. 98). Although both are arched compositions, the fresco shows none of the crowding apparent in the narthex mosaic; also, in the mosaic the three central figures are emphasized, whereas the crypt composition shows greater uniformity and has a more harmonious interaction of figures. The artist's confusion in the configuration of the bench in the fresco is only slightly less in the case of the mosaic, where it is smaller and has a more easily readable horizontal surface; both have the same diagonal hatchings, but they seem less successfully rendered in the mosaic medium. The cloth used for drying, the *lention*, appears in the mosaic but the blue fold of Christ's himation is used for this purpose in the fresco. *Ho Nipter*, as the scene is labeled in the mosaic, stresses the purification aspect of the scene as well as the laying aside of sin.[194] In the crypt version of the scene the basin seems to be proportionately larger than in the mosaic.

At Daphni and Nea Moni the composition is more horizontal, with a very long bench spanning the scene, although the characteristic gesture of Peter is maintained as Christ wipes his feet.[195] In a Sinai icon of the eleventh century, the scene is juxtaposed with the Communion of the Apostles, stressing its eucharistic significance, but it is more often paired with the Last Supper, close in the Passion sequence and celebrated on the same day in the Orthodox church; this is true, for example, in the sixth-century Rossano Gospels.[196] This is also the case in the crypt (see next entry).

The Last Supper. (pl. 8; figs. 61–63)
 (Mt. 26:20–30; Mk. 14:17–25; Lk. 22:14–23; Jn. 13:18–30, 6–22; I Cor. 10:16–33, 11:23–34).

Maundy Thursday (*Lenten Triodion*, pp. 548–64).

The scene of the Last Supper faces that of the Washing of the Feet across the sanctuary of the crypt, and like that scene it suffers from the intrusion of an end of the lintel of the templon barrier. The lintel partly obscures the left end of the table but the figure of Christ is preserved on the end at the left. The twelve disciples are seated around the table with Peter on the right and Christ reclining on a mattress on the left. On the table are a paten and two chalices; in front of Peter an epitrachelion is draped over the edge.

Christ, clad in a royal blue tunic and dark blue himation, is seen reclining full length on a white mattress with a pair of red stripes at head and foot; he holds a closed scroll in his left hand and makes a gesture of speech or blessing with his right. The disciples, dressed in a colorful array of clothing, form an arc ending with Peter who is seen in his entirety, sitting at the end of the table's bench on a red cushion; he wears a blue chiton and gray himation and carries a scroll in his left hand. He gestures with his right hand as do all the disciples, with the exception of Judas who reaches toward the paten. The table is long and oval in shape on the top half and is straight on the other with a triangular corner protruding downward in the middle of the front. The four legs and frame of the table are brownish ocher while its surface has alternating squares in dark green and ocher in a band around the entire edge and a lighter green center. A very large yellow-footed dish on which are two tan fish stands in the center of the table and a small chalice stands next to it on the right. Further to the right, in front of Peter, the epitrachelion draped over the edge of the table is unique in the iconography of the scene.[197] It is ocher with six white stripes and white fringes (fig. 63). The ground zone is in two shades of green and the upper zone above the disciples'

[194] Schiller, *Iconography*, p. 43.
[195] See Diez and Demus, *Mosaics*, pl. 94, and Mouriki, *Nea Moni*, pl. 94.
[196] Weitzmann, *Sinai Icons*, pp. 91–93; Schiller, *Iconography*, pls. 64, 69.
[197] According to Lampe, the epitrachelion is "the stole worn by bishops and priests, a broad strip of silk

with aperture at one end for neck, hanging in front like a scapular, symbolizing rope on neck of Christ when taken to Calvary." Or it is possibly an omophorion, which is "a long scarf worn by bishops . . . which is put off before reading of Gospel to signify that Christ is himself present" (see Isidorus Pelusiota, *Epistularum libri quinque* [*PG*, 78:272C]).

heads dark blue with no visible inscription. A dark red band is visible along the bottom of the composition on the left.

The fresco is pitted and flaking in many areas; the worst damage is the area of Christ's himation and forehead and the areas around the mattress. The faces of most disciples have been gouged and the lower edge in the right half of the lunette is stripped down to stone masonry.

An early depiction of the Last Supper appears in a mosaic panel in the nave of Sant' Apollinare Nuovo in Ravenna; here the sigma table with disciples seated around reflects the format of the depiction of the antique funeral banquet.[198] In the bowl in the center of the table are two fish, as in our crypt fresco. In a sixth-century depiction of the Last Supper, in the Rossano Gospels, the bowl has a large foot and here too, as in the crypt, Judas is distinguished from the others by his gesture of reaching.[199] The chalice on the table of the Last Supper appears in later monumental painting—for example, in Cappadocian frescoes; at Tokalı the composition is very similar to the crypt scene.[200]

An unusual feature of the scene is the wooden table with the visible legs—the table of the Last Supper is usually covered with a cloth that hangs down in front. A similar type is only found in one other case, at Çavuçin in Cappadocia; the table legs are jeweled in this example and there are spanners that do not appear in the crypt fresco.[201]

Just enough of the scene is preserved at Daphni to recognize a composition similar to that at Hosios Loukas and also the bench on which Peter sits and the rounded mattress in back of Christ's head.[202] Another parallel is the fresco at Sant Angelo in Formis of ca. 1100, where John inclines his head toward Christ, in reference to *Jn.* 13:23 and 25.[203]

Two iconographically unique features of our

scene are the angular protrusion of the front of the table and the epitrachelion or omophorion.

Christ's Deposition from the Cross. (pl. 9; figs. 64–66)

Η ΑΠΩΚΑΘΗΛΩΣΙΣ

(Mt. 27:57–60; Mk. 15:42–47; Lk. 23:50–55; Jn. 19:38–43; Apocryphal Gospel of Nicodemus, XI); Homily of George of Nicomedia (*PG*, 100:1480).

Good Friday (*Lenten Triodion*, The Tenth Gospel, pp. 597–98).

In the lunette of the east wall of the southeast bay the scene of the Deposition is dominated, like the Crucifixion, by a huge black cross. The body of Christ is being taken from it by Joseph of Arimathea who stands on a ladder beside which is the Virgin who holds Christ's limp right arm. On the right John stands witnessing the event while a small figure before him bends to remove the nails from Christ's feet with calipers (fig. 65). Mountains covered with sinuous plants form the background of the scene.

The black cross has incised contours including a short upper crossarm whose top is flush with the upper edge of the lunette. Christ, clad in a white loincloth, is held in an angular position by Joseph who stands on a ladder propped against the cross; he wears dark gray chiton and dark mauve himation and cradles Christ's body in his right arm. The Virgin in dark blue maphorion inclines her head toward that of her son (see fig. 66). John, in blue-gray chiton and dark mauve himation, raises his right hand, which is covered with the himation, to his cheek in a gesture of grief and raises his left hand in a gesture of acknowledgment or witness. The himatia of the two disciples are elegantly rendered in patterns that include loops, teardrop shapes, and jagged folds. The figure removing the nails

[198] See for example the Breaking of Bread in the second-century fresco in the catacomb of Priscilla (Beckwith, *Early Christian and Byzantine Art*, cf. pls. 2 and 86); also see Schiller, *Iconography*, p. 31 and pl. 67.

[199] Millet, *Iconographie*, pp. 290f.

[200] Epstein, *Tokalı*, fig. 34, for the Old Church where chalices appear to the left and right of the dish,

and fig. 81 for the New Church. See Restle, *Cappadocia*, 2:107; cf. for manuscript parallels Laurentian VI.23 where the footed bowl, chalices, and reaching Judas appear (Velmans, *Laurentian VI.23*, pl. 27, fig. 110, and pl. 40, fig. 176).

[201] See Restle, *Cappadocia*, 3:313.

[202] Diez and Demus, *Mosaics*, pls. 95, 97.

[203] Schiller, *Iconography*, pl. 72.

from Christ's feet is clad only in a dark blue cloak; his legs and left shoulder are bare. In the background, multiple peaks end in spiky white points, which are silhouetted against the sky and the farther gray mountains. Waving green plants and thin curling green tendrils cover the slopes of the mountains and the green ground. The sky is dark blue, and the name of the scene is inscribed on either side of the cross.

There is general scratching and pitting of the fresco's surface with most damage in the ground zone; the eyes of the Virgin and St. John are gouged out, but the scene is generally in a good state of preservation.

The Deposition is often represented along with the Crucifixion and is clearly derived from that composition, as illustrated by Schiller.[204] In the ninth-century Homilies of Gregory of Nazianzus, the scene is contiguous with that of the bearing of the body, wrapped in a shroud, by Joseph and Nicodemus.[205] The body is not yet bent in its descent from the cross in ninth- and early tenth-century examples, while in an eleventh-century manuscript, Morgan Library 639 in New York, the Deposition on fol. 280r shows an even more angular bending of the body than in our fresco.[206]

In monumental painting, the damaged scene of the Deposition appears in the main apse of the New Church at Tokali in Cappadocia; from what remains, the iconographic features seem to correspond very closely to the crypt scene: black cross with top crossbar, close arrangement of the heads of the Virgin, Christ and Joseph, and the placement of St. John to the right.[207]

Burial of Christ; The Women at the Tomb. (pls. 10, 11; figs. 67–71)
 Burial (Mt. 27:59–60; Mk. 15:46–47; Lk. 23:53–56; Jn. 19:38–42).

Myrophores (Mt. 28:1–8; 16:1–8; Lk. 24:1–9; Jn. 20:1–18; Gospel of Nicodumus XI–XIII [James, pp. 104–6]; Homily of George of Nicomedia [*PG*, 100:1480]).
Holy Saturday (first and third troparia for Matins: *Lenten Triodion*, p. 623).

The Burial of Christ is combined in a large composition with the scene of the Women at the Tomb or Myrophores. On the left the body of Christ, wrapped in a shroud, is being lifted into a sarcophagus by Nicodemus who stands at his feet and Joseph of Arimathea at his head; the Virgin Mary, standing behind the sarcophagus, inclines her face toward her son's (fig. 69). In the right-hand part of the lunette two women shrink from an imposing angel who sits on a block next to the tomb. In the background are colorful and expressive jagged mountains.

Christ is wrapped in white winding sheets in a braided pattern, leaving only his face exposed. The massive antique sarcophagus of gray stone has stepped patterns around its rim and an undulating pattern around the base; the sides and front are ornamented with X's and circles, and two niche-shaped *cubiculi* appear on the front (pl. 10; fig. 68). Joseph of Arimathea wears a dark blue chiton and gray himation, and Nicodemus wears a dark blue chiton and gray and maroon himation; their robes form sharp patterns of wedge shapes and striations. Adjoining and underlapping this group are the two women who have come with their myrrh to anoint Christ's body; they are clad in ocher and gray tunics and dark blue and deep red himatia, and while one clasps a vial of myrrh and makes a gesture of speech, the other gestures in surprise as they confront the angel. The angel of the Resurrection, holding a scepter and pointing to the empty tomb, sits on an ocher block with black veins in it; he is magnificently clad in pas-

[204] Ibid., p. 165. See ivories with these scenes in Goldschmidt and Weitzmann, *Elfenbeinskulpturen*, 2:30, nos. 22, 23, and pls. VI and VII.

[205] Schiller, *Iconography*, pl. 548, p. 165.

[206] Weitzmann, "Constantinopolitan Lectionary," pl. 318 and p. 366.

[207] See Epstein, *Tokalı*, col. pl. 5; Restle, *Cappadocia*, 2:117. There is also a Deposition in the Old

Church that is closely tied to the bearing of the body (see Epstein, *Tokalı*, fig. 39). Both antedate the decoration of the Pigeon House at Çavuçin, which was painted between 963 and 969 (Rodley, *Byzantine Cappadocia*, p. 218); see Restle, *Cappadocia*, 3:pl. 309, for the Deposition at Çavuçin, which is unfortunately in bad condition.

tel green robes, which form swirling patterns and highlights over his knee and belly and which fall in loops and zigzag cascades; in his wing, which is suspended above the heads of the frightened women, individual brushstrokes indicate feathers (pl. 11; fig. 70). He points to a diminutive-scale tomb, consisting of a tall opening with narrow open doors in which one can see a folded piece of Christ's shroud and topped by a small triangular gable (fig. 71). Two mountain complexes frame the figure compositions: on the left an orange mountain in front of a pinkish ocher one frames the three figures at the head of Christ's sarcophagus and on the right a two-tone green mountain frames the heads of the myrophoroi and Nicodemus. Both mountains have frothy white crags in stylized white triangular patterns. The lower zone of the scene is composed of green ground and the sky is dark blue with no preserved traces of inscriptions.

The state of preservation of the fresco is very good in spite of the gouged eyes of the angel and the women; small patches of surface damage occur in the sky and around the feet of the angel.

The shrouded body of Christ appears commonly in scenes of the Threnos or Lamentation of Christ when he lies at the foot of the cross, or in the scene of his burial when he is about to be taken into the cave, as at Çavuçin (fig. 100), but for him to appear shrouded in the scene of burial in a sarcophagus is unusual. On an Epitaphios, the dead Christ is shown clad only in loincloth, lying on a sarcophagus.[208] Our scene, then, seems to combine Lamentation, Burial, and Epitaphios iconography. A more emotional rendering of the scene may be seen at Nerezi (ca. 1164); this type of scene becomes the norm in later painting and shows Christ clad in a loincloth as on an epitaphios, but lying on the ground. It seems either that a canonical type of Lamentation and Burial scene had not yet developed when our fresco was painted or that the artist had a special reason for depicting this arrangement.[209]

The iconography of the scene of the Resurrection or the Marys at the Tomb is discussed by Millet who distinguishes eastern and western types, separating them according to the number of women who come to the tomb; he identifies the two Marys of the Gospel of Matthew who are present in our fresco with the eastern type.[210]

The format of the scene in the Rabbula Gospels of the sixth century is already strikingly similar to that of our scene, except that the sleeping soldiers have been left out in our version.[211] The closest middle Byzantine version in miniature painting occurs in the Leningrad gospels (cod. 21) of the tenth century; the women shrink in a similar manner and the angel points to the empty tomb.[212] In monumental painting, although the scene appears at the Old Church at Tokalı, the closest comparison is with Çavuçin where the angel is also in pronounced contrapposto and the tomb with grave clothes is of similar scale and proportions (see fig. 100).[213]

[208] See the scene of the burial at Çavuçin in Cappadocia where the shrouded body is being carried into a cave or tomb (Restle, *Cappadocia*, 3:309); cf. an *epitaphios* where the loincloth-clad Christ lies on the "anointing stone," a separate event from the burial (Schiller, *Iconography*, p. 173 and pls. 592, 593). The mourning figures of Joseph and Mary usually appear at the foot of the cross where Christ lies in his shroud (Schiller, pl. 568). The Epitaphios of 1407 in the Victoria and Albert Museum (Rice, *Byzantine Era*, pl. 194) is a good example.

[209] The Threnos or lamentation is a middle Byzantine invention inspired by the homily of George of Nicomedia, according to Weitzmann ("Constantinopolitan Lectionary," p. 367); Laurentian VI.23 however maintains the same type of "bearing of the body" composition as earlier (i.e., with a shrouded

Christ) but with the addition of the sorrowing figure behind the body; this reflects the lack of decisiveness of any changes in iconography in the period; variations of the Deposition, bearing of the body, and Burial continued to appear well into the eleventh century (see Velmans, *Laurentian VI.23*, pl. 29, fig. 122).

[210] Millet, *Iconographie*, p. 537.

[211] Beckwith, *Early Christian and Byzantine Art*, pl. 45.

[212] See Millet, *Iconographie*, pp. 521–22 and pls. 563, 570; Schiller, *Iconography*, 3:27 and pls. 33–35; for a series of illustrations of this manuscript, see C. R. Morey, "Notes on East Christian Miniatures," *AB* 11 (1929): 5–103, esp. 53–92 (the holy women are in fig. 75).

[213] Restle, *Cappadocia*, 3:309 and 311; see also Kılıçlar in 2:257.

I found no other examples of these two scenes being combined in one pictorial unit. Indeed the incongruous juxtaposition of the monumental sarcophagus with the diminutive tomb structure that should contain it shows not only lack of logic visually but is an example of unresolved conflict of iconographic traditions and borrowing from diverse models.

The Incredulity of Thomas. (pl. 12; figs. 72–76)
ΤΩΝ ΘΥΡΩΝ ΚΕΚΛΕΙΣΜΕΝΩΝ
(Jn. 20:19–29).
Sunday after Easter.

Christ stands before a large door with groups of disciples to left and right; he bares his side and grasps the wrist of Thomas, who stands on the left, and pulls his hand toward the wound.

The figure of Christ, who wears a dark blue tunic and black himation, is dramatically framed in the monumental doorway where he steps diagonally to the right and turns to the left simultaneously; the doorway consists of a light gray frame with a linear pattern, suggesting marble, and a brown interior with diagonal hatchings in a lighter color intended to indicate the wooden border and panels of a door. Christ stands on a higher level than the disciples who surround him and he is in substantially larger scale; their robes are all in pastel hues in pronounced contrast to Christ's dark one. Thomas, clad in light blue tunic and pale mauve himation runs forward; a sling of drapery encircles his arm as if caught in the wind of his forward momentum, and he extends his index finger to touch Christ's side while his other hand is held, palm open, in a gesture of surprise or recognition. Thomas's gaze is focused on the wound in Christ's side, while Christ looks down on his head and either gestures toward the wound or pulls aside his robe with his left hand (pl. 12; figs. 73, 74). To the right Peter in gray-blue chiton and light green himation holds his right hand in a gesture of witness as he looks back at

Matthew (or John?) who stands beside him and also gestures (fig. 76). The psychological interaction of the disciples with one another, the lively drapery patterns and highlights of their garments, and the attention clearly directed to the central event produce a sense of movement and psychological tension within the scene (fig. 75). The disciples stand on a green ground zone whereas the sky is dark blue (pl. 12). The inscribed name of the scene appears on either side of the door, alluding to the "doors being shut where the disciples were, for fear of the Jews" (Jn. 20:19).

The fresco is in a good state of preservation, especially in the upper areas, although around the disciples' feet and lower border of the scene there is considerable pitting and flaking.

Like the Washing of the Feet, this scene finds its closest parallel in the mosaics of the narthex of the church above. In this, as in the majority of representations of the scene, Christ raises his right arm to show the wound while Thomas points to it but does not touch it (fig. 99).[214] In other examples Christ shows the wound to Thomas who moves forward with finger close to the wound; his open hand is just above Thomas's arm and he stares fixedly at him. In only a very few examples does Thomas touch the wound.[215]

The pulling gesture of Christ is also paralleled in a lead ampulla of the sixth century from the Holy Land and found in Egypt; it depicts Christ grasping Thomas's wrist and pulling his hand toward the wound but not touching it.[216] The early representations of the scene found on ampullae are closest to our example; this is pointed out by Leroy who cites a Syriac manuscript of the thirteenth century as also having these early sources.[217]

The stance of Christ in this scene is very similar to the scene of the Anastasis, for example in the Phocas Lectionary or in the mosaic of the Anastasis in the Katholikon above (but in mirror reversal) where he grasps Adam's wrist in

[214] Diez and Demus, *Mosaics*, pl. 103.

[215] See the ivory plaque at Dumbarton Oaks (Goldschmidt and Weitzmann, *Elfenbeinskulpturen*, pl. 15) and Leningrad cod. gr. 21, fol. 3v (Weitzmann, *Byzantinische Buchmalerei*, pl. LXVI, no. 394, or Morey, "Notes on East Christian Miniatures," p. 57, fig. 65).

An example of Thomas touching the wound appears in a twelfth-century Coptic manuscript (Millet, *Iconographie*, pl. 631).

[216] See Dalton, *Byzantine Art* (Oxford, 1911), p. 627, fig. 399; p. 624.

[217] Leroy, *Manuscrits syriaques*, pl. 691 and p. 277.

dragging him out of Hell.[218] The facial features of Christ bear a very close resemblance to those of Christ in the scene of the Mission of the Apostles in a tenth-century manuscript (Leningrad cod. 21).[219]

Bibliography: *LexChrIk*, 4:302–3; Schiller, *Iconography*, pp. 108–10.

The Koimesis of the Virgin. (fig. 77)

(Apocryphal New Testament, James, pp. 216–17 and 201ff.: "The Discourse of St. John the Divine concerning the Koimesis of the Holy Mother of God"; the Assumption, Narrative by Joseph of Arimathea; John of Thessalonika, Homily on the Dormition of the Virgin).

August 15 (*Festal Menaion*, pp. 504–29): one of the Great Feasts of the Christian Year.

In the scene of the Dormition or Koimesis of the Virgin the bier with Mary lying on it is surrounded by mourning disciples. Christ stands behind the bier holding her soul, a small swaddled figure, and two angels appear overhead. The architectural setting includes a wall with two corniced buildings at left and right.

The Virgin wears a dark blue himation and dark gray maphorion; she lies on a red-brown mattress with pairs of parallel white stripes; the hangings on the bier are dark blue-gray. The disciples wear somber shades of gray, green, blue, and brown; many raise their covered hands in gestures of grief. Expressive drapery can be made out with linear configurations, loops and folds similar to those in other scenes. Christ wears a dark gray chiton and himation, whereas the little haloed soul is lighter in col-

oration. The dark brown wall behind the scene is ornamented with repeated step patterns in light gray and one circular motif is visible; to the right and left the grayish brown stone masonry and lancet windows of buildings can be seen, again with circular motifs on the walls and protruding cornices. One wing of the angel on the left is visible against the dark blue sky but the surface is badly scratched and flaked making it impossible to distinguish any details.

This scene is in fair to poor condition with general pitting and flaking overall; every face has been rubbed out.

One of the earliest examples of the Koimesis appears at Tokalı Kilise in Cappadocia of the last half of the tenth century; the Virgin lies with her feet to the right while Peter stands near her head and Paul bends over her feet. Although more complex at Tokalı, the stances and overall setting are very similar.[220] The scene is in mirror reversal in the tenth-century fresco at Kılıçlar.[221] In some examples the eyes of the Virgin are open indicating she is at the point of death but not yet dead; sometimes there is a single flying angel but there are two in the Munich ivory of the tenth century and in the mosaic at Daphni of ca. 1100.[222] The Phocas Lectionary and Iviron 1 manuscripts on Mount Athos are close to the crypt version in their inclusion of motifs and details.[223] The fully developed fourteenth-century version appears at Kariye Djami showing the impact of literary sources on the early simple version of the crypt.[224]

Bibliography: Schiller, *Iconography*, vol. 4, no. 2, "Der kanonische östliche Bildtypus der Koimesis," pp. 92–95; *RBK*: "Koimesis," 25:154.

The Entrance Vault

Blessing Christ in a Medallion. (fig. 78)
$\overline{\text{IC}}\ \overline{\text{XC}}$

The medallion half-length bust of Christ is in the apex of the barrel-vaulted entranceway to

the crypt. Although the fresco is thin and rubbed, essential traits may be distinguished. Christ's facial features are obliterated but the hair that frames his head and falls behind his shoulders is gray and painted in thin, gently

[218] Diez and Demus, *Mosaics*, pl. XIV.

[219] See Morey, "Notes on East Christian Miniatures," p. 62, fig. 71.

[220] Epstein, *Tokalı*, pl. 100.

[221] Restle, *Cappadocia*, 2:257

[222] See Rice, *Art of Byzantium*, pl. 119, and Diez and Demus, *Mosaics*, pl. 108.

[223] See Pelekanides, *Athos*, 3:33.

[224] See Underwood, *Kariye Djami*, 2:pl. 185 and 1:164–67.

waving lines; the short, dark beard is barely visible. His ocher halo has an inscribed cross in gray with five round dots in each segment. He wears a royal blue chiton; the dark blue-gray himation is pulled across his chest on the left and falls vertically down his left side as he makes a broad gesture of blessing, with both arms spread wide and hands extending outside the mandorla. The cuffs of his garment have a floral pattern in deep ocher. The inscription in white is clearly visible against the dark red background. The figure is encircled by a white band, then a rainbow with five concentric diamond-patterned bands in shades of pink, red, white, dark green, and light green.

The state of preservation of the medallion is fair to poor, for it is rubbed and flaked almost down to bare plaster in places.

Christ must be distinguished from a Pantocrator type of medallion bust, with Christ holding a Gospel in his left hand and blessing with his right, of which examples occur in the Katholikon mosaics in roundels of the east cross vaults of north and south transepts and in the east vault of the northwest chapel. This image should also be distinguished from Christ of the Last Judgment where he accepts and rejects with his outstretched arms, as at the Panagia Ton Chalkeon in Salonika. The Christ of the crypt medallion is an intercession image, for he indicates the recipients of his blessing on either side of the medallion on the walls below, a group of monks and St. Luke of Steiris (see next two entries).[225]

West Wall: *A Group of Monks.* (figs. 79, 80)

A compact group of standing monks appears on the intrado of the barrel vault just to the left inside the door of the crypt. Three prominent figures stand in front of the others; they raise their hands and faces toward the Blessing Christ in the apex of the vault.

The three foremost figures are dressed in the megaloschema of the abbot, the first two having the koukoulion on their heads and the third being bare-headed. Their tunics are ocher, red and green respectively, and all wear the analabos and mandyas; the features of these three figures seem individualized and are probably portraits of specific leaders of the community; those monks in back of them, of which there are perhaps fifteen, also seem to be characterized by specific facial features and hairstyles.

A shadow around the outer contour of the heads, especially around the koukoulion of the foremost figure, indicates that these are changes or replacements of an original painting. In an infrared photograph, the hand of the foremost monk can clearly be seen as an alteration of another hand (fig. 80).

The state of preservation of this group portrait is fairly good, although there are graffiti, including a large three-masted boat etched in great detail on the fresco surface. There is general scratching and rubbing on the surface.

This scene is unique in monumental painting, although individual portraits of monks do appear in Cappadocian cave-churches. The closest parallel is a page from a manuscript, a typikon for the Nunnery of Our Lady of Good Hope in Constantinople.[226]

East Wall: *Holy Luke Standing with an Unrolled Scroll.* (fig. 81)

On the right side of the entranceway opposite the group of monks is the standing figure of a holy man; he wears the megaloschema and points upward with his right hand and holds a hanging open scroll with his left.[227]

Due to deterioration of the surface only the

[225] For the Pantocrator, the best-known example is in the dome of Daphni (Diez and Demus, *Mosaics*, frontispiece). For the Last Judgment Christ at the Panagia Ton Chalkeon, see Papadopoulos, *Wandmalereien*, pls. 4 and 19; Underwood, *Kariye Djami*, 3: pls. 204–2. A later example of this Christ type is found at Mistra in a Christ of the Deesis (see G. Millet, *Monuments byzantins de Mistra* [Paris, 1910], pl. 96,2). A ninth-century manuscript, Leningrad cod. gr. 21 (see Goldschmidt and Weitzmann, *Elfenbein-skulpturen*, pl. 27), also contains this image. The Blessing Christ appears in the Heavenly Ladder of St. John Klimachos where Christ in a roundel awaits the monks ascending the Heavenly Ladder, Princeton, Garrett 16, fol. 4r (Martin, *Heavenly Ladder*, pl. 31).

[226] See Spatharakis, *Portrait*, pl. 154.

[227] See Mouriki in Belting, Mango, Mouriki, *Pammacharistos*, p. 62, for a description of the megaloschema.

reddish brown outlines of the upper part of the figure's body can be distinguished; the koukoulion, mandyas, and analabos are visible in outline, while the ocher-brown tunic and cords for the analabos are well preserved in the lower part of the figure. The inscription on the scroll is illegible.

The state of preservation of the figure is poor and there are numerous graffiti on the entire wall surface, including a boat with fishing nets spread behind it.

Due to its prominent location and the monastic emphasis of the rest of the decoration of the crypt—the group of monks opposite and four vaults containing portraits of holy men—it is very likely that this is a portrait of the monk/founder and first abbot of Hosios Loukas, the saint himself. This iconographic tradition survives in a modern icon of Holy Luke, now in the narthex of the Panagia church, depicting him in the same pose and clearly identifying him by an inscription.)[228]

THE ORNAMENT

The presence of lavishly ornamented surfaces throughout the crypt contributes to the sense of otherworldliness that surrounds the viewer on entering (figs. 84–96). The different kinds of ornament correspond to their locations in the crypt and form three categories: three types of star motifs decorate the vaults; bands with floral and rainbow motifs outline architectural divisions between bays and segments of vaults, and on soffits of arches; and imitation marble or intarsia work appears mostly in the lowest zone near the floor.

The vaults have three varieties of star ornament, which surround the portrait medallions. A starry-sky variety, with blue circles containing white stars, is set in a white field having red filler elements (fig. 84); a white acanthus scroll grows out of a calyx in the lower corners of some groin vaults and encircles stars with four flowerlike petals, each of blue and pink (fig. 85). A third, more complex type has ocher acanthus scrolls, again growing from corner calyxes, which enclose blue roundels emphasized by inscribed, white, six-pointed stars; these appear against a jade green background (fig. 86). At the intersections of the groin vaults are circles with inscribed crosses of various designs and, in the vault before the sanctuary, a hand of God. These are outlined in dark blue and white bands, and the bejeweled ocher crosses are set in grounds of jade green or blue with delicate eight-pointed stars between the crosses' arms (figs. 87, 88). Dividing the segments of the

vaults are simple bands or rainbow bands consisting of rows of diamonds in shades of pink and green.

In the soffits of the arches between the bays are combined geometric and floral bands. They have distinct petal and flower shapes within diamond chains. The background in all cases is white with the geometric elements in dark blue and floral motifs in ocher, pink, red, dark blue, gray, and olive green (figs. 89, 90).

Imitations of marble intarsia and revetment compose the remainder and lower zones of the wall surfaces, between the lower borders of the lunette scenes and the floor. On either side of bay F, on the inner wall over the tombs, there are semispandrels with imitations of intarsia in a bold design. Interlaced circular patterns with small and large pseudomarble roundels are set against a stippled green background. The varied patterns of the multicolored marbles in these are repeated in the imitation marble blocks framing the archways around the tombs and between bays throughout the crypt. Lastly, marble revetment imitating square panels set in one-toned backgrounds, or in matched veined plaques with thick borders of contrasting marble patterns, appears below the scenes (figs. 91, 92); these panels are combined with imposts, in two cases with pseudo-Kufic ornament (fig. 93).

Parallels for these decorative patterns are widespread. The Orthodox Baptistery and Mausoleum of Galla Placidia of the fifth century

[228] The inscription reads: "*Tēs tapeinōseos hē teleotēs esti to pherein exoudenōsin meta charas,*" or "The perfection of humility is to bear humiliation with joy."

provide the closest parallels for the vault ornament of the crypt.[229] The decorative patterns in Cappadocian churches provide some parallels, including the scroll patterns which appear with some frequency.[230] In miniature painting the Menologium of Basil II provides a number of motifs and also a parallel in the general decorative quality and love of lavish and pseudomarble ornament that can be compared with the crypt.[231] But the closest parallel for actual use of marble revetement is in the Katholikon at Hosios Loukas, in the walls of the naos; the petal and floral motifs in a diamond chain appear throughout the Katholikon in mosaic, as well as in the other frescoes of the chapels and the galleries.

Two prominent pseudo-Kufic inscriptions painted on the impost blocks above the two tombs in yellow letters outlined in black are significant within the ornament of the crypt (fig. 93). The use of these motifs that resemble Arabic writing, often appearing as Koranic inscriptions on tiles, textiles and pottery, is especially apparent in Greece from the tenth century on.[232] These inscriptions approximately match in scale the pseudo-Kufic designs in brick on the exterior walls of the Panagia church.[233] Hosios Loukas provides numerous examples not only in exterior brickwork but in the carved moldings and decorative plaques of both churches; one of the finest examples is the carved band around the marble slab covering the tomb in the northeast bay of the crypt (see fig. 4).[234] Pseudo-Kufic designs also appear on the helmet of Joshua in the newly discovered Joshua fresco in the north arm of the Katholikon (fig. 94) and in the mosaics, on the shields of the warriors Procopius and Demetrius and on the baldachin over the altar of the Presentation.[235]

PROGRAM AND MEANING

Reading and understanding the groups of images presented in the catalogue require that we now define the thematic patterns among them and discover the messages and ideas they contain. We will consider the three categories, starting with the most complex, that of the medallion portraits of warrior martyrs, apostles, and holy men, to show the implications of their selection and arrangement. Next, the themes of the eight scenes in lunettes around the walls will be examined as a group, for they also reflect specific preoccupations and meanings. The apse and entrance vault will be considered last, for their messages support and unify those of the other categories. A synthesis of all the subject categories reveals the overall meaning behind the program of the crypt in its selection of decorative subject matter.

Although all the saints and scenes represented in the crypt appear in monumental decoration elsewhere, either singly or in groups, the scheme of the crypt is never repro-

[229] Deichmann, *Ravenna*, pls. 3, 14 (Mausoleum of Galla Placidia) and pl. 37 (Orthodox Baptistery).

[230] Restle, *Cappadocia*: Scroll patterns appear at Tağar (3:360 and 371) and at Karanlık (2:218–44).

[231] Manuscripts such as the Phocas Lectionary are also crowded with borders filled with petal and rinceau designs; a precise set of comparisons should be compiled. See also A. Frantz, "Byzantine Illuminated Ornament, A Study in Chronology," *AB* 16 (1934): 43–76, and Maria Kambouri-Vamvoucou, *Les motifs décoratifs dans les mosaiques murales du XI*e *siècle*, Thèse de doctorat, III*e* cycle (Paris, 1983).

[232] See Grabar, "Décor architecturale," for a discussion of Islamic influences.

[233] See Bouras, *Sculptural Decoration*, pls. 7, 8, 11–14.

[234] See ibid., pls. 165–73, 182–90.

[235] See Stikas, to *Oikodomikon Chronikon*, pls. 40, 47, 51.

duced. Parallels appear in various geographic locations and in different parts of churches where either mosaics or frescoes are preserved, in the naos or narthex or in subsidiary chapels. Similar selections and orientations of subjects in other monuments and media help to understand their associations here. But perhaps most revealing are the parallels within the Katholikon itself, in the mosaics and frescoes in the great church above.

Among all the comparanda, the extraordinary feature of the crypt is the completeness of its program, for there are few losses and for the most part the portraits depict named or identifiable personnages. Elsewhere monumental ensembles survive piecemeal or in poor condition, but here we can observe, intact, almost the whole decoration as it was originally planned; this very completeness even helps us argue for the identification of the two donors among the portraits of the southeast vault. The analysis of this comprehensive program is thus especially useful in recognizing the possible internal range and specificity of meaning of this set of images. It also might serve as a measure against which to assess less complete programs.

ON THE north-south axis of the crypt, between the entrance and the tomb of Holy Luke, are three bays (B, E, and I) whose vaults contain medallions with twelve Warrior Martyrs (see the schematic plan in figure 10).[236] The four in the vault nearest the tomb, Theodore Stratelates, Demetrius, George, and Procopius, are the first four Holy Martyrs mentioned in the *Painter's Manual*; three of these four, Theodore, Demetrius, and George, are called Great Martyrs in the Synaxarium of Constantinople. All twelve warriors were martyred in the third or fourth century except for Arethas, who was martyred in the sixth.

Of the twelve warriors there is one deliberate pairing in their placement: Aniketus and Photius who appear opposite each other in vault I were martyred together under Diocletian and share the same feast day. These are the only warrior martyrs in the crypt classified in the *Painter's Manual* as "Saints of Poverty," or *anargyroi*. This group is well represented in the mosaic decoration of the Katholikon above, but to the exclusion of these two saints.[237] They do appear again as a pair in the soffits of the arches leading to the prothesis at Kılıçlar Kilise in Cappadocia.[238] Photius is also the first saint seen by the viewer on entering the crypt. Small iconographic details of technique and embellishment distinguish this vault from the others; among the three vaults with warrior saints, only in this vault do the saints hold crosses with terminal dots and the brooches have center jewels and differentiated patterns on chlamys and tablion. Also, in this vault the names were inscribed in true fresco for they have survived much better than elsewhere—in vault E, for example. Although Photius and Aniketus do not appear, or perhaps do not survive in the Katholikon at Hosios Loukas, the prominent placement and differentiation of these portraits of the anargyroi signal their special importance for those who used the crypt at Hosios Loukas.

Another prominent position among the warriors of the crypt is held by Theodore

[236] See *LexChrIk* on "Heilige Soldaten."
[237] Cf. Hetherington, *Painter's Manual*, p. 59, "The Saints of Poverty," and a plan of Hosios Loukas with a key to the saints in Diez and Demus, *Mosaics*.
[238] See Restle, *Cappadocia*, 2:pl. 263.

Stratelates, for his portrait medallion is seen directly above the tomb of St. Luke, at the end of the axis leading from the entrance to the tomb. He and many other warrior martyrs found in the crypt also appear in the decoration of the Katholikon above. Along with Theodore Stratelates, the three other warrior saints of vault B, Demetrius, George, and Procopius, appear in full-length portraits dressed in military regalia in the great arches of the naos; these are some of the largest and most prominently placed figures in the Katholikon. Nestor and Mercurius from vault E and Vikentius from vault I are also prominently placed in the naos. Four of the twelve holy warriors appear yet a third time in the Katholikon: Theodore Stratelates in an imposing, life-size, full-length fresco portrait on the north wall of the northwest chapel; and Nicetas, Demetrius, and Nestor on the intrados of the barrel-vaulted arch of the southwest chapel.[239] Theodore Stratelates probably appeared a fourth time, in the prothesis of the Katholikon, corresponding to the half-length portrait of Theodore Tiron in mosaic that survives in the diakonikon.[240] Warrior martyrs are well represented in the Katholikon and in the crypt, but the frequency with which the images of Theodore Stratelates occur is exceptional and indicates a special importance of this saint at Hosios Loukas.

The warriors of vaults B and E appear in monumental decoration of Cappadocia, for example, at Tokalı Kilise at Göreme and the Great Pigeon House at Çavuçin of the tenth century. In the twelfth-century churches of Sicily, holy warriors appear very prominently, as full-length figures, for example, at Cefalù, the Palatine Chapel, Monreale, and the Martorana.[241] In Constantinople the holy warriors appear in force in the parecclesion at Kariyi Djami, their fresco portraits lining the walls on either side of the patrons' tombs.[242]

In ivory carving the warrior saints appear frequently with groupings similar to those on the vaults of the crypt. For example, in the Palazzo Veneziana, Vatican, and Harbaville triptychs of the tenth or eleventh century, warrior saints occupy the wings; seven out of the twelve crypt warriors appear in the Harbaville triptych alone, where they frame a Deesis composition in the central panel.[243] Photius and Aniketus do not appear in the ivories.

Manuscript painting offers one significant example of a grouping of warrior saints with parallels in the crypt. In the frontispiece of the Psalter of Basil II (Venice, Marciana. gr. 17), there are six medallion portraits of saints framing the monumental figure of the emperor: Theodore, Demetrius, George, Procupius, Mercurius, and Nestor.[244] These warrior saints are cited as special patron saints of the emperor, who is invoking their help to win his wars; in the iambic verse opposite the miniature this role is made explicit: "the martyrs fight with him [*sunmachousin*] as friends, laying low the enemies prone at his

[239] See Chatzidakis, *Peintures Murales*, pls. 4, 5, 45, 57, 58.

[240] See Diez and Demus, *Mosaics*, pl. 37; Mouriki notes this likelihood and discusses the appearances of the two Theodores in *Nea Moni*, pp. 256–57.

[241] Demus, *Mosaics of Norman Sicily*, pp. 13–14, 43, 53, 118. Eight out of the twelve appear at the Martorana. In the case of the Palatine Chapel, Demus says

they are "meant to confront the sovereign as at Cefalù" (p. 53).

[242] See Underwood, *Kariye Djami*, 3:pls. 474, 475, 508, 514.

[243] Rice, *Byzantine Era*, p. 314, pls. 99, 101, also 105.

[244] Ibid., pl. XI.

feet."[245] Similarly, groupings of warrior saints appear in the late tenth- or early eleventh-century Exultet Roll no. 1 in Bari.[246]

Although the warriors appear with regularity in Byzantine art in a variety of media, they are especially numerous and prominently placed both in the Katholikon and the crypt at Hosios Loukas. St. Theodore Stratelates appears most frequently of all the warriors, signaling his special importance here; the two anargyroi, Photius and Aniketus, who appear much more seldom, also receive an emphasis in the crypt.

OF THE three categories of portrait medallions in the crypt the apostles are the oldest and most widely encountered group; they appear in three bays (D, F, and G) along the central, east-west axis of the crypt between the bone vaults and the sanctuary. Some aspects of their grouping by vaults appear significant. For example, the Evangelist and apostle Luke, homonymous patron of the monastery's founder, appears in the eastern quadrant of vault F while Luke of Steiris appears in the corresponding quadrant of the neighboring vault to the north, vault C. A third Luke, whom we believe is Luke the Stylite, appears in the northern quadrant of vault J. Thus the apostle represents the middle link in a trio of Lukes in the three vaults on the eastern side of the crypt.

With Luke in vault F appear two more Evangelists, Matthew and Mark; but instead of the fourth Evangelist John, we find Andrew as the fourth portrait, opposite Luke.[247] Thus, the Evangelists do not appear as a united group among the apostles as they do, for example, at Nea Moni where the four Evangelists appear seated, distinguishing them from the rest of the twelve who are not.[248] As in the crypt, the four Evangelists do not appear in any distinct grouping among the apostles in the narthex of the Katholikon.

An exception to the rule occurs in the case of Sts. Peter and Paul in vault D; these saints usually receive prominent placing, most often on either side of Christ, in any grouping of saints, but here they do not appear in what could be considered significant locations within the layout of the crypt. In the narthex mosaics of the Katholikon, in a more customary arrangement, Peter and Paul stand in the intrados of the arches on either side of the entrance to the naos, over which is a lunette with the half-length figure of Christ.

The location of the apostles in the vaults of the east-west axis leading to the apse does compare with early examples of church decoration. San Vitale in Ravenna and St.

[245] Spatharakis, *Portrait*, p. 23, and in another example, the exultet roll of Bari, no. 1 (pl. 61), there is a group of the same warrior saints; this roll is dated 1024–25 and refers to the emperors Basil II and Constantine VIII.

[246] For the groupings of military and other saints in the Bari and other liturgical rolls, see P. C. Mayo, "The Bari Benedictional," *DOP* 41 (1987): 375–79, esp. 388 and pl. 8.

[247] A possible association with Luke and Andrew is that they were both buried in the Church of the Holy Apostles in Constantinople.

[248] Cf. Mouriki, *Nea Moni*, pp. 118–19: "Thus it

becomes clear that the inclusion of twelve figures of apostles, four of whom are the evangelists, is still another rare feature found in the program of the dome of Nea Moni." Furthermore, Mouriki emphasizes the intercessory character of the apostles when seen in conjunction with the Virgin in the apse at Nea Moni (p. 119). This can be extended to the crypt with its Deesis in the apse. The early integration of the four Evangelists into the medallion cycle of the apostles' portraits, although with no distinct grouping, appears in the Panagia Kanakaria on Cyprus, the Katholikon on Mount Sinai, and at San Vitale in Ravenna.

Catherine's on Mount Sinai both have series of medallion portraits of apostles in the arches leading to the sanctuary.[249] In an eleventh-century example, the frescoes of the Panagia Ton Chalkeon in Salonika, the apostles appear as part of the composition spanning the east wall of the narthex, the Second Coming whose central element is a Deesis; they appear in groups of three, all carrying open books.[250] The analogy could again be made between the apostles of this centralized composition around a Deesis, and of the crypt where they appear on the center axis leading to the Deesis in the apse. Their arrangement in both examples emphasizes their importance as intercessors for the fate of mankind.

THERE are more medallion portraits of holy men than of either warriors or apostles, sixteen as opposed to twelve in each of the latter cases. The four corner vaults, A, H, C, and J, are consecrated to portraits of holy men; fifteen of the sixteen portraits can be identified by various means: through their inscriptions; through infrared photography, which revealed lost inscriptions; through Kremos's observations made in the second half of the ninteenth century; and through comparative studies of other portraits and references in documents pertaining to the patrons of the monastery. These monastic portraits are perhaps most important for an understanding of the crypt's program.

In vaults A and H on the west side of the crypt are not so much portraits as labeled stereotypes (figs. 37–44). All seem to have been painted by the same artist. They lack individuality and their traits cannot be used to support their identities; without inscribed names they would be anonymous saints. Most, however, have counterparts in mosaic in the church above and these correspond somewhat in their groupings. For example, the four saints in vault H, Abramius, Theoctistus, Maximus, and Dorotheus, all have counterparts in the northwest vault of the naos of the Katholikon (cf. fig. 95). In all cases they carry martyrs' crosses, like the warrior martyrs, although they are not technically martyrs. The exceptional feature of all the portraits of holy men in the crypt is that none have halos, whereas the warriors and apostles all do.[251]

The four saints of vault H may be seen as two facing pairs: two hermits who became abbots and founded monasteries, Abramius and Theoctistus, and two abbots who were writers and whose works had an important impact on monasticism, Maximus and Dorotheus. The fact that all were abbots of monasteries relates them to St. Luke, the first abbot of Hosios Loukas.

The saints represented in the three surviving identifiable portraits of vault A also appear in the Katholikon: Joannikius, Sisoes, and Makarius, although there may be two individuals named Makarius involved. If this is Makarius of Pelekete, he might be associated with Joannikius, located opposite him in the vault, who was also an abbot and miracle worker in the ninth century in Bithynia. If on the other hand this is Makarius of Egypt, like his namesake in the Katholikon, he would be a representative of Egyptian

[249] See Forsyth and Weitzmann, *Sinai, Church and Fortress*, col. pls. CIII, CXVI, CXVII, and pls. CLII–CLIX.
[250] See Papadopoulos, *Wandmalereien*, fig. 5.
[251] In the Katholikon the distinction seems governed by space and format, for the portraits in medallions do not have halos whereas full- or half-length figures do.

monasticism along with Sisoes next to him in the east segment of the vault. Makarius of Egypt and Sisoes are both represented in the collection of sayings of the Egyptian desert fathers transmitted through Palestine called the *Apophthegmata Patrum*, a popularizing of saints that affected the monastic movement.[252]

The portraits in these two western vaults are meaningful for several reasons. First the holy men depicted represent all the centuries of monasticism, from the fourth to the ninth century, and they represent the regions where monasticism was established, from Egypt, Palestine, and Syria to the holy mountains of Bithynia. The virtues and attributes of holy men are well represented, from self-effacing hermits to abbots and miracle workers. The monastic connotation is unbroken, for there are no patriarchs, bishops, or church fathers—or even angels or prophets—as in other church programs.

The two eastern corner vaults, C and J, must be seen in juxtaposition with each other for they contain portraits of homonymous holy men with the names Philotheus, Loukas, Theodosius, and Athanasius. First, those in vault C are readily identifiable. The portrait of Luke in the eastern and therefore most important segment of the vault represents the abbot and founder of the monastery, Luke of Steiris, for he appears similarly to his portraits in the Katholikon above. In the quadrant opposite Luke is Athanasius the Great and in the north and south segments, Philotheus of Opsikiana and Theodosius the Cenobiarch.

The determining factor for this choice of portraits is more difficult to establish. The garb of each of these holy men is distinctly different and individualized according to his title. Luke (fig. 46) appears as an abbot, wearing the megaloschema as in the mosaic of the north transept of the church above and the fresco of the northwest chapel; he is shown in a modified orant pose, praying with his hands raised before his body instead of to the sides. In the west segment of the vault is Athanasius the Great (fig. 48), dressed as a bishop in phelonion and omophorion, holding a book of his writings that set out the ideals and rules of monasticism (or perhaps this is the jeweled Gospel book).[253] His *Life of St. Anthony* is in many respects a model for all ascetic saints' Lives, for it includes themes common to most: withdrawal from society, usually to the desert; the idea of spiritual voyage in which deprivations test the monk's virtue in his search for perfection; the fight with demons and the devil; and the capacity to work healing miracles.[254] The monk Theodosius (fig. 47) in the south quadrant of the vault can be seen as a representative of Palestinian monasticism, which inherited and supplemented the teachings of the Egyptian fathers. He would also be associated with the greatest stylite saint, Symeon, to whom he was apprenticed for many years, just as Luke of Steiris was apprenticed to the stylite of Zemenna for ten years.[255] His writing of a monastic rule along with St. Sabas was his greatest contribution to the structure of monasticism, especially as this rule in-

[252] The *Painter's Manual* records their sayings and brief descriptions of their traits (pp. 59–60); see also *The Sayings of the Desert Fathers*, trans. B. Ward (Kalamazoo, Mich., 1984), pp. 124 and 212 for Makarius and Sisoes.

[253] Flusin, *Miracles et histoire*, p. 112.

[254] Ibid., pp. 113–17, 161; see R. C. Gregg's translation: *Athanasius, The Life of Anthony and the Letter to Marcellinus* (New York, 1980).

[255] Connor, *Life of Saint Luke*, chap. 35.

fluenced those compiled in later centuries.[256] He is also known for having lived in a cave that later became his burial place and over which a church was built, a further parallel with Holy Luke; further parallels are that he also was a miracle worker, and posthumous miracles occurred at his tomb.[257] Philotheus (fig. 45) in the north quadrant is dressed as a priest and carries a book and a cross. He is the most nearly contemporary for he lived in the tenth century in the Opsikion theme; the entry in the Synaxarium of Constantinople stresses his qualites as a miracle worker or thaumatourgos.[258] According to the Menologium too a spring of healing oil gushes from his tomb, which is "still the source of miracles today"; this description is a close parallel with that of Luke's tomb in the Vita.[259] Thus all the holy men in vault C in some way relate to Luke of Steiris and his qualities as an ascetic, a healer, an abbot, and a virtuous monk.

Luke's qualities, which are reflected in the holy men of vault C, are known through reference to his Vita. Its opening paragraph provides a further key to the meaning of these portraits, and indeed of all the portraits of holy men just discussed:

> The cause of the good life and of zeal for virtue was not truly time, but free will alone and the deliberate choice that loves the good. This is demonstrated by many persons of slightly earlier times who showed forth a life that was unattainable by most people, and who were surpassed not at all or only to a small extent by the exceedingly wondrous men of much earlier times. It is demonstrated all the more by Luke whose festival we celebrate today.[260]

The selection of holy men in these vaults thus may be seen as a summary of the monastic tradition, including holy men of "slightly earlier times" and of "much earlier times." It is a summary geographically and chronologically, including saints of fourth-century Egypt, sixth-century Palestine, and tenth-century Asia Minor, up to Holy Luke's own time. A keen awareness of Luke's place within the monastic tradition is expressed in the passage from the Vita and in the selection of images for the vaults with holy men, with a culmination focusing on his individual exemplary life in vault C.

One vault with portraits of holy men remains to be considered. Vault J contains four portraits of holy men homonymous with those in vault C. Furthermore, their epithets, "*ho hosios pater hemon*" (our holy father), are different from the rest of the portraits in the crypt, which are labeled "*ho hagios*" (saint). The sequence of names of these holy fathers around the vault corresponds to vault C except that all are rotated one position counter-clockwise (see the plan in figure 10). All wear the megaloschema of the abbot, but one, Philotheus, does not wear the koukoulion. Three of the four portraits stand out from all

[256] It is known that there was a manuscript of this rule at the Monastery of St. John of Stoudios in Constantinople and that it was used as a model for the Hypotyposis of Theodore Studites when it was compiled in the ninth century; included in the points adopted by the Stoudite rule were regulations on the conduct of meals (see Leroy, "La vie quotidienne," pp. 48–49).

[257] Festugière, *Moines de Palestine*, 3, no. 3: Theodore de Petra, *Vie de Saint Theodosius*, pp. 83–101; and Cyrille de Skythopolis, *Vie de Theodose*, pp. 57–62.

[258] *CP*, 47–48.

[259] *PG*, 117:49–50; Connor, *Life of Saint Luke*, chap. 85.

[260] Connor, *Life of Saint Luke*, chap. 1.

the others in the crypt for their striking realism and individualization. They appear to be painted from life. The identification and meaning of this group of portraits warrants careful attention.

The first aspect of these portraits that needs explanation is the meaning of the epithet "*hosios pater hemon.*" According to Galavaris, the title "our father" is reserved for the abbot and founding father of a monastery.[261] Mouriki, in reference to portraits of "our father" Theodore Studites in manuscripts, asserts this epithet links the manuscripts to production at the Stoudios monastery.[262] However, there are wider uses of the possessive pronoun and of "*hosios*" in the Theodore Psalter; Michael, the monastery's abbot for whom the psalter was produced, is labeled "our most blessed father" in one case and "our most holy father" in another (fols. 192r and 207v). In monumental decoration the title occurs in the narthex of Hagia Sophia in Salonika, where a portrait of a holy man is labeled "*ho hosios pater*" but the man's name is lost. Also, a full-length portrait of Holy Luke appears in the church of Hagios Demetrios in Salonika on a wall of the south aisle in which he is labeled "*ho hosios pater hemon.*"[263] Thus the term has wider usage and connotations than just indicating the connection of the personnage represented to the place where it appears; however, it consistently indicates the subject was an abbot and is being represented in his role as abbot.[264]

Negative confirmation of this meaning of the term "our holy father" is found in the variety of epithets given the saints and martyrs in the Menologium of Basil II or the Synaxarium of Constantinople. Although they are variously referred to as saint, or holy father, or martyr, or great martyr or holy martyr, when found in monumental decoration they all have the same epithet: "*ho hagios*" or "saint." This is true for all the monastic and other portraits at Hosios Loukas and generally in monumental decoration. But the fact that four portraits were singled out to be labeled "our holy father" in the crypt of Hosios Loukas indicates the special desire on the part of the artist or his patron to stress that these four portraits are of abbots. We can now progress to an explanation of why they were intended to be seen in their capacity of abbots, who they are, and why the portraits are so lifelike in appearance.

According to Chatzidakis, the portraits of vault J are all abbots of the monastery of Hosios Loukas, but I would like to argue against this and his identification of two of them. In brief, he identifies Loukas as the patron saint of the monastery, Theodosius as an associate of Holy Luke mentioned in his Vita, Philotheus as the monk and founder of the Katholikon mentioned in the Offices and Prayers for the day of the translation of his relics, and Athanasius as an unknown abbot of the monastery.[265]

Two of these identifications seem reasonable. It is very likely that Theodosius, shown

[261] Galavaris, "Portraits of St. Athanasius," p. 104.

[262] Mouriki, "Portraits," p. 257; see also Der Nersessian, *Psautiers grecs*, p. 70: "L'emploi du possessif . . . suggère que, soit son modèle, soit le manuscrit lui-même, a des attaches avec le Stoudios."

[263] See Sotiriou, *Basilikē tou Hagiou Dēmētriou*, pl. 80.

[264] This instance has a parallel in the manuscript of the Heavenly Ladder of John Climacus, Princeton, Garrett 16; on fol. 1r John of Raithu is labeled "our holy father" and in the adjoining miniature John Climacus himself is labeled the same way; the labeling indicates they are both being depicted as abbots.

[265] "Date et fondateur," pp. 140–44.

with the features of an old man, is the friend and associate of the saint mentioned in his Vita whom we can imagine succeeded him as abbot after Luke's death. Theodosius had been a member of a wealthy and aristocratic family, as indicated by the description of a visit by his brother the spatharios, Philippuos.[266] It is also very likely that Philotheus is the person who is elaborately praised in the prayers of the Translation service for his part in "thoughtfully bringing about as a truly God-loving deed the reverent transferal of your divine relic, being and being called *Philotheos*"; he is further described as 'the God-loving one who moved you—who became a church, shrine of the Trinity, of the Panagia—all blessed Luke, into a new church which they raised in your name faithfully.' "[267] He is referred to as having shown "zeal to place you [Luke] like a treasured possession in the *thēkē* where you now lie; formerly you were buried in the ground of earth and exuding myrrh."[268] Other sources also show that Theodosius and Philotheus can be identified with two important patrons of the monastery. I believe that Theodosius is the *spatharokandidatos* Theodore Leobachos, on the basis of monastic customs, which we will examine, and the evidence from the Naupactos typikon and the cadaster of Thebes; he was already a monk and had become a close confidant of Luke before his death. Philotheus appears to be the patron of the Katholikon mentioned in the Akoluthiae of the translation of Luke's relics, formerly named Philippus and the brother of Theodore/Theodosius. The evidence for the identity of these two men and their impact on the monastery will be assembled in Chapter III.

The identity of the other two figures, however, is open to question. Chatzidakis's identification of Our Holy Father Loukas as Luke of Steiris seems unlikely since this aged, white-bearded abbot does not in the least resemble his other portraits at Hosios Loukas or elsewhere (cf. figs. 46, 96). Also, he does not have the distinctive horizontal band across his koukoulion, which appears in the other portraits of the saint. Athanasius, as mentioned earlier, Chatzidakis assumed to be an unknown abbot of the monastery.[269]

Another identification and explanation for these two abbots can be advanced but we must start with the key figure who occupies the eastern segment of the vault, corresponding to Luke of Steiris in the eastern segment of vault C: Theodosius. Theodosius, if he were a wealthy abbot and successor to St. Luke, might be seen here as parallel to Luke in the sense of his being the new and current "founder" of the monastery; we can even assume he was responsible for the building of the Katholikon. Such an important role as patron would explain the significant placement of his portrait among the abbots. He alone would have been entitled to this honor and in fact would probably have planned the decorative scheme to a large extent personally. Accordingly he chose to have represented with him two well-known abbot/patrons of the time; as in the parallel vault C, they represent the wider monastic world of which he considered himself a part. To maintain a correspondence with the names in vault C, he chose another Luke, Luke the

[266] See Connor, *Life of Saint Luke*, chap. 63.

[267] Kremos, *Phokika*, 2:100, 130.

[268] Kremos, *Phokika*, 2:99; what is interesting about this passage is that the tomb of Luke is also referred to as the *thēkē* in the Vita in many instances,

and the same verb *katatheinai* is used in the Vita (Connor, *Life of Saint Luke*, chap. 65) to describe Luke's burial.

[269] Chatzidakis, "Date et fondateur," p. 140.

Stylite of Constantinople, a notable holy man, stylite and founder of the Bassanius Monastery in Constantinople where he was buried. This identification can be corroborated by the portrait of Luke the Stylite in the Menologium of Basil II, which strikingly resembles this medallion portrait.[270] The other abbot, Athanasius, is not an unknown abbot of Hosios Loukas as Chatzidakis concluded but, I suggest, Athanasius of Athos, monk and patron of the Great Lavra, who founded the monastery with the help of imperial funds presented him by the emperor Nicephorus Phocas. In this case the frontispiece of an eleventh-century Vita of Athanasius provides us with an early portrait of Athanasius, which, like the crypt medallion, shows the saint in his prime and has the same lifelike quality, suggesting they were both painted from life.[271] If the portrait of Athanasius was painted in the last quarter of the tenth century, it was done while he was founding Mount Athos and before he was recognized as a saint. However, with his fame as a founder and monastic leader already at this time, Athanasius would make distinguished and cosmopolitan company for the abbot Theodosius who wished to be associated with prominent representatives of the contemporary monastic world.[272]

The extreme realism of these three portraits presents an interesting problem, for they seem to have been painted from life. And although portraits of donors are frequently encountered in Byzantine art, much rarer are true portraits of holy men, and especially of holy men who became saints: Luke the Stylite and Athanasius of Athos. A precedent does exist in early Byzantine mosaics, in which two monastic portraits at St. Catherine's on Mount Sinai share the realism of the Hosios Loukas abbots. At either extremity of the band of medallion portraits of apostles and prophets before the apse are Longinus the abbot and John the Deacon; they are dressed in monastic garb and look out at us with the startling directness one can only associate with true portraits.[273] But these holy men would be comparable with Theodosius and Philotheus, for they did not go on to become saints. A similar portrait realism is, however, encountered within Hosios Loukas itself in the striking portraits of Loukas Gurnikiotes and Nikon Metanoite in lunettes in the Katholikon above.[274] To be depicted with halos, these portraits should represent deceased and canonized saints. Nikon's portrait could have been done soon after his death, at the end of the tenth century. But for Loukas Gurnikiotes there are no clues as to his dates or identity. It is possible he was a contemporary of Nikon and was associated with the city of Gournia on Crete, and so his epithet. Nikon was known to have preached and traveled extensively on Crete after its recapture by the Byzantines from the Arabs in 961. Perhaps this Loukas was known and admired in Steiris for similar reasons. In any event, it is clear that highly skilled and sophisticated artists were working at

[270] *Il Menologio*, p. 238.

[271] This is implied by Galavaris as well, who says the portrait has a "lifelike quality" and that "the image was made by someone who was near the saint in time" ("Portraits of St. Athanasius," p. 102).

[272] Awareness of a broader "community of abbots" may be attested by mention in the Vita of Theodore Studites of the other abbots of the holy mountain and in the Vita of Athanasius where the concern for abbots as representative of their communities is stressed. Also, the Life of Peter of Atroa reveals the awareness of other abbots in sympathy with the iconodule position.

[273] Forsyth and Weitzmann, *Sinai, Church and Fortress*, pls. CXX and CXXI.

[274] See Stikas, *Oikodomikon Chronikon*, pls. 27b, 33a.

Hosios Loukas in order to produce these vivid portraits, fulfilling the demands of not just wealthy but also worldly patrons.

Some further comparisons with the vault frescoes of the crypt help us to understand their selection and arrangement. At Nea Moni on Chios, the decorative program corresponds in some important respects with the corner vaults of the crypt at Hosios Loukas. Just as vaults C and J of the crypt contain homonymous saints, the homonymous Symeons are juxtaposed on opposite sides of the narthex at Nea Moni along with two other stylite saints.[275] Furthermore, the arrangement of saints at Nea Moni deliberately includes representatives of the same three areas of monasticism as at Hosios Loukas: Egypt, Palestine, and Constantinople; they are presented in pairs in several instances.[276] Mouriki further states that at Nea Moni "a familiarity with the biographies of the representatives of Christian monasticism reveals that the selection of saints in this category at Nea Moni is not a random one." Similar planning seems to have taken place in the category of monastic portraits at Nea Moni and Hosios Loukas.

The overall selection of saints' portraits in the crypt can be explained in relation to the most comprehensive groups of portraits of saints that are found in the collections of readings of their lives, the illustrated synaxaria or menologia. Most of the saints of the Hosios Loukas crypt vaults are also found, for example, in the Menologium of Basil II, which covers only the first half of the church year, from September through February; this feature has also been noted in other monuments, at Daphni for example, that "the saints included in the programs of Byzantine churches, in their overwhelming majority, are commemorated in the early months of the ecclesiastical year and usually during the first five-month period." This has been attributed to the influence of the Metaphrastian menologion, a tenth-century compilation of saints' lives covering the first half of the calendar year.[277] Due to the many correspondences in the iconography and selection of the monastic and other portraits between the Menologium of Basil II and the crypt, it seems probable that an illustrated service book such as a menologium or a synaxarium served as a model for these medallion portraits.

ON THE walls of the crypt in eight lunettes formed by the arched sides of the vaults are eight scenes from Christ's Passion and Resurrection and in addition the Dormition or Koimesis of the Virgin. The location of these in relation to the viewer is unparalleled in church decoration, except perhaps for some of the small Cappadocian chapels; the accessibility of these scenes affords the kind of intimacy of contemplation most often associated with icons. They share the viewer's space also in the sense that they are all provided with a landscape or other setting with blue sky in the background, thus extending the starry dark blue sky of the vaults into the earthly surroundings of the walls. The visual and spatial environment of the crypt creates a setting conducive to spiritual participation in the events shown.

[275] See Mouriki, *Nea Moni*, plan on pp. 38–39, nos. 82 and 85, St. Symeon the Younger and St. Symeon the Elder; two other stylites appear in corresponding positions on opposite sides of the narthex: St. Aly-pius and St. Daniel the Stylite (nos. 83, 84).

[276] Mouriki, *Nea Moni*, pp. 210–11.

[277] Ibid., p. 211.

The arrangement of the scenes is significant. Two scenes illustrating great feasts of the church are on the north wall of the crypt on either side of the central bay containing Holy Luke's tomb; seen as one faces north are the Dormition of the Virgin to the left, in bay A (see the schematic plan in figure 10) and the Entry into Jerusalem in bay C, to the right. The Entry into Jerusalem may also be seen as the first scene in a Passion cycle, which continues in the Washing of the Disciples' Feet and the Last Supper on either side of the sanctuary and ends in the Crucifixion on the wall adjoining the Entry. The placement of the Washing of the Feet and Last Supper in the sanctuary especially stresses their importance. In the lunette corresponding to the Crucifixion on the south side of the crypt is the Deposition from the Cross, both being on the east walls of the corner bays C and J. Adjoining the Deposition on the south wall of the bay is the double composition of the Burial and the Women at the Tomb with the angel of the Resurrection. The Incredulity of Thomas on the south wall of bay H serves as a sequel to and confirmation of the Resurrection, as does the Koimesis of the Virgin who was also granted resurrection, which completes a clockwise visit around the crypt.

The disciples figure prominently in four of the eight scenes, which is appropriate in view of the message of resurrection of the scenes and the fact that they were the witnesses who attested its truth; their importance has already been discussed in connection with the apostles. All the scenes, with the exception of the Koimesis, are commemorated depending on the date of Easter and as such are related to the liturgical calendar; they can be seen as corresponding to the services for the preparation, celebration, and aftermath of Easter as celebrated, according to the *Lenten Triodion*. The two scenes of the sanctuary located closest to the holy table, the Washing of Feet and the Last Supper, are associated with the readings for Maundy Thursday and are symbolic of the institution of the tradition of the sacraments. The washing of the feet was a ceremony performed at all churches during Holy Week as no doubt for the monks of Hosios Loukas, which might explain the unusually large basin in the scene, while the eucharistic meal was of central and intense significance for all monks. These two scenes were particularly placed in the sanctuary for assimilation by the monastic community on the occasions of its most sacred rituals.

Burial as well as resurrection is emphasized, not only in the Passion scenes leading up to Christ's death and burial but in an iconographic feature of the scene in bay J, the Burial and Three Marys at the Tomb. In this scene, the sarcophagus of Christ is disproportionately huge and massive, with much attention given to details of its decoration. But more important, it is intended to be seen not only from the space immediately in front but also over the top of the large sarcophagus set into bay J (see fig. 5). By this juxtaposition of real and painted sarcophagi, the funerary function of the crypt is emphasized.

The program of the crypt shares important elements with the narthex of the Katholikon at Hosios Loukas. The twelve apostles (the same selection of twelve apostles as in the crypt) appear on the intrados of the four lateral arches, and three scenes—the Crucifixion, the Washing of the Feet, and the Incredulity of Thomas—appear in lunettes. The fourth scene of the narthex is the Anastasis. The narthex program can be read as two

complementary pairs of scenes, the Washing of the Feet as preparatory to the Crucifixion and the Incredulity of Thomas as sequel to the Anastasis.[278] Similarly, the program of the crypt emphasizes death and resurrection, but the presence of the Anastasis in the narthex makes even more explicit the dominant theme of salvation. It is therefore very likely that if there was a fresco on the wall behind the tomb of Holy Luke in the crypt it depicted the Anastasis. The similarities between the programs of crypt and narthex suggest there were also similarities of function.

The crypt of Hosios Loukas has parallels with other narthex programs besides that of the Katholikon. The Washing of the Feet is juxtaposed with the Last Supper in an abbreviated Passion cycle in the narthex at Daphni. At Nea Moni the Entry into Jerusalem appears next to a series of Washing of the Feet scenes that includes preparatory scenes. Thus the nartheces of the three major middle Byzantine church programs all include the Washing of the Feet, while other scenes from the Passion series of the crypt appear in them as well. The function of the narthex in funeral services as described in the Euchologion will be discussed in Chapter II. The question posed by these programmatic similarities is how did the funerary role of the crypt compare with that of the narthex.

The closest overall parallel with the crypt in terms of selection, combinations, and connotations of scenes is in the frescoes of the Panagia Ton Chalkeon in Salonika. In the north transept of the Panagia Ton Chalkeon the Entry into Jerusalem and Crucifixion appear side by side, as in bay C of the crypt, and they appear above an arcosoleum niche for a tomb. The Koimesis and Last Supper also appear at the Panagia Ton Chalkeon, in the southwest corner of the naos. The twelve apostles appear in the narthex in a grand composition of the Last Judgment that includes the Deesis at the center; the intercessory meaning is clear. The Panagia Ton Chalkeon was planned as the principal church at a monastery in which the Katepano or governor of the theme of Langobardia in southern Italy was buried, as stated in the dedicatory inscription. This church of ca. 1028 with its funerary aspect has the decorative program most closely corresponding to the scenes in lunettes of the crypt at Hosios Loukas.[279]

The Deesis in the apse, now lost except for a small trace (see fig. 83), depicted the Virgin and St. John addressing prayers of intercession to a central figure of the enthroned Christ; this is the image connoting intercession par excellence in the Orthodox church. The presence of the Koimesis fresco strengthens this theme within the crypt's program, reflecting the Virgin's intercessory role as proclaimed in the *Festal Menaion* on her feast day, August 15: "In giving birth, O Theotokos, thou hast retained thy virginity, and in falling asleep thou hast not forsaken the world. Thou who are the Mother of Life hast passed over into life and by thy prayers thou dost deliver our souls from death."[280] Also, prayers addressed to Christ with the intercession of the Virgin and St. John are found in the Liturgy of the Presanctified read during Lenten services. The concentration of the cycle of Lenten and Easter images in the crypt therefore fits thematically with the scene of the Koimesis and the Deesis of the apse in a coherent program. Furthermore, "inter-

[278] Mouriki, *Nea Moni*, p. 205.
[279] See Tsitouridou, "Die Grabkonzeption," pp. 438–40.
[280] *Festal Menaion*, p. 511.

cession was officially attributed to certain saints and the Virgin at the Council of Nicaea of 787," ensuring that these would be some of the most significant images in Byzantine art after iconoclasm.[281] The intercession scenes on the entrance vault and on the west wall of the crypt confirm the importance of this theme in the overall scheme (fig. 82).[282]

In the crypt, the large number of saints in particular can be joined with the Deesis as an expression of the prayer of intercession; the Theotokion or prayer to the Virgin that concludes the funeral service as it appears in the Euchologium makes the interconnection explicit in its "invocation to Christ, the Virgin, the Baptist, the apostles, the prophets, bishops, *hosioi*, the righteous and all the saints for the salvation of the deceased."[283] Thierry emphasizes that the core of a funerary program is the Deesis, the central group of a Last Judgment; the apostles are linked with the Deesis as "evangelizers" of the world; military saints also figure prominently in the Cappadocian programs.[284] The Deesis is rare in Greek churches but is found in the apses of many cave churches of Cappadocia.[285] At Karanlık Kilise the donors are at the feet of the Christ of the Deesis, although this depiction is rare.[286] Due to the ruined condition of the Deesis at Hosios Loukas it will never be ascertained whether there were any donors depicted at the feet of Christ.

Another type of intercessory image of Christ that appears at Hosios Loukas is the Blessing Christ in a rainbow medallion in the barrel vault over the entrance door; he appears with arms outstretched, gesturing to a group of monks on the left wall below and to the patron saint, Luke of Steiris, on the right (figs. 78–81). The monks and the saint appear in their role as intercessors with Christ. But their location at the entrance to the crypt has another meaning. Chatzidakis believes they are the monastic donors who sponsored the building and decoration of the church.[287] But the direction in which the monks gaze, to the right, toward the north end of the crypt where the tomb of the saint is located, suggests another connotation of the group.

The crypt functioned not only as a burial chapel but it was also where miracles took place at the saint's tomb. We know this through the Vita of Luke of Steiris, which recounts stories of healing, ranging from cures of demonic possession through incubation, to healing of sore feet through application of oil from the lamp over the tomb. These fifteen Posthumous Miracles at the end of the Vita relate vividly the operation of the healing cult centered at Holy Luke's tomb. It is in this light that we must see the monks receiving Christ's blessing. For they are "the sympathetic brothers" or "God's helpers," or, among them, "the humane one, Pancratius"—terms used in the Vita's description of the role of the monastic community with regard to healing miracles that took place at

[281] Mouriki in Belting, Mango, Mouriki, *Pammacharistos*, p. 58, and p. 70, n. 111.

[282] Chatzidakis, "Date et fondateur," p. 135 and pls. 10–13.

[283] Mouriki in Belting, Mango, Mouriki, *Pammacharistos*, p. 71, and Goar, *Euchologium*, p. 432.

[284] N. Thierry, "Yusuf Koç Kilise: Eglise rupestre de Cappadoce," *Mélanges Mansel* (Ankara, 1974), pp. 204–5.

[285] See Rodley, *Byzantine Cappadocia*, p. 44 (Kılıçlar), p. 53 (Karanlık), p. 90 (Direkli), p. 116 (Eski Gümüş), p. 156 (Yusuf Koç), p. 173 (Yılanlı), etc.; see also Chr. Walter, "Two Notes on the Deesis," *REB* 26 (1968): 311–36.

[286] See A. J. Wharton, *Art of Empire: Painting and Architecture of the Byzantine Periphery* (University Park, Penn., 1988), fig. 2.23.

[287] Chatzidakis, "Date et fondateur," p. 137.

the tomb of the saint.[288] The monks' role was an active one, of *sympatheia*, or encouragement and counseling for the afflicted, but also quasi-medical *therapeia*. The healing ritual, often a lengthy one, included services performed by specially trained monks—what we would call medics—who were something between country doctors and physical therapists. The image refers to the active and prescribed therapeutic role of the monks of Hosios Loukas, and they are depicted here as intercessory agents of Christ's healing grace through the miraculous tomb.[289]

The closest parallel for a monastic group receiving Christ's blessing is found in a manuscript rather than in monumental painting. The typikon of the monastery of Our Lady of Good Hope includes in the dedicatory pages at the beginning of the manuscript a group portrait of the nuns, including their abbess who was also a founder of the monastery.[290] They are shown in rising-viewpoint perspective and all stand in a position of supplication, with hands raised toward an unseen presence. The fact that this group portrait is part of a typikon is significant because the wishes of the donor and the institution's particular function, if any, often set down in the "founder's typikon" of a monastery are intended to be associated with the image of its members. Although no typikon exists for Hosios Loukas, we can see in this group portrait in the crypt a visual statement of the community's main role, an image that would have had clear meaning for visitors or suppliants entering the crypt.

THERE is no completely comparable program of church or chapel decoration to match the Hosios Loukas crypt. Nowhere is such a great number of saints' portraits encountered in a decorative program nor is there one comprising the thematically narrow range of scenes found here. Martyrs, apostles, and holy men appear elsewhere but not without the inclusion of prophets, angels, or female saints; the same is true of the scenes, which occur elsewhere in various combinations with the other great feasts or in addition to short Mariological cycles. This particular selection and emphasis are unique.

Through the analysis of individual as well as more comprehensive parallels in a variety of media for the crypt's frescoes, their funerary message stands out—thoroughly in keeping with a space containing three tombs.[291] What sort of funerary practices might have taken place there will be taken up in the next chapter, in order to understand better how program and usage correspond. Connotations of the program have been elucidated by literary sources, so that different combinations of portraits appear as almost a visual prayer for salvation. The Vita of Luke of Steiris suggests a connection between the pro-

[288] See Connor, *Life of Saint Luke*, chaps. 68–85.

[289] See C. L. Connor, "A Monastic Group Portrait: *Therapeia* at Hosios Loukas," in *Twelfth Annual Byzantine Studies Conference: Abstract of Papers* (Bryn Mawr, 1986), pp. 28–29.

[290] Spatharakis, *Portrait*, pp. 190–206 and pl. 154. There are also portraits of monks on fol. 14a of the Rabbula Gospels showing several monks and an abbot next to an enthroned Christ (Cecchelli, *Rabbula*

Gospels, pl. 14a) and in the manuscripts of St. John Climacus—for example, Princeton, Garrett 16, fols. 4r and 194r (see Martin, *Heavenly Ladder*, pls. 31, 66).

[291] The Pammacharistos church in Constantinople has also been shown to have a program with funerary connotations from its selection of saints and scenes; see Mouriki in Belting, Mango, Mouriki, *Pammacharistos*, p. 71.

gram and the healing cult fostered by the monks at the monastery and will continue to be invaluable for our understanding of the monastery. The portraits in the southeast vault provide unique insights into the individuals and intents behind decorative planning in the middle Byzantine period; artists' methods and training are also demonstrated when we analyze the different types of portraiture. The juxtaposition of programmatic features of the Katholikon's and the crypt's decoration dramatizes the specific and local monastic character and connotations of this carefully planned undertaking. The impact of the intimate and powerful art of these frescoes on the viewer was not only to elicit fervent hope for salvation but also to evoke Holy Luke's presence and his ongoing benevolent role, still attended by monks at his monastery after his death, of working miracles.

STYLE

The "Hosios Loukas style" is both singular and varied.[292] The frescoes of the crypt and mosaics and frescoes of the great church of the Katholikon share a range of consistently used details, technical devices and formulas, and pictorial devices and color schemes. Nowhere else in any surviving monumental ensemble do we find a decorative scheme of such breadth or with an equivalent repertoire or combination of features. Differences in medium, between fresco and mosaic, naturally produce differences in effect, but the style as it appears throughout the monument is unique and identifiable. We are challenged, therefore, to define this style as we find it in the frescoes of the crypt, to recognize its hallmarks and savor its variety. For in characterizing the "Hosios Loukas style" we learn not only how these artists practiced their trade, but also how Hosios Loukas might be situated with regard to other examples of middle Byzantine monumental painting.

Before analyzing individual features composing this style, we will take stock of the overall character of this artistic endeavor. The walls of the crypt are lavishly decorated not only with representations of figures and scenes but also with a range of ornament. The balance between ornament and figural decoration is noteworthy, for in its subtlety this balance produces an impression neither of austerity nor of confusion or overabundance. Each area of painted wall surface clearly reflects its relation to the structure: intrados of arches, divisions between vault segments, frames around the scenes, and so on. Scale is a major factor in this balance, for the decorative borders are planned to complement the figural compositions of scenes and are not so wide as to distract from them. The patterns of vault decoration differ enough to avoid monotony, but do not draw attention away from the medallions they surround. Polychromy imitating marble and intarsia appears in a wide repertoire and varied locations but always in a logical manner. A rich palette of colors appears throughout, but no one shade predominates or seems out of place. A harmony of conception has been achieved in this decorative scheme that

[292] For a discussion of this "Hosios Loukas style," see Mouriki, *Nea Moni*, pp. 259–60.

is both restrained and ornate, orderly and lavish. In other words, this is not a chance solution to a problem of painting an interior, but a highly refined, subtle, and integrated approach that could only have been developed by an experienced master. The balance and clarity of the application of frescoes to wall surfaces are primary features and are integral to their style.

Within the ensemble of representational frescoes, we will look at three major stylistic features: the treatment of human figures, in particular faces and drapery; the treatment of composition and compositional elements; and the color scheme. These constitute important defining elements of the "Hosios Loukas style."

The faces of the portrait busts in medallions differ markedly among the three categories of warriors, apostles, and holy men. The warriors have full faces with generous, rounded chins or beards; there is usually a chin dimple and pronounced cleft between nose and lips—see for example St. Vikentius (pl. 1; fig. 24). Eyes are accented by heavy eyebrows and lids; lashes extend outward in a line in each case, and there are pronounced circles underneath the eyes. Hair is curly or delineated to show loops, and there seems to be a predilection for moustaches.

The apostles have larger eyes in proportion to the rest of the face than the warriors, giving them more spiritual expressions, as with St. Mark (fig. 29). Although relying on preiconoclastic visual models, they are closest to an antique philosopher or "thinker" type, with broad, prominent forehead and short beard. There are distinct mannerisms of the hair in many cases, such as Peter's spiral curls (fig. 25), Andrew's loose ends (fig. 32), Matthew's lock (fig. 31), or Bartholomew's short wisps of hair ringing the top of his forehead (fig. 27). There is often a pronounced triangular V between the eyebrows. When short hair is worn, huge "cauliflower" ears protrude, as in Philip (fig. 35).

For the portraits of holy men, a whole different set of technical devices is used to give them an ascetic look. Most have thin faces with haggard expressions created by heavy outlining and elongation of cheeks, and extreme linearization of features, especially on the bulbous foreheads, like St. Abramius (fig. 41). The beards have a long almond-shaped section over the chin and many have the "cauliflower" ears. Some have a stereotyped, vacant quality of expression, such as in vaults A and H. The three portraits of *hosioi* in vault J, in contrast, have been treated realistically with fine and sensitive modeling and an absence of linear features. Their liveliness and individuality suggest the artist painted them from life (figs. 49–51).[293]

In the scenes, faces are powerfully drawn, with large dark eyes with black pupils; they depict a distinctly eastern complexion and coloring with tawny skin and dark, boldly linear hair, as in the priests of the Entry into Jerusalem or in the Burial (figs. 57, 69; pls. 1, 6). The triangle between the eyebrows appears in all faces. The face of Christ in the Incredulity of Thomas or the Last Supper has a harsh, stern appearance caused by the extreme darkness of the eyes, eyebrows, and circles under the eyes. The darkly delineated nose and black beard contrast with the tan flesh and whites of the eyes (fig. 74). In

[293] For a discussion of these portrait types, see Connor, "The Portrait of the Holy Man in Middle Byzantine Art," pp. 72–73.

Nicodemus of the Burial and in some disciples of the Incredulity of Thomas, another facial mannerism appears: a pronounced line from the bridge of the nose up the forehead, used for faces in three-quarter view (fig. 76).[294]

The coexistence of different facial types within the same program indicates a deliberate choice by the artist to adhere to different types of models for different categories of portraits. The differences among these portraits, which can be classified as the stereotype, the visual model, and the life portraits, demonstrate the flexibility of a style in which the artist adapts his technique to the subject matter; we encounter here an iconography of style. The faces in vaults A and H seem to have been painted by the same artist, as were the three very naturalistic portraits in vault J, but beyond this it is difficult to recognize elsewhere the work of any one individual. When the technique is determined by the intent of the artist to render different facial types, the question of "hands" becomes secondary in importance.

The drapery of figures is ruled by the brushstroke, with no attempt made to disguise it but instead to exploit its expressive potential. The garments of warriors and apostles are painted in medium tones, then dark contours and shadows are added in brushstrokes of shades of low value, with white highlights being applied last. This use of white is free but decisive. The white brushstrokes are parallel to the lines of creases, either straight or zigzag; they define the curves of shoulders by creating rounded patterns on the base tone, and they give a sense of movement to the edges of drapery contours by appearing at intervals as two short, quick parallel strokes (see pl. 7). White pigment is frequently used in a technique resembling chrysography, in the tunics of Bartholomew and Matthew, for example, where triangular areas are painted starting with flat white in a corner and gradually progressing to a sunburst pattern of separate rays (figs. 27, 31). The wedge-shaped motif, and teardrop pattern over the shoulders—seen on the disciples of the Incredulity of Thomas, for example—are produced by clearly visible individual strokes of white paint (fig. 76). The spiral-shaped motif over the abdomen of the angel of the Resurrection or of Christ of the Last Supper is again produced by parallel strokes of low and high value over a medium ground color (figs. 62, 70). The white brushstroke is seen at its most dynamic and expressive in the hem of Peter's chiton in the Last Supper; the sense of fluttering motion is produced solely by the application of a series of wavy white lines and a jagged white hemline (pl. 8; fig. 63).

Clearly visible brushstrokes appear in swirls around the heads of figures in medallion portraits, with lighter tones closest to the head and darker ones toward the border. The effect produced is like the emanation of light from the face or a sense of dynamism and energy surrounding it.

Color is an important consideration for a stylistic evaluation that is often neglected, but without mentioning color it would be impossible to describe the frescoes and to define their effect. The broad and subtle range of pastel shades appears most surprising in the scenes of the crypt. For while we are constantly confronted with stark contrasts

[294] This line up the forehead is found in the frescoes of the Panagia Ton Chalkeon (see Papadopoulos, *Wandmalereien*, pl. 24).

of dark and light—ornamental patterns in saturated colors against light backgrounds in the ornament, or dark eyes in pale faces in figural representations—pastel shades are used much more often in garments and background elements than are deep colors. When dark blue or black do appear, it is for symbolic reasons—for example, in Christ's dark blue himation in the Entry into Jerusalem (pl. 5) or Incredulity of Thomas (pl. 12) or the thick black cross of the Crucifixion and the Deposition (pl. 9). The use of shades of pink and light green is especially frequent in garments (see pls. 5, 11), but there are intermediate shades of mauve, cranberry, jade, and deep olive. Lighter and darker blues appear as base colors, and there are yellow, red, and brown ochers as well as several grays (see pls. 5, 12). Since dark blue sky is used for the background of the scenes and the medallions, the pastel garments of figures stand out from their surroundings in bright contrast, allowing the eye to take in the full range of linear detail and soft transitions from light garment colors to white highlights (see pls. 1–3).

The compositions of the scenes, although pared down to essential elements, do not have the hieratic quality of their counterparts in mosaic.[295] They are not all strictly symmetrical but instead have a more relaxed narrative quality through the use of background elements. For example, Christ riding to Jerusalem is not in the center of the composition; the arrangement of figures is simple, with background mountains framing his head so that the effect is both bold and clear (fig. 54 and pl. 4).[296] The scale and proportions of figures in the scenes are such that they have ample space for movement; figures gesture and respond to one another with a natural lyricism and grace. In the Washing of the Feet, for example, the disciples looking on and preparing to have their feet washed seem well adapted to the space of the lunette, while in the narthex mosaic rendering of the scene the groups are more cramped and distorted (cf. figs. 60, 98). Proportions of figures are natural, being neither elongated nor squat, with drapery that neither envelops nor clings to them; bodies are clearly understood and articulated beneath the drapery. If it were not for the conventions of painting technique breaking drapery up into schematic patterns and simplifying and enlarging facial features, they could be considered to some degree classicizing.

Backgrounds and landscape elements are used expressively and functionally. As has been mentioned, the mountains in the backgrounds of compositions serve as frames as well as accents for the events depicted; they also are expressive of emotional tension in the way their jagged peaks are fragmented into angular, frothy configurations, as for example in the Deposition from the Cross (fig. 64). Without the mountains, the effect would be much more of a flat stage with dark backdrop, analogous to the plain gold ground of mosaic compositions; thus the mountains, with their rich, warm hues and delicate, sinuous plant growth, serve to soften the transition between figures and dark blue sky. The architectural background of the Koimesis frames the central event (fig. 77), and although iconographically the scene may have taken place in the Virgin's house,

[295] Examples from Daphni or Nea Moni, Chios or the Katholikon make this distinction clear; see Diez and Demus, *Mosaics*, for examples from all three.

[296] Morisani's description of compositions of the scenes elaborates on this basic observation: see Morisani, "Gli Affreschi dell' H. Loukas in Focide," *Critica D'Arte* 9, no. 49 (1962): 1–18.

the decorative stepped pattern and towers of the background are a convention made familiar through the medium of manuscript illumination.

Other elements have singular features. The bench of the Washing of the Feet and the table of the Last Supper are clearly of wood construction (figs. 60, 61; pl. 8); they seem to rely on everyday furniture that one would find at a monastery, rather than being jeweled or subtly decorated as in some monumental renderings of the scenes. The great sarcophagus of the Burial has a stepped pattern and decorative motifs and niches like antique sarcophagi (pl. 10; fig. 68). Painted imitations of marble and intarsia work cover every surface where these would appear normally in a church; the inclusion of pseudo-Kufic elements in the decoration of the two capitals next to the sanctuary, and the heavily ornamental quality of architectural members and divisions, indicate a strong concern for covering of surfaces with precious and brilliant materials. A distinctively oriental flavor is evident in the floral ornament of intrados of arches and pseudo-Kufic motifs.

This all-over quality of decoration appears in most cave churches of Cappadocia—for example, Tokalı, Kılıçlar, and Çavuçin—but there the narrative scenes in bands do not at all resemble their placement at Hosios Loukas; in the crypt they are framed as monumental icons, just as in the later "column churches" of Cappadocia. In the mosaics at Nea Moni, Daphni, and the Katholikon at Hosios Loukas the same precious quality is achieved from combining scenes with ornamental borders and variegated marble revetments.

The mosaics and frescoes of the Katholikon provide the closest stylistic parallel with the crypt and it is important to establish the relationship among them. A comparison with the mosaics is facilitated if we examine subjects or scenes that appear in both. The narthex of the Katholikon provides the best opportunity, for there, as we have already noted, three of the four mosaic scenes also appear among the frescoes of the crypt: the Crucifixion, the Washing of the Feet, and the Incredulity of Thomas. The three scenes show many stylistic similarities with their counterparts but we will only cite a few.

First, comparing the Crucifixion in mosaic and in fresco, the composition in both is pared down to three essential elements: the crucified Christ, the Virgin and St. John (cf. figs. 58, 97). The tonalities are generally lighter in the mosaic with a reliance on dark outlines for clear definition of forms. In the figures of St. John, which appear in exactly the same attitude, the painted colors are deeper and richer in the fresco, with an emphasis on modeling of the folds and highlights of his garments. John appears altogether more plastically conceived, more classicizing in the articulation of the body and the folds of drapery over it, although the two seem quite clearly drawn from the same model. The fresco, however, achieves a more convincing rendering of the knees beneath the chiton, with a V-shaped fold indicating where the drapery clings to the leg before falling along the side of the calf. The mosaic, although it reproduces the V shape in dark tesserae, is far less successful in giving an illusion of plasticity or three-dimensionality. The result is a more abstract and sharply patterned arrangement of parallel rows of cubes in graduated tones, from dark creases to light highlights. Also, in the upper torso of St. John, two identically parallel folds with broad zigzag patterns fall from shoulder to waist. But again, the fresco's execution conveys a sense of the plasticity of drapery while the mosaic

repeats the folds as a flat design. Along the edges of the innermost vertical folds of the himation in both St. Johns there are pairs of short horizontal slashes, a singular convention shared by both frescoes and mosaics in many instances at Hosios Loukas. The similarities of style as well as iconography in these two examples are striking, whereas the differences are due mostly to the difference in medium.

In the other parallel sets of examples, the fresco and mosaic versions of the Washing of the Feet and the Incredulity of Thomas, the similarities of figure composition and handling of drapery indicate a common model (cf. figs. 60, 98; and figs. 72, 99). The disciple who twists to observe Christ washing Peter's feet is common to both versions. In the Incredulity of Thomas, the patterns of folds over the thigh in all the figures of apostles and the swag of drapery around the shoulder and right arm of Thomas should convince any observer that these rely on the same models.

A comparison of the medallion portraits of monastic saints shows a similar tendency toward repetition and lack of individuality both in the mosaics and in the frescoes, with the exception of some in each case that rely on established types or on portraits from life (cf. figs. 43, 95).

The frescoes of the northeast, northwest, and southwest chapels of the Katholikon show pronounced similarities with frescoes of the crypt. For example, compare the faces of the five martyrs of the northwest chapel and those of Sts. Bacchus and Nicetas from the southwest chapel with the warrior martyrs of vaults B, E, and I of the crypt.[297]

From these examples it is clear that the same models were used for the mosaics and the frescoes and that they therefore are closely contemporary. We can even suggest that the artists who executed the frescoes were trained in the art of mosaic, which might account for the pronounced graphic and schematic quality of some of the frescoes.[298] Since mosaic was the more precious and expensive medium, the decorative art par excellence, one can assume artists trained in this medium were expressly brought to Hosios Loukas for this purpose and also executed the frescoes, rather than the other way around. We can therefore conclude, from the links between the two works just discussed, that the mosaic and fresco decoration of the Katholikon and the crypt must have been carried out by the same workshop during the same campaign at the monastery.

Now that we have established the contemporaneity of the mosaics and the frescoes at Hosios Loukas, we confront the issues of the date of this campaign and its sponsor. In the absence of foundation inscriptions or documents giving us this information, scholars have variously dated the Katholikon, primarily on the basis of the style of the mosaics. Datings range from the early to the late eleventh century.[299] With the new evidence of the frescoes, we will look at some comparative examples of monumental painting of the tenth and eleventh centuries in an attempt to find in them new criteria for a dating based

[297] See Chatzidakis, *Peintures murales*, pls. 13, 47, 48, for the frescoes of the Katholikon.

[298] This idea was suggested by Doula Mouriki and merits further investigation.

[299] The evidence and arguments for dating are summarized by Pallas, "Topographie und Chronologie." The principal theories are those of Diehl (first half of the eleventh century), M. Chatzikakis (1011), and Stikas (ca. 1045).

on style. In so doing we will also test the limitations as well as the possibilities of dating Byzantine monuments on the basis of style.

As a starting point, a recently discovered fresco of Joshua from the facade of the Panagia church merits special consideration for it must antedate all decoration of the Katholikon (fig. 94).[300] From its inscription and theme of conquest, it can be shown to celebrate the Byzantine capture of Arab-held Crete in 961, an event that had been prophesied by St. Loukas. This campaign, one of the great Byzantine victories, was crucial specifically for the political stability and economic prosperity it brought to central Greece (see Chapter III). The fresco was probably completed soon after 961 but was soon covered by the mosaics of the north arm of the Katholikon. The bold features of Joshua do not seem far removed in their stylistic treatment from the heavily shadowed eyes and full faces of some figures in the crypt frescoes, for example, St. John (or Thomas) in the Entry into Jerusalem (cf. fig. 54 and pl. 5 with fig. 94). The similarities in style between the figure of Joshua and the crypt frescoes are a crucial factor in the argument for dating the monument, as we will see later.

Looking at the wider picture, the frescoes of the Panagia Ton Chalkeon in Salonika are among our few dated examples of monumental painting of the Macedonian period, being dated by an inscription to ca. 1028. Their funerary program also bears comparison with that of the crypt. The Salonika frescoes are in some instances more softly modeled with smooth transitions among planes, but also include the graphic quality of the crypt, as can be seen by comparing, for example, the Incredulity of Thomas of the crypt and the Communion of the Apostles in Salonika.[301] Note especially the linear striations across thighs and slings around the middle body.

The mosaics and frescoes of Hagia Sophia in Kiev, a case where Constantinopolitan craftsmen are known to have been commissioned, have some affinities with the Hosios Loukas style but in my opinion are weaker in articulation of forms and less rational in their linearization; for example, St. Paul from the narthex at Hosios Loukas can be compared with St. Paul from Kiev.[302] They are dated by Lazarev in the second quarter of the eleventh century,[303] although some scholars think an earlier dating is more likely.

A better analogy, perhaps, is the dated fresco ensemble of the so-called Pigeon House at Çavuçin in Cappadocia, ca. 963, funded by the military aristocracy of the family of Nicephorus Phocas.[304] In narrative bands on the walls and the barrel vault, scenes such as the Myrophoroi show some of the hallmarks of this style: tall elongated figures, ocher and other earth colors, and schematic patterns of draperies with striations in brown as well as white.[305] The iconographic similarities between Çavuçin and Hosios Loukas show, in this case, that strip narrative might have influenced the combination of scenes found at Hosios Loukas. The unusual combination of the Burial and the Resurrection in

[300] See Stikas, *Ktitōr*, pp. 103–27, 144–45; and C. Connor, "The Joshua Fresco at Hosio Loukas," in *Tenth Annual Byzantine Studies Conference: Abstracts of Papers* (Cincinnati, 1984), pp. 57–59.

[301] See Papadopoulos, *Wandmalereien*, pls. 8, 25.

[302] Cf. H. N. Logvin, *Saint Sophia, Kiev* (Kiev,

1971), pl. 30, and Diez and Demus, *Mosaics*, pl. 40.

[303] Lazarev, "Regard sur l'art de la Russie prémongole," *Cahiers de Civilisation Médiévale* 14 (1971): 221–38 (esp. 238).

[304] See Rodley, "Pigeon House."

[305] Restle, *Cappadocia*, 3:pls. 309 and 312.

one lunette is otherwise hard to explain (cf. figs. 67, 100). Other iconographic and stylistic similarities with Çavuçin and the related program at Tokalı suggest a date for the crypt frescoes somewhere between Çavuçin and Panagia Ton Chalkeon—that is, between 963 and 1028. Fresco programs of Naxos, Corfou, Cyprus, and Kastoria also share aspects of the Hosios Loukas style demonstrating the variations within the artistic koiné, recognized by Tania Velmans as being part of a broad current in programs around the empire in the last half of the tenth and first half of the eleventh centuries.[306] Unfortunately the evidence of the monumental material just mentioned does not produce strong criteria for offering a specific dating for the frescoes at Hosios Loukas, but rather sets it into a broader, more flexible artistic and chronological framework.

One prominent stylistic feature of the frescoes that seeks explanation is the animated backgrounds with their frothy mountain peaks. Manuscripts provide the closest parallels and exhibit similarities with other features as well. The Menologium of Basil II (Vatican, gr. 1613) of ca. 1000, provides numerous iconographic and stylistic parallels with the frescoes of the crypt. It has already been noted that the majority of saints represented in the crypt have feast days in the first half of the liturgical year and therefore are represented in this menologium of which the first half is preserved. On comparing some of the same saints, there is a striking coincidence of facial types. Among the warrior martyrs, for example, Nicetas or Eustathius have the same hair and beard and also similarly shaped faces and facial expressions.[307] The tendril and cross-hatching patterns of the tablion appear frequently in the warriors of the Menologium.[308] The apostle Andrew has the same grizzled look in each case, with furrowed brow and unkempt beard.[309] Among the holy men, Theodosius the Cenobiarch agrees closely with his Menologium counterpart, with a chin patch and thin, lined face.[310] The correspondence between the two portraits of Luke the Stylite has already been discussed. In all three categories of portraits, the crypt frescoes are closer to the Menologium than to the mosaics of Hosios Loukas itself.

The concept of the human figure and the manner in which drapery falls over the body are closely paralleled in the crypt and in the Menologium. Basically linear in treatment, the same motifs of slings of drapery appear in both: clinging drapery over the thigh with a jagged pattern of thin, superimposed folds; wedge-shaped configurations of folds; and their highlights. The figure of Joachim in the Menologium or the attendant in the Death of Matthew can be compared with John of the Entry into Jerusalem or the disciples of the Incredulity of Thomas.[311] The circular pattern of drapery over the abdomen in some figures in the crypt appears in the Menologium.[312] The unusual decorative motifs on the scarves in the Entry into Jerusalem in the crypt are found on martyrs' tunics in the Menologium.[313]

[306] See Vocotopoulos, "Corfou" (see esp. pls. 8–10), and T. Velmans, "La koiné grecque et les régions périphériques orientales du monde byzantin," *JOB* 31 (1981): 677–723.

[307] *Il Menologio*, pp. 37, 53.

[308] Ibid., p. 207.

[309] Ibid., p. 215.

[310] Ibid., p. 310.

[311] Ibid., p. 23.

[312] Ibid., p. 216.

[313] Ibid., p. 10.

Details of compositions and landscape also may be compared: the wooden bench in the scene of a holy synod in the Menologium has a structure and cross-hatchings similar to those of the benches in the Washing of Feet and the Last Supper in the crypt.[314] The asses ridden by St. John Chrysostom and Mary on the Flight into Egypt in the Menologium resemble strikingly the ass in the Entry into Jerusalem at Hosios Loukas especially, the neck, ears, and musculature of the animals.[315] The crenelated stone walls and the perspective of the tower and doorway of Jerusalem in the crypt all closely resemble the city in the Flight into Egypt as well. The antique stone sarcophagus of the Burial resembles that in the Burial of Philaretus in the Menologium; the arches and border in stepped pattern correspond in each case.[316] Pseudo-Kufic motifs that appear on the imposts in the crypt appear on the shields of soldiers in the Menologium, as they do on the warrior saints of the Hosios Loukas Katholikon.[317] Finally, the framing background mountains with jagged, expressive peaks are found throughout the Menologium; the same may be said for the architectural background of the Koimesis of the Virgin in the crypt, which appears frequently in the Menologium.[318]

The Menologium has much more use of parallel hatching and striations and chrysography on drapery than the crypt, but the general style and character of the two coincide strikingly. Indeed, as with the portraits, the draperies of the crypt frescoes correspond even more closely to those of the Menologium than to the mosaics of the Katholikon. The intimate atmosphere of the crypt is enhanced by this miniature element in its style of painting. The probable derivation of some features of the Hosios Loukas frescoes from a manuscript like the Menologium indicates that painters were relying on models in manuscripts for much of their material. But the monumental character predominates in these bold and expressive frescoes. It is *not* a miniature style. However, there is some kinship in the highly mannerized plays of decorative folds and highlights. The figure style of the Menologium is more classicizing and refined by far, but at the very least we can suggest the artists came from a Constantinopolitan environment where manuscripts had influenced monumental decoration. Or one can even suggest that an illustrated menologium or synaxarium such as the Menologium of Basil II and an illustrated Gospel Lectionary were brought to or were already in the possession of the monastery and served as models. These manuscripts would have been close in place and time to the Constantinopolitan Menologium of Basil II of ca. 1000.[319]

THE frescoes of the crypt represent a program with a specifically directed message emphasizing the funerary, commemorative, and cult functions of the crypt. The style of the frescoes with its bold, heavily linear, and ornamentally highlighted drapery, powerful, expressive faces, and soft colors finds its place in the wider context of tenth- and eleventh-century Byzantine art. Because this style is not an exact counterpart of any one

[314] Ibid., p. 108.
[315] Ibid., pp. 178, 274.
[316] Ibid., p. 218.
[317] Ibid., p. 62.
[318] Ibid., p. 63, for the architectural background

with cornices.
[319] I. Ševčenko, "On Pantoleon the Painter," *JOB* 21 (1972): 241–49; A. Cutler, "The Psalter of Basil II," *Arte Veneta* 30 (1976): 9–19; 31 (1977): 9–15.

surviving monument or work of art but reflects a set of complex programmatic, icono-graphic, and stylistic features that can be recognized in widespread examples of art of the tenth and eleventh centuries, it illustrates the limitations of stylistic dating. Factors other than artistic ones must thus be weighed carefully as well.

The artists who executed the frescoes in the crypt were working from the same models and at the same time as those who executed the mosaics of the Katholikon. Similarities of iconography, composition, style, and technique indicate that a group of artists was working contemporaneously in the two media, and was probably brought from Con-stantinople for this large undertaking. The fresco painters seem, however, to have been more adaptable in their interpretations of standard scenes and rendered their subjects in a freer and more classicizing manner. A variety of hands must have been at work but this is not a significant point to argue, as the overall style of the crypt shows a consistency despite the inclusion of various concepts or types. This achievement is best demonstrated in the portraits that were done by skilled artists while working within three established modes of portraiture, as described earlier.

A flexibility and versatility of the Byzantine artist must thus be recognized; he must be given due credit for originality within a framework that included a set repertoire of modes and figure types. At the same time, this repertoire allowed for individual expres-sion and precise interpretation of the wishes of his patron. Just as Athanasius of Athos was working on the scaffolding helping build his church when he fell and was killed, the monastic patrons of Hosios Loukas must have had direct contact with the artists per-forming the needed services of decoration; the crypt bears witness to this individuality of conception and the immediacy of involvement of those carrying out the project.

ARCHITECTURE
AND LITURGY

As an architectural ensemble the monastery of Hosios Loukas is undoubtedly the best-preserved middle Byzantine monument we have today. Impressive as these physical remains are, however, little has been said about their function. Those spaces of most concern to us are the two churches and the crypt: they form the core of the monastery and present many unanswered questions of usage, either separately or in relation to one another. There is no written record of their specific liturgical uses, as there is for some foundations. Nor does a chrysobull, or a typikon or any other reliable document survive to answer even the most basic questions of who built the monastery—providing the vast funds necessary for the construction and decoration of the Katholikon—to say nothing of the necessary endowment for maintenance.

Although we cannot discover in any detail the history of the foundation of the monastery or how life was regulated here, there are such indications surviving in documents pertaining to other monasteries; in fact, in most cases we have the document without the monastery. From these typika and service books describing orthodox worship in general or cult practices at particular monasteries, we can reconstruct the daily patterns of usage of the churches. The crypt, however, poses a special challenge, for parallels are quite rare for this period, especially ones as large as the Hosios Loukas crypt, and we have no document at all that clearly states how a Byzantine crypt functioned liturgically.

To understand the likely patterns of usage of spaces at the monastery, especially involving the crypt, there are several types of evidence that help reconstruct the picture. First, archaeological evidence enables us to compare the crypt architecturally with other similar monuments whose usage is, in some cases, ascertainable. Second, literary sources describing the operation of other monasteries suggest possible liturgical uses of crypts. Third, the Vita of Holy Luke itself sheds valuable light on the healing cult of the saint, with specific implications for the crypt at Hosios Loukas and more general ones for the nature of healing cults at the tombs of holy men in the middle Byzantine period.

One aim in examining this problem is to test the assumption that there was a connection between certain aspects of church design and liturgical use in the middle Byzantine period.[1] Hosios Loukas serves as a test case not only in the interrelation of architecture

[1] T. F. Mathews, "Private Liturgy in Byzantine Architecture: Toward a Re-appraisal," *CA* 30 (1982): 125–38; T. F. Mathews, "Architecture, Liturgical Aspects," in *The Dictionary of the Middle Ages* (New York, 1982), 1:441–445.

and liturgy but also with respect to decoration, for, as I will show, the program of frescoes discussed in Chapter I reflects the liturgical and cult functions of the crypt.

THE ARCHITECTURE

Monastic churches often survive either in total isolation, as with Sotir Likodemou in Athens, or surrounded by ruins of their original settings, as at Daphni and Nea Moni on Chios. The churches at Hosios Loukas, however, still stand as part of a great cluster of monastic buildings, the whole complex enclosed within substantial walls (see the plan in fig. 1). The ensemble has survived so largely intact in part because the monastery has remained in use almost continuously, from the time of its construction to the present day, and also because of its isolated location.[2] The church of the Panagia has been variously dated but I will argue for a dating in the mid-tenth century. The adjoining Katholikon, or principal church of the monastery, has been dated by most scholars to the eleventh century.[3] A new dating for the construction of the Katholikon and its crypt in the third quarter of the tenth century will be one of the major results of this study. Other buildings in the complex are the old monks' quarters on several levels, a gate with nearby stables, a bell tower, refectory, warming house, well house, store rooms, guest houses, remains of a hospital (?), and a cistern.[4]

The churches naturally receive most attention because of their splendid architecture and, in the case of the Katholikon, magnificent interior decoration. The masonry is remarkably intact and the recent restorations by the Greek Archaeological Service have been limited to a prudent consolidation of the existing fabric. These two churches and the crypt thus survive largely as they appeared when they were built.[5] The physical evidence indicates the original organization of interior space, including window and door openings, galleries, chapels, and other passages, as well as the location of barriers and arrangements for interior lighting. A brief look at plans and elevations reveals essential features and thereby basic implications with which to start our investigation. The plan of the Panagia church is cross-in-square with two narthexes, the main narthex being very large and consisting of six bays supported by two columns; this plan is found in churches throughout the empire from the tenth century on.

The Katholikon is a more unusual type, a domed octagon with chapels in the four corners and a single narthex.[6] A number of parallels do exist in churches of similar de-

[2] The best overall work on the monastery is still R. Schultz and S. Barnsley, *The Monastery of St. Luke of Phocis and the Dependent Monastery of St. Nicolas in the Fields Near Skripou in Boeotia* (London, 1901). On the long-term operation of the monastery, see pp. 3–5.

[3] For the founding of the Panagia church and patronage by the general Krinites, see Stikas, "Nouvelles observations," p. 313, and Connor, *Life of Saint Luke*, chap 59. The Katholikon has been dated on the basis of the style of the decoration to the fourth decade of the eleventh century; see Mouriki, "Stylistic

Trends," p. 86.

[4] For a brief description, see P. Lazarides, *The Monastery of Hosios Lukas* (Athens, 1979).

[5] An exonarthex was added to the Katholikon in the twelfth century but removed in the nineteenth; see L. Philippidou-Bouras, "The Exonarthex of the Katholikon of St. Luke in Phocis," *DCAE*, ser. 4, vol. 6 (1972): 13–28 (in Greek, summary in English).

[6] Krautheimer, in *Early Christian and Byzantine Architecture*, p. 409, describes the plan as "a Greek-cross octagon."

sign: Nea Moni on Chios, Sotir Lykodemou in Athens, Daphni, St. Sophia at Monemvasia, St. Theodore at Mistra, Christianou at Trifilia, Chortiatis near Salonika, St. Nicholas in the Fields near Orchomenos in Boeotia, St. George Mangana in Istanbul, and, most recently discovered, the church on Heybeliada Island near Istanbul, with the addition of the church of Christ of the Chalke Gate of the tenth century.[7] Thomas Mathews attributes the origins of this church type to the domed churches with squinches of Armenia of the seventh and tenth centuries.[8] The crypt under the Katholikon is generally cruciform in plan with ten low groin-vaulted bays and three barrel-vaulted arms extending west (see the plan in figure 2).

In elevation the interior organization of space is on three levels: ground levels, galleries, and crypt. First, on the ground level there are the parallel churches with their eastern sanctuaries; there is, however, a clear focus at this level on the ciborium or *proskynetarion* of the saint, which is located at the spot where the two churches join and interlock.[9] This shrine must have held a container of healing oil or water, and on the slab below the octagonal canopy there was an icon with his portrait; the tomb in the crypt was venerated as his burial place. The shrine was located so as to be easily accessible to great numbers of pilgrims who came to venerate the saint; the tomb of Holy Luke is located directly below in the crypt and is less easily accessible.[10]

Second, the gallery levels, are only accessible by means of stairways from the monks' quarters outside the northwest corner of the Panagia church. Ascending, one arrives at the north end of a wide passage directly above the exonarthex of that church; from here one may enter a large porticoed room that is above the inner narthex of the Panagia church. The passage also gives access to the galleries of the Katholikon where circulation is possible on the south, west, and north, which permits good visibility of events taking place in the naos below.

Third, on the crypt level, is the tomb of Holy Luke located directly below the shrine in the Katholikon. The spot was established as the burial place before the Katholikon with its crypt was constructed, and the crypt was designed to shelter this important relic in the tomb (*taphos*) of the monastery's founder. Access is limited to one stairway, which

[7] See T. F. Mathews, "Observations on the Church of Panagia Kamariotissa on Heybeliada (Chalke), Istanbul," *DOP* 27 (1973): 117–27, esp. 125. Mango dates two examples on this list, the church of Christ of the Chalke Gate, built ca. 972, and St. George of Mangana, built in the mid-eleventh century by Constantine IX; see C. Mango, "A Note on Panagia Kamariotissa and Some Imperial Foundations of the Tenth and Eleventh Centuries at Constantinople," *DOP* 27 (1973): 128–32. See Ch. Bouras, *Nea Moni on Chios, History and Architecture* (Athens, 1982): pp. 135–39, on the problem of the domed octagon plan and p. 137 on domed octagon churches.

[8] See Mathews, "Observations on the Church of Panagia Kamariotissa," p. 126.

[9] See Stikas, *Oikodomikon Chronikon*, pp 186–87.

For the most recent discussion of the implications of this unusual joining of two churches and the use of the surrounding rooms, see Pallas, "Topographie und Chronologie," p. 101 and fig. 2.

[10] Pallas explores the implications and usage of such shrines in his "Le ciborium hexagonal de Saint-Démétrios de Thessalonique," *Zograf* 10 (1979): 44–58. The lavishness and complexity of this arrangement are evoked by descriptions of a church at the monastery of Nikon of Sparta. These passages, which speak of galleries, stairways, variegated marble decorations, and a shrine of the saint, almost seem to be describing features of the Katholikon of Hosios Loukas. See Dennis F. Sullivan, *The Life of Saint Nikon* (Brookline, Mass., 1987), chaps. 35, 37, 38, 58, 66.

descends on the south side of the church; the crypt could only be reached from outside. Thus, whereas circulation was free and open with many alternative routes for passing in and out of the churches at ground level, the gallery and crypt levels had limited circulation and only one means of access in each case.

To gain an understanding of the use and function of the crypt, the archaeological evidence must first be examined. Wide steps lead down from the ground level on the south side of the Katholikon to the entrance of the crypt; inside the doorway is a short barrel-vaulted passage. The crypt is cruciform in plan with ten groin-vaulted bays, of which those on the middle axes—four on the east-west axis and three on the north-west axis—are significantly larger, thus emphasizing the shape of a cross. Three barrel-vaulted arms extend west, the two on the north and south being smaller and considerably narrower than the middle one. Four squat stone piers support the vaults of the crossing and are paired with two more at the entrances to the northeast and southeast bays (see figs. 5, 6).

The furnishings of the crypt are sparse. On the north wall directly opposite the entrance to the crypt, set into an arcosoleum niche (a standard form of wall grave from the time of the catacombs) is a large white marble sarcophagus (fig 3). Popular tradition at the monastery has long designated this as the tomb of the saint, which is now covered with twentieth-century marble revetment.[11] Two tombs are set in the northeast and southeast bays beneath arched openings and framed at their west ends by stone piers (figs. 3–6). These tombs are constructed of brick and stone masonry and covered with marble slabs, the northern one having elaborate pseudo-Kufic ornament and polychrome inlay and the southern one being plain except for a small oblong cutting to receive a plaque.[12] The ornate slab (fig. 4) has been studied by Lascarina Bouras and dated on the basis of comparison with other pseudo-Kufic decoration in the Panagia church to the second half of the tenth century; she also surmises it originally covered the tomb of Holy Luke.[13] Dividing the sanctuary from the nave of the crypt is a templon barrier with a lintel that rests against the lateral walls, partly obscuring the fresco scenes on their surfaces. It has four columns with capitals; a horizontal rail and floor molding connect the two right-hand columns only (fig. 7). The cross and tendril design sculpted on the capitals of the templon barrier and of one of the stone piers of the crypt bear close resemblances to sculptural details in the Panagia church.[14] A holy table consisting of a monolithic block of stone capped by a slab of marble stands inside the sanctuary. On the north wall of the sanctuary a stone shelf capped with a marble slab protrudes; there is a hollow about five inches in diameter roughly cut into its surface. The floor of the crypt is paved with brick tiles. In the apexes of the groin vaults, iron hooks are imbedded in the masonry.

[11] Schultz and Barnsley, *Monastery*, p. 16; the tomb is labeled in Greek: "The tomb of Saint Loukas." For further description and discussion of its former appearance, see Pallas, "Topographie und Chronologie," p. 96.

[12] The corners of the more elaborate tomb slab are cut out, and L. Bouras suggests that the slab was re-

used, having been taken from a setting where ciborium columns rose through these cuttings (*Sculptural Decoration*, p. 133).

[13] Ibid., pp. 112–14, 133, and fig. 9.

[14] See Bouras, *Sculptural Decoration*, pl. 132 and compare our fig. 9.

Several inferences may be drawn based on this physical evidence about the use of the crypt. The presence of three tombs indicates it was originally intended for burial. Confirming this, the tunnel-like vaults on the west end of the crypt were being used as an ossuary to store exhumed bones of monks early in this century (fig. 8).[15] Furthermore, scholars have stated that the arrangement of the tombs with their framing columns and arches indicates the crypt was planned in order to accommodate them.[16]

The crypt served more than burial purposes, for it was planned for celebration of the Divine Liturgy, as indicated by the presence of the altar, prothesis niche, and templon barrier. This usage must be at least as early as the fresco decoration, for the lintel of the templon barrier abuts the lunettes of the sanctuary partly obscuring their fresco scenes, indicating the barrier was moved into this location after the frescoes had been executed. The hooks in the ceiling indicate that hanging oil lamps or chandeliers were used for illumination. One further feature of the crypt is of interest: the plan of the crypt in Schultz and Barnsley's publication indicates there was a pair of long benches against the walls just ouside the crypt entrance in 1901, although there is nothing there today.

We will now look at the architectural evidence in an attempt to elucidate some of these features and to determine what ritual or rituals this crypt was intended to accommodate—whether its use here was unique, prescribed by a patron or founder or by special needs of the cult of Holy Luke, or whether it fits a pattern attested by other monuments. Assembling architectural parallels for the crypt among the handful of surviving churches with substructures is made difficult primarily because there is no consensus on their classifications. It is not clear which are really crypts—spaces for burial that can therefore reasonably be compared to Hosios Loukas—and which are merely supporting structures with no liturgical purpose. These questions must be approached first by assembling the physical evidence and then correlating it with information on the use of substructures from written sources.

THE earliest significant number of substructures appears in the monasteries of Palestine. They date from the time of the great monastic founders, successors of the Egyptian desert fathers, in the fifth and sixth centuries. One of the most important of these, the monastery of St. Euthymius (377–473), was identified in the course of excavations at Khan-el-Ahmar near Jerusalem with the help of the sixth-century descriptions of Cyril of Skythopolis.[17] Just north of the basilica are the remains of a chapel with a crypt, built

[15] Schultz and Barnsley, *Monastery*, pp. 11–12.

[16] Ibid., p. 35; Stikas, *Ktitōr*, pp. 93–98, fig. 20, and text pls. 3 and 4. Stikas is keenly interested in the question of the predecessor of the crypt and he gives us a hypothetical plan of the "holy oratory" referred to in the Vita of the saint (pp. 3–15); Babić, *Chapelles*, p. 164, reviews scholars' opinions on this question.

[17] See Schwartz, *Kyrillos von Skythopolis*, p. 61, nos. 17–33. The archaeological evidence is reviewed by Babić in *Chapelles*, pp. 16ff., including plans by the excavators; for a preliminary report on the excavations, see D. J. Chitty and A.H.M. Jones, "The

Church of St Euthymius at Khan el-Ahmar, near Jerusalem," *Palestine Exploration Fund Quarterly for 1928* (1928): 175–78; see also D. J. Chitty, "Two Monasteries in the Wilderness of Judaea," in the same issue, pp. 134–52; and Barrois, "Une chapelle funéraire au couvent de Saint-Euthyme," *Revue Biblique* 39 (1930): 272–75, which gives a detailed plan of the funerary chamber and its tombs on p. 273. See more recently, Yizhar Hirschfeld, "The Judean Desert Monasteries in the Byzantine Period: An Archaeoloagical Investigation," dissertation, Hebrew University, Jerusalem, 1987.

in the fifth century by Fidus the Deacon. The chapel is square in plan, vaulted on the main level with a single groin vault, whereas the crypt, accessible only by a stairway on the north side, has a barrel-vaulted ceiling; there is an altar on the east side. A number of tombs are dug into the floor of the crypt, with one large one situated before the altar and seven smaller ones to the sides and within niches in the east wall. This chapel with its crypt must be the one described by Cyril of Skythopolis that was erected on the site of Euthymius's burial cave; the grave (*thēkē*) of the saint was placed in the middle while around it were graves for the abbots of the monastery.[18] Frescoes and mosaics of the twelfth century decorate the walls replacing the fifth-century originals of which fragments survive. Another underground chamber with three oblong passages was discovered under the northeast room of the basilica, in which were discovered bones, suggesting it may have been an ossuary.

Similarly, a rock-cut ossuary chapel at nearby Khirbet-el-Mardes, a monastery also founded by Euthymius ca. 420, also contains fresco decoration but is better preserved than at Khan-el-Ahmar.[19] This chapel has eight tombs and the walls are painted with full-length portraits of monks, mostly Palestinian fathers. The frescoes, although somewhat repainted, are of the seventh century.

The monastery of St. Sabas, the great leader who organized cenobitic life in Palestine, remains standing and in operation; although altered many times and therefore not as rich in archaeological evidence to indicate burial practices, the original appearance of this monastery can again be gleaned from the valuable accounts of Cyril of Skythopolis. He leaves us the best near-contemporary description of Sabas (439–532), his life, death, and burial.[20] Finding the little church built for his first community too small, Sabas was guided by a miraculous column of fire to his new church, already complete, in a grotto shaped like a cross. This grotto still exists. Above it Sabas installed himself in a tower that communicated directly with the rock-cut church. Later, a new church, the Katholikon, was built and dedicated to the Virgin.[21] The location of Sabas's tomb in relation to the old and the new churches is described by Cyril: "and thus his [Sabas's] precious relic was deposited at the Great Lavra between the two churches, on the spot where he had seen the column of fire."[22] Judging from accounts of later pilgrims to the site, Sabas's burial chapel must have resembled that at the monastery of St. Euthymius, discussed previously, with its burial chamber and tombs on a lower level.[23]

Another Palestinian burial chapel, that of the monk Theodosios who founded his monastery on Sabas's model, was located on the site of his hermit's cave, a frequent practice among the monks of the Judean desert.[24] It is described by a twelfth century

[18] See Schwartz, *Kyrillos von Skythopolis*, pp. 42, 61.

[19] Ibid., p. 18.

[20] Festugière, *Moines de Palestine* 3, no. 2: 43–45 and Schwartz, *Kyrillos von Skythopolis*, pp. 85–201.

[21] Festugière, *Moines de Palestine*, 3, no. 2: 43–45.

[22] Schwartz, *Kyrillos von Skythopolis*, p. 184.

[23] See Khitrowo, *Itinéraires russes*, pp. 33–34, for the early twelfth-century description by the abbot Daniel, and pp. 188–89, for the description of the ar-

chimandrite Grethenius (ca. 1400).

[24] See Hirschfeld, "Judean Desert Monasteries," pp. 481–93, on the burial place within the monastery, especially of the founders in splendid, prominently placed tombs (pp. 481–82) and of monks in the caves they had used as cells (pp. 483–85). See also on monastic burials in Palestine: G. Kühnel, "Wiederentdeckte monastische Malereien der Kreuzfahrerzeit in der Judaischen Wüste," *RQ* 79 (1984): 163–88.

pilgrim: "Situated in the middle of the monastery, it was covered by a vault. On the ground floor of the chapel a cave was arranged to shelter the tombs of Theodosius and of other saints."[25]

On the basis of archaeological evidence and literary descriptions of the sites, we know that the Palestinian fathers of monasticism were buried in chapels with underground chambers, surrounded by abbot successors or important members of the monastic community. Often the chapel stood over the cave or cell where the holy man had lived and had later been buried. These burial chapels were next to rather than under the principal church, but were often at the center of the monastery and built especially to shelter the tomb of the deceased founder. This early evidence constitutes the most thorough parallel for the architecture and burial practices associated with the crypt and the tomb of Holy Luke, as will be discussed, but first, several other bodies of evidence should be noted.

Several middle Byzantine churches in Constantinople bear architectural similarities to Hosios Loukas in that they have substructures, but there is no evidence they were used for burial or served similar liturgical purposes to the crypt at Hosios Loukas. The Bodrum Camii, or Myrelaion, was built by Romanus Lecapenus ca. 922 as a burial church for himself and his family. It was the principal church of a monastery (a convent) and adjoined more ancient structures on the site belonging to a huge palace.[26] Striker, after archaeological investigation of the church, asserts the substructure under the Myrelaion was intended only to raise the church to the level of the palace in order to provide easy access and that evidence of burials dates only from the Paleologan period.[27]

The Odalar Camii, dated in the eleventh or twelfth century and often identified with a monastery, either Theotokos ta Kellarias or Theotokos Kecharitomene, had an elaborate substructure of nineteen chambers, some decorated with frescoes and containing tombs.[28] This substructure was only accessible from the north and the west by descending a stairway on the north side. Brunov, in his discussion of two-story churches, has compared this church to the Bulgarian sepulchral churches, especially Bachkovo; he and Grabar both see in these an origin in "oriental" forms, known from Christian churches further to the east.[29]

The Gul Camii, a large monastic foundation dating to the eleventh or twelfth century has a developed substructure consisting of a system of vaulted passageways in the general form of a cross. The church is built on a terrace that encloses the substructures as at Bodrum Camii and Odalar Camii, all of which are entered from outside the church; no interior stairway is present in any case. Schäfer, although he sees connections between

[25] The description is by Phocas, in *Pravoslavniyi Palestinskii sbornik* 23 (1889): 18, 47. Note that Theodosius is depicted in mosaic in the Katholikon and in fresco in a medallion portrait in the crypt at Hosios Loukas.

[26] Janin, *Géographie*, pp. 364–66.

[27] Striker, *The Myrelaion*, pp. 28, 33. I find it perplexing that so elaborate a substructure would have gone unused, especially when the church was erected as a burial church and the interior could not have held all the burials attested.

[28] Mathews, *Churches*, pp. 220–21 and pl. on pp. 222–24, also bibliography on p. 221; Müller-Weiner, *Bildlexikon*, p. 188 and pl. 201; Janin, *Géographie*, p. 196.

[29] N. Brunov, "Die Odalar-Djami von Konstantinopel," *BZ* 26 (1926): 359–62; Janin, *Géographie*, pp. 135–44, esp. p. 142; also cf. S. Grabar, "Les églises sépulchrales bulgares," *BIAB* 1 (1921): 103–35.

the construction and design of these three churches and their substructures, can find no explanation for their use.[30]

The substructure under the church of Fetiye Camii, with tunnel vaults supported by fourteen reused columns and capitals and describing the shape of a cross, is usually classified as a cistern.[31] Many churches of Constantinople have cisterns nearby, but it is not common for them to be located under the church, nor is their customary shape that of a cross. The east wall has three indented niches and in the west a separate transverse bay is appended to the cross. The church structure is thought to be of the Comnenian period, although the "cistern" may reflect "an earlier building or the crypt of an earlier church"; it was vaulted at the same time as the building of the church.[32] The entrance to this "cistern" was a single one, on the south side; when the pareoclesion was built adjoining the church on the south side this entrance became unusable. There is, however, no evidence of burial (except at Odalar Camii) or of an arrangement for celebration of the liturgy in any of these Constantinopolitan substructures.

Another body of archaeological evidence comprising churches with substructures is represented by the Bulgarian two-story churches, first singled out and discussed by S. Grabar, then by Brunov and Bals.[33] These scholars focused on the two-story elevations, comparing them with Roman *martyria* built over the tombs of saints, with the two-story mausoleum churches of Armenia, and with the more common Russian two-story churches of the seventeenth century. The Bulgarian churches of Bačkovo, Boiana, and Assene all functioned as funerary chapels over mortuary crypts.[34]

The most interesting of these and most important parallel for our purposes is the ossuary chapel of Bačkovo, which consists of an upper church or chapel built over a burial chapel of the same dimensions.[35] There are apses at the east end on both levels and the upper church has two tombs, while the lower contains further burials and bone vaults. The lower church can only be reached by one door, on the west end; a flight of steps connects it with the level of the upper church. This church was part of a monastery built by the Armeno-Georgian Gregory Pakourianos between 1074 and 1083; in this rare case the founder's typikon is preserved, describing the function of the monastery; this will be discussed in the section on sources. Like Hosios Loukas, the ossuary has a fresco-decorated lower level, with only one means of access, that was used for burial and for celebration of the Divine Liturgy.

Less than half an hour's drive from Hosios Loukas is the church of St. Nicholas in the

[30] H. Schäfer, *Die Gul Damii in Istanbul*, Istanbuler Mitteilungen, Beiheft 7 (Tübingen, 1973): pp. 53–59; he also cites the crypt of St. Karpus and Papylus (Hag. Menas), which was used for liturgical purposes but only used for burial in the late period, perhaps under western influence (p. 61, n. 110).

[31] See Belting, Mango, Mouriki, *Pammacharistos*, p. 2 and pl. 5; Müller-Weiner, *Bildlexikon*, pp. 132–36 and figs. 124, 125a.

[32] Belting, Mango, Mouriki, *Pammacharistos*, p. 5 and n. 9.

[33] Grabar, "Les églises sépulchrales bulgares," pp. 103–35; N. Brunov, "Concerning the Question of Two-Story Tomb Churches," *BIAB* 4 (1926–27): 135–144 (in Russian); G. Bals, "Contribution à la question des églises superposées dans le domaine byzantin," *BIAB* 10 (1936): 156–67.

[34] Bals, "Contribution," p. 162. The Assene church is not positively known to have held tombs but its form suggests it served the same function as the others.

[35] Grishin, "Bačkovo Ossuary," pp. 90–91.

Fields, north of Orchomenos in Boeotia, the small, principal church of a *metochion* or dependent monastery of Hosios Loukas. It is modeled on Hosios Loukas, but in miniature, including its crypt; the church has been recently dated in the thirteenth or early fourteenth century by Maria Panagiotide.[36] The crypt corresponds in layout to that at Hosios Loukas, with the addition of a chapel in the northeast corner; there is an altar in the apse and a small shelf against the wall to the right of the altar table. There is, however, no evidence of sarcophagi or burials as at Hosios Loukas. The crypt and main church above are still in use. The preserved vault decoration consists of medallions of the Apostles surrounded by foliate scrolls, again corresponding closely to the scheme of decoration of the Hosios Loukas vaults.[37]

By no means all churches with substructures that are or could be burial crypts have been included in the preceding summary. The question of small repositories under churches to house relics of saints has not been taken up because this discussion is limited to spaces that could have accommodated a liturgical rite; the tiny chamber under the sanctuary of St. John of Stoudios in Constantinople, for example, has been excluded for this reason. The crypt under the east end of the basilica of Hagios Demetrios in Salonika presents a different picture again for it does not house a tomb or relics of a saint but a hagiasma or healing spring. The rock-cut burial chapel under the early tenth-century church of Tokalı Kilise in Cappadocia appears to have many features in common with Hosios Loukas, but it is an example about which we have as yet little information;[38] it is being studied as part of a forthcoming dissertation.[39]

Architectural parallels for the crypt at Hosios Loukas range from true superimposed churches to churches with chapels and tombs on a lower level or chapels with two levels adjacent to churches. What they all have in common is that there is a space for celebration of the Divine Liturgy superimposed on a lower space, which may or may not contain an apse or an altar, but which does contain, or is likely to have contained, burials. The burials are not isolated but tend to be clustered around one (or more) important tomb, often the tomb of the founder of the monastery. The context of the churches and chapels is monastic; the chapels are relatively small and have limited access, usually with only one doorway. Decoration, when extant, usually consists of portraits of saints, but sometimes there are scenes as well. The earliest examples of monastic substructures for burial go back to the fifth century, close to the very origins of the monastic movement. At this time a practice was established in Palestine of constructing chapels with crypts that contained not only the grave of the holy man but also of his important successors.

[36] Maria Panagiotide, "Oi Toichographies tēs Kruptes tou Hagiou Nikolaou Sta Kampia tes Boiotias," in *Actes du XVe Congrès International d'Etudes Byzantines*, Athens, September 1976 (Athens, 1981), 2:597–622; see also Schultz and Barnsley, *Monastery*, pp. 68–71 and pls. 56–60.

[37] Cf. Schultz and Barnsley, *Monastery*, figs. 8, 17, 18, and my fig. 84. The repainted ornament around the intercession scene in the Hosios Loukas crypt (my fig. 82) resembles the H. Nicholas vault ornament strikingly.

[38] Since this crypt or chapel was the first church on the site, and the Old and New Churches represent later expansion phases of carving out more of the rock, it is quite distinctly different from the built churches we are considering here. See A. J. Wharton, *Art of Empire, Painting and Architecture of the Byzantine Periphery* (University Park, Penn., 1988), pp. 21–23 and fig. 2.3.

[39] N. Teteriantnikov, "Burial Places in Cappadocian Churches," *Greek Orthodox Theological Review* 29, no. 2 (1984): 147, fig. 8.

Now that the archaeological evidence for the Hosios Loukas crypt and relevant parallels has been reviewed, we can turn to a little recognized but very important source on the building of the monastery, the Vita of the saint. This document confirms that the monastic tradition of building funerary chapels to shelter the tombs of saints and founders just examined was followed at Hosios Loukas. It also clarifies the stages of construction and embellishment that took place at Hosios Loukas, culminating in the building of the Katholikon. The position taken in this book is that the Vita of the saint describes the churches as we see them today. The correlation of the architecture at the monastery and the descriptions in the Vita supports new datings for the two churches—the Panagia church and Katholikon with its crypt—as I will now demonstrate.[40]

The problem of dating the Panagia church and the Katholikon has stemmed partly from scholars' assumptions that their construction is totally undocumented. However, the building of two churches is described in passages in the Vita that are succinct and unelaborated: the church of St. Barbara, built during Luke's lifetime, and a church sheltering his tomb, built shortly after his death.[41] Although aware of these passages, scholars have never given proper emphasis to them or examined them closely enough for their possible implications.

The first significant building phase at the monastery is described in the Vita. Krinites, the strategos or military governor of that district, became the saint's devotee and admirer after an incident in which the strategos offended the saint. But Krinites, realizing his error, apologized and immediately was forgiven. Then, according to the story, to make amends, this powerful individual provided funds for the building of a church dedicated, appropriately, to the patron saint of armorers, St. Barbara.

> He was drawn to the holy one with an affection so warm that his soul "was glued onto him," if I may use the phrase of David, and he did not want to be separated from him at all, not even for a short time. Indeed he tended to his every need, and most zealously performed every service and made every expenditure, as for example in donating what was most essential for the construction of the church of the superbly victorious martyr Barbara: much money along with the work force.[42]

This passage refers to the church that has come to be called the church of the Panagia, and on the basis of internal evidence in the Vita it must have been begun in 946.[43] Confusion has arisen because Kremos in his grand late nineteenth-century study of the monastery referred to the crypt of the Katholikon as the church of St. Barbara.[44] However,

[40] See also C. Connor, "Implications of the *Vita* of Saint Luke of Steiris for Dating the Monastery of Hosios Loukas," in *Fourteenth Annual Byzantine Studies Conference: Abstracts of Papers* (Houston, 1988), pp. 27–28.

[41] See Connor, *Life of Saint Luke*, chaps. 59 and 67.

[42] Ibid., chap. 59.

[43] See Jenkins, "Slav Revolt," pp. 210–11, for a review of these dates and of others mentioned in the Vita. L. Bouras in her study of the sculptural decoration of the Panagia church concludes the church was founded by the emperor Romanus II (959–63) while stylistic evidence points to a date after 960 (Bouras, *Sculptural Decoration*, p. 134). Concerning the change of dedication from St. Barbara to the Virgin, Panagia, it was not at all uncommon for a church to be dedicated to several saints, one of whom was often the Virgin, as Janin (*Géographie*) points out; the dedication to St. Barbara was simply dropped at some point in favor of the more universal and popular dedication to the Virgin.

[44] Kremos, *Phokika*, 2:192.

architectural similarities with two dated churches in Constantinople, Constantine Lips of 907 and the Myrelaion of 920–22, support the possibility of a date in the first half of the tenth century for the Panagia church.[45] It is very likely this is the former church of St. Barbara. Further descriptions in the Vita confirm the present relationship between the two churches, as a further building phase consisting of three stages took place.

The second significant building phase at the monastery is described in more detail by the Vita; it starts immediately after the saint's death and concerns the successive embellishment of his burial place. A range of terms is used to refer to the tomb and these will be noted along with the changes in the tomb's appearance at the successive stages described in the Vita. The last stage refers to the building of the Katholikon, as I will now show.

The burial place of Holy Luke is the focus during this more complex building phase, but the first mention of his burial place comes even before his death which Luke himself had prophesied. Having said farewell to the brothers and his friends, he retired to his cell (*kellion*).[46] The monk Gregorios, attending him on his deathbed, asked for instructions about where he wished to be buried. Luke replied:

> You will find fired bricks [*plinthous optas*] when you dig out the spot [*topos*] where I am lying. Lifting these out and beautifying the place [*ton choron*] in a modest fashion, take care to give dust to dust; then arrange the bricks on the surface of the earth, for God will bring glory to this place [*topon*] by the indescribable reasons which He Himself knows, until the end of the world, as crowds of believers come together there praising His divine name.[47]

The morning after Luke's death Gregory did as he was instructed:

> At dawn the presbyter called the villagers from the neighborhood and, digging out the spot [*topos*] and embellishing it as best he could, completed the customary service; and he placed the sacred body in it as if it were great wealth, not in a mean or stingy way, as if the treasure were laid up for himself alone, but as a common source of enjoyment for those who love Christ. Then, laying the bricks [*plinthous*] above as he had been ordered, he left the pavement [*edaphos*] for the moment in that fashion.[48]

[45] Cf. Bouras, *Sculptural Decorations*, pls. 2, 132–46 and Mathews, *Churches of Istanbul*, pls. 35–13, 19, 21, 23, 25, 27, where the low reliefs with foliate motifs bear an especially strong resemblance to each other.

[46] Kremos, *Phokika*, 2:52, col. 2; *PG*, 111:473B; Connor, *Life of St. Luke*, chap 64: "*eis to heautou kellion epanelthonta.*"

[47] Connor, *Life of Saint Luke*, chap 64; *PG*, 111:476A: "Τὸν τόπον, ἐν ᾧ κατάκειμαι, φησίν, ἀνορύξας, πλίνθους ὀπτὰς εὑρήσεις, ἃς διάρας καὶ τὸν χῶρον μετρίως φιλοκαλήσας, ἀποδοῦναι τὸν χοῦν τῷ χοΐ φρόντισον· εἶτα τὰς πλίνθους τῇ ἐπιφανείᾳ παράθες τῆς γῆς· μέλλει γὰρ τῷ θεῷ, φησί, λόγοις οἷς αὐτὸς οἶδεν ἀρρήτοις δοξάσαι τὸν τόπον, ἄχρι γοῦν καὶ τῆς συντελείας, πλήθους τῶν πιστῶν ἐνταῦθα συνερχομένων καὶ τὸ ἐκείνου θεῖον ὄνομα δοξαζόντων."

[48] Connor, *Life of Saint Luke*, chap. 65: Ἔωθεν δὲ τοὺς ἐν γειτόνων χωρίτας μετακαλεσάμενος ὁ πρεσβύτερος τὸν τόπον τε διορύττει καὶ ὡς οἷόν τε κοσμεῖ τόν τε συνήθη κανόνα ἐπιτελέσας τὸ ἱερὸν ἐν αὐτῷ κατατίθησι σῶμα, οἷόν τινα πλοῦτον οὐ φειδωλῶς οὐδὲ μικρολόγως ὡς ἑαυτῷ μόνῳ κεῖσθαι τὸν θησαυρὸν, ἀλλ' ὥστε κοινὴν εἶναι τοῖς φιλοχρίστοις ἀπόλαυσιν· εἶτα τὰς πλίνθους ἄνωθεν ᾗ προσετάγη καταστρωσάμενος, τὸ μὲν παρὸν ἐπὶ σχήματος τὸ ἔδαφος καταλείπει.

The terms referring to the burial spot are *topos* and *choros*; the tomb itself is lined and covered with fired bricks, *plinthous*, leaving the appearance of the burial place as a flat pavement, *edaphos*. The tomb at this first stage is flush with the ground; it has not yet been clearly stated whether or not the burial was in Luke's cell, *kellion*, as he had requested.

The next stage of embellishment is accomplished six months later through the efforts of the itinerant monk Kosmas, who is advised in a dream to halt his journey to Italy in order to serve the divine and "new" Luke.

> As if drawn by some divine hand, he was guided to the saint's cell [*kellion*], and standing there and recognizing the delightfulness of the place [*tou topou*] and how well adapted it was to tranquility, and being exceedingly pleased, he promised God to dwell there for the rest of his life. He immediately noticed the lack of beauty and care to the sacred tomb [*thēkē*] and its surroundings, and he thought it deserved some moderate attention. He embellished it with slabs [*plaxi*] of the local stone, and, setting lattice work in a circle around it [*kinglidas kuklō*] and garlanding it, he thus made it a place not to be trodden upon [*abaton*] or touched except by those wishing to draw near to it in faith with much veneration.[49]

The tomb was indeed located in Luke's former cell, *kellion*, and is referred to as the blessed *thēkē*; the term used for the area around the tomb, *abaton*, is the ancient term for the sacred precinct of a cult place.[50] The appearance of the tomb after Kosmas had completed his project must still have been unpretentious; however, now it was covered with slabs of local stone *plaxi te tais enchoriois*.[51] It was also separated off by a barrier, perhaps a colonnade in circular or semicircular form similar to that in the crypt of Hagios Demetrios in Salonika.[52] The burial place had not been changed or moved, but only embellished and set off from its surroundings in such a fashion as to command the respect it deserved.

The last phase of renovation of the *kellion* took place two years later as part of a general

[49] Connor, *Life of Saint Luke*, chap. 66; *PG*, 111:476B–C: Ὁ δὲ μηδὲν ὅλως ἐπιδοιάσας, ὥσπερ ὑπό τινος θείας χειρὸς ἑλκόμενος πρὸς τὸ τοῦ ἁγίου ποδηγεῖται κελλίον, ἔνθα παραστὰς καὶ τὸ ἐπιτερπὲς οἷον τοῦ τόπου καὶ πρὸς ἡσυχίαν ἡρμοσμένον καταμαθὼν καὶ λίαν ἡσθείς, τὸ λοιπὸν οἰκεῖν ἐκεῖσε τῷ θεῷ καθυπέσχετο. Αὐτίκα γοῦν ἀκαλλῆ καὶ ἀνεπιμέλητα τὰ περὶ τὴν ἱερὰν αὐτοῦ θήκην ἰδὼν, μετρίας τέως ἀξιοῖ τῆς φροντίδος· ὑψοῖ τε γὰρ αὐτὴν καὶ τῆς γῆς ὑπερανέχειν παρασκευάζει, πλαξί τε ταῖς ἐγχωρίοις κοσμεῖ καὶ κιγκλίδας κύκλῳ περιστήσας καὶ στεφανώσας ἄβατον οὕτως αὐτὴν καὶ ἄψαυστον εἶναι ποιεῖ, ὅτι μὴ μόνοις τοῖς πιστῶς ἐγγίζειν αὐτῇ βουλομένοις μετὰ πολλοῦ τοῦ σεβάσματος.

[50] As an adjective, *abaton* can be translated "inviolate" (cf. Edelstein, *Asclepius*, p. 387, on sanctuaries, testimony no. 744); as a noun, it was the place where suppliants went to have miraculous visions (pp. 221–

23, on healing, testimony no. 423, lines 6, 11).

[51] According to Cyril of Skythopolis, Euthymius's tomb was covered with a slab (*plaka*) and encircled with a barrier, which had been sent by the archbishop for the purpose: *tēn te epikeimenēn plaka . . . kai ta kukuklounta kankella* (Schwartz, *Kyrillos von Skythopolis*, p. 61, lines 23, 24). Peter of Atroa's tomb was embellished with a slab of marble (*plakiō auto marmarou*); see Laurent, *Saint Pierre d'Atroa*, p. 147, sec. 97, line 10.

[52] In the case of Hagios Demetrios in Salonika, the physical evidence is supported by a literary description of the hagiasma in the crypt of the basilica: it is described in one of the Miracula of St. Demetrius: *tōn kuklō tēs theias autou sorō murodochōn dexamenōn* (*PG*, 116:1421, 39). See also Sotiriou, *Basilikē tou Agiou Dēmētriou*, pl. 15a.

expansion of the monastery which must have been necessitated in part by the large number of pilgrims to the site—as the saint had prophesied, the "crowds of believers coming together . . . praising His divine name."[53] The specific reason for the large number of visitors is clearly stated: "the cures that welled up as if from a fountain or a spring."[54] This expansion inspired by the miraculous cures was a large undertaking and transformed the entire appearance of the monastery:

> Two years later some of his disciples, seeing the cures that welled up as if from a fountain or a spring, thought they would be unworthy children of a worthy father if they did not appear to reward him suitably after his death—as if in gratitude for his nurturing them—and they immediately applied themselves to building cells [*kelliōn*] and a church [*naou*]. First they completed in haste the church of the divine martyr Barbara which was still incomplete, adding as much embellishment to it as was in their power. Then they built a number of small structures [*oikiskous*], various in design, both for communal use and for the reception of visitors. Then they transformed that very cell [*kellion*] in which was the tomb [*taphos*] of the great man from its former appearance, and they made it over very beautifully [*pankalōs*] into a holy oratory in the shape of a cross [*hieron euktērion en staurikō tō skēmati*]. Thus came to fulfillment what the blessed one had said both concerning that very place [*topou*] and concerning those coming there in large numbers.[55]

There is a note of pride in the author's relating the completion of this project, which left the monastery in the form that he knew. The term *topos*, used when Holy Luke designates his burial place, refers again here to the precise spot that has continued to be respected and embellished as a place of veneration. The tomb itself is referred to as his *taphos* rather than as his *thēkē*, as in the preceding passage.

The passage focuses at the start on the outcome of the people's devotion and gratitude

[53] See Connor, *Life of Saint Luke*, chap. 64.

[54] Connor, *Life of Saint Luke*, chap. 67; *PG*, 111:476D: *ekei bluzousas iaseis isa kai pegaiois namasi kathorōntes*. This water and gushing language using *bluzo* and *anabluzo* is common in descriptions of tombs of saints—cf. Schwartz, *Kyrillos von Skythopolis* on Euthymius's tomb (p. 61): *hētis chōnē . . . anabluzei pantodapas euergesias*; Laurent, *Saint Pierre d'Atroa*, p. 147, sec. 97, line 15: *pēgē murou iamatodes ek tes sorou anablusasa*; and Miracula of St. Demetrius (*PG*, 116:1421, 39): *ek tou paneutimou Dēmētriou sōmatos anabluzousan tōn murōn pēgēn*.

[55] Kremos, *Phokika* 2:54, col. 1; *PG*, 111:476D; Connor, *Life of Saint Luke*, chap 67: παραχρῆμα πρὸς οἰκοδομὴν κελλίων καὶ ναοῦ διανίστανται· καὶ πρῶτα μὲν τὸν τῆς θείας μάρτυρος Βαρβάρας ναὸν ἀτελῶς ἔχοντα σπουδῇ τελειοῦσι, κόσμον αὐτῷ περιθέντες τὸν κατὰ δύναμιν, εἶτα καὶ οἰκίσκους ἱκανούς τε καὶ τὸ σχῆμα διαφόρους οἰκοδομοῦσι πρός τε κοινὴν χρείαν καὶ τῶν ἐπιξενουμένων ὑποδοχήν. Ἔπειτα καὶ αὐτὸ δὴ τὸ κελλίον, ἐν ᾧπερ ὁ τοῦ μεγάλου τάφος, τῆς προτέρας μεταβάλλουσιν ὄψεως καὶ εἰς ἱερὸν εὐκτήριον ἐν σταυρικῷ τῷ σχήματι παγκάλως μεταποιοῦσιν, ὥστε πέρας λαβεῖν τὸ ὑπὸ τοῦ μακαρίτου λεχθὲν καὶ περὶ τοῦ τόπου δηλαδὴ τούτου καὶ περὶ τῶν ὡς αὐτὸν εἰς πλῆθος συνερχομένων. In Cyril of Skythopolis's Life of Euthymius, the two-story chapel is "the oratory [*koimētērion*] on the place of the grotto where Euthymius had led his solitary life" (Schwartz, *Kyrillos von Skythopolis*, p. 61, lines 23, 24). Similarly, Peter of Atroa's final resting place is in his monk's cell, a grotto that has been transformed into an oratory church (*tou euktēriou naou*); see Laurent, *Saint Pierre d'Atroa*, p. 147, sec. 97, line 9. Cf. the cell of Neophytos (1134–1214), which became a church, its wall paintings, his typikon, his miraculous tomb, and so forth in C. Mango and E. Hawkins, "The Hermitage of St. Neophytos and Its Wall Paintings," *DOP.* 20 (1966): 120–206.

for the miracles of healing, that is, in the words of the author, "building cells and a church" (*oikodomēn kelliōn kai naou*). The stages seem to build in importance: first (*proton*) the earlier church is completed "in haste" (*spoudē*); then (*eita*) "various small structures" are built, a reference to the initial definition of "building cells"; then (*epeita*), finally, the rest of the project was completed, defined simply as building "a church." Here the author elaborates somewhat, for this part of the project concerns the holiest place at the monastery: "that very cell in which was the tomb of the great man"—this was the goal of the crowds of pilgrims: the miracle-working tomb. This they "transformed from its former appearance . . . and made over very beautifully into a holy oratory [*eis hieron euktērion*] in the shape of a cross [*en staurikō tō schemati*]." Because the term *euktērion*, which means oratory or prayer chapel (coming from the word for prayer, *euchē*, and often referring to a funerary chapel) is used here, Stikas and Chatzidakis have dismissed the passage as referring to a diminutive chapel that was supposedly replaced when the present Katholikon was built.[56] But I think the implications of the passage are clear. The "holy oratory in the shape of a cross" clearly refers back to the initial definition of the undertaking, namely the building of "cells and a church" where the term *naos*, the proper term for a true church, was used; to refer to the same building as a *euktērion* further on simply is one of many examples of the author's use of *variatio*. *Euktērion* is used to refer to large and significant churches in both earlier and later Byzantine texts as well as to small funerary chapels.[57]

The description of the church tells us only one thing about its appearance, that it was "in the shape of a cross," which must refer to its plan.[58] This of course could apply to buildings of any scale in Byzantium, from a huge public church to a tiny private chapel, but the passage seems to build up and culminate in this detail, which could well refer to the bold design and large scale of the present Katholikon whose axial design below the great dome certainly describes a cross. The intent of the author, we should remember, is not *ekphrasis* or elegant praise or description of this church, for he wishes only to emphasize what it represented—that is, the fulfillment of a prophecy by the saint on his deathbed and a place of miraculous cures. Since his account was written after 961,[59] the Katholikon was already well known to him and he already took it for granted, which also might account for this matter-of-fact description.[60]

[56] See Stikas, *Ktitōr*, p. 97, pl. 21, and Chatzidakis, "Date et fondateur," p. 128.

[57] For the wide range of the word *euktērion*—as chapel, church, tent, martyr memorial—see Lampe, s.v. *euktērios* B. The application of the word to the church of the Anastasis in Jerusalem (Eusebius, *Vita Constantini* 3.25 [*PG*, 20:1085a]) and the church built by Helena in Jerusalem (Socrates, *Historia Ecclesiastica* 1.17.7 [Hussey = *PG*, 67:120 B] shows that the word indicated a large building in early usage. The twelfth-century Pantokrator monastery in Constantinople has three churches, the middle of which is a burial chapel for the founders; it is variously referred to in the typikon of the monastery as a *heroon*, *euktērion* and *naos* (see Gautier, "Pantocrator Typikon," lines 730, 860, 878).

[58] A parallel example is the burial chapel, in fact a large church, at the Pantocrator monastery in Constantinople, which is described along with the Eleousa church (*naou*) as "another oratory in the shape of a heroon" (*heteron euktērion en schēmati heroou*): see Gautier, "Pantocrator Typikon," lines 730–31; cf. the plan of this chapel and the surrounding churches in Mathews, *Churches*, p. 74.

[59] See Patlagean, "Sainteté et pouvoir," p. 90.

[60] Because the scale and quality of other churches in Greece at this time is unknown, with the exception of the church at Skripou, we cannot gauge whether

After this last stage of building, the entire monastery's appearance had been transformed. The earlier church of St. Barbara, the building commissioned and paid for by Krinites during the saint's lifetime, was still not finished nine years later. It was completed in the building campaign that started in 955. Then this church was joined by another church that sheltered the saint's tomb, which must have been started ca. 956. Judging from the relative size of the two churches, this one must have taken longer to build, say fifteen years, giving us a completion date for the Katholikon of ca. 970. This cross-shaped church could have been either larger or smaller than the St. Barbara church, but the text implies that the preexisting church was hastily finished—they did what they could—in order to concentrate efforts on the main thrust of the undertaking, which was accomplished, in contrast, "very beautifully," even "magnificently," as *pankalōs* could be translated. A further reason for mentioning the completion of the Barbara church as a necessary first stage would have been that the new church was planned to adjoin it; otherwise this detail would have been irrelevant and illogical. Finally, if the new church was meant to accommodate such large crowds of visitors, then it probably was not smaller than the existing church of St. Barbara, but rather larger. The fact that a larger space was required best supports the argument that this new church was none other than the present Katholikon. Since this campaign started two years after the death of the saint in 953, we can conclude with a new dating for the Panagia church of ca. 946–56 and for the Katholikon of ca. 956–70.

Stikas relies on the same passage we just examined for his reconstruction of the oratory containing the saint's tomb; he believes it must have adjoined the church of St. Barbara on the south.[61] He believes that in a further building phase beyond that described in the Vita, the cross-shaped oratory was replaced by the present Katholikon with its crypt, all the while respecting the original burial place of the saint. It is however much more likely that this passage in the Vita on the rebuilding of the monastery essentially describes the existing situation at Hosios Loukas, just as the earlier passage describing Krinites' church of St. Barbara refers to the present Panagia church.[62] No dating of the architecture of the churches has been firm enough to rule out the possibility that both churches were built in the tenth century; and the previously unrecognized coincidence of the last building phases described in the Vita with the current layout and plan of the churches makes this highly probable.[63] This assumption also provides a simpler and more direct explanation

the Katholikon stood out greatly from the norm. For the dating of the churches, see also Connor, "Implications of the *Vita* of St. Luke of Steiris for Dating the Monastery of Hosios Loukas," pp. 27–28.

[61] See Stikas, "Nouvelles observations," p. 315.

[62] Schultz and Barnsley assume none of the buildings from the tenth-century phases survive (*Monastery*, pp. 3–4), as does Diehl (*L'église*, p. 20); Bouras dates the Panagia church after 960 and therefore does not identify it with any of the buildings mentioned in the Vita (*Sculptural Decoration*, p. 134); Stikas believes the Panagia church is the church of St. Barbara of the Vita ("Nouvelles observations," p. 311) and that the

Katholikon was built by Constantine Monomachos in the mid-eleventh century (*Oikodomikon Chronikon*, pp. 9–10, 244–45); Chatzidakis dates the Katholikon to 1011 ("Date et fondateur," pp. 127–29.); Cyril Mango does not attempt a new dating in his *Byzantine Architecture* (New York, 1976). Krautheimer stresses the individuality of the Greek school, dating the Katholikon 1011 or 1022 (agreeing with Chatzidakis) and noting that the two churches were designed a generation or less apart (*Early Christian and Byzantine Architecture*, p. 408).

[63] Megaw concludes his very useful study of the chronology of middle Byzantine churches in Greece

as it avoids hypothesizing an intermediary phase of demolition and rebuilding on the site.

In the absence of documentary records dating the monastery of Hosios Loukas, the Vita of the saint provides valuable testimony to this great undertaking. The passages just discussed support a new dating for the building of the Panagia church in the mid-tenth century and of the Katholikon in the third-quarter of the tenth century—worthy fulfillment of a saint's prophecy.

THE CRYPT AND FUNERARY RITUALS

The question of what ritual or rituals took place in the Hosios Loukas crypt is an important one, considering the tradition of monastic architecture that stands behind it. Does a similar tradition of usage also pertain here or was there a unique use of the crypt dictated by the cult at Holy Luke's tomb? Both these questions have affirmative responses and exploring them brings us to a full awareness of the fascinating practices that must have taken place in the crypt, as I will show in this and the final section of the chapter on the healing cult at the tomb. Since the crypt was planned to house not only the saint's tomb but two other large masonry tombs, our attention is first directed to funerary uses. General source material pertaining to funerals and commemoration of the dead provides an orientation with funerary liturgies. Since we are dealing with a monastic setting, sources relating to monasteries will be examined, especially focusing on monastic funerary practice where a founder's tomb is involved. A range of sources will help in reconstructing the liturgical uses of the crypt.

In the preceding section we discerned two principal architectural aspects that belonged to the original planning of the crypt. First, the tombs are prominently placed, with the tomb of Holy Luke directly opposite the entrance on the north side of bay B, and the two other tombs symmetrically placed on either side of the nave, with space to move around them on either side; small chapel-like enclosures are thus created next to the tombs in bays C and J. Second, there is an altar in the apse, on the left is a prothesis table with niche above it, and a templon screen divides the sanctuary from the rest of the crypt; the crypt was thus set up for celebration of the eucharistic liturgy. To explain the likely uses of the crypt in view of these architectural features, two types of sources can be consulted: the Great Euchologium and the typika. The Euchologium, equivalent of the Rituale of the Western church, contains the rubrics and texts of Greek Orthodox services for a variety of occasions, ranging from the great liturgies to short prayers required if, for example, there were a local drought. The Euchologium would have routine liturgical

with a table that places the Theotokos church [Panagia church] at Hosios Loukas in the second quarter of the eleventh century and the Katholikon in the first quarter: see H. Megaw, "The Chronology of Some Middle-Byzantine Churches," *BSA* 32 (1931–32):

129. Since the discovery of a fresco on the wall joining the two churches proves the Panagia church to be the earlier of the two, this chronology must be revised, all of which simply proves how difficult it is to date Byzantine architecture, even within a century.

* 83 *

use at all churches and monasteries. The typika are documents associated with specific churches or monasteries regarding their regulation or Rule; these normally have two sections. In the first, called the founder's typikon, there is a formulation of the pattern and regulation of life according to the special wishes of donors and founding families. The second section is the liturgical typikon or synaxarium, which contains a yearly schedule of the services for each calendar day, indicating which saints are to be commemorated and what prayers are to be said in succession each day throughout the year. The typikon for each monastery is different but they are obviously modeled on one another to some extent.

The *Great Euchologium*, edited by Jacobus Goar in 1647, goes back to manuscripts of the eighth or ninth century, but some offices, funerals for example, are probably still more ancient.[64] An important aspect of Eastern church tradition was that no more than one eucharistic liturgy could be celebrated on the same consecrated altar in any one day; hence, if more than one liturgy was required the second liturgy had to be said in some annex of the main church, a separate chapel, oratory, or parecclesion.[65] One of these special needs was the commemoration of the dead and the commemoration of various saints and martyrs on their feast days. These commemorative services held a place of great importance in the Greek church as stressed by G. Babic.[66]

A variety of services connected with death, burial, and commemoration of the dead are included in Goar's *Great Euchologium*. First, there are separate funeral services, *akolouthiae*, for laymen (pp. 423–38), monks, (pp. 438–51), and priests (pp. 451–67). The rubrics for these services include washing and preparation of the body, processions, disposition of crosses around the bier, and lighting with candles. There are indications of where these services took place: monks' bodies were brought into the church and deposited in the middle of the naos while laymen and priests were deposited in the narthex (pp. 439, 451). A monk's bier was then carried to the koimeterion or funerary chapel where further prayers took place before he was buried; the same practice was followed for priests (pp. 447, 465). Thus the basic features of funerals are included in the rubrics of the Euchologium.

One manuscript of the Homilies of Gregory of Nazianzus provides a rare depiction of funerals to support the rubrics of the Euchologium. In the illustrated Homilies in Paris (Bibliothèque Nationale, gr. 510) of 880–82, the sainted brother and sister of Gregory are shown on their funeral biers.[67] They are being carried in procession; the scene takes place outdoors as it may have appeared in the late ninth century. St. Gregory leads the funeral procession carrying incense and a perfume box; the procession moves toward a gray church with a red-tile roof where a red curtain is pulled aside over the door. For Gregory's sister Gorgonia's funeral, the procession seems to have left one building and

[64] Goar, *Euchologium*, 2nd ed., 1730, was reprinted in 1960; on the early origins of funerary rituals, see Babić, *Chapelles*, p. 9.

[65] Babić, *Chapelles*, p. 10; Goar, *Euchologium*, p. 13.

[66] Babić, *Chapelles*, p. 10: "On sait que l'église grecque réservait une place importante aux offices commémoratifs, dédiés aux morts, aux donateurs et aux fondateurs des églises."

[67] Omont, *Miniatures*, Paris Gr. 510, fol. 43v; S. Der Nersessian, "The Illustrations of the Homilies of Gregory of Nazianzus, Paris gr. 510," *DOP.* 16 (1962): 197.

is processing to another, from a two-towered, domed building to another decorated with arcades. Candles, present here, were an important feature at funerals and their use at this service was full of symbolism going back to ancient, pre-Christian traditions.[68]

The second service in the Euchologium associated with burial and commemoration of the dead is the Kolyvos (pp. 524–26). The name is taken from the mixture of boiled wheat, honey, and raisins distributed at the portal of the church after the service as a reminder of the resurrection of the dead.[69] Honey represents "the sweetness of bliss in the future life"; in the dish of kolyva is set upright a lighted candle, symbol of eternal life.[70] The Kolyvos takes place after the Pannuchis or Requiem office for the dead. According to the eighteenth-century traveler Barskij, the kolyvos was practiced in all the churches in Greece; his most detailed description is of Mount Athos where it was celebrated every Friday at the Lavra of St. Athanasius usually in the lateral chapels of the main church, but also in the koimeterion or burial chapel of the monks.[71] Unfortunately the antiquity of the kolyvos service is unclear, but according to Freistedt's study of early funeral practices it has a very ancient origin.[72]

Finally, the *Great Euchologium* gives us the long commemorative service for the dead, the Agrupnia, or all-night vigil (pp. 606–9). The service begins with Great Vespers and ends with Orthros or Matins.[73] In the *Great Euchologium*, Goar provides the first lines of innumerable prayers, which amount to an entire night of singing, responsive chanting, and psalming; prayers said in processions around the church (*litē*), are also included. At the weekly Saturday night Agrupnia, the Resurrection of the Lord is particularly commemorated.

Another commemorative office called the Pannuchis is associated with older versions of the Euchologium but is hardly mentioned in Goar's edition.[74] Etymologically it should also mean all-night office and therefore correspond with the Agrupnia, but instead it has different meanings; there have been three services by this name. First, pannuchis was the general term for vigil in the early church, whether or not the vigil was associated with the dead; second, pannuchis has been applied to the current Horologion and Triodion in which it is a requiem—that is, a commemorative office for the dead inserted between Vespers and Matins on the Saturday before Pentecost and on the Saturday of Carnival. The tenth-century typikon of the Great Church indicates that the pannuchis, in this sense as a general commemoration of the dead, was celebrated after

[68] Rush, *Death and Burial*, pp. 221–28. Tall candlesticks form part of the painted wall decoration on the north wall of the northwest chapel of the Katholikon of Hosios Loukas and fit into the funerary iconography of the chapel: Chatzidakis, *Peintures murales*, p. III. See also M. Alexiou, *The Ritual Lament in Greek Tradition* (Cambridge, 1974): pp. 24–35, on early Christian funeral rituals.

[69] Goar, *Euchologium*, p. 527, notes give the recipe and its intended connotations. The practice is described in the Life of St. Peter of Atroa: Laurant, *Saint Pierre d'Atroa*, pp. 144–45.

[70] Hapgood, *Service Book*, p. 613.

[71] See Babić, *Chapelles*, p. 46 and nn. 105–7.

[72] Freistedt, *Altchristliche Totendächtnistage*, pp. 104–5; see also *DACL*, S. V. "Colybes."

[73] Mateos, "Vêpres," pp. 250–51; Egeria called this service *lichnikon* (*lucernare*) because it began between four and five in the evening, at lamplighting (p. 251). The ancient origin of the Agrupnia is attested in Egeria's description of the liturgies of fourth-century Jerusalem; see Wilkinson, *Egeria*, pp. 124, 136.

[74] Arranz, "Pannychis I," pp. 314ff.

vespers of the Agrupnia on the eve of seventeen feast days of the year as well as another ten special days. A third use of pannuchis connected with monastic commemorations of the dead was a separate office that was performed along with Vespers at the tombs of the dead, especially of the founders of monasteries.[75] Arranz's study of the pannuchis concludes that this was a very popular office, coming into frequent use in the ninth century with the Studite offices of monastic-Palestinian origin.[76] The custom of celebrating this office on the third, ninth, and fortieth days after a death has ancient roots; one tradition is the wandering of the soul during this time, as described by Makarius of Alexandria.[77] The other is symbolism connected with Christ's Resurrection, appearance on the earth, and Ascension.[78]

All of these services took place, at least in part, in the crypt at Hosios Loukas, either as part of the burial or commemoration of deceased monks or priests, or in commemorations of the founder. The crypt was large enough to permit a gathering of some size at a special occasion—well over one hundred people—and it could easily contain the entire monastic community.[79]

Gatherings for services such as those just mentioned are described in the next category of sources, the typika, which are our most valuable and reliable witnesses to funerary practices at individual monasteries. Although their formats vary, the two sections of the typika are both useful for determining how and where liturgical observances took place at monasteries. With their help we come even closer to an understanding of how the crypt at Hosios Loukas was used.

The influence of the Palestinian tradition was keen throughout Byzantine monasticism; this is reflected at Hosios Loukas, for example, in the presence of full-length portraits of Sabas and Euthymius and of their successors Theodosius and Theoctistus in the mosaic decoration of the Katholikon. Also, a medallion portrait of Theodosius adjoins that of Holy Luke in the northeast vault of the crypt (fig. 47), and Theoctistus, one of the representatives of Palestinian monasticism, is in vault H (fig. 43). Architectural parallels between Hosios Loukas and the monasteries of Palestine have been discussed above; standing figures of saints occurred in their decoration also as at Hosios Loukas. The first typikon to be consulted will therefore be one associated with those monasteries, the typikon of St. Sabas. This liturgical typikon must date from the sixth century, although it only survives in a copy of the eleventh; it also served as a model for later typika of the middle Byzantine period.[80]

The liturgical typikon of St. Sabas is preserved in a manuscript at Mount Sinai (ms. 1096); in it special consideration is given to the commemoration of Sabas himself on

[75] Arranz, "Pannychis II," pp. 119, 121–22.

[76] Arranz, "Pannychis I," pp. 338–39.

[77] For this fourth-century saint's description, see PG, 34:388; for twelfth-century references to this office, see Gautier, "Pantocrator Typikon," lines 274, 281, 642, 799, 873, 1336.

[78] Freistedt, Altchristliche Totendächtnistage, p. 11.

[79] Calculating the number of monks at Hosios Loukas at any given time is difficult in the absence of records, especially since the number does not always seem to relate to the size of the foundation; for example, even a very large imperial monastery of the twelfth century only recorded fifty to eighty monks (see Gautier, "Pantocrator Typikon," pp. 60–61).

[80] DACL, S. V. "Sabas" (15, no. 1: 189–204); Babić, Chapelles, p. 15, emphasizes that the typikon of Sabas was probably developed by his mentor Euthymius, in the fifth century.

December 5, his feast day.[81] The offices celebrated on this day therefore give us an idea of how a monastic founder—one who became a saint, at that—would be commemorated at his monastery after his death. The description of the liturgical events of December 5 starts with the agrupnia or vigil, in the Agrupnia Megale, or Great Vespers. Listed are a number of readings, hymns and chants (*stichera, idiomeloi*), and psalms, *(psalmoi)* in certain tones *(ichoi)*. The Entrance *(Eisodos)* takes place with incense and two candelabra. Later a singing procession goes out of the church *(exerchetai ē litē)* into the tomb chamber of the holy one *(en tē thēkē tou hagiou)*, according to the stated order. The blessing of bread, wine, and water takes place, followed by a reading of the Life of the holy one in a shortened version, a *metaphrasis*; the Gospel is read, followed by the Great Doxology. Then all go out from the tomb chamber of the holy one *(exerchometha eis tēn thēkē tou hagiou)* and the service ends. Thus a long vigil was held on the eve of the sainted founder's feast day and included processions out of the church and into the tomb chamber.

The burial place of St. Sabas is referred to both in his typikon and in his Vita, his Life, written by Cyril of Skythopolis in the sixth century; it is called his *thēkē*, which can mean either a burial chamber or a tomb. Cyril was present when Sabas's *thēkē* was opened sixteen years after his death; at that time he went down *(katebēn)* to venerate the saint.[82] Babić concluded that the burial chapel of Sabas must have had two levels, like that of Euthymius.[83] The whole structure is called a *koimētērion*, while the lower level with the sepulcher is called the *thēkē*. The construction of Euthymius's burial chapel is described by Cyril of Skythopolis:

> Fidus the deacon made great haste to construct the funeral chapel [*koimētērion*], on the location of the cave where the venerable Euthymius had led his life in solitude. . . . In the center, he built the tomb [*thēkē*] of the saint; on the sides, he arranged the tombs [*thēkēn*] for abbots, priests and all other holy men.[84]

In a subsequent rebuilding of the monastery the funeral chapel is referred to:

> The fathers wanted the dedication of the church and of the monastery to take place on the day when the precious relic of the holy father had been transferred and laid in the new funeral chapel [*koimētērion*].[85]

These references to the burial place of Euthymius supplement the information contained in the Sabas typikon. The events described there also took place in a tomb chamber *(thēkē)* where other holy men were buried; the chamber was below ground level, on the lower story of a two-story funerary chapel *(koimētērion)*.

Later typika show that the practice of celebrating the memory of founders and monks at services "on their tombs" continues into the middle Byzantine period.[86] A typikon more nearly contemporary with Hosios Loukas describes commemorative practices as-

[81] Babić, *Chapelles*, p. 21; Dmitrievskij, *Typika*, 3:34–35.

[82] Schwartz, *Kyrillos von Skythopolis*, p. 184, line 15; Festugière, *Moines de Palestine*, 3, no. 2: 114.

[83] Babić, *Chapelles*, p. 18.

[84] Schwartz, *Kyrillos von Skythopolis*, p. 61; Festugière, *Moines de Palestine*, 3, no. 2: 115–16.

[85] Schwartz, *Kyrillos von Skythopolis*, p. 65, and Festugière, *Moines de Palestine*, 3, no. 2: 119.

[86] The Hypotyposis of the Stoudios monastery or-

sociated with monastic founders of the mid-eleventh century. The typikon of the Monastery of the Theotokos Evergetis near Constantinople was written by the monk Timothy, brother of the founder Paul who died in 1054.[87] Both monks are commemorated on the same day, April 16th; the liturgical typikon gives the prescribed services for this day and describes how the founder and his brother were commemorated. The typikon of foundation of the Evergetis monastery provides insights into general funerary and commemorative practices: "On this day take place the memorial services of our holy fathers and founders the monk Paul and the monk Timothy."[88] Vespers is the first service mentioned; it was celebrated starting on the eve of the feast day. After Vespers a new service began: "Then we go down [katerchometha] to the funerary chapel [koimētērion] and we celebrate the pannuchis on the holy tombs [en tois hagiois taphois]."[89] After this service is dismissed another follows, the pannuchis of the agrupnia, which, as we know, is the all-night vigil of commemoration. Orthros or Matins comes next and is the most elaborate service on this day. After a long series of readings and hymns, we are given a glimpse of the more practical side in the rubrics:

> Then the chapel custodian or the one in charge of the grave goes down and makes everything proper and ready down below [katō]; he lights the waxes and the candles and he censes the funerary chapel, all of it. . . . Then, after psalming, we all go out through the royal doors, we go down [katerchometha] into the funerary chapel. . . . The liturgy is performed in the funerary chapel [Hē de leitourgia teleitai en tō koimētēriō].[90]

Here, then, in the liturgical typikon of the Evergetis monastery we have without a doubt reference to a performance of the Divine Liturgy as part of the commemorative services for the monk-founders of the monastery on their feast day. The chapel is described several times as being katō, or down under, very likely referring to a crypt on the lower level of the chapel (koimētērion). As Babić has noted, the disposition of this funeral chapel could have been like those at Hosios Loukas or Bachkovo.[91]

The typikon of foundation of the Theotokos Evergetis monastery, recently published in translation by Gautier, describes the rules of everyday life there and gives further indications of commemorative practices.[92] Stipulations are made in chapter 35 concerning the commemoration of the founder: that it should be celebrated brilliantly and with an office that lasts all night; special considerations are made only if it falls on a feast day in Lent.[93] In chapter 36 the pattern of commemoration for monks is laid out. It specifies that the pannuchis or vigil of intercession should be said for dead monks, but when too

dered celebration on the tombs of the brothers (eis tous taphous tōn adelphōn) on certain days of the year (see Babic, Chapelles, p. 40, and Dmitrievskij, Typika 1:229–30).

[87] See Gautier, "Evergetis Typikon," pp. 6–11, for a history of the monastery.

[88] Dmitrievskij, Typika 1:446; the two monks are referred to as tōn hosiōn paterōn emōn kai ktētorōn.

[89] Ibid., p. 446: "Eita katerchometha eis to koimētērion kai poioumen en tois hagiois taphois autōn pannuchida."

[90] Ibid.

[91] Babić, Chapelles, p. 49.

[92] Gautier, "Evergetis Typikon"; commemorative liturgies are described on pp. 76ff.

[93] Ibid., pp. 76–77.

many need commemoration the typikon indicates an alternative: some of the brothers can withdraw to another place to say the canon for the dead. Unfortunately the typikon does not say where. The memory of a former abbot, however, must be celebrated separately. The text continues, saying that the man in charge of the graves (*taphiotes*) should make the best of all these arrangements that he can, and in the case of those who have left substantial endowment for this purpose, "we recommend that the *kolyvos* at the doorway should be generous."[94]

From this document it becomes clear that there is an emphasis on the pannuchis, indicating that this office is closely associated with the commemoration of dead monks. Also, the kolyvos after the service is referred to as a ceremonial act of charity, providing a meal for the poor and sick, but taking into account the rank or number of those commemorated rather than the degree of need of the recipients of the charitable distributions.

Another typikon of the late eleventh century, that of Gregory Pakourianos for the monastery of the Theotokos of Petritzos at Bačkovo, Bulgaria, does not include a liturgical calendar; this founder's typikon, however, indicates the concerns of the monk-founder Gregory, first abbot of the monastery. He exorts his successors to commemorate him and his relatives by a banquet and by distributions of money to the monastic community and to the poor.[95] The kinds of services and their locations seem to have been self-evident, for there is never a mention of where the commemorations were to take place. In the introduction of the typikon, however, the building program is described as having included a monastery (*monē*) and a funerary chapel (*koimētērion*).[96] Grishin, in his study of the Bačkovo ossuary in relation to the typikon, identifies the existing ossuary as the koimeterion; he concludes that the founders' tombs are here along with those of the monks.[97] The stipulations regarding commemoration of an abbot or a monk specify that:

> The brothers should honor him gloriously with incense and candles, and should observe for him with psalms and hymns the habitual ceremonial according to his rank, either monk or priest; and near his tomb [should offer] a distribution of twelve nomismata.[98]

On this occasion there was also to be extra food and drink, and all the masses were dedicated to him; on the third day there was a pannuchis, also on the fortieth and on the last day of the year. A monk's death would have been honored similarly. Finally, the Pakourianos typikon places great emphasis on the commemoration of the dead gener-

[94] Ibid., pp. 76–79 and n. 58.

[95] Gautier, "Pakourianos Typikon," pp. 114–15. There was also a commemoration for the founder on his name day, the feast of Gregory the Theologian; since the founder, Gregory, was also the monastery's first abbot, the importance of maintaining commemorative services and distributions of food and money is emphatically stressed in regard to his successors: "If any abbot after him neglects these duties or violates the stipulations of the typikon, after his death or during his lifetime, he in turn will be cursed instead of commemorated and will be expelled from the monastic community."

[96] Ibid., pp. 38–39.

[97] Grishin, "Bačkovo Ossuary," p. 93. Grishin finds the typikon's evidence convincing, even though the koimeterion is outside the walls of the monastery.

[98] Gautier, "Pakourianos Typikon," pp. 102–3.

ally: "without fail, by the divine liturgy, in continual memory of the dead"; this would have taken place in the oratory of John the Baptist in the main church of the monastery and consisted of a vigil (agrupnias), all-night psalming, and a divine liturgy (hieras leiturgias).[99]

The distribution of the various commemorative services between the main church of the monastery, the katholikon, and the koimeterion is not made clear by the typikon. However, the Sabas and Evergetis typika clearly indicate the connection between commemorative services and the place of burial, the koimeterion. Therefore, if monks and abbots are celebrated at their tombs in the koimeterion, then the founder, since he also is buried there, would have been commemorated there as well. The ossuary is supplied with an altar; this supports the idea that, as at the Evergetis monastery, commemorative celebrations for the founder Gregory, and perhaps also for other members of his family and for the monastery's abbots, culminated with celebrations of the Divine Liturgy in this koimeterion.

From the Pantocrator monastery in Constantinople not only does a typikon of 1136 survive but so do extensive remains and standing churches of this once glorious religious establishment. Since this was an imperial monastery, the typikon, drawn up by the Emperor John II Comnenus in 1136 and describing in detail the regulation of daily life and commemorative practices, represents commemorative practices at a further and more elaborate stage of development than in the typika just discussed.[100] A chapel (euktērion), some distance away from the main churches was used for celebration of services for deceased monks; Saturday services and vigils (agrupniae) are prescribed by the typikon for this chapel.[101] The founder and members of his family were buried separately in the chapel of the Archangel Michael located between the two churches. This large eukterion was built to hold the imperial tombs and to accommodate commemorative services and rituals for the imperial dead.[102] The services held in the chapel are the vigils (agrupniae), with pannuchis, and include processions (litē); certain amounts of oil and wax and precise numbers of candles are prescribed for various services, the divine liturgy being celebrated three times a week.[103] After the liturgy, the kolyvos was distributed at the portal along with money and wine.[104] On special days, an icon of the Virgin, the famous Hodegetria icon, was carried from the imperial palace to the chapel where it remained near the tombs throughout the night.[105]

The commemorative ceremonies at the Pantocrator monastery reflect strong concern, almost obsession, with proper and lavish remembrance and are by far the most elaborate encountered. The richly decorated chapel of the Archangel, though ostensibly serving the same purpose as a monastic koimeterion, is here the setting for burial and commemoration on a grand scale and for the imperial family.[106] The monks are buried elsewhere

[99] Ibid., pp. 108–9.
[100] Gautier, "Pantocrator Typikon."
[101] Ibid., pp. 40–42.
[102] Ibid., p. 80.
[103] Ibid.
[104] Ibid., p. 83.
[105] Ibid., p. 83; Babić, Chapelles, p. 48.
[106] The decoration and furnishings of this burial

chapel and the adjacent church of the Eleousa are described in the "Pantocrator Typikon"; see Gautier, pp. 36, 74, and 80–82. The subjects of what must have been mosaics, or, less likely, frescoes, on the walls of these churches are mentioned only in relation to the kind of lighting prescribed by the founder; for the funeral church of St. Michael the subjects are: the Adoration of the Archangel, Crucifixion, Resurrec-

and have a separate program of memorial services. Judging from the great enumeration of services in the typikon, it was commemoration of the founders that had become the major preoccupation of the Pantocrator monastery.

The liturgical evidence closely parallels that of architecture for funerary chapels. Both indicate a tradition of monastic chapels, koimeteria, which were places of burial and where commemorative rituals took place. The typika describe the tomb of the saint or founder(s) in the koimeterion as the focus for yearly commemorations by the monastic community on the anniversary of his death. A long vigil, pannuchis with agrupnia, started the eve of his feast day and included processions out of the main church and down into the koimeterion to celebrate "on the tomb of the holy one." Correspondingly, at Hosios Loukas these services must have been performed to commemorate Holy Luke at his tomb in the crypt; the occupants of the large tombs on either side of the sanctuary, probably abbots or patrons of the monastery, were also commemorated on the anniversaries of their deaths.

The Divine Liturgy was celebrated as part of the commemorative ritual for the founder in the funerary chapel, as we learn from the Evergetis typikon; the presence of an altar, prothesis niche, and templon barrier in the crypt confirms that this practice must have existed at Hosios Loukas. The bone vaults also indicate that the crypt was used as an ossuary for monks. Indeed the commemorative services in the crypt must have been quite frequent, since deceased monks were remembered on the third, ninth, and fortieth days after death; annually; and when their bones were removed from the earth for reburial in the ossuary, that is, three years after burial.[107] The size and limited access of the crypt indicate that its funerary and commemorative use was primarily for the monastic community. The crypt at Hosios Loukas reflects a fundamental dependence of middle Byzantine funerary rituals and architecture on the early monastic traditions of Palestine where the traditions of commemoration of founders and holy men at their tombs first became established. Although there is no liturgical typikon for the monastery of Hosios Loukas, many of the commemorative practices mentioned in the Euchologium and described in the typika just discussed must have taken place in the crypt at Hosios Loukas. In fact, even in the absence of such a document, so many monastic practices are mentioned incidentally throughout the Vita, it can almost be considered to serve a similar purpose to a typikon.[108] We have gleaned much information from wider sources about

tion, Holy Sepulcher, Christ Appearing to the Marys, and Christ over the passage leading to the tombs; for the church of the Pantocrator they are: Pantocrator, Resurrection, Crucifixion, Last Supper, Washing of the Feet, Dormition of the Virgin, and Ecumenical Councils. This extraordinary testimony merits close attention for its details and implications for twelfth-century monumental decoration and the ties between architecture and liturgy.

[107] See Freistedt, *Altchristliche Totendächtnistage*, pp. 3–11, on commemorative observances; see also Makarios of Alexandria on his receipt of the third-, ninth-, and fortieth-day custom from an angel in *PG*,

34:388. The Evergetis typikon shows concern for handling an unusually large number of commemorative services in any given week: "If because of a great number of deceased brothers the memory of three or four falls in the same week, collective services with the pannuchis are held" (Gautier, "Evergetis Typikon," p. 76).

[108] Perhaps this was really part of the author's intent; Gregory of Nazianzus described Athanasius's Life of Anthony as a "monastic rule cast in narrative" (R. C. Gregg, *Athanasius' the Life of Anthony and the Letter to Marcellinus* [New York, 1980]: p. 14).

funerary rituals and practices, which suggest that those that took place in our crypt were especially focused on the saint himself and on the deceased monks and abbot-patrons buried there.

The importance of rituals associated with death and burial in a monastic context is also reflected in the Lives of saints. Dorothy Abrahamse in her article "Rituals of Death in the Middle Byzantine Period," emphasizes that the middle Byzantine period differed from the Justiniac period by attaching more importance to the burial and commemoration of the dead, especially of saints, but also of aristocratic and lay people.[109] The rituals, though basically conservative, tended to become more and more elaborate. Details mentioned in saints' lives indicate how and where such rituals took place; they describe the processions and the participation of mourners. An astounding continuity between Byzantine and modern Greek funerary rituals can also be detected.[110] Saints' Lives contribute details about the treatment of death, especially in relation to tombs and commemorations at the tomb, including psalming, hymns, processions, and forty-day and other observances.[111]

The period of mourning often coincided with the time it took to construct a permanent tomb in an appropriate location. Until this time there was temporary burial; sometimes a holy man's body was placed before the sanctuary of the church for an extended period of time. For example, in the case of St. Peter of Atroa, the saint was interred on the anniversary of his death when the body was taken from the oratory where it had rested for a year to the grotto chapel. Here, in the place where the saint had prayed and held services, he was finally buried in a tomb covered with a marble plaque.[112]

Evidence from saints' Lives allows Abrahamse to trace an important development in the middle Byzantine period:

> The emphasis on post-funerary commemoration of the dead, delayed interment and even reburial of the dead in these texts indicates an important development in the ways some deaths—those of ascetic leaders—were seen and celebrated. If these last rituals had not become more elaborate during this period, they had certainly become more significant in the whole celebration of death. . . . I suspect that this reflects, above all, a greater integration of veneration for a particular living figure—the ascetic—with that of his dead body as relic and source of miracles for the community that perpetuated his memory and promoted his cult.[113]

Abrahamse's conclusion from her study of death and burial rituals is important here for two reasons. It confirms evidence from the typika, that there was a growing preoccupation with rituals and commemoration of the dead, not just of patrons who could pay for commemoration, but of holy men as well. Second, it confirms that the place of burial of the holy man indeed assumes new importance in this period as a place of pilgrimage and becomes the center of his posthumous cult.

[109] Abrahamse, "Rituals of Death," pp. 125–34.
[110] Ibid., p. 125 and n. 2; see also Loring Danforth, *The Death Rituals of Rural Greece* (Princeton, 1982).
[111] Abrahamse, "Rituals of Death," pp. 131–32.
[112] Ibid., pp. 132–33; Laurent, *Saint Pierre d'Atroa*, pp. 142, 146; cf. also descriptions of the burial of Holy Luke with a marble plaque covering the grave (Connor, *Life of Saint Luke*, chap. 66).
[113] Abrahamse, "Rituals of Death," p. 134.

A still-unexplored dimension of the monastery of Hosios Loukas is its role and importance as a pilgrimage center for healing. Since the Lives of saints were productive for Abrahamse's study of death rituals, we will next look at the Vita of Holy Luke as a source of information on the operation of his cult. The crypt with its tomb of Holy Luke proves to have served other purposes than just as a place for burial and death rituals.

THE HEALING CULT AT
THE TOMB

Now that we have established that the crypt was used for funerary and commemorative purposes—from the character of the decoration, from comparisons with other monuments, and from literary sources—we turn again to a source that suggests a further way in which the crypt was used. The Vita of Holy Luke, which has already provided valuable testimony on the building of the monastery, was written by an anonymous monk who compiled the Life by conversing with individuals who had known the saint personally. This account, although it belongs to a long tradition of highly formulaic hagiographical literature, also conveys many precise and interesting details concerning the cult of Holy Luke and the events and practices associated with his tomb. Those relating to the healing cult are described after the building of the Katholikon with its crypt, in the Posthumous Miracles at the end of the Vita.[114] From them we get a vivid glimpse of the early functioning of the healing cult at Hosios Loukas, of the social milieu surrounding it, and of beliefs and practices associated with the working of miracles. The descriptions in the Vita contribute to our understanding of the early and intended use of the crypt at Hosios Loukas.

A preoccupation of the Vita is with Luke's role as a miraculous healer, a thaumatourgos,[115] and the variety of miracles that took place during his life, including levitation, prophecies, miraculous feedings, and the healing of the sick; after his death, all miracles involved the healing power of the saint's tomb. The agents of this healing include oil from the lamp above the tomb, moisture exuded from the tomb, and dreams experienced when sleeping near the tomb in the practice called incubation. Both before and after the building of the Katholikon with its crypt, the tomb of Holy Luke must have been a place of pilgrimage for those seeking miraculous cures;[116] after the completion of the building projects described in chapter 67 of the Vita, the crypt became the focal point of the miracle cult at the tomb.

The terminology for the tomb is maintained in the Miracles, as it was in the Vita proper, but with some additions. It is important to become acquainted with these terms in order to understand the operation of the cult. The chart helps tabulate the terminology and content of the miracles, where they are numbered one through fifteen. The tomb

[114] See Connor, *Life of Saint Luke*, chaps. 68–84. See also the chart of the Fifteen Posthumous Healing Miracles.

[115] Luke is classified as a thaumatourgos in the *Synaxarium of the Great Church*, which depends on the Vita for its entry on Holy Luke (*CP*, 450).

[116] The decision to build the church over Luke's tomb results from "the cures that welled up as if from a fountain or a spring" (Connor, *Life of Saint Luke*, chap. 67).

The Posthumous Healing Miracles in the Vita of Saint Luke of Steiris

Vita chap. no.	Miracle no.	Column no. 1 Name or place of origin (man, woman, anon.)	2 Illness or problem	3 Length of time for miracle	4 Source of Miracle[a]	5 Agent[b]	6 Manner of anointment	7 Status of suppliant	8 Reaction to miracle	9 Medical references: doctors, drugs, etc.	10 Monks' participation in healing process	11 Where suppliant stays	12 Other significant references
69	1	woman; her son	paralyzed hands and feet; demon	1 hour	Th, T	M (he drinks it)	M from TH	poverty (cf. no. 4)	words of thanks, could not pay			sits next to T	water imagery; double miracle mentions attendant
70	2	two children of Nicolao	lame	8 days +	T	P		poverty (cf. no. 4)	hymns	seeks "cure without a fee"		sits by the T leads donkey to T	
71	3	woman	sores on face	8th day	T, S	E, M	E from lamp N from S	poverty (cf. no. 4)		tried doctors, yes			
72	4	old woman of Boeotia	eye ailment	delay—a few days	Sem, Tem, S	Mixture of E and N	E from lamp N from S	poverty		yes			
73	5	Nicolaos	sores (leprosy?)	straightaway	Tem, L	falls into dexameni, E, N	E from lamp N from Larnax			yes		sits by the L falls in receptacle	
74	6	man	demon	repeated visits of 3 or more days	Th, S	O			praise		yes		Luke exorcises demon through mouth
75	7	John	demon	delay—after 6 months	T	M, E, O	E from lamp M from T				Monk Pankratius anoints him		Luke shares "secrets" with him
76	8	John	demon	no mention		O			Thanksgiving and songs				Luke hooks the demon
77	9	anonymous	blind	postponed, then gradually	Th, Tem, Naos, Sem	P			Thanksgiving and good praises	yes			Mentions icon, monastery
79	10	John from island of Tervania	Sore feet, bedridden	not many days	Gives thanks later at Naos, S, T	P (from a distance)						at a distance	reference to kissing the S, to the monastery to the miraculous T
80	11	Demetrias Kalonas	rupture	3 days	Naos, L, S, Th, T	E (portable cure)		Laborer	hymning and good pr				mentions "therapon"
81	12	Constantine from Thermopylae	demon	delay—6 months	S, Tem	mixes E with tears; P				yes			mentions "therapon" received salvation
82	13	anonymous from Euboea vs. Christopher	demon	no mention	Naos, L, S, Th, T	O		Christopher is a Kommerkiarius	rejoices		hospitality of monks	stays close to T	Luke pulls out black hair with beetle
83	14	Nicolaos from Davlia	dropsy		L, S	sponges off the sores and anoints		cleric		"no fee," yes, tried doctors	Pankratius sympathizes and anoints	sat next to L	tomb called "common good of the west"
84	15	Nicolaos from Rastamiti in Boeotia	sores on face	a few days	T	E (from a distance = portable)	E from lamp T the TH	man of substance		wasted money on doctors, yes		at a distance	

[a]Key: L = Larnax; Naos = Naos; S = Soros; Sem = Semneion; T = Taphos; Tem = Temenos; Th = Theke.

[b]Key: E = Elaion; M = Myron; N = Notidi; O = Onar (dream); P = Prayers.

was referred to in descriptions of the burial place as the *thēkē* and the *taphos*. Several more terms seem to be interchangeable in reference to the tomb. For example, in the first miracle, a woman paralytic was brought to the tomb (*pros ton . . . taphon*) where "a little while before, the *thēkē* of the saint had exuded a sweet smelling myron."[117] The attendant filled a lamp with the myron and hung it over the sacred tomb (*taphos*). In the third miracle, a supplicant goes into the tomb (*eis ton taphon*) of the holy one to take oil (*elaion*) from the lamp; the *taphos* must be thought of here as a space into which one can enter.[118] The use of the term *thēkē* for the tomb in the sixth miracle also connotes a room or chamber one can occupy, for he is described as "remaining in it a few days."[119]

In the thirteenth miracle, another term for tomb, [*soros*], is shown to mean the same thing as *thēkē*. Here a supplicant asks permission "to sleep by the tomb [*soros*]" and so displaces another supplicant who is described as having been "deprived of remaining near the divine tomb [*thēkē*]."[120] Yet another term for the tomb is juxtaposed with *soros* in the fourteenth miracle. The supplicant is described as sitting next to the *larnax* of the divine Luke when one of the monks takes a sponge, "wipes off this divine *soros*, and with it annoints the sick one."[121] Although all these terms—*taphos*, *thēkē*, *soros*, and *larnax*—have slightly different meanings in classical or antique usage, they are used interchangeably in the Vita to refer to the tomb as an object or as a space into which one can enter.[122]

Two additional terms indicate the area of the tomb, *semneion*, which can mean a sacred place or room, or a monastery (Lampe, *A Patristic Greek Lexikon*), and *temenos*, a precinct (Liddell, Scott, and Jones). In the fourth miracle an old woman afflicted by blindness "approaches the *semneion* of the saint, enters into the *temenos*, and falls down to worship at the holy *soros*."[123] Similarly, in the twelfth miracle a man possessed by a demon "reaches the sacred *temenos* of [Luke]; he falls down at the divine *soros* and washes it with

[117] Connor, *Life of Saint Luke*, chap. 69; *PG*, 111:477C. Cf. Laurent, *Saint Pierre d'Atroa*: a spring of myron gushes out of the tomb of St. Peter of Atroa: "*pege murou iamatodes ek tes sorou anablusasa*"; Hagios Demetrios is a typical emitter of myron, a *myroblytos*: cf. V. Goodlett, "The Accommodation of the Cult of the Saint at Agios Demetrios, Thessaloniki" (Unpublished paper, Institute of Fine Arts, New York University, 1984), p. 16: she translates from the Miracula the "Vision of Myrrh": "Who does not know that from the body of the blessed Demetrius gushes forth a wave of myrrh in such profusion as to overflow the reservoir of the coffin itself and the circuit of the holy place" (p. 18). See also C. Walter, "St. Demetrius: The Myroblytos of Thessalonika," *Eastern Churches Review* 5 (1973): 163.

[118] Connor, *Life of Saint Luke*, chap. 71; Martini, "Supplementum," p. 109: "*opse gar eis ton tou hagiou phoitesasa taphon.*"

[119] Connor, *Life of Saint Luke*, chap. 74; Martini, "Supplementum," p. 110: "*Husteron de te tou hagiou proselthōn thēkē hēmeras te ouk oligas en autē prosmeinas. . . .*" *Thēkē* is also used in Sabas's Vita to denote

the tomb chamber: "when the precious tomb was opened . . . I went down to venerate the body of the divine man [*tēs gar timias thēkēs anoichtheisēs . . . katebēn proskunēsai tou theiou presbutou to sōma*]" (Schwartz, *Kyrillos von Skythopolis*, p. 184).

[120] Connor, *Life of Saint Luke*, chap. 82; Martini, "Supplementum," pp. 115–16: "*epei kai tēs pros tēn hieran thēkēn ekbeblētai prosedreias.*"

[121] Connor, *Life of Saint Luke*, chap. 83; Martini, "Supplementum," p. 117.

[122] This variety and occasional ambiguity of terms can be explained by borrowings from other accounts of miracle-working tombs and also by the apparent enjoyment of the author in using synonyms wherever possible throughout the work. Lampe defines *taphos* as tomb; *soros* as tomb, or chest containing sacred relics; *larnax* as coffin; the lexicon of Liddell, Scott, and Jones (LSJ) defines *thēkē* as grave or tomb.

[123] Connor, *Life of Saint Luke*, chap. 72; Martini, "Supplementum," p. 110: Αὔτη τοιγαροῦν τῷ τοῦ ἁγίου προσελθοῦσα σεμνείῳ καὶ τὸ θεῖον τέμενος εἰσελθοῦσα τῇ ἁγίᾳ προσπίπτει σορῷ χαί, ὦ χάριτος ἀπόρρητα δυναμένης.

tears."[124] In the ninth, a blind man prays to the saint: "Let me see your image [*eikona*]. I will behold the tomb [*thēkēn*], look upon the monastery [*semneion*], delight in the sanctuary [*temenous*]."[125] *Temenos* must refer to the area directly around the tomb, whereas *semneion* seems to be a general term for the holy place or the monastery as a whole. From the use of these terms in other miracles, it seems they all refer to the burial place of Holy Luke. When compared with the description in the Vita proper of the burial place, it appears that the circular enclosure given the *thēkē* by Kosmas the monk corresponds to the *temenos* of the miracle accounts. Although there is no longer any trace of this enclosed area around the tomb as it presently appears, it can be imagined from the descriptions in the Vita.

The terms used in describing the healing cult at the tomb are associated with the crypt and its function from the time of the building of the Katholikon in the third-quarter of the tenth century. Accounts of the operation of the miracle cult at the tomb bring a new dimension to our understanding of the function of the crypt, a liturgical use of this space only recorded by the Vita of the saint. The nature of the healing process and other types of factual information contained in this record bear closer attention.

The Posthumous Miracles all refer to, rely on, or take place near the tomb of Holy Luke. They are very like the posthumous miracles encountered in so many saints' Lives, including even a statement by the author that because many more miracles took place than he could possibly describe, he presents only a selection.[126] This collection of fifteen miracles is significant for it reveals the typical preoccupations, patterns, and people associated with the cult, information that has been classified and tabulated in order to show recurring elements and themes contained in the miracle accounts (see the chart). They describe the tomb, the people who were cured, their ailments, their concerns, the kinds of miracles they experienced, how long it took for the cure to take place. On the whole we get a remarkably vivid glimpse of the healing cult and its milieu.

Patterns of the cult emerge. Typically, each miracle account introduces the sufferer and describes his ailment; these ailments are either physical maladies or cases of demonic possession. The sufferers approach the tomb as suppliants, usually with little success at first, but then, after a delay, they are cured. The tomb itself is described with several terms already discussed (see chart, col. 4). Another group of terms, also discussed, is used for the agents of healing: *myron*, a substance exuded from the tomb, is collected and contained in the lamp that hangs over the tomb; *elaion* is used in the same way as myron and both refer to a healing oil.[127] Another substance, *notis*, is also emitted from the tomb

[124] Connor, *Life of Saint Luke*, chap. 81: Παριδὼν ἅπασαν τὴν ἐξ ἀνθρώπων ἐπικουρίαν ἐπὶ θεὸν καὶ τὸν αὐτοῦ θεράποντα καταφεύγει καὶ τὸ ἱερὸν ἐκείνου καταλαβὼν τέμενος τῇ θείᾳ προσπίπτει σορῷ καὶ θερμοῖς αὐτὴν λούει τοῖς δάκρυσιν.

[125] Connor, *Life of Saint Luke*, chap. 77: . . . ἴδω σου τὴν εἰκόνα· προσβλέψω τὴν θήκην· τὸ σεμνεῖον θεάσωμαι· τοῦ τεμένους κατατρυφήσω. For the importance of icons in the church, see Brown, "Iconoclastic Controversy," esp. pp. 160–61, and Galavaris, "Por-

traits of St. Athanasius," pp. 97–98.

[126] The introduction to the Posthumous Miracles in the Life of Saint Luke states: "Now it is time to recount the miracles which took place after the death of the wise man, not all of them or in detail, or in chronological order—for how could one, when there are so many" (chap. 68); cf. Patlagean, "Ancienne Hagiographie," p. 123.

[127] See Connor, *Life of Saint Luke*, chaps. 69, 75.

and collected in a receptacle near the tomb; this is a healing water.[128] These are applied as an ointment separately or are mixed, to obtain miraculous cures (see chart, col. 5).

The third miracle is an example of the cure of a physical malady through anointment. A woman suffers from sores on her face, "an undiminished source of great pain and embarrassment for her"; the account continues:

> She tried countless medical treatments but found no relief at all and recognized that she had lost the opportunity for swift healing. Finally, going into the tomb [*eis ton . . . taphon*] of the holy one she took some oil [*elaion*] from the lamp that was there and some moisture [*notidi*] from the esteemed tomb [*soros*], and anointed the suffering spot. Shedding many tears on the sacred tomb [*taphos*], not for many days did she ask for healing but the eighth day totally freed her from her suffering, and the skin on her face was pure, without even a small trace of her former misfortune to be seen.[129]

A second type of ailment encountered in the Posthumous Miracles is possession by a demon. In most cases the cure comes about through incubation, that is, the sufferer sleeps near the tomb at night; the saint appears to him in a dream and exorcises the demon. For example, in the sixth miracle a man was "held down by a demon" and was "for many years broken down by its harsh tortures, pulled apart and thrown about by dread fears"; his cure takes place over a number of visits to the tomb:

> But at length he came to the tomb [*thēkē*] of the saint and, remaining in it a few days he too experienced that grace, . . . even though it was delayed . . . for he still went frequently and prostrated himself at the tomb [*soros*] in entreaty; he would remain three or even more days and then would decide to return home. Once when he had come and was joined by the fathers in entreating the saint, he had a dream [*onar*] when he was asleep in which he was called by name and ordered to open his mouth. And when he swiftly did what he was ordered, that one breathing into him said, "Depart now in health, announcing to all the wondrous works of God." And he awakened from his sleep and recognizing that the dream presented a clear truth, he described it to all.[130]

[128] *Notis, notidi* in the dative, is defined in Lampe as dew or moisture; since in miracle number 5 (Martini, "Supplementum," p. 110, Connor, *Life of Saint Luke*, chap. 73) Nicolaos falls into the *dexamenē* containing it, the interpretation as water seems justified.

[129] Connor, *Life of Saint Luke*, chap. 71; Martini, "Supplementum," p. 109: Αὕτη μυρίων ἰατρικῶν ἀνασχομένη βοηθημάτων μετὰ τοῦ μηδόλως τυχεῖν ὠφελείας ἔτι καὶ χρόνον ἀπολέσασα διέγνω θεραπείας πρωιμοτέρας· ὀψὲ γὰρ εἰς τὸν τοῦ ἁγίου φοιτήσασα τάφον καὶ τοῦτο μὲν ἀπὸ τοῦ ἐλαίου τῆς ἐκεῖσε φωταγωγοῦ, τοῦτο δὲ καὶ τῶν νοτίδων τῆς τιμᾶς σοροῦ λαμβάνουσα καὶ τὸ πάσχον ἀλείφουσα μέρος δάκρυά τε πολλὰ τοῦ ἱεροῦ κατασπένδουσα τάφου, πολλῶν οὐκ ἐδεήθη πρὸς τὴν ἴασιν ἡμερῶν, ἀλλ' ἀτεχνῶς ἡ ὀγδόη

τοῦ πάθους αὐτὴν ἀπήλλαξε καὶ καθαρὰν παρέσχε τῷ προσώπῳ τὴν ἐπιφάνειαν, μηδὲ μικροῦ ἴχνους ὑποφαινομένου τοῦ προλαβόντος κακοῦ.

[130] Connor, *Life of Saint Luke*, chap. 74; Martini, "Supplementum," pp. 110–11: Ὕστερον δὲ τῇ τοῦ ἁγίου προσελθὼν θήκῃ ἡμέρας τε οὐκ ὀλίγας ἐν αὐτῇ προσμείνας, ὅμως μέλλουσαν καὶ αὐτὸς εἶχε τοῦ θερμῶς ἐπικουροῦντος τὴν χάριν. Τί οὖν ὁ εὐσεβὴς ἀνὴρ καὶ φιλόθεος; Ἀναστρέφει μὲν οἴκαδε πλὴν καὶ οὕτως οὐκ ἀπέγνω τὴν θεραπείαν, ἀλλὰ καὶ ἔτι θαμινὰ προσῆει καὶ προσέπιπτε τῇ σορῷ δεόμενος καὶ τρεῖς ἢ καὶ πλείους ὑπομένων ἡμέρας· οὕτως ὑποστροφῆς ἐμέμνητο. Ποτὲ γοῦν ἐλθόντι καὶ σὺν τοῖς πατράσι τὸν ἅγιον αἰτουμένῳ, ὄναρ αὐτῷ καθεύδοντι ἐπιφαίνεται, πρὸς ὄνομά τε καλεῖ καὶ τὸ στόμα δια-

The two usual methods of healing at the tomb of Holy Luke are through anointment and exorcism. In some miracles the methods are combined, in others the miracle takes place at a distance. In two cases the oil from the lamp over the tomb is brought to the sufferer.[131] In the tenth miracle John, from the island of Tervania who suffers from sore feet and is bedridden, visits the tomb in his imagination:

> For it was impossible for him to ride a horse because of the intolerable pain, and to make such a journey in his bedridden state was plainly difficult. What did he do? He arrived at the place in his imagination, hastening on with the wings of faith. He tasted that very tomb [*soros*] with his lips; even though he was far away in body he called upon the one who does not through his grace fail to be present, saying . . . "grant that I should come to see your tomb [*soros*] with my feet healed." The saint . . . suddenly lightened his pains, releasing the fetters from his feet . . . he strode freely and also jumped. . . . A little later he visited the monastery, flourishing in his feet as in his faith. Entering the divine church [*naos*] he prostrated himself at the miraculous tomb [*sēmeiophorou taphos*], saying, "I thank you, o man of God, since you have delivered my eyes from tears and my feet from stumbling."[132]

The tomb thus plays a crucial role in all types of miraculous cures, whether through physical contact or imagined contact.

Proximity to the tomb is a prerequisite for healing, except in the three long-distance cures (see chart, col. 11). The suppliant "sits next to" the tomb in a number of the miracles; in the second miracle, the donkey bearing the lame children is led "right up to the tomb" where the mother, "sitting and waiting beside it," asked the saint for aid.[133] In the fifth miracle, Nicolaos is sitting next to the receptacle for the moisture (*notidi*) emmitted by the tomb when he accidentally falls into it.[134]

In incubation, the necessity of being near the tomb as well as being the only one to sleep there is also clear, as in the case of Christopher:

> When evening came he asked permission to sleep by the tomb [*para tē sorō*]. Although the fathers had permitted him to worship there, they said, "No other person except the one who is ill remains there."[135]

In the same miracle one who is possessed by a demon was discouraged because he was

νοῖξαι κελεύει· τοῦ δὲ ταχέως τὸ κελευσθὲν δράσαντος, ἐκεῖνον ἐμφυσήσαντα ἔνδον, «Ἄπιθι νῦν, εἰπεῖν, ὑγιὴς ἀπαγγέλων πᾶσι τὰ τοῦ θεοῦ θαυμάσια.» Καὶ ὃς ἐγερθεὶς τοῦ ὕπνου καὶ τὸ ὄναρ μὴ ἀγνοήσας φανερὰν ὑπάρχειν ἀλήθειαν πᾶσί τε διηγεῖτο καὶ σὺν αὐτῷ πάντας εἶχε θεὸν καὶ τὸν αὐτοῦ θεράποντα μεγαλύνοντας. This type of miracle is best paralleled by Christ's healing miracles; cf. Harnack, *Luke the Physician*, trans. J. R. Wilkinson (London, 1967), pp. 195–96; W. M. Alexander, *Demonic Possession in the New Testament* (Edinburgh, 1902), chap. 3, pp. 61–146; Patlagean, "Ancienne hagiographie," p. 117.

[131] Connor, *Life of Saint Luke*, chaps. 80, 84; Martini, "Supplementum," pp. 113–14, 117–18.

[132] Connor, *Life of Saint Luke*, chap. 79; Martini, "Supplementum," pp. 112–13. Cf. the Life of St. Athanasius the Athonite in a healing miracle: "*edoxe kat'onar ton sēmeiophoron emon horan patera*" (Petit, "Vie de S. Athanase," p. 83, sec. 75, line 17).

[133] Connor, *Life of Saint Luke*, chap. 70.

[134] Ibid., chap. 73.

[135] Ibid., chap. 82. See C. Mango, "On the History of the *Templon* and the Martyrion of St. Artemios at Constantinople," *Zograf* 10 (1979): 40–43, esp. 41, where the crypts of Constantinopolitan churches are discussed in connection with the practice of incubation near the tombs of the patron saints.

displaced by Christopher from remaining near the divine *thēkē*; he fears the cure will not take place unless he is close to the tomb.

The suppliants at the tomb are mostly men (there are only three women) and they are mostly local people of humble origins:

> Let the old woman of Boeotia come forward, afflicted in a similar fashion to those mentioned above but not having in the same measure that they did a life of poverty.[136]

Most of the suppliants are from nearby; they are peasants or laborers. In the case of three, however, there is a suggestion of slightly higher social status. The *kommerkiarios* Christopher clearly outranks the suppliant whom he displaces at the saint's tomb, for he is treated with special privilege and respect by the fathers. Nicolaos, a cleric from Davlia had hired physicians to cure his dropsy, but at their hands "he exceedingly diminished his substance without achieving any cure."[137] Most clearly a person of some means was Nicolaos from Rastamiti in Boeotia (see chart, miracle 15) who had terrible sores on his face; he "entrusted himself to physicians and gave them much gold."[138] Prior to his coming to the tomb for a cure, he was long subjected to the hypocrisy and expenses of the physicians who treated his illness:

> As long as he was open handed and his purse was not empty, everything he heard from [the physicians] was encouraging, and he was filled with good hopes and opened his hand more readily to them.[139]

Those who came to the tomb were not for the most part people of wealth or influence, but local people, from the island of Euboeia or from nearby villages and towns within a close radius of the monastery. They suffered from specific physical disorders or demonic possession, the latter perhaps due to epilepsy or mental illness.[140] There is never mention of payment or donations to the monastery in return for a cure, even though some remain for extended periods of time awaiting their cures. More than half the accounts refer to another type of healing, medical healing, in such a way as to contrast the methods and expensive fees of physicians with God's miraculous healing through the saint, his *therapon*, who offers "the cure without a fee."[141]

Luke's role as intercessor is implicit in all the accounts. The author of the Miracles makes clear in his epilogue to the Miracles that they are meant to be examples of the saint's successful intercession with God:

> He has not ceased until now nor will he cease performing charitable and astonishing miracles, since he was a disciple and servant of a charitable God and imitated the

[136] Connor, *Life of Saint Luke*, chap. 72.

[137] Ibid., chap. 83.

[138] Ibid., chap. 84.

[139] Ibid.

[140] The description of the illness in miracle no. 12 (Connor, *Life of Saint Luke*, chap. 81) resembles epilepsy: "He frequently wandered about and fell on the ground and suffered all the misfortunes of those who have demons: writhings, lacerations, vertigo, and everything that those experience who are fettered by such an evil."

[141] See Connor, *Life of Saint Luke*, chap. 83: "*te amisthō kai apseudei therapeia*"; see also Magoulias, "Lives of Saints," on physicians, pp. 128–33; and Talbot, *Faith Healing*, p. 17 and n. 26.

streams of ever-flowing rivers; but we have selected for narration a few examples of his intercession [*parrēsia*] with God, presenting the whole from a taste, as they say.[142]

The miracles (*thaumata*) are acts of divine grace, part of God's plan; they demonstrate Luke's role and power—both during his lifetime and after his death—as intercessor with God.[143]

Not only does the Vita provide proof of the central role of the saint's tomb in cult practices, but it also vividly conveys the importance and enormously popular appeal the cult must have had locally. By direct interaction with and healing of the local people, Luke won over his believers; the continuing charity (*philanthropia*) of the monks at the monastery was the personal legacy of the saint.[144] The recording and subsequent recitation of the Miracles are more than acts of piety; they are acts of personal loyalty and service to a living presence. The Vita reflects active popular sentiment and popular support for the cult after the saint's death among the people of Steiris.

The importance of a document such as the Vita for the flourishing of a cult should not be underestimated. Also important to remember is that it was intended to be used—for reading aloud, not for private contemplation. The great public event of the reading of the Life at the saint's monastery on his feast day focused attention on the saint in a way that reaffirmed the beliefs, values, and conduct of all present. This event is described for the monastery where St. Peter of Atroa was buried in the mid-ninth century; in the Posthumous Miracles, St. Peter's biographer, the monk Sabas, is himself the beneficiary of a miracle taking place at this event:

> It happened that I was there at the monastery one day for the commemoration of the saint; kissing the slab [*plaka*] covering his tomb—the slab was thin and without a trace of humidity—I awaited the gushing forth [*anablusin*] as of another Siloam. And here, during Orthros, as the marvelous Life of the saint was being read to all the assembled crowd, suddenly the flow gushed forth, and the crowd, sensing the [saint's] presence, anointed their faces fervently. And I was among them when the wound I had on one of my legs was healed after I had anointed it.[145]

[142] Connor, *Life of Saint Luke*, chap. 85.

[143] Cf. Cyril of Skythopolis on St. Sabas: on contemplating the coffin of the holy man, he says: "he was endowed with a great power of intercession with God [*pros theon parrēsias*]" (Schwartz, *Kyrillos von Skythopolis*, p. 184, line 20). On this important quality, see Patlagean, "Sainteté et pouvoir," p. 96, and P. Brown, "Iconoclastic Controversy," pp. 268–69 and n. 83.

[144] In the miracles, *philanthropia* is mentioned in connection with Pangratius, a leader among the monks, and of the "fathers" as a group to describe various forms of aid they provided, including anointing of the sick and sympathy and encouragement in their troubles: see chart, col. 10.

[145] Laurent, *Saint Pierre d'Atroa*, p. 148, sec. 98: Ἐγένετο γάρ με ἐν μιᾷ αὐτόθι διὰ τὴν τοῦ πανοσίου μνήμην παραγενέσθαι τε καί, ἀσπασάμενος τὴν τὸ θεῖον ἐκεῖνο καὶ πανίερον σκῆνος περικαλύπτουσαν πλάκα ἰσχνὴν τέως καὶ ἄνικμον ἐνυπάρχουσαν, ὡς ἄλλου Σιλωὰμ ἐκδέχεσθαι τὴν ἀνάβλυσιν. Ὅθεν κατὰ τὸν ὄρθρον, πλήθους παρόντος καὶ τοῦ θαυμαστοῦ αὐτοῦ βίου ἀναγινωσκομένου εἰς ἐπήκοον πάντων, τὸ ἰαματῶδες ἐκεῖνο ἔβλυσεν νάμα, οὗ καὶ τὸ πλῆθος τὴν παρουσίαν αἰσθόμενον μυρίσαι ἑαυτῶν τὰ πρόσωπα θερμῶς ἅπαν ἐκεῖσε συνέρρεον καὶ συνέτρεχον, μεθ'ὧν κἀγὼ ἐφ' ἑνὶ τοῖν ποδοῖν ἐσχηκὼς τραῦμα ἀλειψάμενος ὑγιώθην· . . . Several parallels between this passage and the Vita of Holy Luke are the reference to a slab (*plaka*) covering the tomb, the welling up or gushing forth of a healing substance out of the tomb, and comparison of the tomb to Siloam. For a discussion of the reading of the saint's life at Hosios Loukas, see C. Connor, "The Setting and Function of a Byzan-

From this account in the Vita of Peter of Atroa we are best able to visualize the liturgical event of the reading of Holy Luke's Vita as it must have taken place before a huge crowd in the Katholikon at Hosios Loukas every year on February 7. The accounts share important imagery as well: Peter's miracle-working tomb is compared here with the healing pool of Siloam (Jn. 9:7), just as is Holy Luke's tomb in the first Posthumous Miracle.[146]

The Vita of Holy Luke provides our best witness to the healing practices and to the local appeal of the cult associated with the tomb, while its own liturgical use—its reading on the feast day of the saint—becomes even more vivid.

The crypt at Hosios Loukas was, as the burial place of the founder, Holy Luke, the center of his cult. As the burial place of the founder, the crypt served as his place of commemoration and also served funerary and commemorative needs of the monastic community. The architecture of the crypt bears comparison with other church substructures and although crypts are rare, those that survive probably functioned similarly. The typika bear witness to these liturgical practices, a continuation of ancient Palestinian traditions of commemoration of holy men on their tombs. Further valuable evidence of how the crypt functioned is found in the Vita of Holy Luke; the crypt served as a center of healing and incubation practices. The reading of the saint's Vita at his monastery on his feast day was an important event for his cult and contributed to its flourishing, for it expressed not only a mode of conduct but the personal beliefs and hopes of those prepared to experience the intercessory power of the saint through his miracles. In a description in his Vita Holy Luke is observed praying:

> And whenever he sent up a prayer to God his feet seemed not to touch the ground, but stood away from the earth as if by one cubit [hosei pechon ena].[147]

A similar vision of the saint levitating must also have entered the minds and imaginations of those suppliants who prayed in the crypt of the monastery, intent on seeing him in their dreams.

tine Miracle Cult," in *1990 Annual Conference of the College Art Association, New York: Abstracts and Program Statements* (New York, 1990), pp. 69–70.

[146] In Luke's first miracle, a paralyzed woman is brought "to the new Siloam—the tomb of the blessed Luke [*pros ton neon Silōam ton tou makariou Louka pherousi taphon*]." The waters of Siloam are mentioned frequently in the Bible: Isa. 8:6 makes them the symbol of the gentle, beneficent, and unobtrusive power of God. John suggests a connection between Siloam, meaning "sent," and Christ who was sent by the Father to bring salvation to the world (Jn. 3:17; 8:42; 17:3). Also in John is the association of "the rivers of living water" with the sending of the Holy Spirit (Jn. 7:2, 37–39). Siloam is alluded to in other miracle accounts: in Sophronius's Miracles of Cyrus and John (no. 46, Marcos); when a church was built over the pool in the fifth century by Eudokia (see Festugière, *Moines de Palestine*, 3, no. 2: 96–97, and n. 211); when

the waters of the pool ran down the ravine on which was built Sabas's Lavra (Festugière, *Moines de Palestine*, 3, no. 1:148). Some topographical association with the pool of Siloam—perhaps a healing shrine visited by pilgrims—must have been responsible for its continuing healing connotations. Siloam is the key to the abundant water imagery in the Vita: Luke "imitated the streams of flowing rivers"; Luke's tomb is compared to the gushing waters of Siloam because he was sent by God, just as Christ sent out Luke's predecessors, the apostles, to heal and to exorcise demons (*Mt.* 4:23; 9:35; 10:1; *Lk.* 6:12–17).

[147] Connor, *Life of Saint Luke*, chap. 7; this description is also included in the entry for Holy Luke on February 7, in the *Synaxarium of the Great Church*, that is, Hagia Sophia in Constantinople: *CP*, 450; a mental image of the saint levitating would thus have been evoked whenever a reading of the entry took place, throughout the empire.

III

CONTEXT AND
PATRONAGE

Hosios Loukas is an extraordinarily lavish monastic foundation by any standard. Compared with surviving urban or provincial monastic complexes it represents a very large investment, particularly in the churches and in their sculptural and wall decoration. The complexity and quality of the mosaics of the Katholikon as well as the fresco decoration of the crypt indicate that the most sophisticated and highly trained craftsmen were responsible. And these craftsmen and their precious materials must have been brought to this remote area at considerable expense. How can we account for this?

Hosios Loukas, as we have seen, was the center of a miracle cult that operated locally but was surely known throughout the empire. The cult focused on Holy Luke's relics in the crypt, whose liturgical function included rituals of burial and commemoration. Through the Vita of the saint we get a vivid sense of this remote monastery's social and historical context. Not only does it provide our best account of the foundation and early operation of the monastery with its miracle cult but it provides further insights that might explain the splendor and lavishness of the foundation. Additional historical and textual material supplements and expands our acquaintance with this time and clarifies our picture of the probable circumstances of the founding and flourishing of the monastery. The fresco portraits of abbots in the southeast vault of the crypt make possible the connection between these circumstances and the individuals responsible for the costly undertaking. Seen within its wider contemporary context, the crypt thus leads to a set of explanations for the character and rich patronage of the foundation as a whole.

SOCIAL AND RELIGIOUS
FACTORS

Monks and monasteries played a central role in middle Byzantine society; several aspects of this role are relevant in understanding how Hosios Loukas must have functioned in its provincial setting.[1] As we examine certain of these aspects, the implications of the fresco program become clearer.

[1] For a summary of these roles, see the articles in *Byzantine Saints and Monasteries*, ed. N. M. Vaporis (Brookline, Mass., 1985), and J. M. Hussey, "The Monastic World: The Religious Vocation," in *The Byzantine World* (New York, 1961), pp. 114–30.

One important role of monks and monasteries was philanthropic: care and healing of the sick. However, miraculous healing by relics is sometimes difficult to distinguish from medical cures in hospitals run at the monasteries. The miraculous cures at the shrines of "medical saints" such as the anargyroi, Cosmas and Damian, are well documented; in this case the entire church, the Kosmidion in Constantinople, served as a gathering place for the sick.[2] Living saints and holy men often had divine powers of healing; Theodore of Sykeon, for example, exorcised demons or healed through anointment or touch. The relics of holy men retained the power they had when alive and healed those visiting their tombs.[3]

Distinctly separate from the miraculous healers were the physicians who were organized into guilds and whose practices and fees were regulated by the state.[4] Traditionally, monasteries had their own hospitals.[5] The earliest monastic hospitals were in Egypt and Syria. Palestinian hospitals came later, and some of these were described by Egeria on her travels through the Holy Land.[6] A famous early founder of hospitals attached to monasteries in Palestine was the empress Eudocia. Justinian, at Sabas's request, founded one in Jerusalem that was under the direction of monks. There was also a hospital associated with Sabas's own monastery and with that of Theodosios.[7] These hospitals were used for lodging by pilgrims from an early time, and therefore the term for an inn or hospice (*xenon*) is often the same as for a hospital for the sick (*nosokomeion*). Those treated in hospitals run by the church were mainly the poor or homeless, for the rich could afford to pay physicians for expensive private treatment. Therefore the founding of hospitals was a charitable act, usually undertaken by the wealthy or the emperor.

In the middle Byzantine period the Macedonian house is known to have renovated hospitals; Romanus Lecapenus founded the Myrelaeon monastery, which had a hospital famous for its treatments.[8] Basil II was a founder of hospitals and other philanthropic institutions.[9] The best-known Byzantine hospital of the Comnenian period was that at the Pantocrator monastery in Constantinople where a variety of ailments were treated by a staff that included many categories of physicians and nurses.[10] The operation, or at

[2] See Magoulias, "Lives of Saints," pp. 139–42.

[3] See Dawes and Baynes, *Three Byzantine Saints*, p. 91, for Theodore's healing methods; exorcism of demons was another type of healing associated with holy men and shrines: Brown, "Learning and Imagination," pp. 18–19.

[4] See Charanis, "Some Aspects," p. 67.

[5] Ibid., p. 68; Charanis, "The Monk," p. 82; Kashdan and Epstein, *Change in Byzantine Culture*, pp. 156–57.

[6] Philipsborn, "Fortschritt," pp. 341–42; on the first hospitals in Cappadocia founded by Basil the Great and Gregory of Nyssa, see Miller, *Birth of the Hospital*, pp. 61, 85.

[7] Philipsborn, "Fortschritt," p. 346; Festugière, *Moines de Palestine*, 3, no. 2: 43, 114, 140. Cyril of Skythopolis also records the care by Abramius of the sick: Schwartz, *Kyrillos von Skythopolis*, p. 247. Ma-

goulias records mentions of monks and nuns tending the sick in hospitals in "Lives of Saints," p. 135.

[8] See Miller, *Birth of the Hospital*, p. 114.

[9] Constantelos, *Philanthropy and Social Welfare*, p. 170; ibid., p. 52; Philipsborn, "Fortschritt," p. 352. The Monastery of the Virgin Petritzos had three hospitals, according to the typikon (see Gautier, "Pakourianos Typikon," p. 110).

[10] See Gautier, "Pantocrator Typikon," pp. 12–13; Constantelos, *Philanthropy and Social Welfare*, p. 55, gives the names for these institutions as *nosokomeia*, *xenones*, *ptochotropheia*, and *gerocomeia*. As Constanteles states, "*xenon* and *nosokomon* or *nosokomeion* are interchangeable terms" (p. 186), but it seems there is a distinction being made in the Pantocrator typikon between hospital (*xenon*) and infirmary of the monastery (*nosokomeion*); on terms see also Miller, *Birth of the Hospital*, p. 23; for a fascinating study of the mon-

least the ideal operation, of this hospital is known in detail from the founder's typikon drawn up by the emperor John Comnenus in 1136, and further evidence of hospitals and healers associated with monasteries appears in other documents, among which are the Vitae of Byzantine saints.

Many monastic hospitals were highly organized, although it is not clear to what extent monks became trained as physicians or therapists to carry out the necessary services in them.[11] The Vita of Hosios Loukas makes it clear that healing is the principal association with the saint after his death; he is a thaumatourgos, or wonderworker, and the most numerous examples of his powers are miracles of healing. In the Vita, accounts of fifteen posthumous healing miracles conclude the text read annually on his feast day.[12] The operation of this healing cult has been discussed in Chapter II and the miracles are listed in a chart presented in Chapter II. Most of the miracles took place near the tomb of the saint, but there is reason to think that healing took place not only though miraculous means. References to the long time periods spent at the monastery by some of the sick— we know that one stayed six months—and in particular to the role of the monks in caring for the sick suggest there was quasi-medical care provided by the monks of Hosios Loukas.[13]

The monk Pancratius, mentioned several times in the Vita, was the central figure in the first healing cult and was perhaps even a skilled physical therapist *cum* social worker:

> The brother Pancratius anointed him with his own hands; for it was his custom always to sympathize with this one and with others who were similarly afflicted, and to be a supporting and charitable right hand for them.[14]

The renovation of the monastery after the saint's death involved the building of "houses for the reception of visitors," and the visitors included not only ordinary pilgrims but also the sick in need of care or therapy who are described in the Posthumous Miracles.[15] Although there is no archaeological evidence for a hospital, a group of these "houses for the reception of visitors" may have served such a purpose.

Healing shrines often existed alongside medical hospitals, both of which were closely associated with monasteries from earliest times. Penalties were imposed in the case of monastic establishments that did not properly perform their care of the sick.[16] In remote areas of the provinces this role was a particularly vital one: for the poor it was the only way of obtaining medical treatment at all. Hosios Loukas with its miracle-working

astery's hospital, see Codellas, "The Pantocrator, The Imperial Byzantine Medical Center," *Bulletin of the History of Medicine* 12 (1942): 392–410.

[11] See Charanis, "The Monk," p. 83.

[12] Connor, *Life of Saint Luke*, chaps. 68–85.

[13] The twelfth miracle recounts Constantine's cure, which took six months (Connor, *Life of Saint Luke*, chap. 81); the Vita of Holy Luke is among a group of vitae particularly rich in medical terms for this period: "The *vitae* of the Constantinopolitan Luke the Stylite, Luke the Younger or Steiriotes of the area around Thebes, the Peloponnesian Nikon Metanoeite, Athanasios of Athos, and Nilos of Rossano, all

written around 1000, are especially rich in medical information" (Kazhdan and Epstein, *Change in Byzantine Culture*, p. 155); see C. L. Connor, "A Monastic Group Portrait: *Therapeia* at Hosios Loukas," in *Twelfth Annual Byzantine Studies Conference: Abstracts of Papers* (Bryn Mawr, 1986), pp. 28–29.

[14] Miracle no. 7 (Connor, *Life of Saint Luke*, chap. 75; Pancratius is also mentioned in chaps. 61 and 83 as the authority on cures).

[15] See Connor, *Life of Saint Luke*, chap. 67.

[16] Constantelos, *Philanthropy and Social Welfare*, pp. 154, 184.

tomb, the "common good of the West," was a place of miraculous healing where the monks aided in the process and provided psychological and physical remedies for the afflicted.[17]

ANOTHER important role of monks and monasteries was to promote and participate in pilgrimage. Monks themselves were among the most dedicated pilgrims and they constantly moved about. Travelers visited shrines or other pilgrimage sites, most often situated within monasteries or churches, to pay homage to holy places or to seek miraculous cures. The main objective of a pilgrim was to visit the holy place, the *topos*, sometimes, to pay homage to living holy men or to the relics of deceased holy men.[18] The powerful attraction of pilgrimage is conveyed by the fifth-century pilgrim Egeria in her account of her participation and her observations at the sites she visited.[19] Significant portions of saints' vitae are dedicated to descriptions of their travels, mostly pilgrimages. Theodore of Sykeon in the sixth century had a career punctuated by a number of pilgrimages, as did Peter of Atroa; the monasteries they visited, either as goals of pilgrimage or merely along the route, are described with a sense of gratitude as familiar types of surroundings, havens of rest, of physical and spiritual regeneration, and of prayer.

For monks, there were three great pilgrimage centers: Jerusalem, Rome, and Constantinople.[20] The travels of St. Lazarus the Galesiote, for example, take up much of his Vita; the chart of his itinerary shows the wide geographical range of this itinerant monk.[21] However, Jerusalem was the only center with which Lazarus was familiar; he never reached the others: "Rome was for him (or rather, for his biographer) a disembodied, ideal city, only to be dreamed about."[22] St. Nikon of Sparta, a contemporary of Holy Luke whose portrait appears in mosaic in the upper church at Hosios Loukas, took to the road as a traveler and pilgrim visiting sites and monasteries all over the eastern Mediterranean and Greece in the late tenth century.[23]

The location of a monastery was important in determining its accessibility to pilgrims but also the degree of contact it maintained with the rest of the world. The Vita of Holy Luke confirms that the monastery was near an important trade and pilgrimage route. Two monks on their way from Rome to Jerusalem first enable the young Luke, then living near the site of the present monastery at Vathy, to leave home and travel as far as Athens with them where he receives tonsure from the abbot of a monastery.[24] When Luke is living on Mount Ioannitza on the Corinthian Gulf, he is visited by monks traveling to Rome, who bestow on him the Great Habit.[25] After Luke's death, the monk Kosmas traveling from Paphlagonia, on the Black Sea, to Italy passed through the region

[17] Connor, *Life of Saint Luke*, chap. 83.

[18] The essence of this practice of making pilgrimages from the late antique period on is summarized by Peter Brown as a "need to achieve closeness to a specific category of fellow-humans—the saints" ("Learning and Imagination," p. 7).

[19] See esp. *Egeria's Travels*, ed. J. Wilkinson (London, 1971), pp. 91–152.

[20] Ringrose, "Monks," p. 134; Talbot, "Monastic Experience," p. 14.

[21] Ševčenko, "Constantinople from the Eastern

Provinces," p. 723 and fig. 4 on p. 745.

[22] Ibid., p. 723.

[23] Da Costa-Louillet, "Saints de Grèce," pp. 351–53. See particularly in D. Sullivan's *The Life of Saint Nikon* (Brookline, Mass., 1987), chap. 11, the definition of Nikon's extensive travels as a heavenly mission of preaching repentence; chaps. 12 to 33 describe the events and routes of these travels.

[24] Connor, *Life of Saint Luke*, chap. 9.

[25] Ibid., chap. 21.

and visited Luke's tomb at the monastery.[26] The Gulf of Corinth was clearly one of the sea routes between the Aegean and the Adriatic, and the Monastery of Hosios Loukas must have been a stopping point for travelers as well as a goal of pilgrimage, being located a short walk from a good harbor on the gulf.[27] The "crowds of believers" whom Luke prophesied on his deathbed would come to visit the place where he was buried became the anticipated pilgrims, gathered to venerate his relics, for later in the Vita, the author states: "Thus came to fulfillment what the blessed one had said concerning the ones coming there in large numbers [peri tōn hōs auton eis plēthos sunerchomenōn]."[28] These pilgrims lodged in the houses built for visitors, both those who were making long journeys to visit many sites and those who lived in nearby villages and towns.[29]

MONASTERIES were also concerned with providing burial and commemoration of the dead. These charitable services were performed by the spoudaioi and philoponoi who served the poor already in sixth-century Jerusalem and seventh-century Constantinople and were organized in urban centers around the empire.[30] In some cases they lived in monastic communities and in others they seem to have been free agents, performing charitable services wherever needed. Societies or guilds were formed from early times, and great monasteries such as the Stoudios and Pantocrator provided free burial and commemoration of the dead.[31]

For the region of Hosios Loukas there was the Confraternity of the Naupactian Women, a philanthropic burial society that existed in the second half of the eleventh century, as we learn from its preserved charter.[32] The confraternity included both men and women and its members circulated among monasteries from Naupactos to Daphni carrying its most valued possession, an icon of the Virgin, and holding its meetings on the first day of each month in a different church in the region. One of its principal functions was funerary:

> If one of our brothers leaves this life and passes on to his eternal resting place, assembling for a procession of his remains, let us hold a funeral service with our own beeswax, if such be necessary. Moreover we shall make commemoration of him according to the custom practiced by Christians, on the third, ninth and fortieth day of his burial and on the anniversary of his demise.[33]

[26] Ibid., chap. 66.

[27] The easiest access to the monastery was from the harbor of Antikyra at the Metochion (now destroyed): "von hier lief der Pilgerweg in einem sanft ansteigenden Tal direkt zu dem Kloster" (Koder and Hild, Hellas und Thessalia, p. 97); see also the map in that publication and in Stikas, Oikodomikon Chronikon, opposite p. 226.

[28] Connor, Life of Saint Luke, chap. 67.

[29] For the geographical range of those mentioned in the Miracles, see the chart in chapter II. In Luke's encounter with the strategos Krinites we learn that the general came from Constantinople to Thebes not by sea but by land, for "when he was on the way there and was approaching Larissa [in Thessaly] his ears were filled with the stories about the saint" (Connor, Life of Saint Luke, chap. 59).

[30] Magoulias, "Lives of Saints," pp. 133–34. See also Nesbitt and Wiita, "Confraternity," p. 361 and n. 5.

[31] See Leroy, "Réforme Studite," p. 197 and n. 124, and Gautier, "Pantocrator Typikon," lines 1324–44.

[32] See Nesbitt and Wiita, "Confraternity," p. 363.

[33] Ibid., p. 370.

The members of the confraternity (mostly ecclesiastical, according to their signatures on the charter) were assured a funeral, burial, and commemorative services. They also took on the larger responsibility for the poor of the area.

The Naupactian charter also has specific implications for the history of Hosios Loukas, for among its special remembrances are those for the "all-holy late monk and abbot of Steiris, lord Theodore Leobachos and for the present abbot of this monastery."[34] This passage not only indicates involvement between the monastery and the wealthy Leobachoi of Thebes, but also a close affiliation of the confraternity with Hosios Loukas. I believe Theodore Leobachos has been singled out because he was *the* principal benefactor of Hosios Loukas and therefore an important figure in local history. The time when Theodore was abbot at Hosios Loukas does not necessarily have to coincide with the date of the founding of the confraternity, as Nesbitt and Wiita assume; it is just as likely that this important figure lived twenty-five or fifty or more years earlier. A tenth century Theodore Leobachos, a spatharokandidatos, is attested by a seal; other members of this prominent old family are mentioned in the land records of the Cadaster of Thebes—in fact, Leobachoi are mentioned no less than forty-five times.[35] There is no reason the tenth-century Theodore and our abbot Theodore cannot have been the same person.

A wealthy and titled aristocrat named Theodore is described in a funerary inscription found at the monastery of Hosios Loukas;[36] this person took the monastic name of Theodosius on his retirement to the monastery (see the entry on Our Holy Father Theodosius in Chapter I). This Theodosius is very likely the one whose portrait appears in the crypt; he must have been abbot at the time the Katholikon was built and decorated. If, as I propose, he had been Theodore Leobachos in his wordly life, he would indeed deserve special recognition in the Naupactian charter as the key patron and benefactor of Hosios Loukas. This connection also explains the many portraits of the two Theodores in the Katholikon and the crypt, for the name-saint of a church's patron would receive special attention. The correlations between different types of evidence suggest that Theodore Leobachos was the abbot and principal patron of Hosios Loukas.

Burial and commemoration of the dead were concerns of the monks of Hosios Loukas, as they were of all monks, not only for the patrons but also common people. In fact these concerns are evident in the Vita in connection with a murder. After a murderer confesses his crime to Holy Luke, the saint stipulates that his sincere repentance be accompanied by strict performance of the proper rites for his victim:

> He encouraged him by imposing disciplinary rules that he could bear, stressing especially that he should go to the tomb of the murdered one, shed many tears there, and complete at great expense the services of the third, ninth, and fortieth day. He should make genuflections there—if possible not less than three thousand . . .[37]

Proper, if not free, burial and commemoration of the dead were strong concerns of the Church at this time and were the responsibility of society—of monks, of lay and religious societies, and, in short, of all pious Christians. They were prime concerns of

[34] Ibid., pp. 365, 369.
[35] Svoronos, "Cadastre," pp. 41–42, and 74, n. 4.
[36] See Stikas, *Oikodomikon Chronikon*, pp. 28–29.
[37] Connor, *Life of Saint Luke*, chap. 30.

the monastic community at Hosios Loukas, as seen in the uses of the crypt, in the Naupactos charter, and in the Vita.

PROPHECIES associated with monks and holy men played a decided role in the history of Hosios Loukas. The famous story of the widow Danielis in Theophanes Continuatus concerns a monk's prophecy about the future emperor Basil I.[38] The great eleventh-century philosopher and historian, Michael Psellos, scoffs at these monks with the power of prophecy, thereby confirming the strength of popular belief in their powers. As Charanis points out, "the point is that prophecies were very common, that they influenced people, and that the prophets were almost always monks."[39]

The ability to prophesy was the sure mark of the holy man, and instances from the Life of Holy Luke are numerous. He prophesies the Bulgarian invasion, the Slavic invasion of the Peloponnese, and the Byzantine reconquest of Crete; he even prophesies his own death.[40] He also has the ability not only to see future events but to see "things that were at hand but escaped notice"; this includes knowledge of the hiding place of treasure in two cases and also of a gift of food intended for the saint but hidden.[41] If these services were lucrative, it is never made explicit, for the Vita never mentions donations to the monastery in thanks for prophecies or other services rendered to individuals. The general Krinites makes a substantial donation, but it is on account of the holy man's reputation as a miracle worker and the personal impression he creates that the strategos is inspired to make his contribution:

> He [Krinites] became joined to the holy one with an affection so warm that his soul was "glued onto him." . . . Indeed he tended to his every need, and most zealously performed every service and made every expenditure, as for example in donating what was most essential for the construction of the church of the superbly victorious martyr Barbara, much money along with the work force.[42]

Shortly afterward, the saint prophesied the general's next post. This account represents the only written record of the initial patronage to the monastery, brought about by the general Krinites' personal contact with the saint and his prophetic and inspirational powers.

Luke's most famous prophecy concerned the victorious Byzantine campaign on the island of Crete in 961; the prophecy is recorded in chapter 60 of the Vita and will be discussed here among the military factors for the monastery's patronage.

An account follows in the Vita in which Philippus, a spatharios from Thebes, was entertained by the saint, his arrival having been prophesied by Luke. In a miraculous dream Philippus was shown that his suspicions about the saint's character were unfounded, but we are not told how the repentant spatharios made amends to the saint.[43]

Contact between Luke and these wealthy local dignitaries came about through his

[38] Charanis, "The Monk," p. 75.
[39] Ibid.
[40] Connor, *Life of Saint Luke*, chaps. 24, 60, 64.

[41] Ibid., chaps. 23, 27, 31.
[42] Ibid., chap. 59.
[43] Ibid., chap. 63.

powers of insight, healing, and prophecy; such stories indicate known and probable sources of patronage for the monastery.

MONKS and holy men play one of their most crucial religious roles as intercessors with Christ, as opposed to their social ones of healing and promoting pilgrimage. The effects of this belief on individuals and institutions were felt throughout Byzantine civilization.[44]

> The Monk's prayers thus became much more effective than the prayers of ordinary folk, and the effectiveness of a monk's prayers was often the principal reason why many laymen founded new monasteries or endowed old ones.[45]

Belief in this power of intercession is reflected in the reading of the diptychs during the liturgy, which underlined the responsibility of the monastic community to offer commemorative and intercessory prayers for the eternal salvation of a founder, for example. The visual form of their prayers of intercession shows monks or donors in attitudes of supplication, as in frescoes at Karabaş Kilise in Cappadocia.[46]

The Lives of the saints demonstrate the respect of all classes for the monk or holy man who was marked as "a friend of God," as one who could mediate on any matter on behalf of his fellow Christians. Practical matters are also solved by the prayers of a holy man, as when Theodore of Sykeon brings an end to a disastrous drought.[47] Intercession with Christ and the saints was made possible because the monk had become one of the saints through his condition of life, his choice of an ascetic life.[48]

The theme of intercession is expressed in the frescoes of the crypt at Hosios Loukas, as discussed in Chapter I, in the Deesis of the apse (fig. 83), in the medallion of Christ with outstretched arms (fig. 78), and the scene of Holy Luke interceding for an unknown abbot on the west wall of the crypt (fig. 82).

Intercession is the primary concern reflected in two pairs of inscribed marble plaques on either side of the Royal Door of the Katholikon, the door from the narthex into the naos of the church. The two inscriptions read:

> Thrice blessed Luke receive at the hands of Gregory, this pious work of sculpture which he has wrought encouraged by the intercessions [*presbeiais*], giving it for the ending and remission of sins.

> O Christ grant remission of sins to me, Gregory the monk, thy servant, who wrought this marblework.[49]

[44] See Brown, "Holy Man," pp. 121, 136; and Brown, "Dark Age Crisis," p. 269, on the late antique roots of this belief: "Thus the core of the holy man's power in late antique society was the belief that he was there to act as an intercessor with God. Whether living or dead he was a favoured courtier in the distant empire of heaven: he had gained a 'boldness' to speak up successfully for his protégés before the throne of Christ."

[45] Charanis, "The Monk," p. 74.

[46] See Rodley, *Byzantine Cappadocia*, pp. 198–200.

[47] Dawes and Baynes, *Three Byzantine Saints*, p. 155: Theodore of Sykeon."

[48] "Men entrusted themselves to him because he was thought to have won his way to intimacy with God—*parresia*"; see Brown, "Holy Man," p. 136.

[49] See Schultz and Barnsley, *Monastery*, p. 28, for drawings of the plaques and transcriptions and for

In hopes of intercessory prayers, the monk Gregory donated funds for the embellishment of the Katholikon. The question of who this Gregory is finds one possible explanation in the Vita. A friend and follower of Holy Luke who was a priest (Luke himself was not a priest) is mentioned several times, especially in his role of ministering to the saint on his deathbed and arranging his burial.[50] If the Gregory of the inscription is the Gregory of the Vita, he made his donation with special zeal for he had known the saint personally and had good reason to hope for a sympathetic response to his prayer for intercession.

The Vita of the saint itself also reflects this important belief in a number of passages. For example, in the epilogue to the Life and Miracles the author states: "we have selected for narration a few examples of his [Luke's] intercession [*parresia*] with God," and later that he hopes that "by your [Luke's] intercession [*presbeiais*], guidance, and illumination from above you save my soul and rescue it from eternal punishment."[51]

Just as the decoration of the crypt and the marble plaques in the Katholikon express the hope for benign intercession with God by Holy Luke and the saints in behalf of the faithful, the author of the Vita expresses a similar belief. He states clearly for all to hear as the work is read aloud that his work is written as a form of dedication, indicating his trust in the intercessory power of the saint.

IN THE wake of iconoclasm the role of monastaries as strongholds of orthodoxy became crucial, and in this too the role of Holy Luke and his monastery was significant. Orthodox faith was maintained in the empire through the monastic presence that also served to consolidate the immigrant populations into orthodoxy; communities of monks thereby greatly contributed to its economic and political stability. Both in the cities and in rural regions this presence became increasingly important in the middle Byzantine period.[52]

During the great period of territorial expansion of the empire from the end of the ninth century to 1071, the varied ethnic populations needed to be assimilated quickly.[53] The Church was instrumental in the Hellenization of the Slavs in Greece in the ninth century as part of the overall process of synthesis. The Greek language maintained solidly by the Church played a role in the Hellenization as well as the Christianization of the empire.[54]

The Chronicle of Monembasia describes the cutting off of the Balkans from the rest of the empire in the eighth and ninth centuries, but it is clear that Greeks who had fled returned, reestablishing both the language and the religion.[55] Monasteries in particular kept the essential elements of Byzantine society alive.[56] There is evidence that Greek

these translations of the inscriptions.

[50] See Connor, *Life of Saint Luke*, chaps. 57, 64.

[51] Ibid., chaps. 85, 87.

[52] Charanis, "The Monk," pp. 64–71.

[53] Charanis, "Observations on the Demography of the Byzantine Empire," in *Proceedings of the XIII^th International Congress of Byzantine Studies* (Oxford,

1967), p. 17.

[54] Ibid., p. 19; Charanis, "How Greek Was the Byzantine Empire?" *Bucknell Review* 11 (1963): 114–15.

[55] Herrin, "Aspects of Hellenization," p. 116.

[56] Ibid., p. 118.

refugees in Italy kept the language and religion consolidated until the threat ceased and enabled them to return to Greece. The chronicle reports the results of reconquest of the Balkans and the policy of settlement there of Christians from other parts of the empire: "In this way the barbarians were instructed in the will and joy of God and were baptised and brought into the Christian faith."[57] Central Greece was Hellenized by a gradual, piecemeal, rural policy of local pursuit of "evangelization" and of reinstallation of Greek language and of Orthodoxy.[58]

The role of the holy man has been recorded in this time of unrest as not only helping convert the barbarians to Christianity and maintain the Christian tradition but performing numerous social roles of teacher, missionary, and physician; according to Herrin, Bishop Athanasius of Methone was responsible for converting the entire area to Christianity, whereas Peter of Argos, who became a bishop, aided his countrymen under seige from Bulgarians and Arabs.[59]

The Vita provides a glimpse of the uncertainty of the times due to successive invasions of barbarians. The saint's grandparents were forced to flee invaders more than once, and the presence of military patrols on roads resulted in mishaps for the rebellious young Loukas.[60] The saint himself, and later his monastery, constituted an important Christian presence in Hellas. Invasions of Saracens (Arabs) called *agarenes*, then of Bulgarians (*Skythikoi*) and Hungarians (*Tourkoi*) caused death and destruction for the inhabitants of the area.[61] Luke led bands of refugees to the island of Ampelos for refuge; when invaders were in the area, Luke signaled the people when they should flee and when to stay, thanks to his prophetic vision.[62] There are frequent references throughout the Vita to heathens or barbarians, as opposed to believers. The Vita demonstrates that Christianity was the binding identity of the Greeks of Hellas and that to many Holy Luke represented the power and protection of the religion.

THE monastery of Hosios Loukas played an important social and religious role in the life of the immediate area. Philanthropic undertakings provided cures, both miraculous and medical, and especially help for the poor. The poor were also provided with burial and commemorative services, as the monastic community acted together with the confraternity of Naupactos. Since Hosios Loukas was on a well-traveled route between the Adriatic and Agean seas and had a substantial volume of traffic due to its location, this kept the monastery in touch with the wider Byzantine world. Visits from governmental or ecclesiastical officials were thus a common occurrence there. That the monastery served as a refuge is dramatized in the Vita by the descriptions of invading barbarians,

[57] P. Lemerle, "La chronique improprement dite de monemvasie," *REB* 21 (1963):10–11.

[58] Herrin, "Aspects of Hellenization," p. 120. Also, Megaw in referring to ninth-century sculptures and church building in Greece states: "the churchbuilding which this group attests in the main urban centres under Basil I probably reflects a further consolidation of ecclesiastical authority in connexion with renewed campaigns of evangelization, campaigns in which foundations in rural areas, such as that at Skripou, would doubtless have played their part" ("Skripou Screen," p. 22).

[59] Herrin, "Aspects of Hellenization," pp. 123–24.

[60] Connor, *Life of Saint Luke*, chaps. 2, 5.

[61] See Da Costa-Louillet, "Saints de Grèce," pp. 332–38. For the Turks, see Connor, *Life of Saint Luke*, chap. 50.

[62] See Connor, *Life of Saint Luke*, chap. 50.

and we are assured it was through the insight and miraculous powers of the saint that it was protected. The prophetic and intercessory powers of the saint gained for the monastery renown and patronage during the saint's lifetime. Religious and social factors governing conditions of life at Hosios Loukas, known mainly through the Vita, thus correspond with documented roles and trends current at the time.

MILITARY AND POLITICAL FACTORS

The monastery of Hosios Loukas maintained its place in relation to the broader military and political organization of the empire. The Byzantine empire was divided into themes for military and administrative purposes in the late seventh century, and the theme of Hellas was established as the area of central Greece.[63] Although Thebes was the military and administrative center for the theme, records concerning its role and position are fragmentary. The tenth century, like the preceding centuries, was a time of unrest, and there was a constant threat of invasion of Hellas by Arabs, Bulgarians, and others. One of the most important sources on Greece in this troubled period is the Vita of Holy Luke, which describes the impact on the villagers in the area of successive waves of invaders. The implications of this military and political climate for the monastery of Hosios Loukas need to be explored, for the circumstances that led to its founding are linked to this climate.

Having been under Slav control from the late sixth century, the themes of Hellas and the Peloponnese again functioned as part of the Byzantine empire in the late eighth century.[64] The strategoi of these themes traditionally had an important responsibility of vigilance and military surveillance to protect themselves from attacks from all sides; raids by the Arabs on Crete, captured by them in 820, were especially threatening since swift attacks could be mounted on the villages from anywhere along the coastline. The *Taktika* of Leo VI states that it is the responsibility of the strategos to recruit his own soldiers for defensive campaigns and that these soldiers must be relatively prosperous persons who in return for military service receive exemptions from taxation.[65] The strategos presided over a system of resident troops whose maintenance was firmly linked with ownership of land. This institution of *strateia* was in effect in Hellas by the ninth century.[66]

A strong military presence was crucial to the prosperity of ninth- and tenth-century Greece.[67] Evidence that the area did thrive economically is provided by documents as

[63] The first mention of a strategos of Hellas is in A.D. 695 (see Oikonomides, *Les listes de préséance*, p. 351, for lists of administrative officials including the Strategos of Hellas). See also Charanis, "Hellas," p. 173. The western themes were less prestigious than the eastern ones; the strategoi of the eastern ones received their pay from the treasury, whereas the western ones raised their own pay; for the military system of command and terms, see in general: "The Government and Administration of the Byzantine Empire," in *The Cambridge Medieval History,* 4, part 2 (Cambridge, 1967), esp. pp. 35–45.

[64] Herrin, "Aspects of Hellenization," p. 119.
[65] Lemerle, *Agrarian History*, pp. 141–43.
[66] Ibid., p. 150.
[67] Herrin, "Aspects of Hellenization," pp. 124–25.

well as surviving architectural monuments. For example, a study of sculptures from ninth-century churches in central Greece shows artistic activity was able to flourish.[68] Under Basil I (867–86), the area was sufficiently stable for a major foundation to be built—Skripou in Boeotia, in 873–74.[69] It has been suggested that its founder, the *protospatharios* Leo, was also strategos of Hellas. Megaw maintains, however, that Leo's title in the founder's inscription indicates simply that he "had charge of the imperial domain throughout the province."[70]

Megaw concludes from an elegant epigram inscribed on the south wall of the narthex that the wealth of the protospatharios Leo came not from his imperial connection but from his own fertile estates around Orchomenos, and he attributes the main purpose of the foundation to "an avowed propagandist purpose."[71] Whether or not the foundation was intended as a symbol of imperial solidarity and power in the area, it is nonetheless Leo's burial church. The terms of supplication to the Virgin in the founder's inscription show that the monument stands in the tradition of burial churches erected at great expense in the hope that the founder's soul would be saved. The foundation of the monastery of Skripou with its large and handsomely decorated katholikon—larger even than the Katholikon of Hosios Loukas—may be linked to the military and political stabilization of Greece in the late ninth century. Furthermore, through its construction, the wealthy Leo, probably a resident of nearby Thebes, makes a clearly intelligible *local* statement simultaneously of his power and of his piety.[72] The Katholikon at Skripou with its dedicatory inscriptions represents an important precedent in the area of Thebes for church patronage by a wealthy local official and landowner.[73]

In ninth- and tenth-century Hellas the role of the military was crucial for the security of the province, especially in warding off attack from the sea. For this reason the military element formed the backbone of society at this time, for, according to Setton, "the Aegean world was harrassed incessantly throughout the entire ninth century by Syrian and Cretan Arabs."[74] Under Basil I a major victory over the Arabs had been led by the strategos of Hellas, Oeniates. When a fortress on Euboea was attacked, soldiers were conscripted from the entire theme, which enabled Oeniates to repulse the invaders.[75] Also

[68] Megaw, "Skripou Screen," pp. 18–20.

[69] The origin of much of Basil's wealth in Greece, through gifts of the wealthy widow Danielis who lived in Patras, indicates imperial interest and involvement in the area.

[70] Megaw, "Skripou Screen," p. 23 and n. 84; for the inscription, see the small booklet put out by the symbolio (C. Chatzicharalampous et al.) *Ho Naos tēs Panagias tēs Skripous Boiotias* (Athens, 1983), pp. 14–15.

[71] Ibid., p. 25.

[72] Megaw compares the lengths of the two churches ("Skripou Screen," p. 25, n. 103). Recent new evidence of officials patronizing churches appears in a dedicatory inscription at Eğre Taş Kilisesi in Cappadocia of ca. 925; in this case the donor holds

both military and civil administrative titles: see N. Oikonomides, "The Dedicatory Inscription of Eğre Taş Kilisesi (Cappadocia)," in *Okeanos, Festschrift for I. Ševčenko*, Harvard Ukranian Studies (Cambridge, 1983), pp. 501–6.

[73] The use at Skripou of ancient building materials from the ruins around Orchomonos also provides a local parallel to the use at Hosios Loukas of the marble from ancient Stiris (Megaw, "Skripou Screen," p. 28).

[74] Setton, "Raids," p. 311. See also V. Christides, "The Raids of the Moslems of Crete in the Aegean Sea: Piracy and Conquest," *Byzantion* 51 (1981): 71–111.

[75] Ibid., p. 312.

under Basil, a Peloponnesian strategos led a similar victory at Methone. Aegina however fell victim to the Moslems in 826 and again in 896 causing the inhabitants to flee.[76] At least one attempt was made by the military administration of Hellas in the ninth century to raise troops for an attempt to regain Crete, the closest and best-established base of Arab operations threatening the Greek coast.[77]

There is little evidence of the flourishing Arab culture that must have existed on Crete during the ninth and tenth centuries.[78] The fall of the capital city of Candia to the Byzantine general Nicephoros Phocas in 961—and the succeeding Crusades—seem to have all but obliterated traces of Arab dwelling and culture.[79] Some idea of the great lavishness and wealth of Arab Crete can be gleaned from the description by Leo Diakonos of the booty taken at its capture, as displayed in Nicephorus's triumph in Constantinople:

> After a magnificent reception by the emperor Romanus, he celebrated a triumph at the Hippodrome, before all the assembled people who marveled at the magnitude and splendor of the booty. For a vast amount of gold and silver was to be seen, as well as barbarian coins of refined gold, garments shot with gold, purple carpets, and all sorts of treasures, crafted with the greatest skill, sparkling with gold and precious stones. There were also full sets of armor, helmets, swords and breastplates, all gilded, and countless weapons, shields and back-bent bows (If someone happened by there, he would think that the entire wealth of the barbarian land had been collected at that time in the Hippodrome).[80]

Unfortunately none of this booty survives that can be identified with certainty, although we can get an idea of its elegance and quality from some pieces in the treasury of San Marco in Venice.[81] What must be surmised is the wider impact of this booty on the empire, particularly after it fell into the hands of the troops and their strategoi who had contributed to the victory.

As military support was solicited from the themes previously, it was undoubtedly required by Nicephorus Phocas at the time of the Cretan campaign of 961, especially from the themes most affected by the marauding Arabs: the themes of Thrace (of which Nicephorus was himself strategos), Hellas, Peloponnese, and the Aegean Sea. Help in the form of prayers was also solicited by Nicephorus from monasteries around the em-

[76] Ibid., p. 313.

[77] Herrin, "Aspects of Hellenization," p. 125 and n. 80; Miles, "Byzantium and the Arabs," pp. 57, describes the impact of Arab assaults on Greek inhabitants.

[78] Miles, "Byzantium and the Arabs," pp. 29–30; the question of whether Athens was occupied by Arabs is still unresolved. Numerous pseudo-Kufic and animal motifs appear in architectural decoration in Greece at this time, but the means and spirit of their transmission remain unclear. See also Grabar, "La décoration architecturale," pp. 15–37.

[79] Miles, "Byzantium and the Arabs," p. 17.

[80] I owe Alice-Mary Talbot thanks for this transla-

tion from Leo the Deacon (Bonn ed., pp. 27–29), from chap. 12.

[81] A number of objects of ninth- and tenth-century Abbasid origin survive in the Treasury of San Marco in Venice. Some of them might have been part of the spoils brought from Constantinople to Venice after the Fourth Crusade, but in any case give us an impression of the character of these "treasures crafted with the greatest skill" (see in *The Treasury of San Marco Venice*, Metropolitan Museum of Art catalogue [New York, 1984], Daniel Alcouffe, "Islamic Hardstone-carving," pp. 207–8 and catalogue nos. 29–32 with plates on pp. 207–27).

pire; monastic communities were urged to pray fervently for the defeat of the Arab infidel.[82] One community where prayers were solicited was Mount Athos, and St. Athanasius of Athos himself came to Crete at the time of the campaign to offer spiritual support. Soon after, Nicephorus handsomely endowed Athanasius with funds necessary to commence the building of his monastery, the Great Lavra.[83]

Luke of Steiris had prophesied Nicephorus's victory on Crete:

These things are indeed a source of wonder but his prophecy concerning Crete almost provokes disbelief, even though it is well attested, for nearly twenty years earlier he made a prediction that it would be conquered and under whom the conquest would take place: he said clearly, "Romanus will subdue Crete." But since Romanus the elder was ruling the empire at the time of his prediction, someone asked him if this meant the one who was currently ruling and he said, "Not this one, but another one."[84]

The monastery of Hosios Loukas thus acquired special distinction after this victory since it was Luke's burial place.[85] We can also assume it would have received some form of recognition, although we have no specific record of this. Participating *strategoi* and their soldiers would have reaped substantial rewards, either from spoils or as gifts from their leaders. The Cretan victory not only relieved the area of central Greece of a dangerous threat to its security but it was also the cause of a great influx of wealth. A natural repository for some of this wealth would have been gifts and offerings to monasteries in gratitude for monks' prayers. Furthermore, it follows that a chief recipient of these gifts would have been the monastery of Hosios Loukas—in recognition of the prophecy fulfilled, which took on special significance at this time as evidence of divine protection of Hellas through the intercession of the saint.

ADMINISTRATIVE AND ECONOMIC FACTORS

The third set of factors to be considered in relation to Hosios Loukas are administrative and economic ones, for we should understand the possible regional incentives for the founding of this monastery. Exploring questions of ownership, patronage, and regulation of monasteries in relation to the community or society around them leads to a practical view of what the situation at Hosios Loukas must have been.

The first question, of ownership of monasteries, has been studied recently, contributing greatly to our understanding of the various systems in effect during the middle Byzantine period.[86] The proprietary system of church or monastery ownership has its roots in Justinian's legislation in which lay owners were first given rights to repair exist-

[82] Darouzès, *Epistoliers byzantins, du Xè siècle* (Paris, 1960), p. 147, letter no. 83.
[83] Lemerle, "Vie ancienne," p. 92.

[84] See Connor, *Life of Saint Luke*, chap. 60.
[85] Ibid., xvii.
[86] See Thomas, *Private Religious Foundations*.

ing structures in return for the title of *ktetor* or *ktistes* (founder).[87] In the first half of the tenth century many private and imperial monasteries were founded, for example, in the Peloponnese, where high officials were granted the *stauropegeion* or foundation charter.[88] However, the abuse of the system of private ownership by owners' using their positions for personal profit led to Nicephorus Phocas's Novel of 964 banning the founding of new ecclesiastical foundations, in order to bolster support of existing ones. Also initiated at this time, before the reign of Basil II, was the system called *charistiki*, a public program allowing private management of religious institutions by lay benefactors.[89] Private profit often motivated this local sponsorship of monastic foundations when local bishops granted them "in charistiki."[90] It was out of a *charistikarios*'s desire for personal profit that the system so often failed.[91]

The custom then arose of naming local government officials as trustees or protectors of the monasteries. The rights of the founders in relation to the trustees were carefully formulated in typika, so that the monastery was protected from exploitation and remained essentially autonomous and self-governing.[92] One of the most important rights of the founder was burial and commemoration within the monastery. By the late eleventh century all monastic charters used this form of organization.[93] Since there are no surviving records that indicate whether the monastery of Hosios Loukas was under the control of a charistikarios or whether it had its own founder's typikon and operated more autonomously, both of these options will be explored; this information combined with what indications do survive in documents on Hosios Loukas allows us to construct a hypothetical view of the monastery's administration and patronage.

Patronage necessary for setting up or expanding a monastery could come through two principal chanels: imperial or aristocratic and local. Imperial patronage is documented in the case of the Lavra founded by St. Athanasius on Mount Athos in 961; Nicephorus Phocas in gratitide for Athanasius's spiritual support of his reconquest of Crete gave the money necessary for the founding of the Great Lavra monastery. Later the emperor John Tzimiskes also made contributions.[94]

Patronage by wealthy aristocrats was responsible for the building of churches in some provincial centers. Kastoria in Macedonia is an example. There, a number of small churches were founded by members of the local elite in the tenth and eleventh centuries with enough endowment to be run as monasteries.[95] These were family foundations with calculated benefits for the patron; in her study of these churches Ann Wharton says:

A private monastery in Byzantium in the Middle Ages represented an investment

[87] Ibid., pp. 53–58.

[88] Cf. the strategos of the Peloponnese in the Vita of Nikon; see Da Costa-Louillet, "Saints de grèce," pp. 360–62.

[89] Charanis, "Monastic Properties," pp. 72–73.

[90] Thomas, *Private Religious Foundations*, pp. 157–63; Ph. Meyer, *Die Haupturkunden für die Geschichte der Athoskloster* (Leipzig, 1894), p. 107; Charanis, "Monastic Properties," p. 73.

[91] John of Antioch does not allow for any generous use of the position of charistikarios; see Thomas, *Private Religious Foundations*, pp. 186–91.

[92] Ibid., pp. 231–36.

[93] Ibid., p. 223.

[94] Lemerle, "La vie ancienne," pp. 75–78. Athanasius's reproaches of Nicephorus when he failed to become a monk as he had promised resulted in gifts of even more money for the monastery.

[95] Epstein, "Kastoria," pp. 200–202.

in some ways analogous to a modern insurance policy. It provided the donor with prayers for his and his family's souls, with a respectable place of retirement and/or burial for the members of his family, and even, if he were lucky, with a small profit.[96]

The size and lavishness of the undertaking was relative to the local wealth, some communities being able to support larger foundations than others.[97]

Provincial churches of Cappadocia were patronized by local landowners. In the case of the "Pigeon House" at Çavuçin it is thought that local landowners, perhaps members of the family of the emperor Nicephorus Phocas, who were connected with the army were responsible and that the church was founded in thanks for a military victory and as an invocation for continued divine support.[98]

A late eleventh-century document, the will of Eustathius Boilas, gives valuable testimony about the concerns of a wealthy landowner, a protospatharios, in the eastern provinces, in the theme of Iberia. His immense possessions which are deeded to various persons, include churches and monasteries along with their staffs and their precious movable objects: icons, vessels, clothing, and books.[99] The commemorative services for one church intended to serve as his own burial place and that of his family are precisely outlined. The monasteries, as with other parcels of land, were owned outright by him.

For tenth-century Hellas, the information on land use and the sources and distribution of wealth is scattered. Our most illuminating document is the cadaster of Thebes that we have already mentioned, a fiscal treatise on land-holdings in Boeotia compiled in the second half of the eleventh century.[100] Since it deals with a region adjoining Steiris, it is of interest in connection with Hosios Loukas's patronage. It is noteworthy that the treatise refers to landowners of high social status, not to peasants or the poor; "by the end of the eleventh century the land was in the hands of the dynatoi, some of whom lived far from their fields and were even connected with southern Italy and Sicily."[101] Furthermore the conditions described in the cadaster can be assumed to have applied in the tenth century as well, according to Svoronos: "A primary conclusion is then imposed: the continuity of fiscal policies, in spite of differences of application from the tenth to the end of the eleventh century."[102] The picture given by the cadaster is of wealthy and titled landowners alongside peasants who lived in rural communes on their own lands. As

[96] Ibid., p. 201; see also p. 200, on family patronage patterns.

[97] Another family foundation was the Panagia Ton Chalkeon in Salonika, founded according to the inscription in memory of the katepano of Langobardia by his wife; see Papadopoulos, Wandmalereien, pp. 11–12.

[98] Vryonis, "Decline of Medieval Hellenism," p. 72; see esp. Rodley, "Pigeon House," pp. 323–24 and 327: "More probably the area harboured hermits or small communities of monks whose presence attracted the attention of patrons who provided for the excavation and decoration of churches." A further

similarity exists in the frescoes of Joshua before the Archangel, a scene of assurance of divine aid, which appear both at Hosios Loukas and at Çavuçin. See C. Connor, "The Joshua Fresco at Hosios Loukas," in Tenth Annual Byzantine Studies Conference: Abstracts of Papers (Cincinnati, 1984), pp. 57–58.

[99] Ringrose, "Monks," p. 142, and Vryonis, "Will of Eustathius Boilas," pp. 267–70.

[100] Svoronos, "Cadastre."

[101] For an overview of the significance of the Cadaster, see Kazhdan and Epstein, Change in Byzantine Culture, p. 57.

[102] Svoronos, "Cadastre," p. 144.

Lemerle points out, however, the status of the population mentioned would seem to be more bourgeois than aristocratic.[103]

In the Vita of Holy Luke there is ample evidence of two social and economic groups. The first group comprises villagers who are settled along the Gulf of Corinth. These join the saint's following and are described as belonging to the *chorion*.[104] They are the people with whom the saint is most concerned, indeed his agrarian origins as one of them are defined, for his grandfather was a squatter on land near Kastorion when the family first moved to the region.[105]

The second group is the wealthy and powerful class also mentioned by the Vita. The spatharios Philippus was accustomed frequently to associate with Luke because his brother was one of the saint's close associates; when the three meet, Luke shares in luxurious banqueting, a symbol of Philippus's great wealth.[106] The saint's contact with wealth and power is also apparent in the account of the visit of the archbishop of Corinth, the most wealthy and influential person of Luke's acquaintance, who offers to make a contribution in gold.[107]

Another source of wealth is also suggested by the Vita. Ships and shipowners are mentioned, and trade routes, like pilgrimage routes, must have used the Gulf of Corinth.[108]

> There was a ship sailing from Italy, and in the middle of the night it was greatly tossed about by a storm. Having escaped the danger through his [Luke's] prayers it came with difficulty to his island. Now since the saint who lived there was not unknown to the sailors, as soon as they disembarked from the ship they went to the saint and told him what had happened and recounted their unexpected salvation.

The graffiti of ships and nets on the walls of the crypt attest the continuing association of the monastery with mariners (figs. 79, 81). The occurrence of the most graffiti of this type on the two walls inside the entrance of the crypt suggests they were a form of supplication for intercessory prayers for a safe journey.

One reason why there would regularly be ships from Italy in the Gulf of Corinth would be the silk trade.[109] In Weigand's investigation of the Byzantine silk industry he

[103] Lemerle, *Agrarian History*, p. 198; for an outline of the rural structure of landholding the commune, see pp. 37–39 and p. 76 on the Rural Code; the *chorion* was the unit for dwelling and for cultivation of land, a unit made up of the lands whose cultivators lived in a single village, as already established in the Novels of Justinian (nos. 18, 30).

[104] Connor, *Life of Saint Luke*, chap. 50.

[105] Ibid., chap. 2.

[106] Ibid., chap. 63; however, spatharios is not as high a rank as spatharokandidatos by the mid-tenth century.

[107] Ibid., chap. 42.

[108] The story of Demetrios the shipowner makes one wonder what manner of shipping brought him to the region of Ioannitza for frequent visits (Ibid., chap. 31). In another story (chap. 52) a "ship sailing from Italy" was saved from shipwreck by the intervention of the saint and came safely to shore on Ampelos; the crew already knew about Holy Luke, evidently because this was a regular route for them. What was it carrying? Although this may have been on a route for transferring trade goods across the isthmus of Corinth, was the traffic also in products produced along the Gulf itself?

[109] On silk production, see N. Oikonomides, "Silk Trade and Production in Byzantium from the Sixth to the Ninth Century: The Seals of Kommerkiarioi," *DOP.* 40 (1986): 33–53; and Lopez, "Silk Industry." See also A. Starensier, "An Art Historical Study of

concludes that Thebes was its center, probably from the tenth century or earlier.[110] Along with Patras, Corinth, and Athens, Thebes was the leader of this group of silk-producing towns.[111] Weigand posits that pseudo-Kufic and stylized animal designs made their way into the sculptural vocabulary of the region from the ninth century on through designs on silk cloth. These popular designs were then carried via the silk trade not only throughout central Greece, where they are typical, but later to Sicily, Venice, and western Europe. Thebes was a natural center of the industry because of its abundance of water and the presence of certain minerals in the water, important for the washing and dying process.[112] A further reason for supposing the early establishment of the silk industry was in Thebes is cited: "Thebes ranked as a bishopric at the beginning of the ninth century and was throughout this time the seat of the strategos of Hellas."[113] As a seat of religious and political authority, Thebes was suitably the center of this luxury industry in the western empire.

The importance of the silk industry lay in its high monetary and symbolic value for the empire. Silk "was the attire of the Emperor and the aristocracy, an indispensable symbol of political power and a prime requirement for ecclesiastical ceremonies."[114] It was crucial for the emperor to maintain control, in fact a monopoly, on the silk industry; its price was kept at a high level, and only the privileged were allowed to wear garments of silk.

As a further source of the local wealth that was applied to the early patronage of Hosios Loukas, silk must be considered. There is abundant evidence in the decoration of the monastery of inspiration by motifs used on silks. The animal designs on the plaques under the windows are similar to those on silk weavings; pseudo-Kufic ornament in the brickwork as well as in the mosaic and fresco decoration has been cited as undeniable evidence of Islamic influence, which might have spread by various media including silk.[115] If Thebes was a great silk-producing center, not only would these motifs have been available as a possible inspiration for sculpture and painting, but the great wealth generated by the industry may well have been instrumental indirectly in supporting a local economy that could produce such a lavish foundation as Hosios Loukas.

An episode in the Vita provides an intriguing reference to this luxurious cloth industry. In the story of the visit of Philippus the spatharios to the monastery, he had a dream with a vision of the saint:

Then he raised his eyes toward the person being pointed out and saw a great and marvelous thing: an exceedingly precious purple cloth [*porphyra*] was spread out over the earth and above it the great man [Holy Luke] was standing, gleaming won-

the Byzantine Silk Industry" (Ph.D. diss., Columbia University, 1982), esp. p. 235, for a discussion on *porphyra*, the silk used only for imperial garments.

[110] Weigand, "Helladisch-Byzantinische Seidenweberei," pp. 507 and 510.

[111] Ninth-century evidence for Patras's role in the industry comes from the Life of Basil I (Vogt, *Basile*

I [Paris, 1908]), p. 389.

[112] Wiegand, "Helladisch-byzantinische Seidenweberei," pp. 507–8.

[113] Ibid., p. 507.

[114] Lopez, "Silk Industry," p. 1.

[115] Grabar, "La décoration architecturale," pp. 15–37, esp. p. 34 on the influence of silk designs.

drously and indescribably both from his body and from his clothing and seen entirely as light.[116]

This appears to be a psychological image, for purple silk cloth would have been associated with the spatharios possibly because of the industry in which he was engaged: the production of purple silk for the imperial house.[117] If the image is the author's, it could still indicate Philippus's connection with silk of highest quality, an industry probably controlled by the civil aristocracy of Thebes.[118]

Civil patronage could have come to the monastery of Hosios Loukas partly through Philippus the wealthy spatharios of Thebes who may have been granted the monastery in charistiki. Military patronage could also have played a significant role because of the sudden influx of wealth into Hellas after the Cretan campaign. However, both these factors converge if we return to the connection of the monastery with Theodore Leobachos, the abbot of Hosios Loukas mentioned in the Naupactos charter.

A HYPOTHESIS will now be considered that correlates with the three factors we have discussed: religious, military, and economic. It hinges on the two fresco portraits of abbots, Theodosius and Philotheus, in the southeast vault of the crypt.

Military patronage of monasteries in nearby communities is documented. In the Peloponnese military governors became protectors and patrons of the monasteries of prominent holy men.[119] The great prominence of portraits of military saints at Hosios Loukas may indicate patronage for the Katholikon by a powerful local military figure, a strategos who had acquired great wealth in the Cretan campaign.[120] Among the military portraits of the Katholikon alone it has been noted that there were at least five Theodores; it has been suggested this could reflect the wishes of a donor by that name, Theodore Leobachos.[121]

If Theodore Leobachos took the monastic name of Theodosius when he retired from the world, he could be the titled aristocrat described on the funeral plaque discovered at the monastery with the inscription:

[116] Connor, *Life of Saint Luke*, chap. 63. *Porphyra* (f.) can be the color term, or a purple robe of an emperor (Lampe); that the robe would be of silk cloth is, I think, understood. For the production of purple silk in the Thebes, see Lopez, "Silk Industry," p. 24.

[117] It is well known that there was a large Jewish population in Thebes in the medieval period, and also that Jews often took on the task of dying and also of finishing and embroidering silk, (Weigand, "Helladisch-byzantinische Seidenweberei," pp. 205, 506).

[118] A *kommerkiarios* is also mentioned in one of the healing miracles of the Vita; these people were the officials responsible for overseeing the production and distribution of silk (Connor, *Life of Saint Luke*, chap. 82). Also, the name of one of the members listed in the Naupactos charter, Blatas, from the word for "purple cloth of silk," suggests he was connected with the silk industry (see Nesbitt and Wiita,

"Confraternity," p. 377 and n. 27); for a study of the economy of the region of Thebes and Naupactos in the medieval period, see C. G. Hatzidimitriou, "The Decline of Imperial Authority in Southwest Central Greece and the Role of Archontes and Bishops in the Failure of Byzantine Resistance and Reconquest 1180–1297 A.D." (Ph.D. Columbia University, 1988), esp. pp. 39–72.

[119] This was the case of Nikon Metanoite of Sparta. That he was considered part of the local milieu is demonstrated by the prominent placing of his portrait on the west wall of the naos at Hosios Loukas.

[120] For further discussion of this possibility in connection with the decoration of the church, see my discussion in the section "Program and Meaning" in Chapter I.

[121] Mouriki, *Nea Moni*, p. 256.

Formerly Theodorus, in turn Theodosius, distinguished proconsul, now the monk, the patrician who conducted himself nobly, now the *katepano* against the haughty, and the thrice bearer of the mystic garment.[122]

In the significantly placed portrait medallion of the crypt we could then recognize the same person, but as the abbot Theodosius, who was referred to as "the all-holy late monk and abbot of Steiris lord Theodores Leobachos," in the Naupactos charter.[123]

Furthermore, this hypothesis would fit logistical aspects of the crypt. In the manner of the monks Paul and Timothy of the Evergetis monastery, whose typikon is one of our best records of monastic customs, the brothers Theodosius and Philippus of the Vita might have become patron-founders and abbots of Hosios Loukas.[124] If Philippus had taken the monastic name of Philotheus he could be the founder mentioned in the Akolouthia (the prayers for the translation of Luke's relics) as being responsible for the building of the church.[125] The two tombs in the crypt on either side of the sanctuary would then be explained: they were built for the two brothers who were the patrons for the construction and decoration of the Katholikon. The locations of their portraits and those of their namesakes in the southeast and northeast vaults were planned to correspond to their tombs in the bays beneath.

The rich and powerful of Thebes no doubt played a role in the building, decoration, and maintenance of the monastery: in its structures, its undoubtedly opulent portable objects, its other material embellishments, and its attached land-holdings. The Katholikon at Scripou sets a significant precedent for wealthy Theban patronage of a burial church in the area. That the Katholikon was founded to be the final resting place of Holy Luke and of the monastery's patrons, two aristocrats of Thebes who had become monks, seems likely in the light of the cultural and social currents in tenth-century Hellas.

[122] See Stikas, *Oikodomikon Chronikon*, p. 28; Judith Herrin kindly tells me that *anthypatos* in combination with *patricios* probably indicates he held the position of theme governor, for the same title occurs three times in the twelfth-century Vita of Hosios Meletios with this meaning; the term *katepano* is current in South Italian administration (A. Bon, *Le Pelopponese byzantin* [Paris, 1904], p. 93); the phrase "thrice bearer of the mystic garment," however, demands elucidation, although the mention of a garment might again suggest ties with silk production, or a robe signifying a high office.

[123] Nesbitt and Wiita, "Confraternity," p. 369.

[124] See Gautier, "Evergetis Typikon," pp. 6–9; also see Connor, *Life of Saint Luke*, chap. 63.

[125] At the time of the translation of Luke's relics, these prayers were written to be part of the service of Great Vespers for May 7; see Kremos, *Phokika*, 2:71–133; I discuss them in connection with Philotheus in Chapter I. See also Pallas, "Zur Topographie und Chronologie von Hosio Loukas," pp. 102–3.

CONCLUSION

* * * * * *

LEAVING THE crypt and the subtle colors and white highlights of its frescoes, we now recognize that they represent a coherent view. The beauty of these frescoes first challenged us to answer questions they posed: Who is represented? Why were these images selected? What messages did the Byzantine viewer find encoded in them? Their style and models also required definition. How did they fit into the artistic developments of the time, and what was the relationship between artist and patron? Fundamental to the study was the question of function: What was the connection between the frescoes and the use of space in the crypt? Here we were fortunate to have the Life, which enabled us to recognize the full significance of the frescoes. With the Life, a comprehensive view of the undertaking became possible. Through it the circumstances surrounding the mid-tenth-century founding of the monastery became intelligible, something rarely possible in the study of a Byzantine monument. The Vita evokes the times of threat and trouble for village people in the region of the Gulf of Corinth, patterns of monastic life, and Luke's miraculous powers of prophecy and healing which became part of the consciousness and identity of the people of Hellas. Even after his death, his miracle-working tomb offered protection and healing, bringing fame and crowds of pilgrims to the place.

The events of this Life contribute a new set of criteria for dating the monastery in the last half of the tenth century. They provide not only valuable testimony supporting new and precise datings for the building of the Panagia church (946–55) and the Katholikon (956–70) but also a vivid sense of the lives and concerns of this holy man, of other monks, and of all those associated with him and his monastery. Among them, we have argued, were wealthy officials from Thebes who in retiring from the world financed the building and decoration (ca. 970–1000) of the great Katholikon, with the crypt as their burial place; they are the abbots Theodosios (known also by his worldly name, Theodore Leobachos) and Philotheus, who still look down from their medallion portraits above the southeast bay of the crypt. The Vita mentions Gregorius the monk who was very likely the donor of the marble revetment of the Katholikon. Pancratius the healer can also be imagined in his role at the tomb. The Life helps explain many features of the crypt and its frescoes while providing a vivid sense of their religious, social, and historical context. The local pride of pious villagers and wealthy patrons alike in their own miracle-working saint (his popular appeal being analogous in many ways to that of urban saints of Thessaloniki or Constantinople) emerges as the clear incentive for the monastery's creation.

The monastery of Hosios Loukas has only begun to yield up its secrets. For not only does the great Katholikon merit closer study than could be attempted in this monograph, but the crypt itself is made up of much more than the graceful and expressive figures of the frescoes or of the hymning and processions we imagine on the saint's feast

day. For it involves people, their lives, skills, beliefs, everyday habits, and mutual concerns. All combine here as part of a remote and complex past: saints, monks, artists, villagers, pilgrims, patrons, suppliants. Through them the process of creation of this monument, at this time and in this place, becomes momentarily intelligible as art and context merge in a new and vivid reality.

BIBLIOGRAPHY

* * * * * * *

Abrahamse, D. "Rituals of Death in the Middle Byzantine Period." *The Greek Orthodox Theological Review* 29, no. 2 (1984): 125–34.

Arranz, M. "Les prières presbytérales de la 'Pannychis' de l'ancien Euchologe byzantin et la 'Panikhida' des défunts." Parts 1, 2. *OCP* 40 (1974): 314–43; 41 (1975): 119–39.

Attwater, D. *Saints of the East*. New York, 1938.

Babić, G. *Les Chapelles annexes des églises byzantines: Fonction liturgique et programmes iconographiques*. Paris, 1969.

Beckwith, J. *Early Christian and Byzantine Art*. 2nd ed. Harmondsworth, 1979.

Belting, H., C. Mango, and D. Mouriki. *The Mosaics and Frescoes of St. Mary Pammakaristos (Fethiye Camii at Istanbul)*. Dumbarton Oaks Studies 15. Washington, D.C., 1978.

Bouras, L. *Ho gluptos diakosmos tou naou tes Panagias sto monastēpi tou Hosiou Louka*. Bibliotheke tes Archaeologikes Hetaireias 95. Athens, 1980.

Brown, P. "A Dark Age Crisis: Aspects of the Iconoclastic Controversy." *English Historical Review* 88 (1973): 1–34. Reprinted in *Society and the Holy in Late Antiquity*, pp. 251–301. Berkeley, 1982.

———. "The Rise and Function of the Holy Man in Late Antiquity." *Journal of Roman Studies* 16 (1971): 80–101. Reprinted in *Society and the Holy in Late Antiquity*, pp. 103–52. Berkeley, 1982.

———. "Learning and Imagination." Inaugural Lecture, Royal Holloway College. 1977. Reprinted in *Society and the Holy in Late Antiquity*, pp. 3–21. Berkeley, 1982.

Butler, A. *Lives of the Saints*. 4 vols. Revised and edited by H. Thurston and D. Attwater, New York, 1956.

Cecchelli, C., G. Furlani, and M. Salmi. *The Rabbula Gospels*. Lausanne and Olten, 1959.

Charanis, P. "Hellas in Greek Sources of the VI, VII and VIII Centuries." In *Late Classical and Medieval Studies in Honor of A. M. Friend, Jr.*, ed. K. Weitzman, pp. 161–73. Princeton, 1955.

———. "Monastic Properties and the State." *DOP* 4 (1948): 51–118.

———. "The Monk as an Element of Byzantine Society." *DOP* 25 (1971): 63–84.

———. "Some Aspects of Daily Life in Byzantium."

Greek Orthodox Theological Review 8 (1962–63): 53–70.

Chatzidakis, M. "A propos de la date et du fondateur de Saint Luc." *CA* 19 (1969): 127–50.

Chatzidakis-Bacharas, Theano. *Les peintures murales de Hosios Loukas; Les chapelles occidentales*. Athens, 1982.

Connor, C. L. and W. R. Connor. *The Life and Miracles of Saint Luke of Steiris, A Translation and Commentary*. Brookline, Mass. (to be published).

Constantelos, D. *Byzantine Philanthropy and Social Welfare*. New Brunswick, N.J., 1968.

Cormack, R. *Writing in Gold: Byzantine Society and Its Icons*. New York, 1985.

Da Costa-Louillet, G. "Saints de Grèce aux VIIIᵉ, IXᵉ et Xᵉ siècles." *Byzantion* 31 (1961): 330–43 for "Vie de S. Luc le Jeune (890–953)."

Dawes, E. and N. H. Baynes. *Three Byzantine Saints*. London and Oxford, 1948.

Deichmann, F. W. *Frühchristliche Bauten und Mosaiken von Ravenna*. Mainz, 1958.

Delehaye, H. *Les légendes grecques des saints militaires*. Paris, 1909.

———. *Les saints stylites*. Subsidia Hagiographica 14. Brussels and Paris, 1923.

Demus, O. *The Mosaics of Norman Sicily*. London, 1949.

Der Nersessian, S. *L'illustration des psautiers grecs du moyen age, II, London 19.352*, Bibliothèque des Cahiers Archéologiques 5. Paris, 1970.

———. "Remarks on the Date of the Menologium and the Psalter Written for Basil II." *Byzantion* 15 (1940–41): 104–25

Diehl, Ch. *L'église et les mosaiques du Couvent de Saint Luc en Phocide*. 1889. Reprinted, Paris, 1968.

Diez, E. and O. Demus, *Byzantine Mosaics in Greece, Hosios Lucas and Daphni*. Cambridge, Mass., 1931.

Dmitrievskij, A. *Opisanie Liturgicheskikh Rukopisei*. 2 vols. Kiev, 1895; Petrograd, 1917.

Edelstein, E. J., and L. Edelstein. *Asclepius: A Collection and Interpretation of the Testimonies*. Baltimore, 1945.

Epstein, A. W. "The Middle Byzantine Churches of Kastoria; Dates and Implications." *AB* 62 (1980): 190–206.

———. *Tokalı Kilise, Tenth-Century Metropolitan Art*

in *Byzantine Cappadocia*. Dumbarton Oaks Studies 22. Washington, D.C., 1986.

The Festal Menaion. Translated by Mother Mary and K. Ware. London, 1977.

Festugière, A. J. *Les Moines d'Orient*: Vol. 3, *Les Moines de Palestine*. No. 1, Cyrille de Scythopolis, *Vie de Saint Euthème*. No. 2, Cyrille de Scytho-polis, *Vie de Saint Sabas*. No. 3, Cyrille de Scytho-polis, *Vie de Théodose et Theodore de Petra, Vie de Saint Théodose*. Paris, 1962.

Flusin, B. *Miracle et histoire dans l'oeuvre de Cyrille de Scythopolis*. Etudes Augustiniennes. Paris, 1983.

Forsyth, G. H. and K. Weitzmann *The Monastery of Saint Catherine at Mount Sinai, The Church and For-tress of Justinian*. Plates. Ann Arbor, 1973.

Freistedt, E. *Altchristliche Totendächtnistage und Ihre Be-ziehung zum Jeneseitsglauben und Totenkultus der An-tike*. Liturgiegeschichte Quellen und Forschungen 24. Münster, 1928.

Galavaris, G. "The Portraits of St. Athanasius of Athos." *Etudes Byzantines* 5, nos. 1–2 (1978): 96–124.

Gautier, P. "Le typikon du Christ Sauveur Pantocra-tor." *REB* 32 (1974): 1–145.

———. "Le typikon du Sebaste Grégoire Pakouri-anos." *REB* 42 (1984): 1–145.

———. "Le typikon de la Theotokos Evergetis." *REB* 40 (1981): 5–101.

———. "Le typikon de la Theotokos Kecharito-mene." *REB* 43 (1985): 5–165.

Goar, Jacobus *Euchologion sive rituale Graecorum*. Ven-ice, 1730. Reprinted, Graz, 1960.

Goldschmidt, A., and K. Weitzmann. *Die byzantin-ischen Elfenbeinskulpturen des X.–XIII. Jahrhunderts*. Vols. 1, 2. Berlin, 1930, 1934.

Grabar, A. "La décoration architecturale de l'église de la Vierge à S. Luc en Phocide et les débuts des in-fluences islamiques sur l'art Byzantin de grèce." *CRAI* (1971): 15–37.

Grishin, S. "Literary Evidence for the Dating of the Bačkovo Ossuary Frescoes." In *Byzantine Papers*, ed. E. Jeffreys, M. Jeffreys, and A. Moffatt. By-zantina Australiensia 1. Proceedings of the First Australian Byzantine Studies Conference. Can-berra, May 1978. Sponsored by the Australian As-sociation for Byzantine Studies. Canberra, 1981.

Hapgood, I. F., ed. *Service Book of the Holy Orthodox Catholic Apostolic (Greco-Russian) Church*. Cam-bridge, Mass., 1906.

Herrin, J. "Aspects of the Process of Hellenization in the Early Middle Ages." *BSA* 68 (1973): 113–26.

Hetherington, P. *The "Painter's Manual" of Dionysius of Fourna*. Translation and commentary. London, 1974.

Iconoclasm. Edited by A. Bryer and J. Herrin. Papers given at the ninth Spring Symposium of Byzan-tine Studies, University of Birmingham. Birming-ham, 1979.

Il Menologio di Basilio II (Cod. Vaticano Greco 1613). Codices e Vaticanis Selecti, 8. Vol. 2, plates. Tu-rin, 1907.

Janin, G. R. *La géographie écclesiastique de l'empire by-zantin: Constantinople, Les églises et les monastères*. Paris, 1953.

Jenkins, R.J.H. "The Date of the Slave Revolt in the Peloponnese under Romanus I." In *Late Classical and Medieval Studies in Honor of A. M. Friend*, Jr., ed. K. Weitzmann, pp. 204–11. Princeton, 1955.

Kazhdan, A. P. and A. W. Epstein, *Change in Byzan-tine Culture in the Eleventh and Twelfth Centuries*. Berkeley, 1985.

De Khitrowo, S. P. *Itinéraires russes en orient*. Geneva, 1889.

Kitzinger, E. *The Mosaics of Monreale*. Palermo, 1960.

Koder, J., and F. Hild. *Tabula Imperii Byzantini I: Hellas und Thessalien*. Vienna, 1976.

Krautheimer, R. *Early Christian and Byzantine Archi-tecture*. 3rd ed. New York, 1979.

Kremos, G. *Phokika, proskunētariou tēs en Phokidi monēs tou Hosiou Louka toupiklen Steiriotou*. Vols. 1 and 2. Athens, 1874, 1880.

Laurent, V. *La Vita Retractata et les miracles posthumes de Saint Pierre d'Atroa*. Subsidia Hagiographica 31. Brussels, 1958.

Lemerle, P. *The Agrarian History of Byzantium from the Origins to the Twelfth Century: The Sources and Problems*. Galway, 1979.

———. "La vie ancienne de saint Athanase l'Athonite composée au début du XIe siècle par Athanase de Lavra." In *Le millénaire du Mont Athos 963–1963: Etudes et mélanges*, Chevotogne, 1963. 1:59–100.

The Lenten Triodion. Translated by Mother Mary and K. Ware. London, 1984.

Leroy, J. *Manuscrits syriaques à Peintures conservés dans les bibliothèques d'europe et d'orient*. Paris, 1964.

———. "La réforme studite." *OCP* 153 (1958): 181–214.

———. "La vie quotidienne du moine Studite." *Ireni-kon* 27 (1954): 21–50.

Lopez, R. S. "Silk Industry in the Byzantine Empire." *Speculum* 20 (1945): 1–42.

Magoulias, H. J. "Lives of Saints as Sources for the History of Byzantine Medicine." *BZ* 57 (1964): 127–50.

Maguire, H. *Art and Eloquence in Byzantium*. Prince-ton, 1981.

Mango, C. *Materials for the Study of the Mosaics of*

Saint-Sophia at Istanbul. Dumbarton Oaks Studies 8. Washington, 1962.

Martin, J. *The Illustrations of the Heavenly Ladder of John Climacus.* Studies in Manuscript Illumination 5. Princeton, 1954.

Martini, E., ed. "Supplementum ad acta S. Lucae Iunioris." *Analecta Bollandiana* 13 (1894): 81–121.

Mateos, J. "La synaxe monastique des vêpres byzantines." *OCP* 36 (1970): 248–72.

Mathews, T. F. *The Byzantine Churches of Istanbul.* University Park, Penn., 1976.

Megaw, H. "The Chronology of Some Middle Byzantine Churches in Greece." *BSA* 32 (1931–32): 90–130.

———. "The Skripou Screen." *BSA* 61 (1966): 1–32.

Meyer, Ph. *Die Haupturkunden für die Geschichte des Athosklöster.* Leipzig, 1894.

Miles, G. C. "Byzantium and the Arabs." *DOP* 18 (1964): 1–32.

Miller, T. *The Birth of the Hospital in the Byzantine Empire.* Baltimore, 1985.

Millet, G. *Monuments d'Athos.* Paris, 1927.

———. *Recherches sur l'iconographie de l'Evangile aux XIVᵉ, XVᵉ et XVIᵉ siècles.* Paris, 1916. Reprinted 1960.

Mouriki, D. *The Mosaics of Nea Moni on Chios.* Athens, 1985.

———. "The Portraits of Theodore Studites in Byzantine Art." *JOB* 20 (1971): 249–80.

Mouriki, D. "Stylistic Trends in Monumental Painting of Greece during the Eleventh and Twelfth Centuries." *DOP* 34–36 (1980–81): 77–124.

Müller-Weiner, W. *Bildlexikon zur Topographie Istanbuls.* Tübingen, 1977.

Nesbitt, J. "A Geographical and Chronological Guide to Greek Saint Lives." *OCP* 35 (1969): 443–89.

Nesbitt, J., and J. Wiita. "A Confraternity of the Comnenian Era." *BZ* 68 (1975): 155–75.

Oikonomides, N. *Les listes de préséance byzantin des IXᵉ et Xᵉ siècles.* Paris, 1972.

Omont, H. *Miniatures des plus anciens manuscrits grecs de la Bibliothèque Nationale du VIᵉ au XIVᵉ siècle.* 2nd ed. Paris, 1929.

Pallas, D. I. "Zur Topographie und Chronologie von Hosios Lukas: Eine kritische Uebersicht." *BZ* 78 (1985): 94–107.

Papadopoulos, K. *Die Wandmalereien des XI. Jahrhunderts im Panagia ton Chalkeon in Thessaloniki.* Graz and Köln, 1966.

Patlagean, E. "Ancienne hagiographie byzantine et histoire sociale." *Annales: Economie, Société, Civilisation* (1968): 106–26.

———. "Sainteté et pouvoir." In *The Byzantine Saint,* ed. S. Hackel, pp. 88–105. Spring Symposium of Byzantine Studies, Birmingham, 1980. London, 1981.

Pelekanides, S. *Kastoria, Buzantinai toichographiai.* Thessalonica, 1953.

Petit, L. "Vie de saint Athanase l'Athonite." *Analecta Bollandiana* 25 (1906): 5–89.

Philipsborn, A. "Der Fortschritt in der Entwicklung des byzantinischen Krankenhauswesens." *BZ* 54 (1961): 338–65.

Réau, L. *Iconographie de l'art Chretien.* 3 vols. Paris, 1959.

Restle, M. *Byzantine Wall Painting in Asia Minor.* 3 vols. Recklinghausen, 1967.

Rice, D. T. *Art of the Byzantine Era.* New York, 1966.

———. *The Art of Byzantium.* London, 1959.

Ringrose, K. M. "Monks and Society in Iconoclast Byzantium." *Etudes Byzantines* 6 (1979): 130–51.

Rodley, L. *Cave Monasteries of Byzantine Cappadocia.* Cambridge, 1985.

———. "The Pigeon House Church, Çavuçin." *JOB* 33 (1983): 301–39.

Rush, A. C. *Death and Burial in Christian Antiquity.* Washington, D.C., 1941.

Schiller, G. *Iconography of Christian Art.* 2 vols. London, 1971–1972.

Schultz, R., and S. Barnsley. *The Monastery of St. Luke of Phocis and the Dependent Monastery of St. Nicolas in the Fields near Skripou in Boeotia.* London, 1901.

Schwartz, E. *Kyrillos von Skythopolis.* In *Texte und Unterzuchungen zur Geschichte der Altchristlichen Literatur* XLIX, 2. Leipzig, 1939.

Setton, K. "On the Raids of the Moslems in the Aegean in the 9th and 10th Centuries and Their Alleged Occupation of Athens." *AJA* 58 (1954): 311–19.

Ševčenko, I. "Constantinople Viewed from the Eastern Provinces in the Middle Byzantine Period." *Harvard Ukranian Studies* 2 (1979–80): 712–47.

Sherrard, P. *Athos, der Berg des Schweigens.* Olten, 1959.

Skawran, K. M. *The Development of Middle Byzantine Fresco Painting in Greece.* Pretoria, South Africa, 1982.

Sotiriou, G. "Peintures murales byzantines du XIᵉ siècle dans la crypte de Saint-Luc." In *Actes du IIIᵉ Conférence international des études byzantines,* pp. 390–400. Athens, 1930.

Sotiriou, G., and M. Sotiriou. *Hē Basilikē tou Hagiou Dēmētriou Thessalonikēs.* Athens, 1952.

———. *Eikones tēs Monēs Sina.* Collection de l'Institut français d'Athènes 100. 2 vols. Athens, 1956, 1958.

Spatharakis, I. *The Portrait in Byzantine Illuminated Manuscripts.* Leiden, 1976.

Stikas, E. G. *Ho Ktitōr tou Katholikou tēs Monēs Hosiou Louka*. Athens, 1974–75.

———. "Nouvelles observations sur la date de construction du Catholicon et de l'église de la Vierge du monastère de Saint Luc en Phocide." *CorsiRav* (1972): 311–30.

———. *To Oikodomikon Chronikon tēs Monēs Hosiou Louka Phōkidos*. Athens, 1970.

Striker, C. L. *The Myrelaion (Bodrum Camii) in Istanbul*. Princeton, 1981.

Svoronos, N. "Le cadastre de Thèbes." *BCH* 83 (1959): 1–166.

Talbot, A.-M. *Faith Healing in Late Byzantium: The Posthumous Miracles of the Patriarch Athanasios I of Constantinople by Theoktistos the Stoudite*. Brookline, Mass., 1983.

———. "The Monastic Experience of Men and Women." *Greek Orthodox Theological Review* 30 (1985): 14–15.

Thomas, J. *Private Religious Foundations in the Byzantine Empire*. Washington, D. C. 1987.

Tsitouridou, A. "Die Grabkonzeption des ikonographischen Programms der Kirche Panagia Chalkeon in Thessaloniki." *JOB* 32, no. 5 (1982): 435–41.

Underwood, P. *The Kariye Camii*. Bollingen Series 70. 3 vols. New York, 1966.

Velmans, T. *Le tetraévangile de la Laurentienne Florence, Laur. VI.23*. Paris, 1971.

Vocotopoulos, P. L. "Fresques du XIᵉ siècle à Corfou." *CA* 21 (1971): 151–80.

Vryonis, S. *The Decline of Medieval Hellenism in Asia Minor and the Process of Islamization from the 11th through the 15th Century*. Berkeley and London, 1971.

———. "The Will of a Provincial Magnate, Eustathius Boilas." *DOP* 11 (1957): 263–77.

Weigand, E. "Die helladisch-byzantinische Seidenweberei." In *Eis Mnemēn Spiridonos Lampros*, pp. 503–14. Athens, 1935.

Weitzmann, K. *Die byzantinische Buchmalerei des 9. und 10. Jahrhunderts*. Berlin, 1935.

———. "The Constantinopolitan Lectionary Morgan 639." In *Studies in Art and Literature for Belle da Costa Greene*, ed. D. Miner, pp. 358–73. Princeton, 1954.

———. *The Monastery of Saint Catherine at Mount Sinai: The Icons*. Vol. 1. Princeton, 1976.

———. "A Tenth Century Lectionary, A Lost Masterpiece of the Macedonian Renaissance." In *Byzantine Liturgical Psalters and Gospels*, pp. 617–41. Variorum reprints. London, 1980.

Wilkinson, J. *Egeria's Travels*. London, 1971.

INDEX

✳ ✳ ✳ ✳ ✳ ✳ ✳

ILLUSTRATIONS

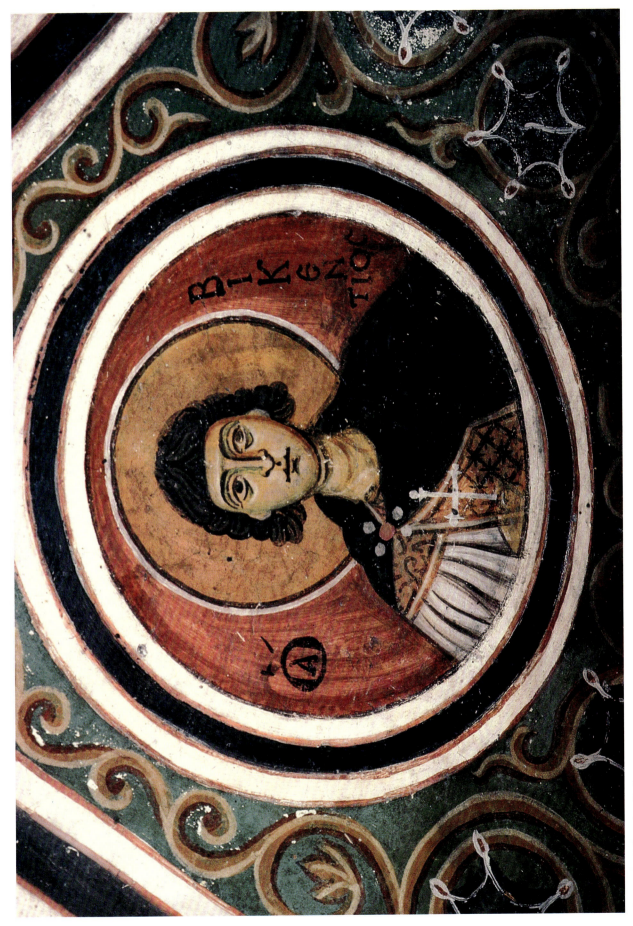

Plate 1. St. Vikentius (I 4)

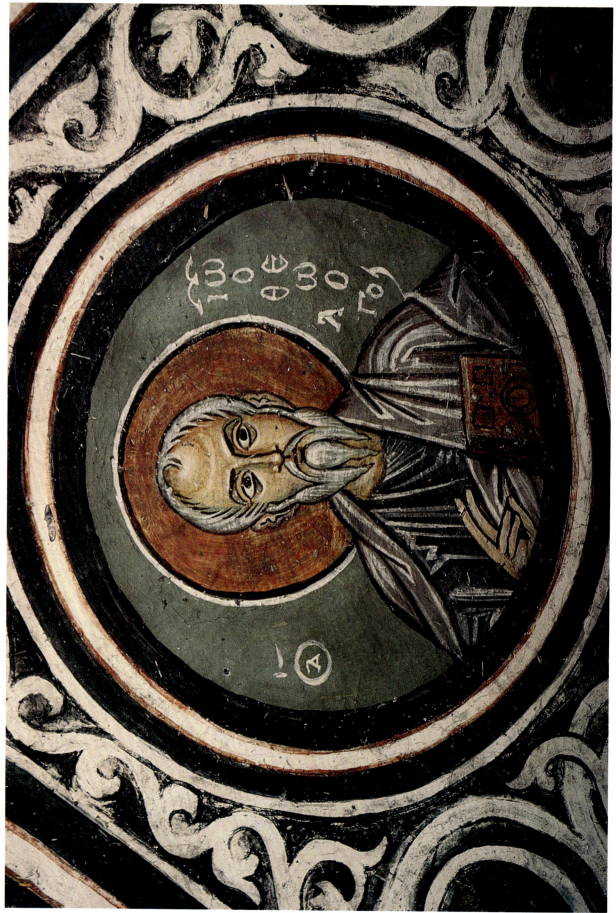

Plate 2. St. John the Theologian (D 2)

Plate 3. Our Holy Father Loukas (J 1)

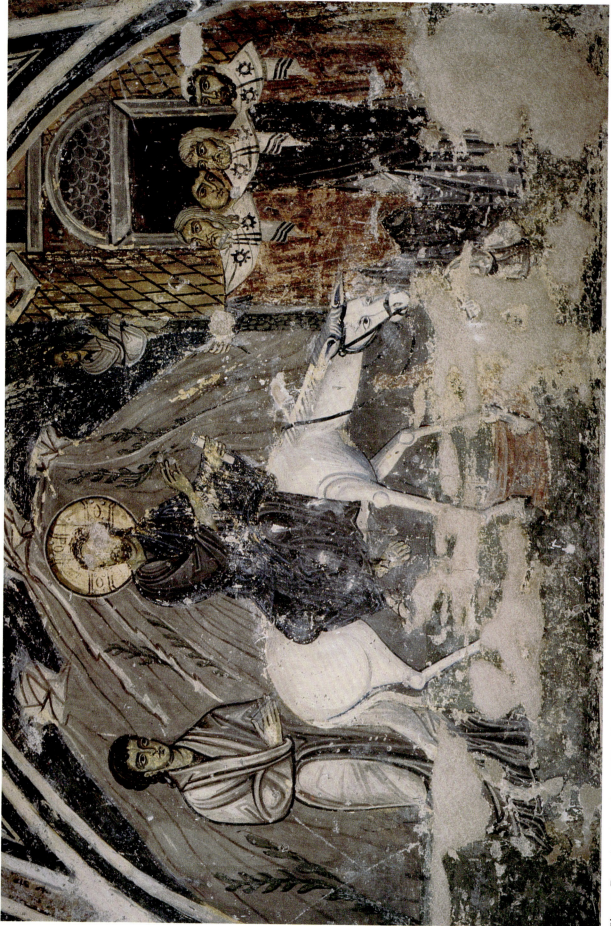

Plate 4. Entry into Jerusalem (C North)

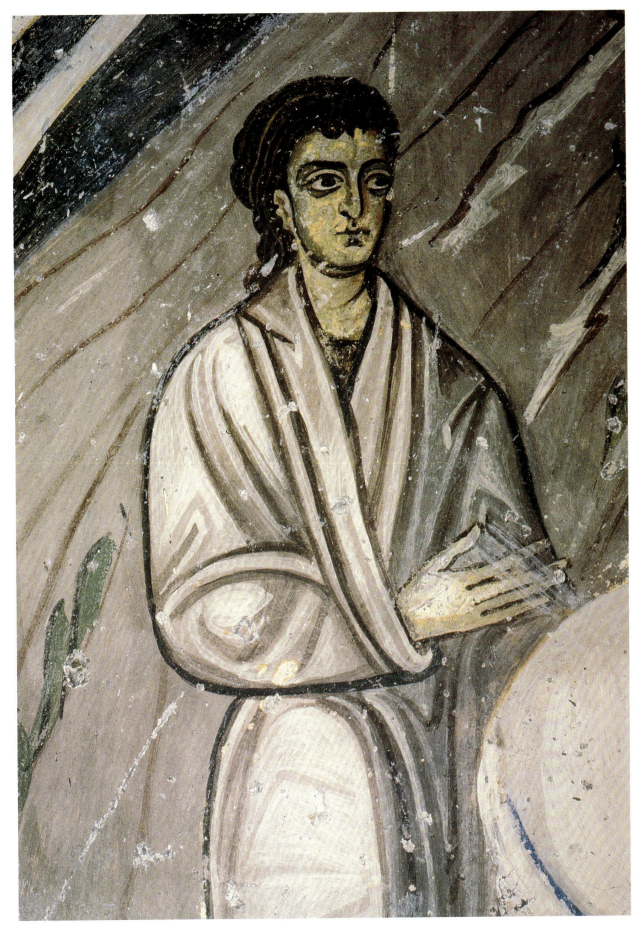

Plate 5. Entry into Jerusalem, detail: St. John or St. Thomas

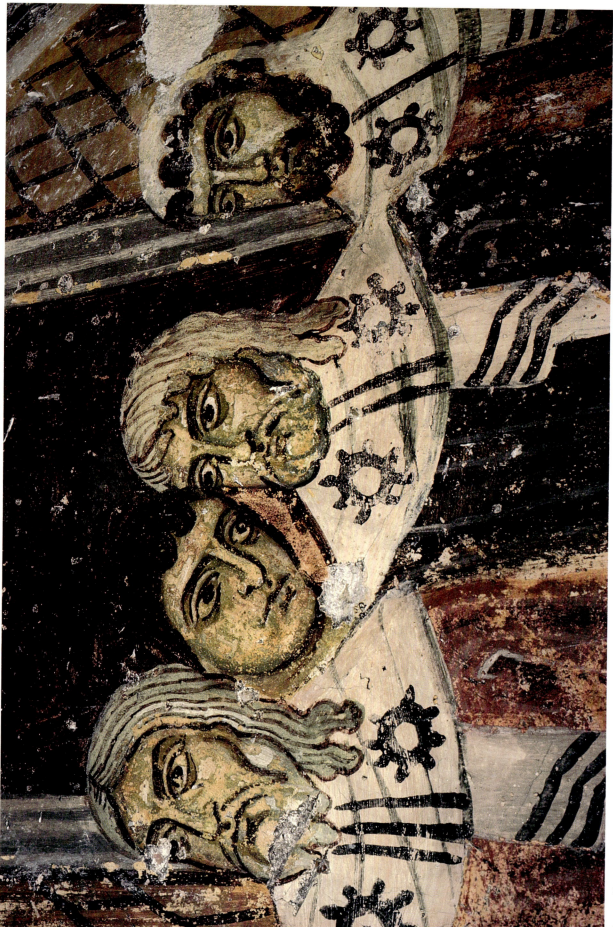

Plate 6. Entry into Jerusalem, detail: Elders

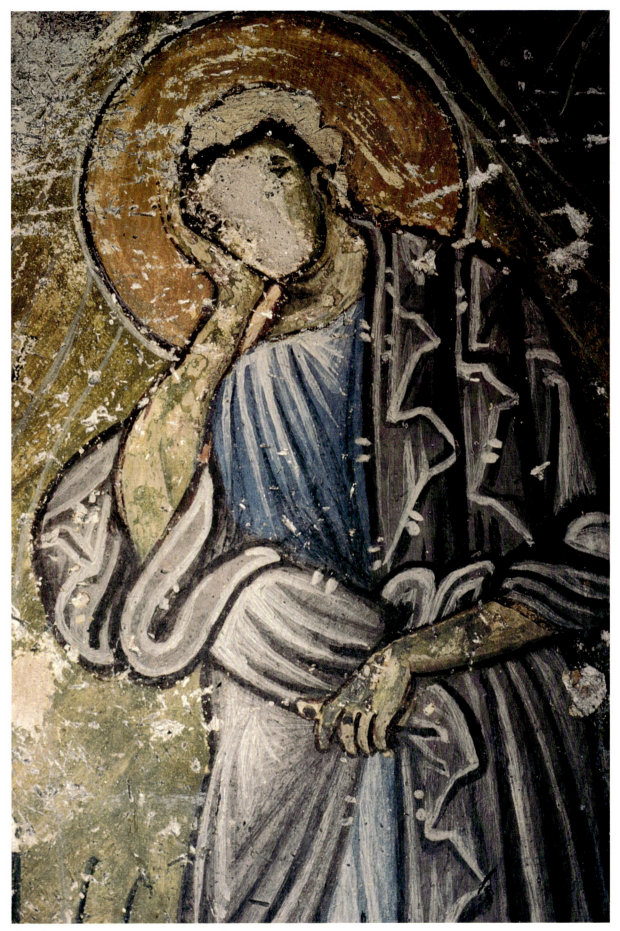

Plate 7. Crucifixion (C East), detail: St. John

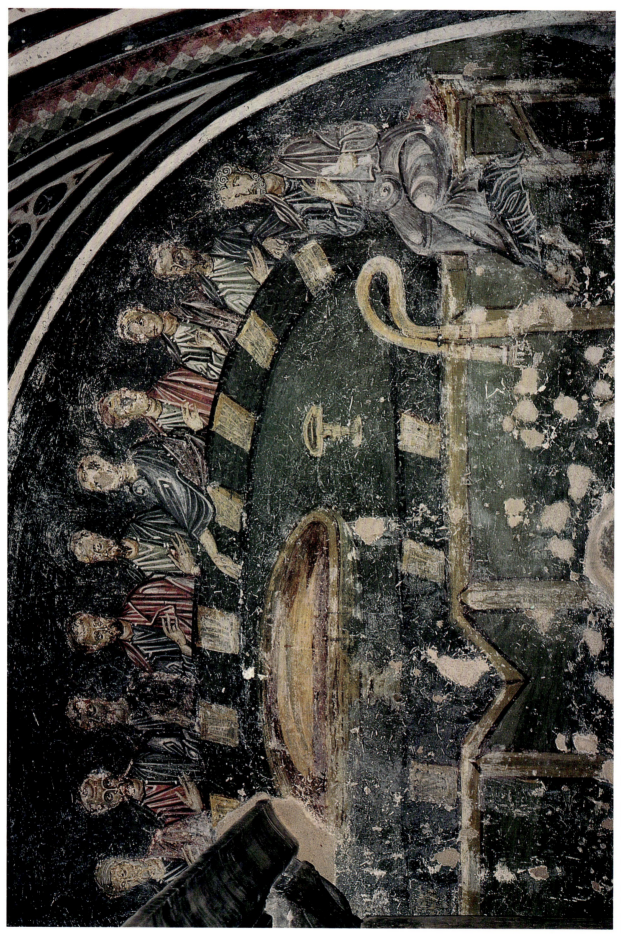

Plate 8. Last Supper (G South), detail

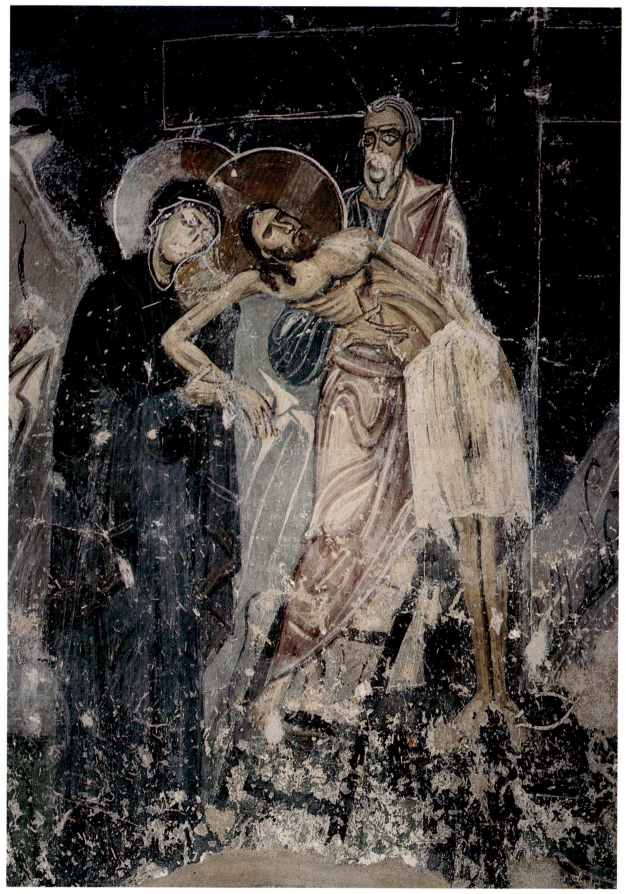

Plate 9. Deposition (J East), detail

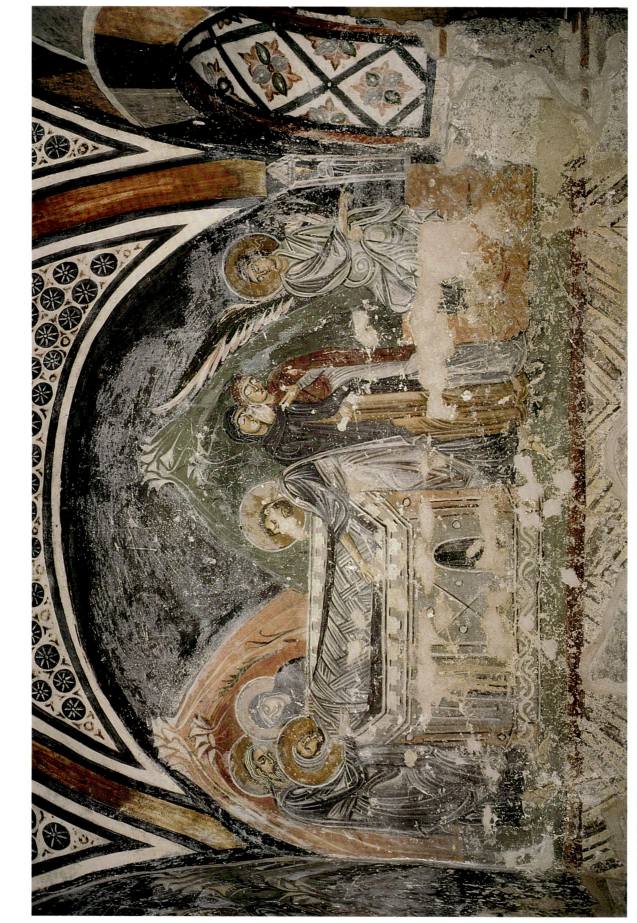

Plate 10. Burial; The Women at the Tomb (J South)

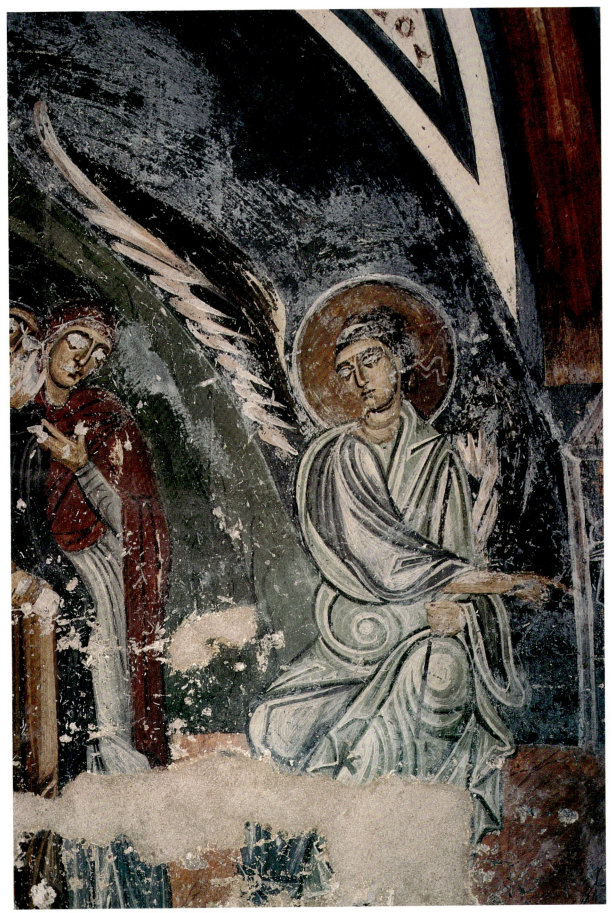

Plate 11. The Women at the Tomb (J South), detail

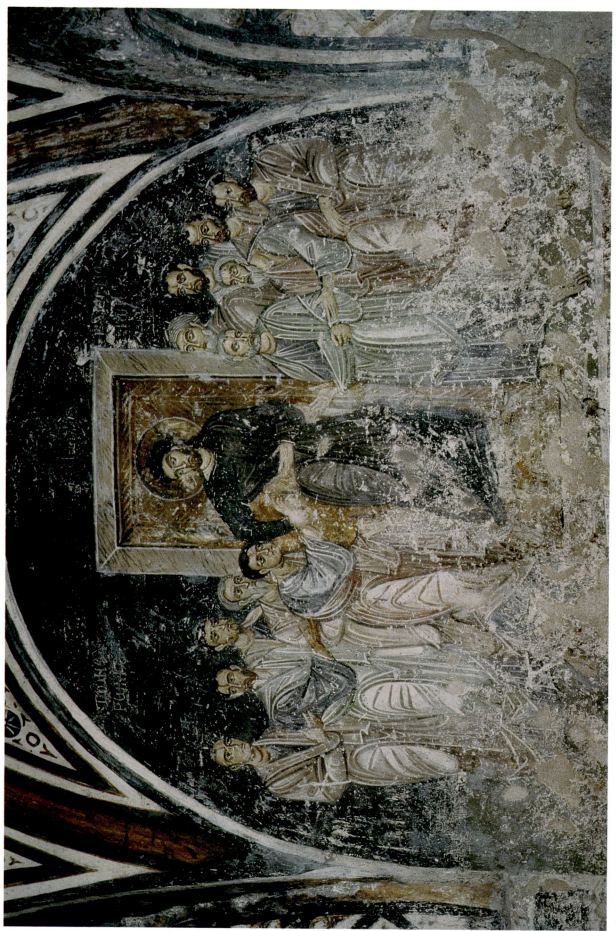

Plate 12. Incredulity of Thomas (H South)

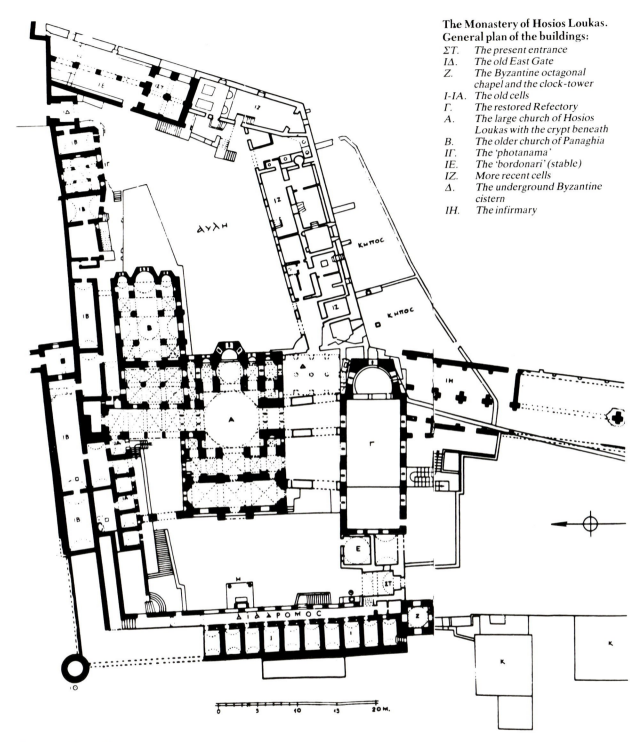

The Monastery of Hosios Loukas.
General plan of the buildings:

ΣΤ. *The present entrance*
ΙΔ. *The old East Gate*
Z. *The Byzantine octagonal*
chapel and the clock-tower
Ι-ΙΑ. *The old cells*
Γ. *The restored Refectory*
Α. *The large church of Hosios*
Loukas with the crypt beneath
Β. *The older church of Panaghia*
ΙΓ. *The 'photanama'*
ΙΕ. *The 'bordonari' (stable)*
ΙΖ. *More recent cells*
Δ. *The underground Byzantine*
cistern
ΙΗ. *The infirmary*

Figure 1. Plan of the monastery

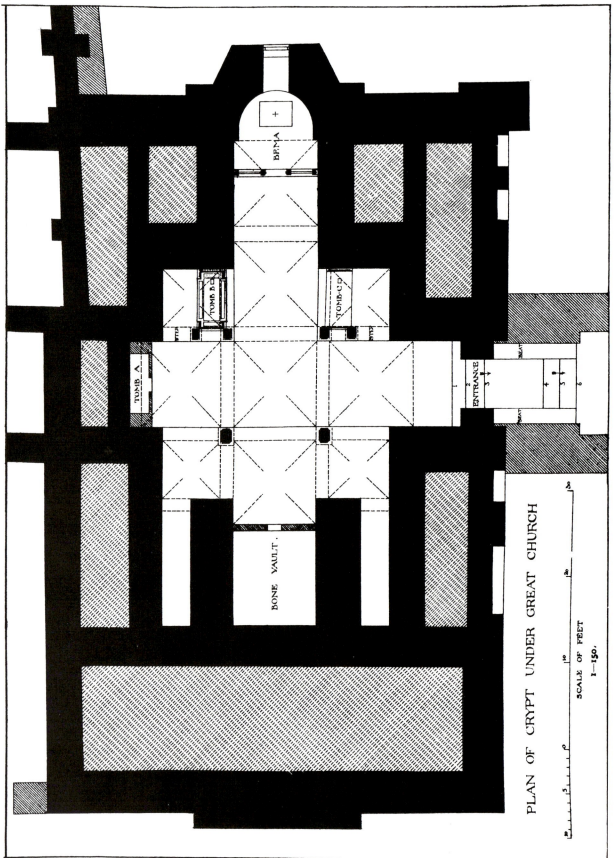

PLAN OF CRYPT UNDER GREAT CHURCH

SCALE OF FEET
1-150.

Figure 2. Plan of the crypt

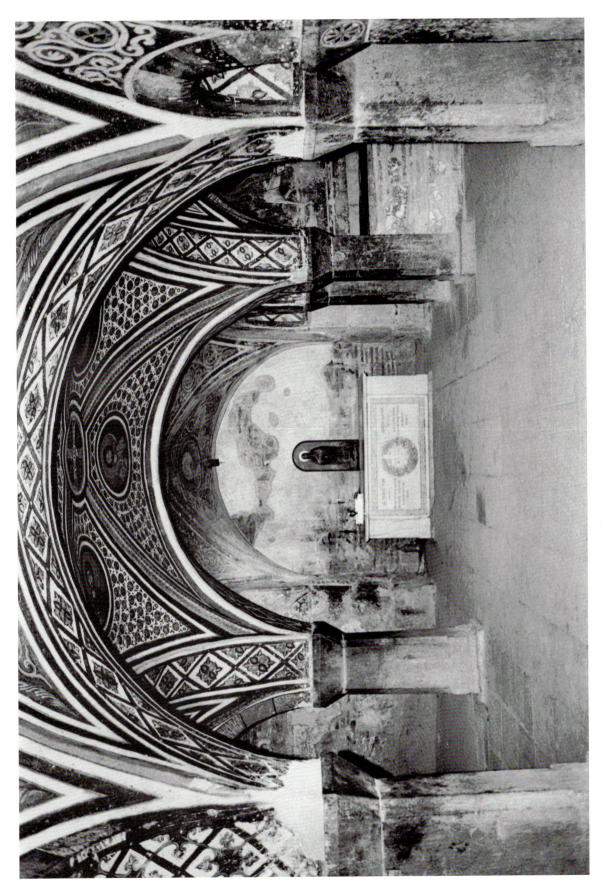

Figure 3. Interior view of the crypt, looking north, with the tomb of Holy Luke

Figure 4. Tomb in the northeast bay

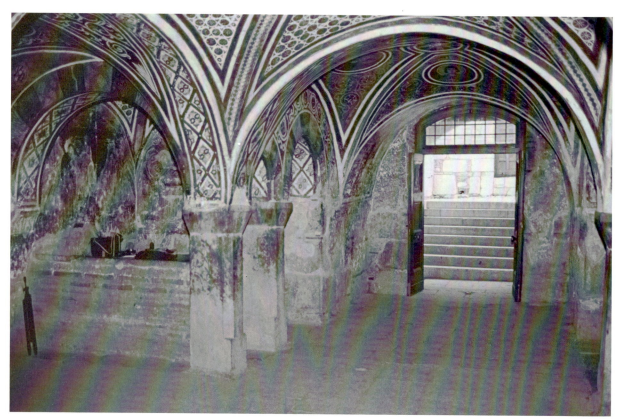

Figure 5. Interior view with the tomb in the southeast bay and entrance

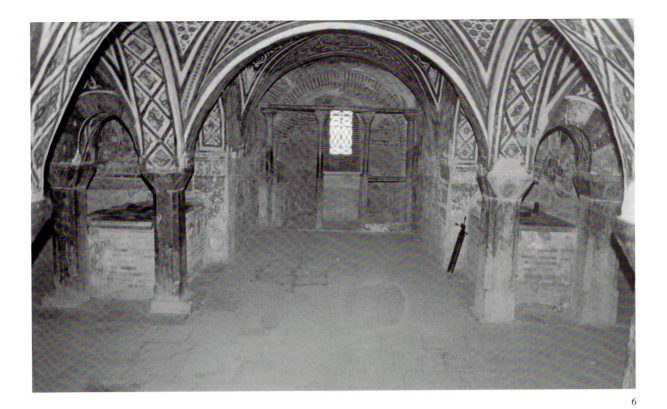

6

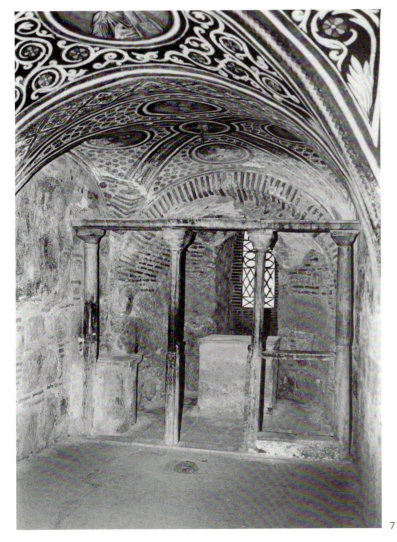

Figure 6. View east showing two tombs and sanctuary

Figure 7. Sanctuary of the crypt with templon barrier, altar, and shelf with prothesis niche

7

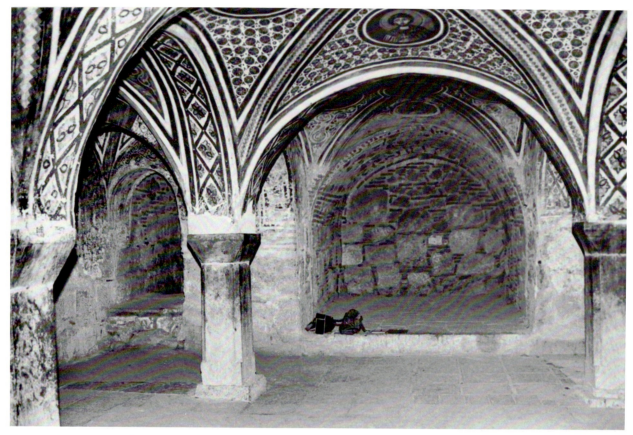

Figure 8. View west with ossuary vaults

Figure 9. Capital on the northeast pier of the crypt

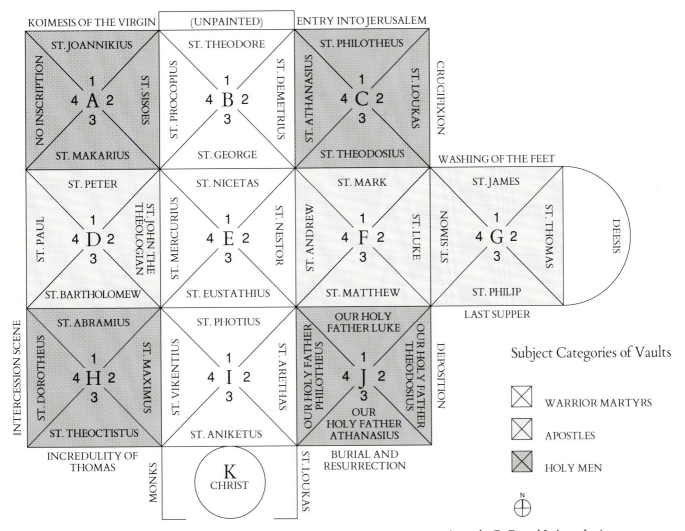

KOIMESIS OF THE VIRGIN (UNPAINTED) **ENTRY INTO JERUSALEM**

ST. JOANNIKIUS

NO INSCRIPTION 1 ST. SISOES
4 **A** 2
3

ST. MAKARIUS

ST. THEODORE

ST. PROCOPIUS 1 ST. DEMETRIUS
4 **B** 2
3

ST. GEORGE

ST. PHILOTHEUS

ST. ATHANASIUS 1 ST. LOUKAS
4 **C** 2
3

ST. THEODOSIUS **CRUCIFIXION**

WASHING OF THE FEET

ST. PETER

ST. PAUL 1 ST. JOHN THE THEOLOGIAN
4 **D** 2
3

ST. BARTHOLOMEW

ST. NICETAS

ST. MERCURIUS 1 ST. NESTOR
4 **E** 2
3

ST. EUSTATHIUS

ST. MARK

ST. ANDREW 1 ST. LUKE
4 **F** 2
3

ST. MATTHEW

ST. JAMES

ST. SIMON 1 ST. THOMAS
4 **G** 2
3

ST. PHILIP **DEESIS**

LAST SUPPER

INTERCESSION SCENE

ST. ABRAMIUS

ST. DOROTHEUS 1 ST. MAXIMUS
4 **H** 2
3

ST. THEOCTISTUS

ST. PHOTIUS

ST. VIKENTIUS 1 ST. ARETHAS
4 **I** 2
3

ST. ANIKETUS

OUR HOLY FATHER LUKE

OUR HOLY FATHER PHILOTHEUS 1 OUR HOLY FATHER THEODOSIUS
4 **J** 2
3

OUR HOLY FATHER ATHANASIUS **DEPOSITION**

INCREDULITY OF THUMAS ST. MONON **K CHRIST** ST. LOUKAS **BURIAL AND RESURRECTION**

Subject Categories of Vaults

☒ WARRIOR MARTYRS

☒ APOSTLES

☒ HOLY MEN

N

Figure 10. Schematic plan of the fresco decoration of the crypt. Warrior Martyrs appear in vaults B, E, and I; Apostles in D, F, and G; and Holy Men in A, C, H, and J.

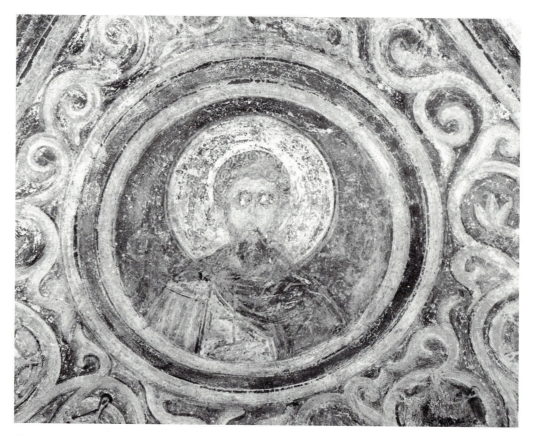

Figure 11. St. Theodore (B 1)

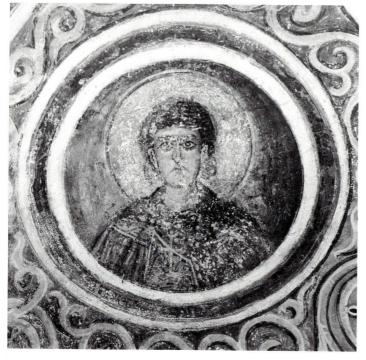

Figure 12. St. Demetrius (B 2)

Figure 13. St. Demetrius in infrared photograph

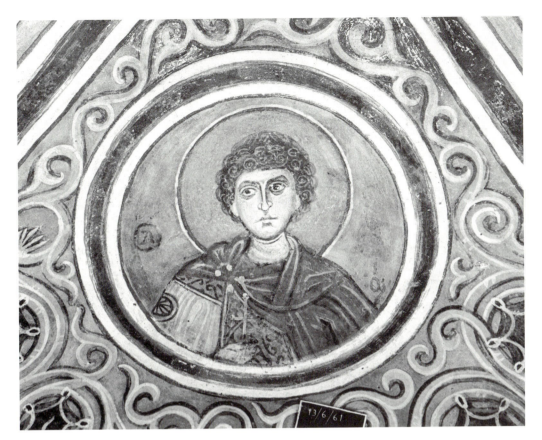

Figure 14. St. George (B 3)

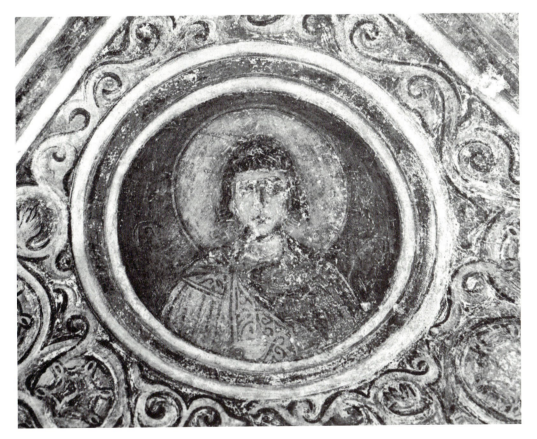

Figure 15. St. Procopius (B 4)

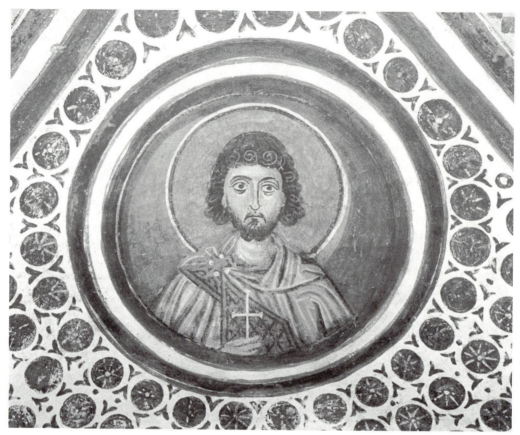

Figure 16. St. Nicetas (E 1)

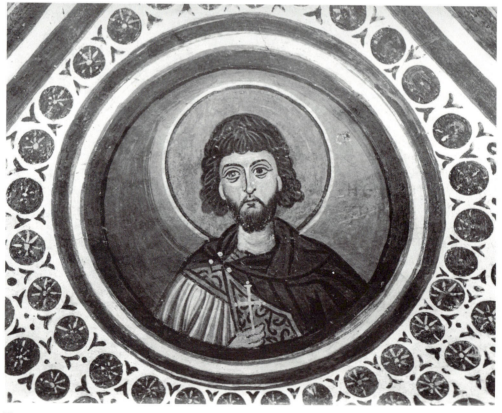

Figure 17. St. Nestor (E 2)

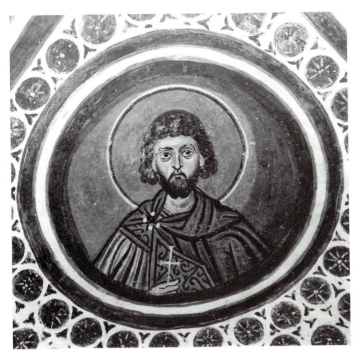

Figure 18. St. Eustathius (E 3)

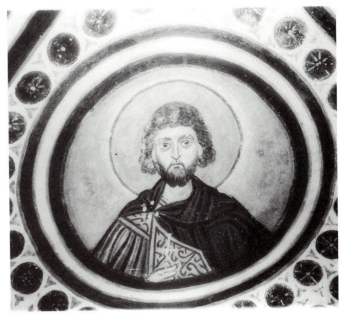

Figure 19. St. Eustathius in infrared photograph

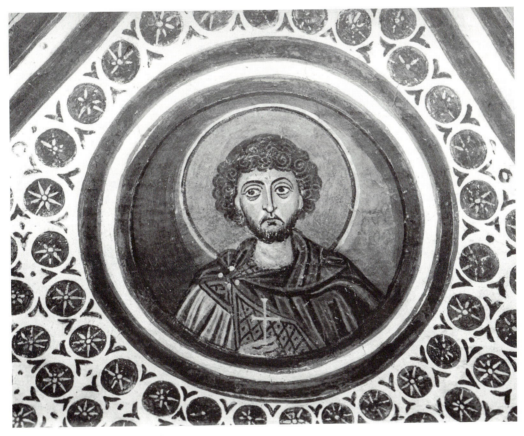

Figure 20. St. Mercurius (E 4)

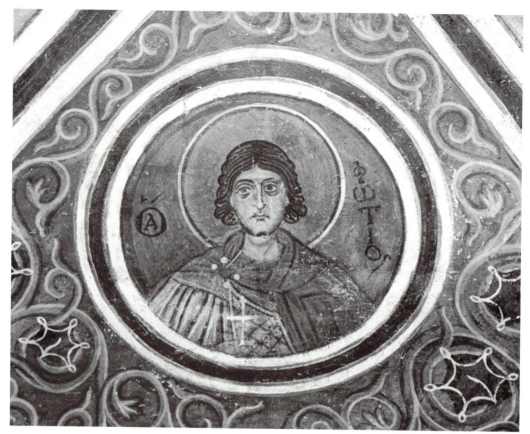

Figure 21. St. Photius (I 1)

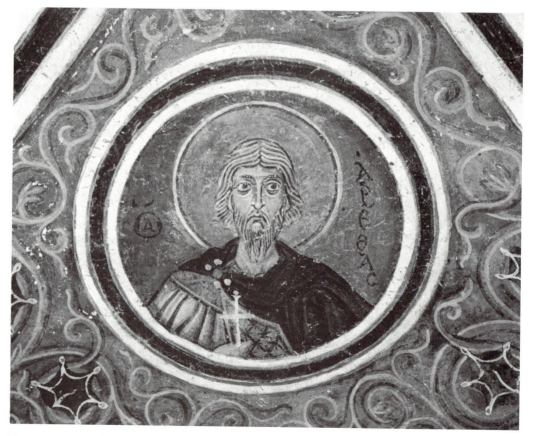

Figure 22. St. Arethas (I 2)

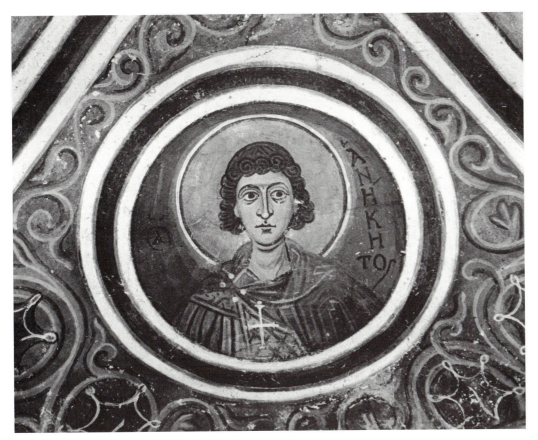

Figure 23. St. Aniketus (I 3)

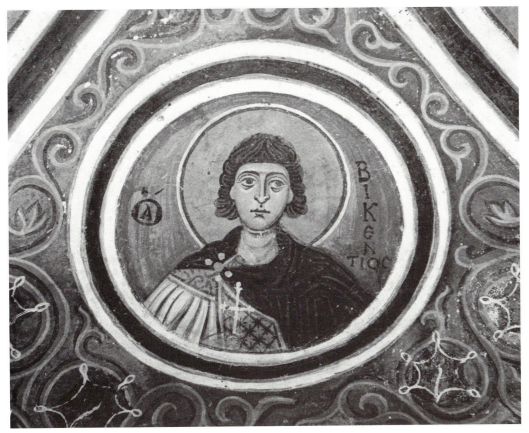

Figure 24. St. Vikentius (I 4)

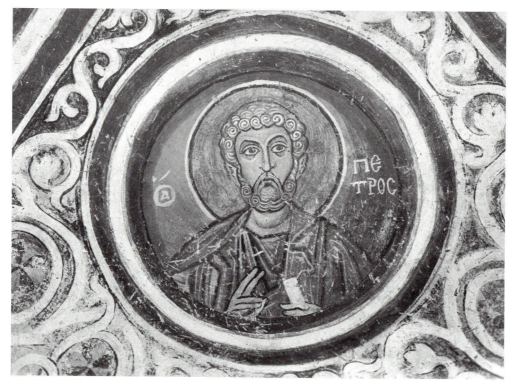

Figure 25. St. Peter (D 1)

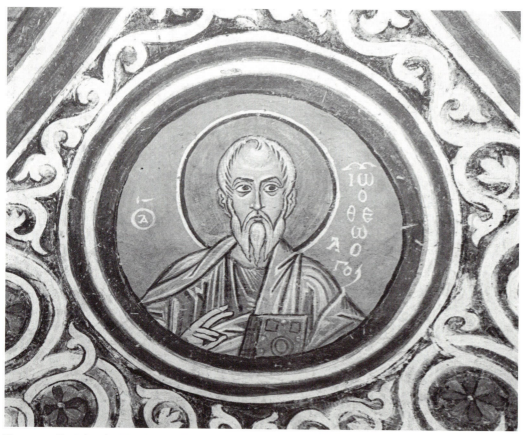

Figure 26. St. John the Theologian (D 2)

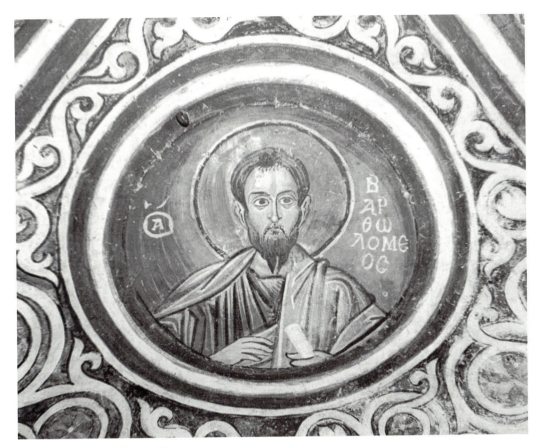

Figure 27. St. Bartholomew (D 3)

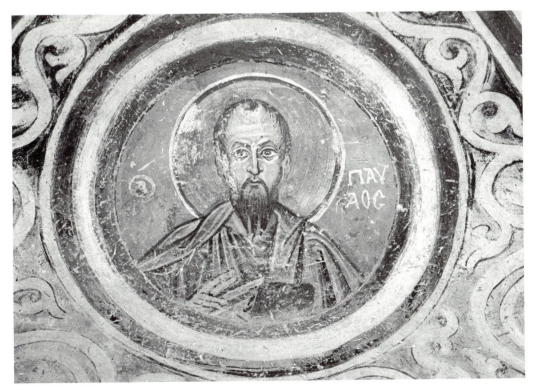

Figure 28. St. Paul (D 4)

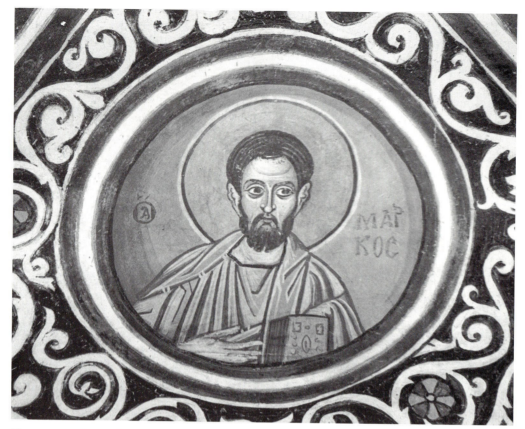

Figure 29. St. Mark (F 1)

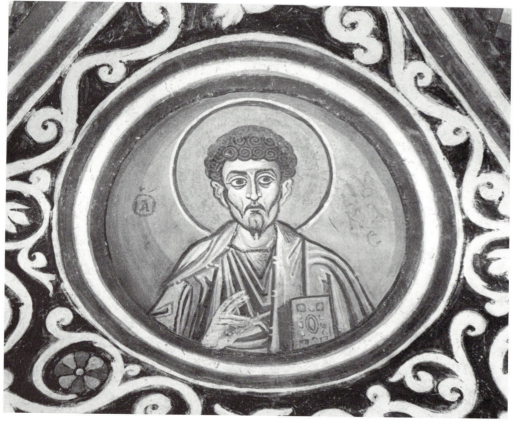

Figure 30. St. Luke (F 2)

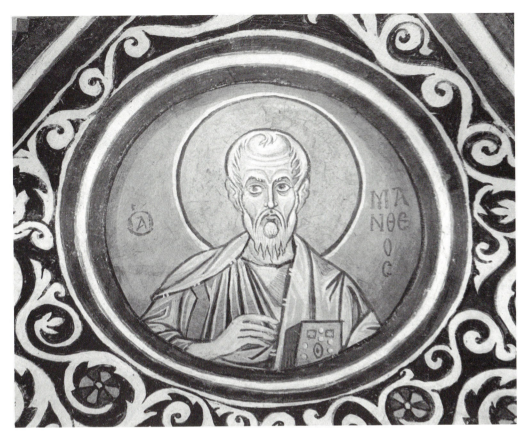

Figure 31. St. Matthew (F 3)

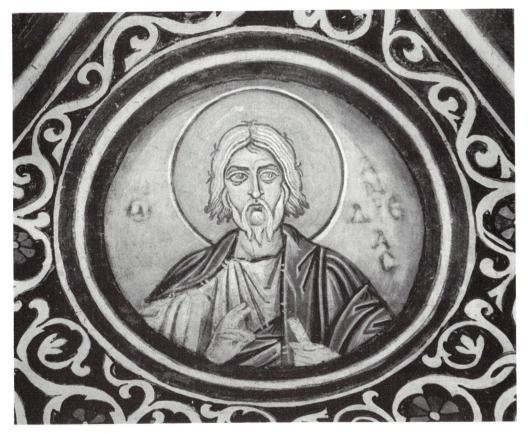

Figure 32. St. Andrew (F 4)

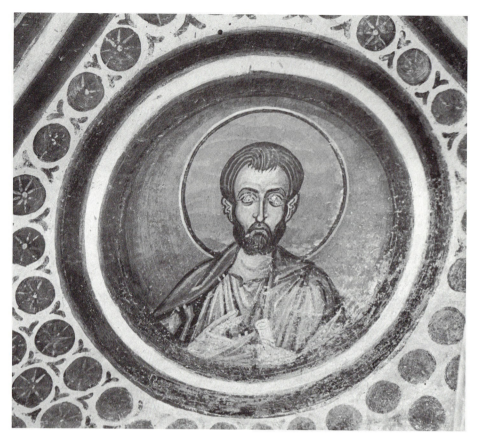

Figure 33. St. James (G 1)

Figure 34. St. Thomas (G 2)

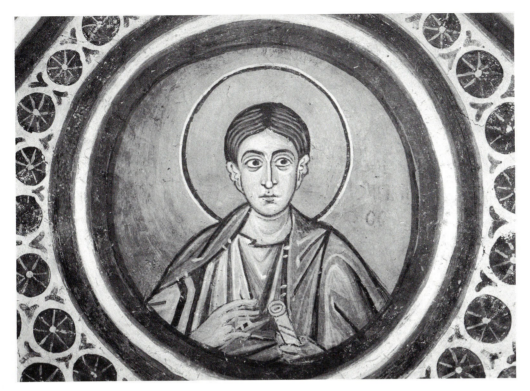

Figure 35. St. Philip (G 3)

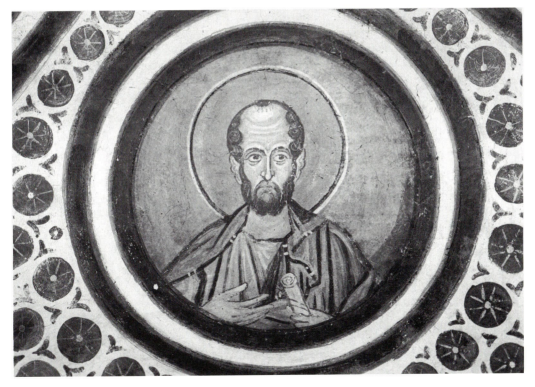

Figure 36. St. Simon (G 4)

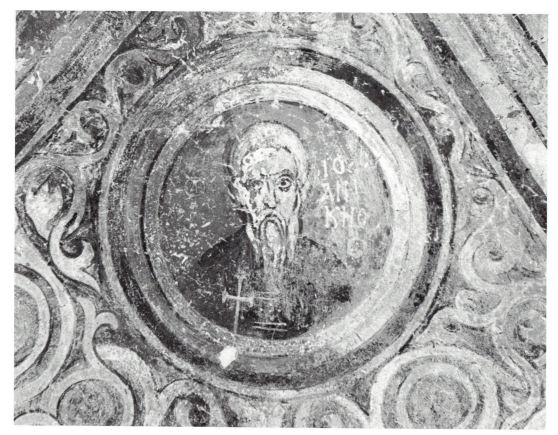

Figure 37. St. Joannikius (A 1)

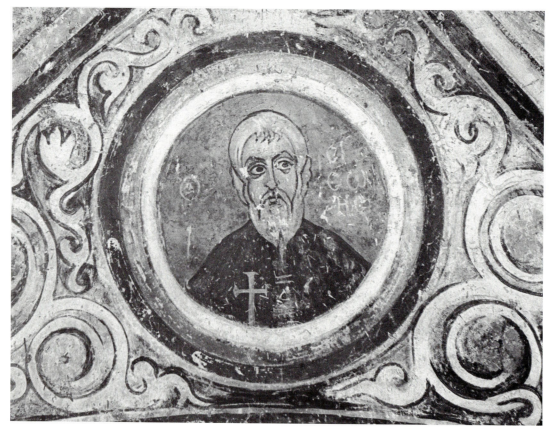

Figure 38. St. Sisoes (A 2)

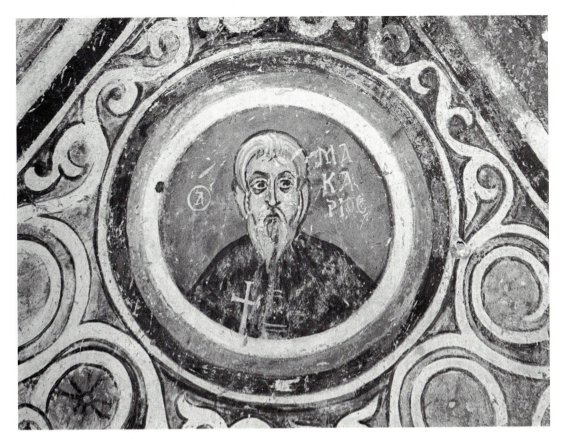

Figure 39. St. Makarius (A 3)

Figure 40. Unidentified saint (A 4)

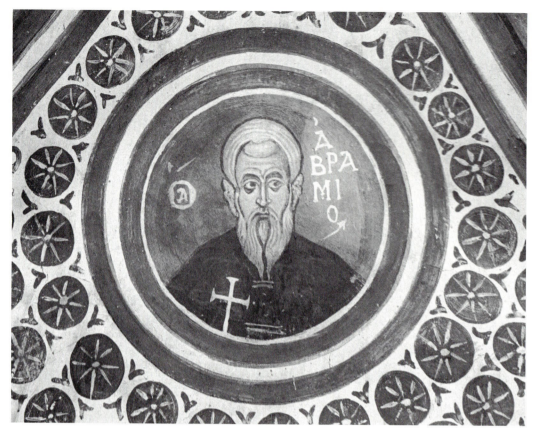

Figure 41. St. Abramius (H 1)

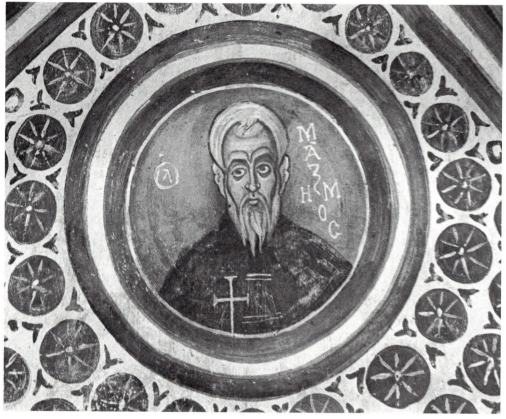

Figure 42. St. Maximus (H 2)

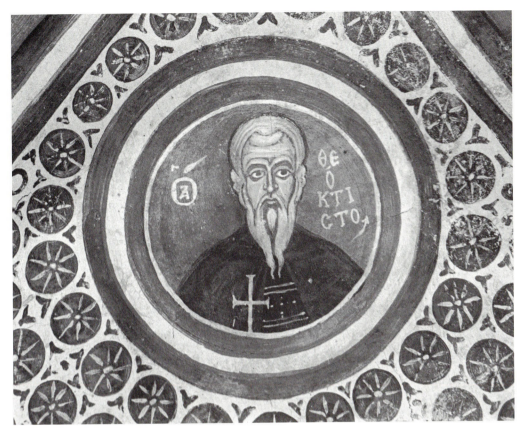

Figure 43. St. Theoctistus (H 3)

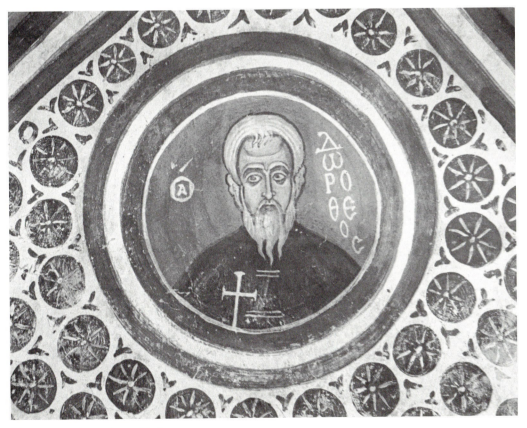

Figure 44. St. Dorotheus (H 4)

Figure 45. St. Philotheus (C 1)

Figure 46. St. Loukas (C 2)

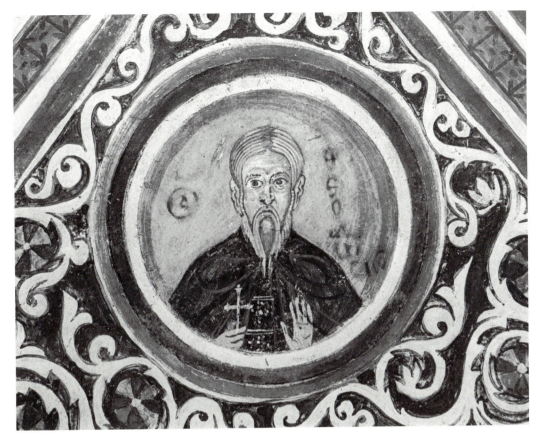

Figure 47. St. Theodosius (C 3)

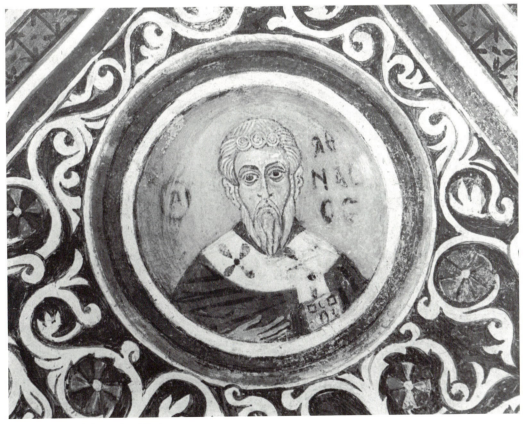

Figure 48. St. Athanasius (C 4)

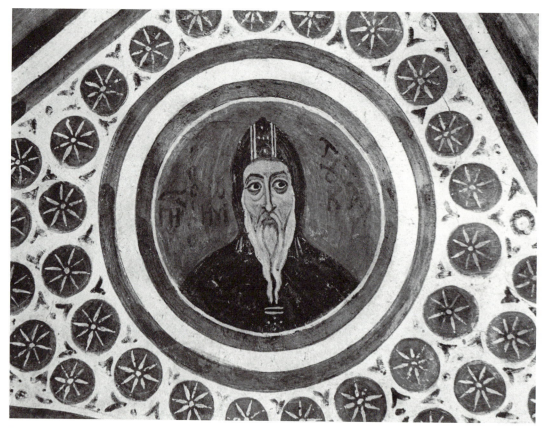

Figure 49. Our Holy Father Loukas (J 1)

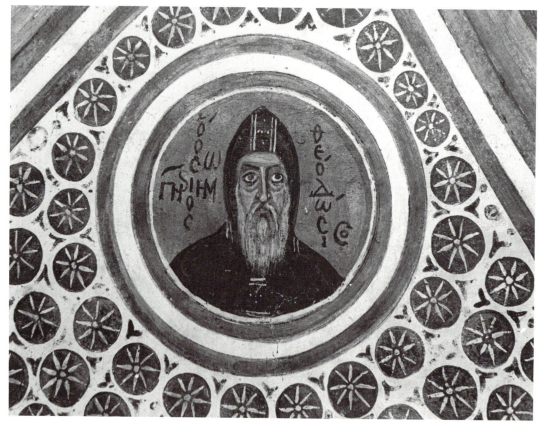

Figure 50. Our Holy Father Theodosius (J 2)

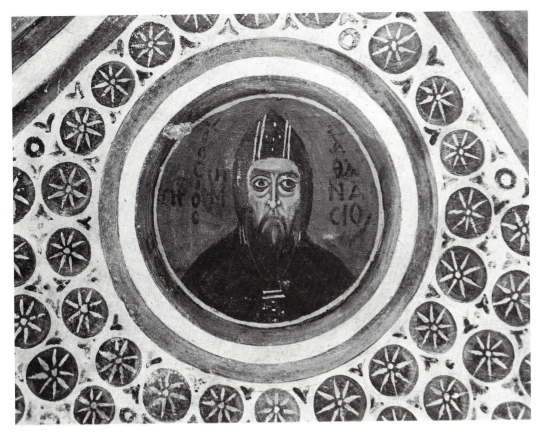

Figure 51. Our Holy Father Athanasius (J 3)

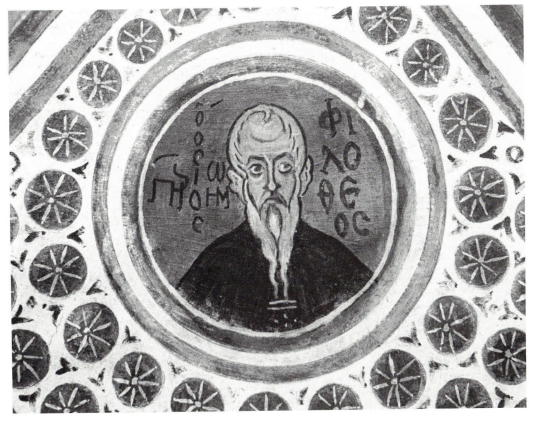

Figure 52. Our Holy Father Philotheus (J 4)

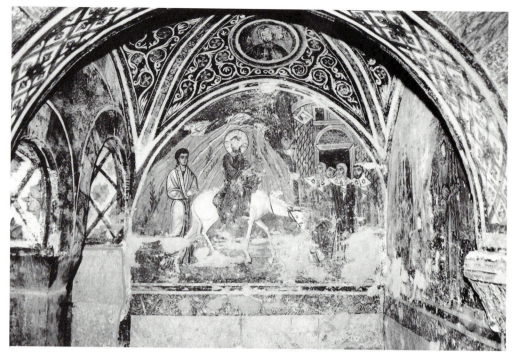

Figure 53. Christ's Entry into Jerusalem (C North)

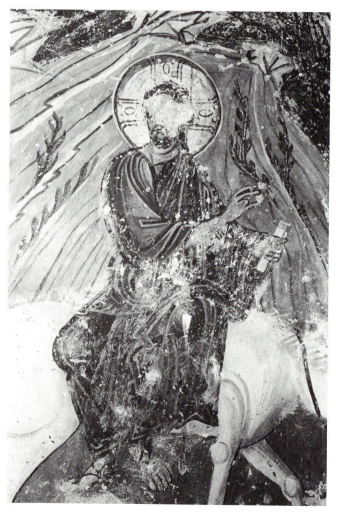

Figure 55. Entry into Jerusalem, detail: Christ

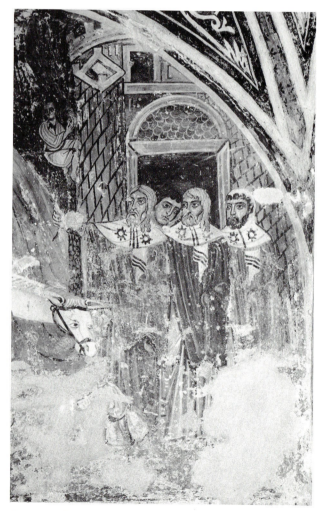

Figure 56. Entry into Jerusalem, detail: elders before the city

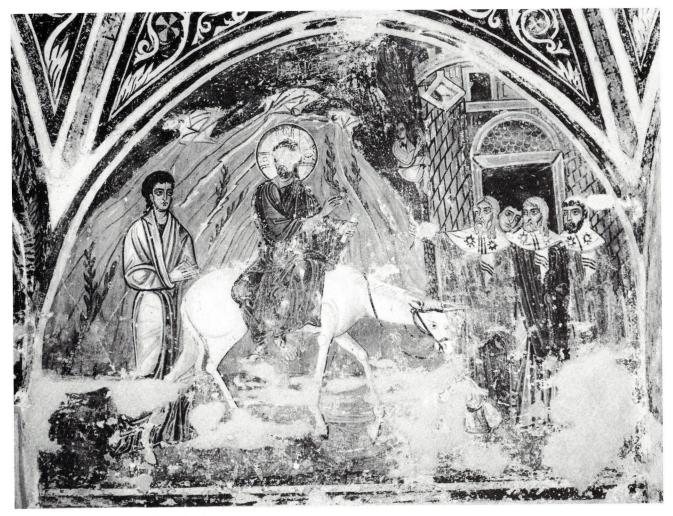

Figure 54. Entry into Jerusalem, detail

Figure 59. The Crucifixion, detail: St. John

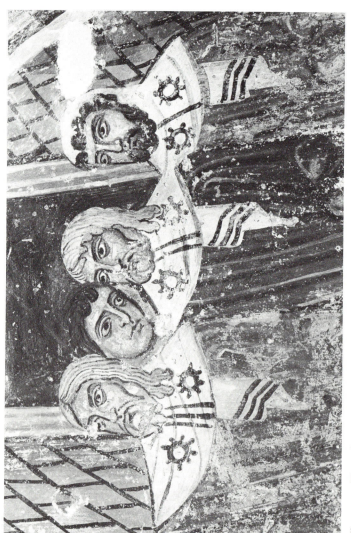

Figure 57. Entry into Jerusalem, detail: faces of the elders

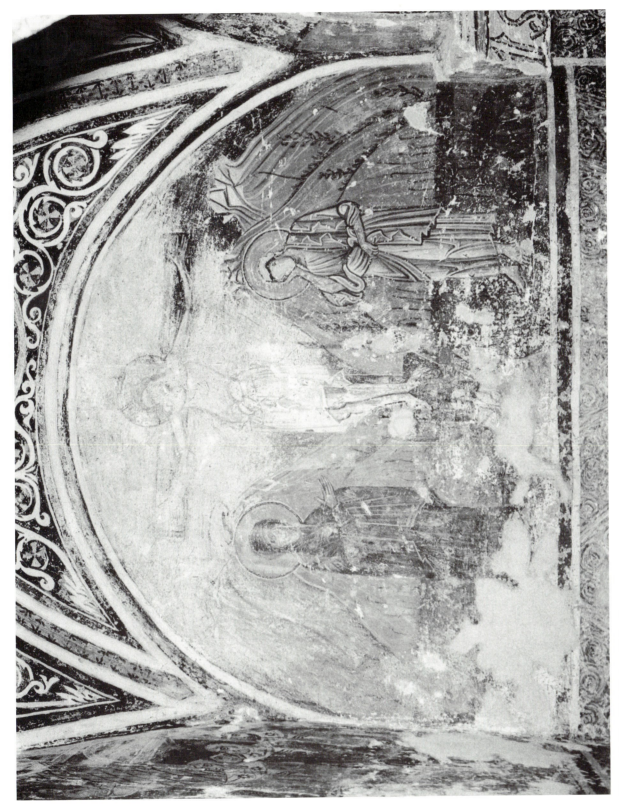

Figure 58. The Crucifixion (C East)

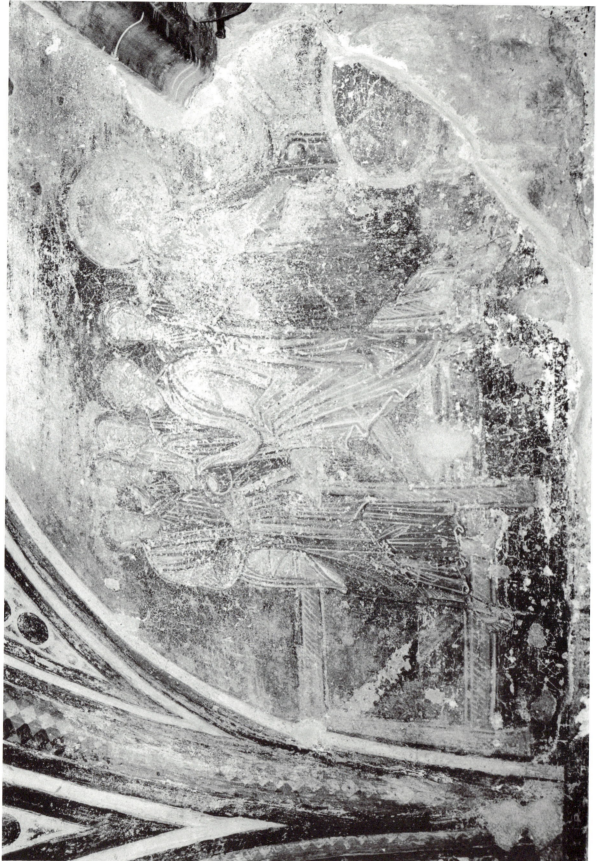

Figure 60. Christ Washing the Disciples' Feet (G North)

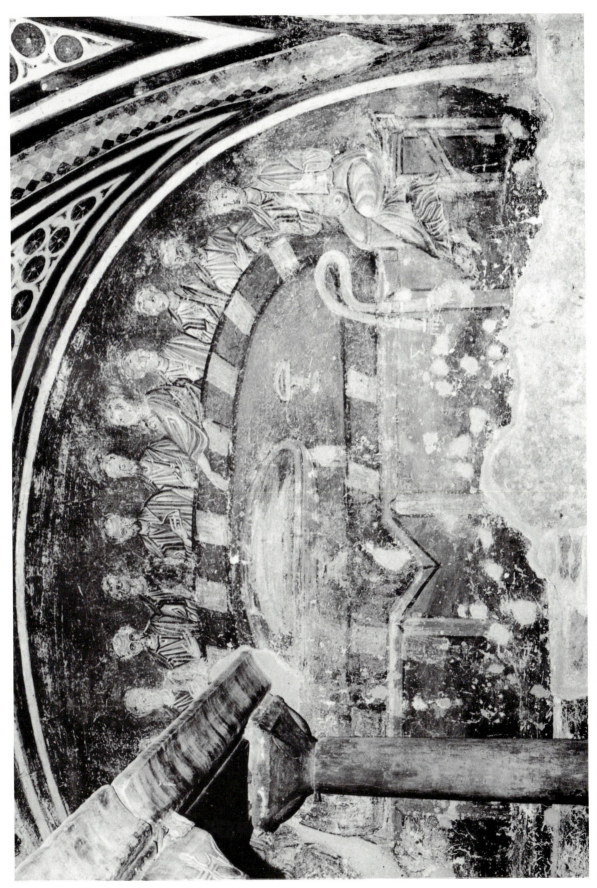

Figure 61. The Last Supper, right portion (G South)

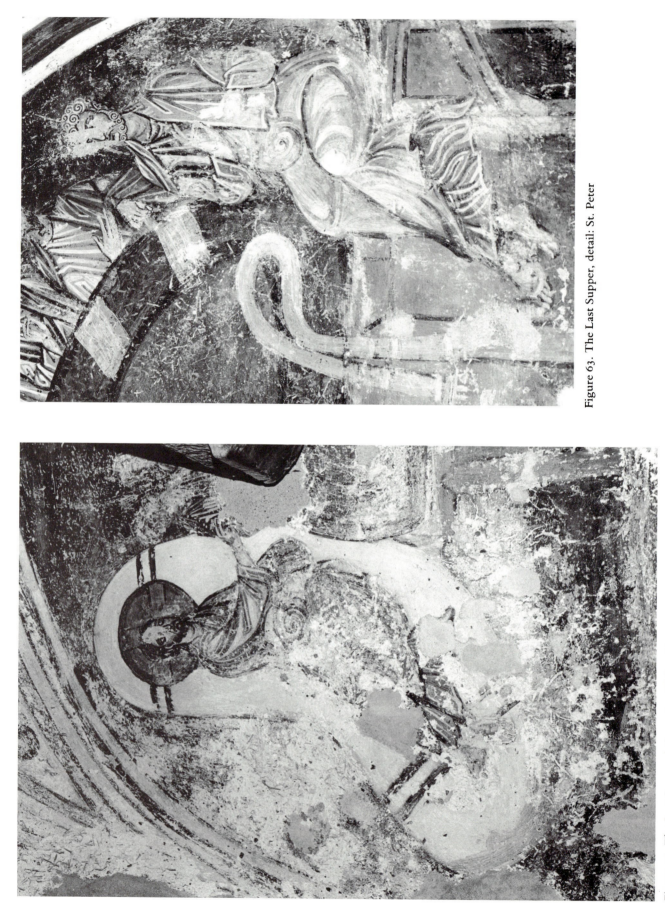

Figure 63. The Last Supper, detail: St. Peter

Figure 62. The Last Supper, left portion (G South)

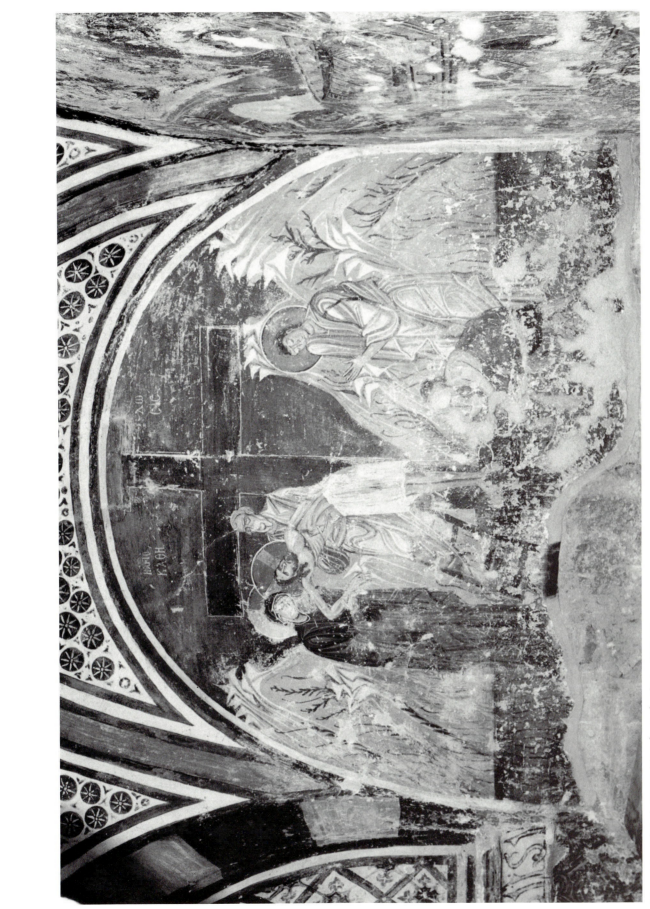

Figure 64. Christ's Deposition from the Cross (J East)

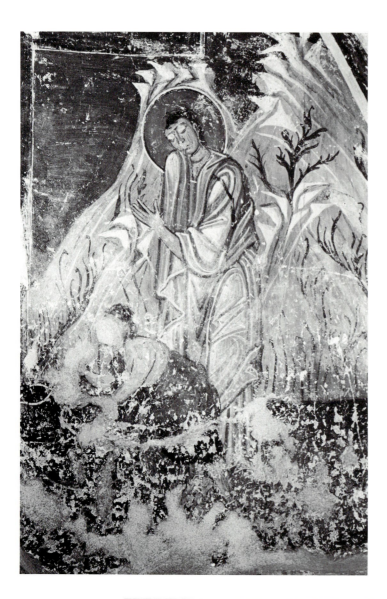

Figure 65. Deposition from the Cross, detail: St. John and an unidentified figure

Figure 66. Deposition from the Cross, detail

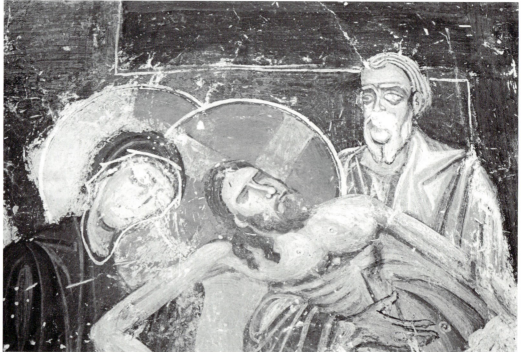

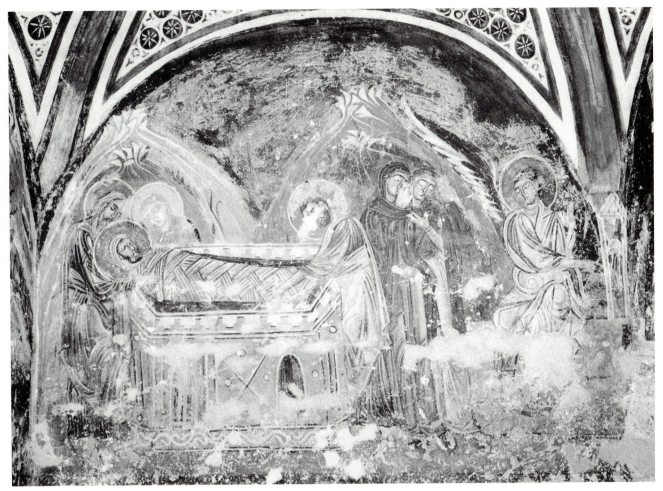

Figure 67. Burial of Christ; The Women at the Tomb (J South)

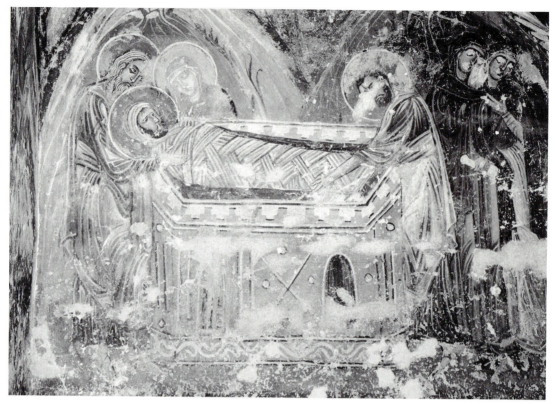

Figure 68. Burial of Christ

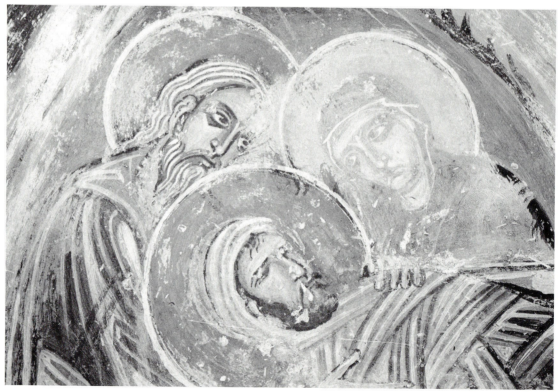

Figure 69. Burial of Christ, detail

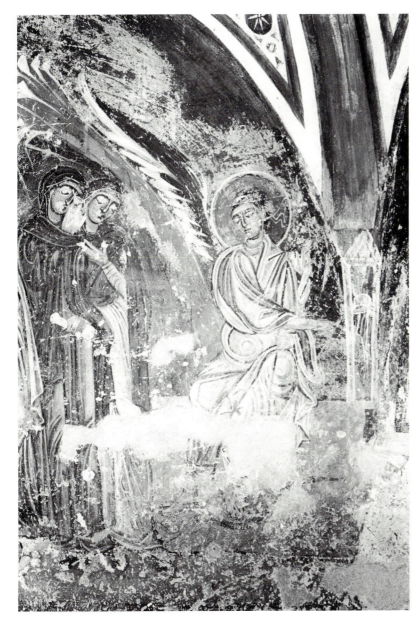

Figure 70. The Women at the Tomb

Figure 71. The Women at the Tomb, detail: the tomb

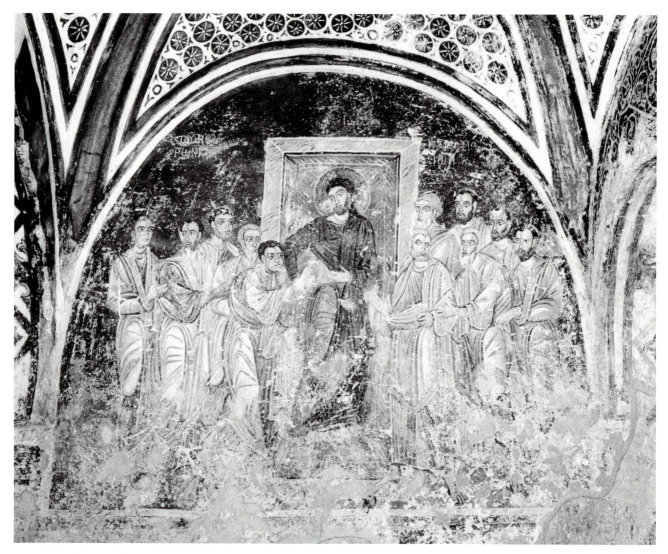

Figure 72. The Incredulity of Thomas (H South)

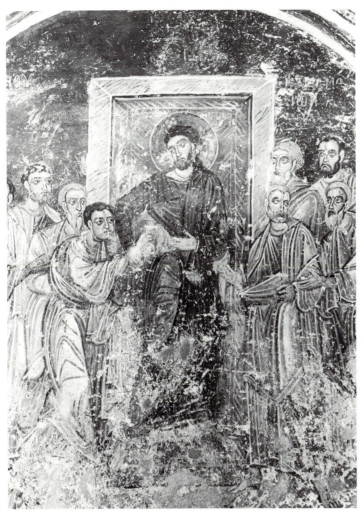

73

Figure 73. Incredulity of Thomas, detail

Figure 74. Incredulity of Thomas, detail

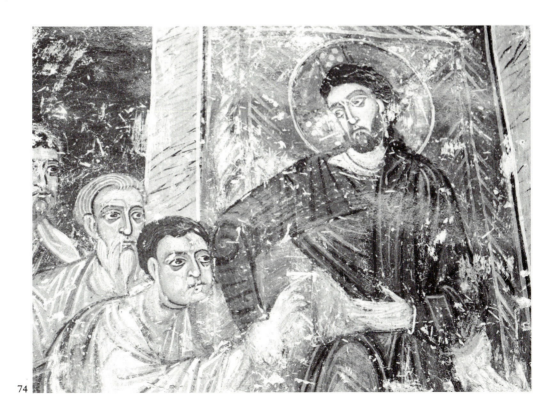

74

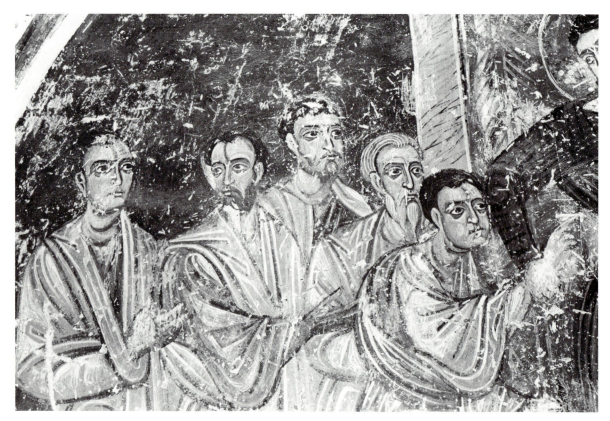

Figure 75. Incredulity of Thomas, detail: disciples

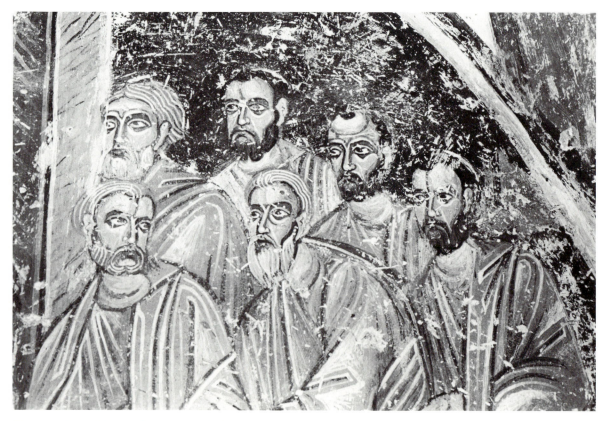

Figure 76. Incredulity of Thomas, detail: disciples

Figure 77. Koimesis of the Virgin

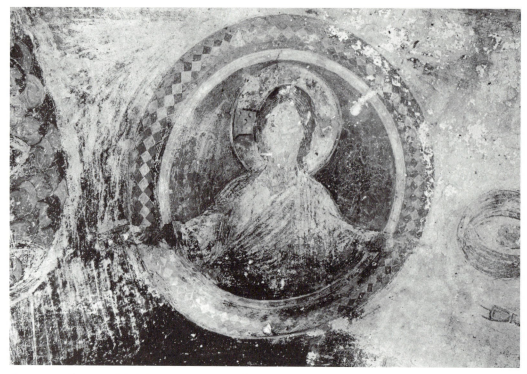

Figure 78. Christ in a Medallion (entrance vault K)

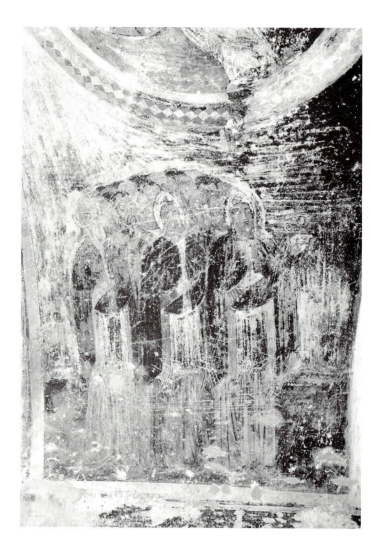

Figure 79. Group of Monks (K West)

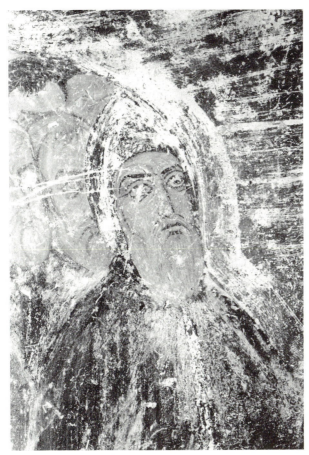

Figure 80. Group of Monks, detail: an abbot

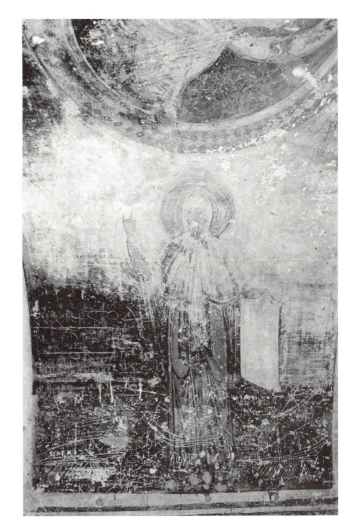

Figure 81. Holy Luke with a Scroll (K East)

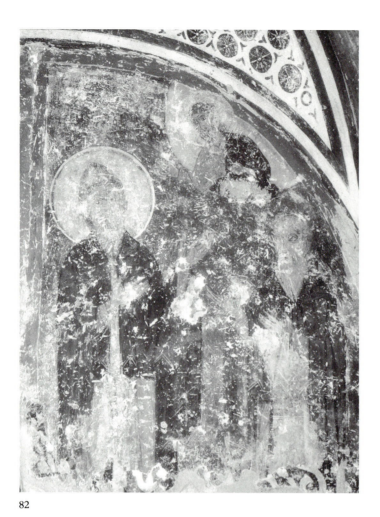

82

Figure 82. Intercession scene (H West)

Figure 83. Apse: last traces of a fresco of the Virgin of the Deesis

83

Figure 84. Ornament, Vault E

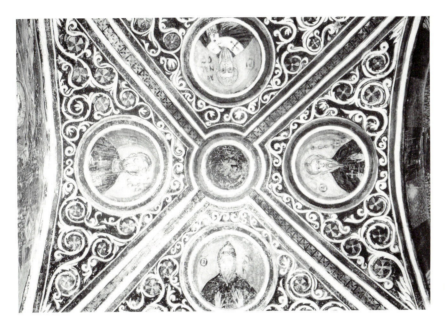

Figure 85. Ornament, Vault C

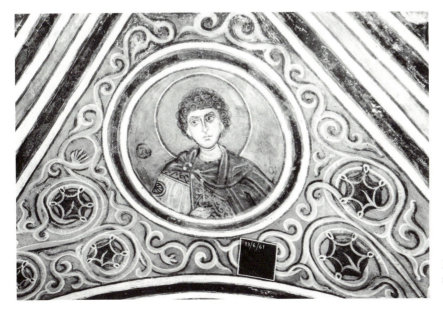

Figure 86. Ornament, Vault B
showing uncleaned patch

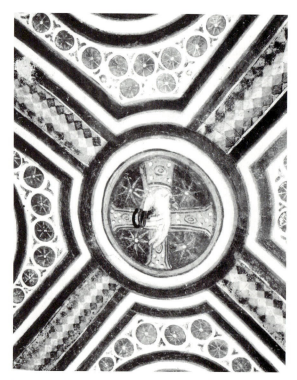

Figure 87. Cross, apex of Vault E

Figure 88. Hand of God, apex of Vault F

Figure 89. Ornament on soffit of arch

Figure 90. Ornament on soffit of arch

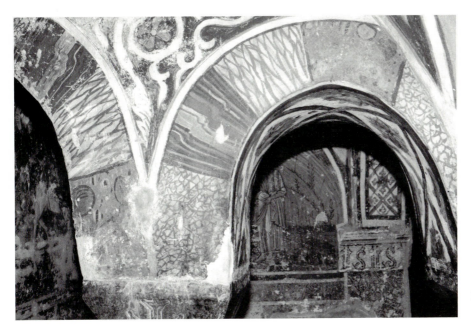

Figure 91. Imitation marble ornament

Figure 92. Imitation marble ornament

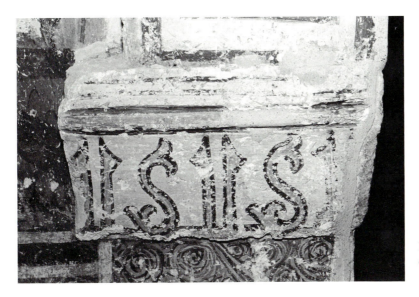

Figure 93. Pseudo-Kufic ornament
on impost

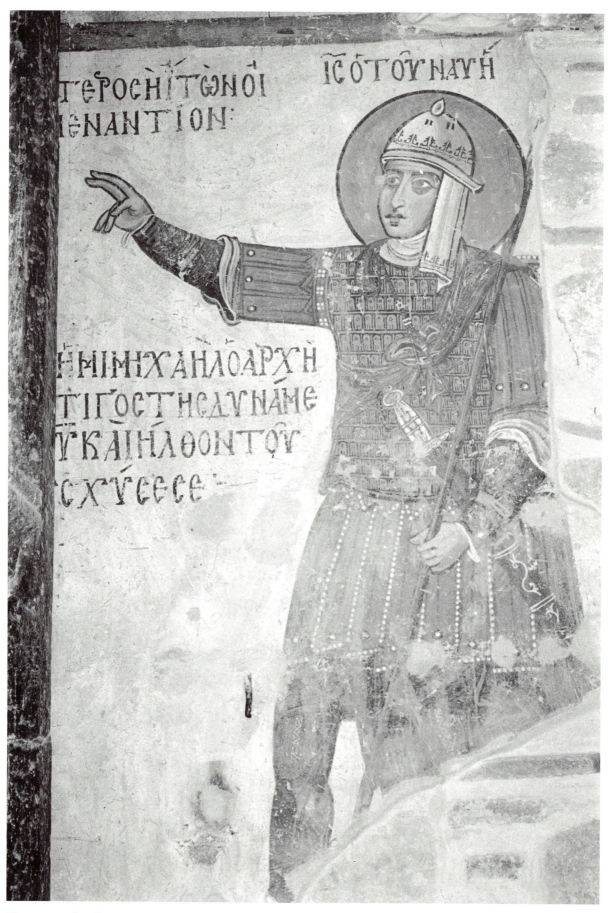

Figure 94. Joshua fresco, north arm of the Katholikon, Hosios Loukas

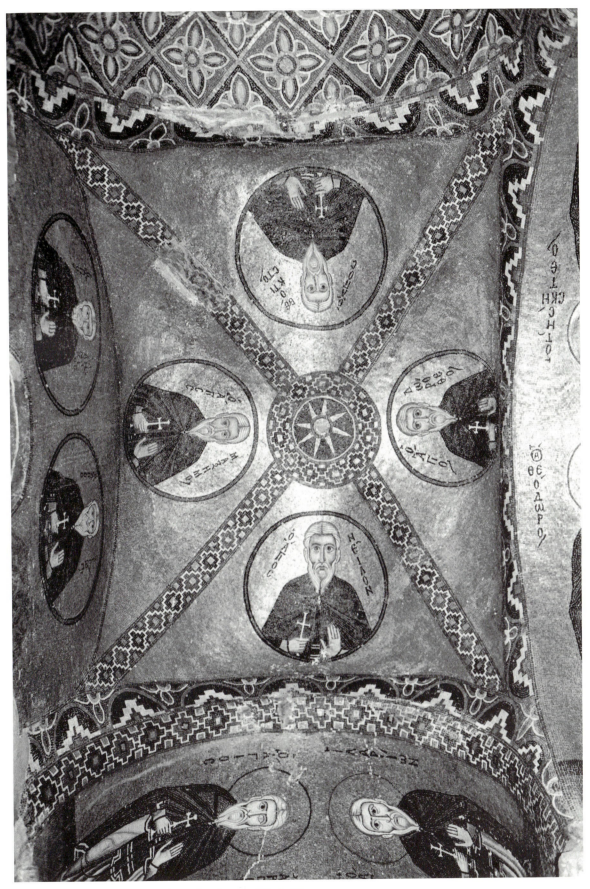

Figure 95. Holy men, mosaics in vault of naos of Katholikon

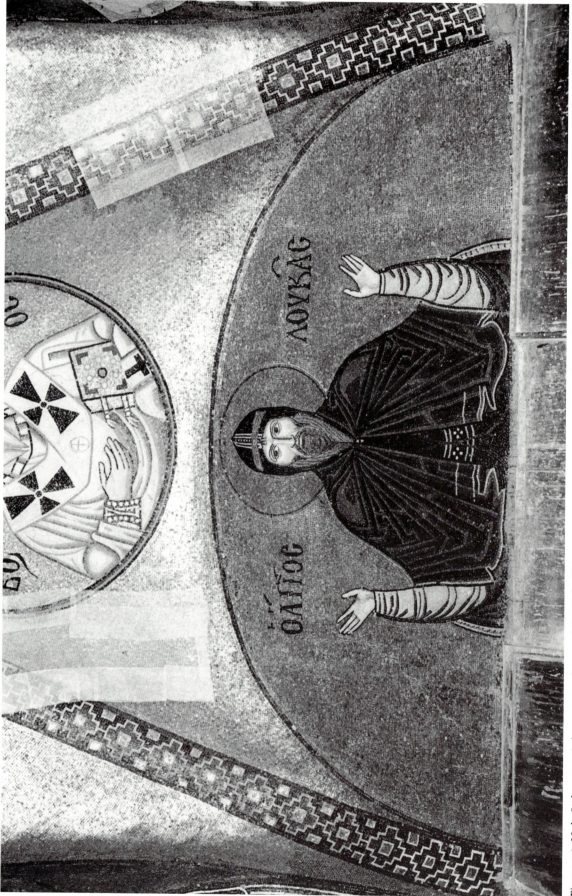

Figure 96. Holy Luke, mosaic lunette, north arm of the Katholikon

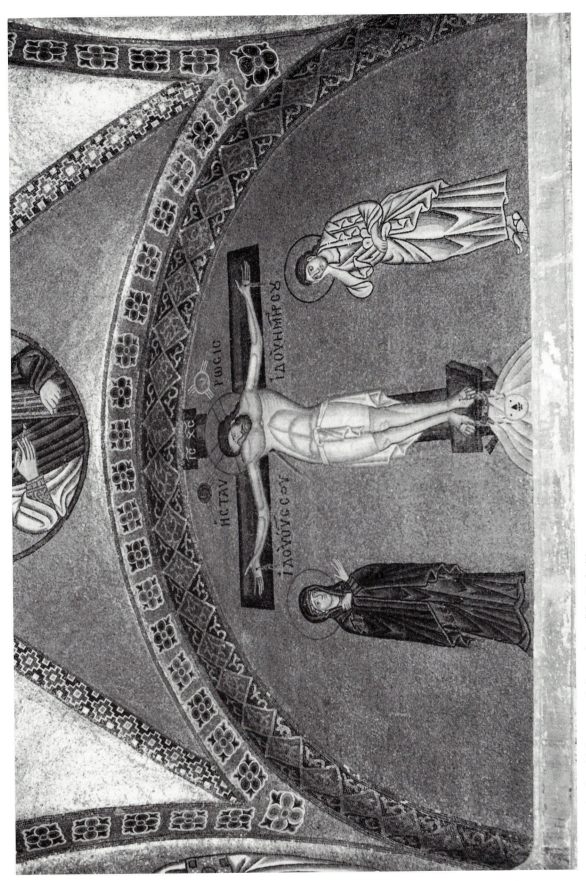

Figure 97. The Crucifixion, mosaic in narthex of the Katholikon

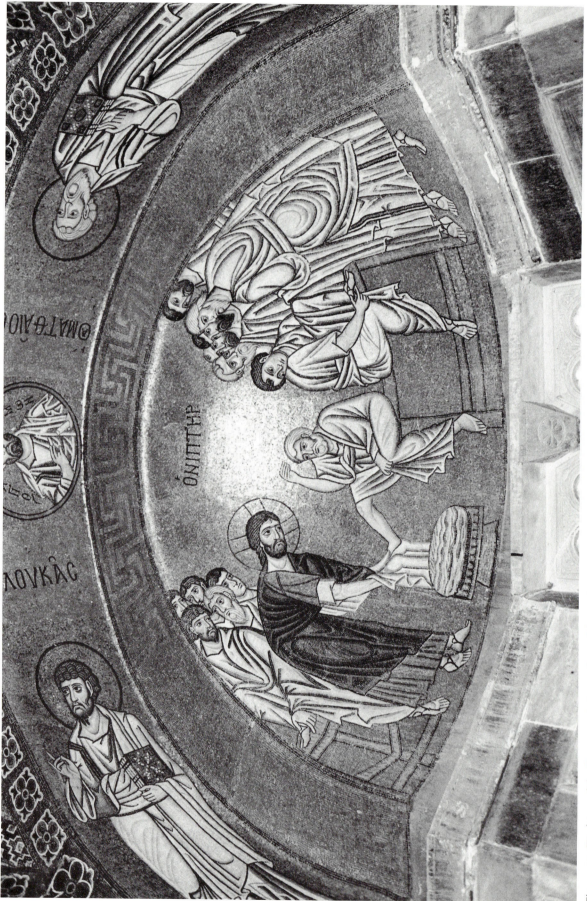

Figure 98. Washing of the Feet, mosaic in narthex of the Katholikon

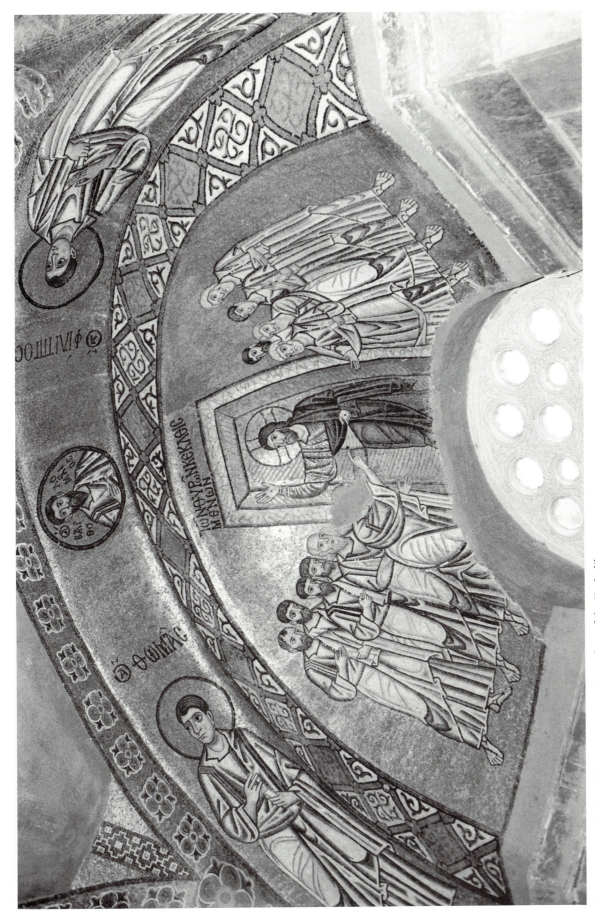

Figure 99. Incredulity of Thomas, mosaic in narthex of the Katholikon

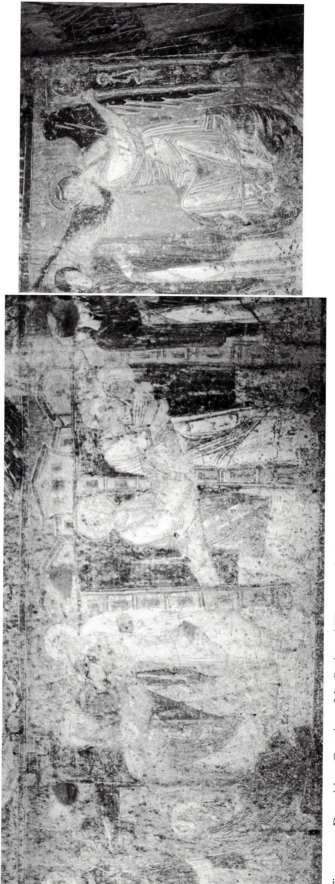

Figure 100. Deposition, Carrying of the Body and Women at the Tomb, fresco at Çavuşin in Cappadocia